SYMBOLS IN STONE

Symbolism on the Early Temples of the Restoration

SYMBOLS IN STONE

Symbolism on the Early Temples of the Restoration

Matthew B. Brown

Paul Thomas Smith

Covenant Communications, Inc.

Pictures and Illustrations

The pictures and illustrations for this book have been generously provided by a number of individuals and institutions. The architectural drawings for the Nauvoo and Salt Lake temples, as well as the pictures of Brigham Young, Joseph Smith's Mansion House rainspout (decorated with the sun, moon, and stars), the plat of the City of Zion, and the Salt Lake Temple's electrician hanging from the spire, were all provided by the Historical Department of The Church of Jesus Christ of Latter-day Saints and the LDS Church Museum of History and Art.

Pictures of the Salt Lake Temple's symbols were graciously provided by Jerry Silver, and the photograph of the Nauvoo temple sunstone replica was taken by Michael P. Lyon. The photograph of Wilford Woodruff and his crown comes from the old Coalville, Utah, tabernacle and was provided by the Utah State Historical Society. Ron Romig of the RLDS Church Archives provided permission for the publication of the interior photographs of the Kirtland Temple. Finally, the drawings of the Kirtland Temple symbols, the Nauvoo Temple baptismal font, and the moonstone course of the Salt Lake Temple were rendered by Matthew B. Brown.

Published by Covenant Communications, Inc.
American Fork, Utah

First Printing: August 1997

 04 10 9 8 7 6

ISBN 1-57734-134-1

Printed in Canada

CONTENTS

ABBREVIATIONS

BYUS	*Brigham Young University Studies*
CHC	*Comprehensive History of the Church*
CR	*Conference Report*
DNTC	*Doctrinal New Testament Commentary*
DS	*Doctrines of Salvation*
HC	*History of the Church*
IE	*Improvement Era*
JBMS	*Journal of Book of Mormon Studies*
JD	*Journal of Discourses*
JI	*Juvenile Instructor*
JS-H	Joseph Smith—History
JST	Joseph Smith Translation
MD	*Mormon Doctrine*
MS	*Millennial Star*
NWAF	*New Witness for the Articles of Faith*
TS	*Times and Seasons*
TPJS	*Teachings of the Prophet Joseph Smith*
WJS	*The Words of Joseph Smith*

INTRODUCTION

The Salt Lake Temple is perhaps the most widely recognized symbol of The Church of Jesus Christ of Latter-day Saints. Visitors to Temple Square can often be seen looking upward at its majestic beauty and towering grandeur. One cannot help but see the golden angel shining brightly atop the highest spire, but there are also many other symbols that adorn the temple's exterior. Questions naturally arise among those who view these emblems. Where did they come from? Who placed them there? Why do they adorn the temple? What do they mean? The purpose of this book is to provide some meaningful answers to these interesting questions.

Because this is such a unique subject, we decided that the approach of this book should be unique as well. Three different perspectives have therefore been applied to this study. The first perspective is historical. This book will examine the New Jerusalem, Kirtland, and Nauvoo temples in order to explain the influences that each had upon the symbolism of the house of the Lord in Salt Lake City. We will also demonstrate throughout this study that many of the symbols incorporated into early LDS temples were also in use among the ancient Hebrews and early Christians. In many respects, these visual devices can be considered as part of the latter-day restoration of the gospel.

The second perspective is doctrinal. Since gospel symbols are designed to be teaching devices, an understanding of their underlying doctrines is critical if they are to be interpreted with any degree of validity. The doctrines that are evoked by these symbols will be discussed through the use of numerous scriptural citations and the teachings of the Lord's prophets.

The third perspective is spiritual. Many accounts of spiritual manifestations have been included in this book because of their relationship to the figures that are under discussion. These singular experiences will help to breathe life and meaning into these emblems and help the reader to see them in a broader, eternal context.

Several of the topics that will be discussed in this book include: the many symbols that are found inside the Kirtland Temple; the horizontal angels that were planned for the spires of the Nauvoo and Salt Lake temples; the latter-day temples that were seen in vision prior to their construction; the interpretation of the Salt Lake Temple's cloudstones; several little-known visions given to the Prophet Joseph Smith regarding the Lord's sanctuaries; the reason why twenty-four temples were once planned for Jackson County, Missouri, and why that particular location is considered to be so holy; the royal symbolism of the beehive; the connection between the pulpits inside the Kirtland Temple and the Mount of Transfiguration; the many visions that were seen regarding the Salt Lake Temple and Isaiah's personal involvement in those revelations; the meaning of the inverted stars on the Nauvoo and Salt Lake temples; the misidentification of the angel that visited the Kirtland Temple during its dedicatory services; the reason why statues of Joseph and Hyrum Smith once stood at the eastern doors of the Salt Lake Temple; the meaning of the emblems that adorn the Nauvoo Temple's sunstones; the symbols originally planned for the Salt Lake Temple that were never actually incorporated into the facade; and the connection between the symbols of the Nauvoo Temple and the vision of John the Revelator.

We would like to extend our appreciation to the many people who have helped and encouraged us during this project. First and foremost, we would like to thank our families who have endured the process of publication. We also greatly appreciate the cooperation of the staff members of the LDS Church Historical Department, the LDS Church Museum of History and Art, the Utah State Historical Society, the Harold B. Lee Library at Brigham Young University, and the J. Willard Marriott Library at the University of Utah. We are grateful for the assistance that was given to us by the staff of the Kirtland Temple Historic Center and the RLDS Church Archives. Our gratitude also goes out to those individuals who critiqued this work in its many forms and offered their valuable insights and suggestions. Finally, we could not have brought this work to completion without those who provided the wonderful photographs, editing, and production. Our special thanks to Valerie Holladay for her editing and Mike Johnson for his production and design.

There are two important items that must be noted at this point. First, we have decided to standardize the spelling, punctuation, and grammar of all quotations taken from early sources in order to ensure the flow of the text. Second, the reader should not fail to explore the extensive endnotes found after each chapter because they contain a large amount of valuable information that was simply too cumber-

some to be placed in the main body of the book.

Although the views expressed in this volume are the sole responsibility of the authors and do not necessarily reflect the official views of the LDS Church or any other entity, we can reassure the reader that throughout this endeavor we have diligently sought wisdom "out of the best books" and our learning has come "by study and also by faith" (D&C 88:118). It is our sincere hope that the information presented within these pages will help the reader to see temples, symbols, and the gospel of Jesus Christ in a brighter light.

CHAPTER 1
The Language of Symbolism

And behold, all things have their likeness, and all things are created and made to bear record of me. (Moses 6:63)

In July of 1996, the prime minister of England announced that after seven hundred long years a sacred relic called the Stone of Destiny would finally be returned to its rightful home in Scotland. According to legend, the Patriarch Jacob was sleeping upon this rock when he saw the Lord in a glorious vision and received the blessings of the Abrahamic Covenant. One of the blessings of the covenant was the divine conferral of royal status (see Genesis 28:10-19; 32:24-30; Abraham 1:2).[1] Because the Stone of Destiny signified this idea, it was used for centuries in the coronation rites of the Scottish kings. Realizing its great symbolic power, King Edward I of England plundered the rock in 1296 A.D. Thirty-five English kings and queens were subsequently coronated while seated upon a chair that held the stone beneath it. The English and the Scots have cherished this very ordinary object for centuries because of its extraordinary symbolism.

Indeed, symbols can be powerful devices. One symbol can represent many ideas or concepts, stir a multitude of emotions, remind us of lessons once learned, instruct on several different levels of understanding, and even motivate us to action. The dove is one example of how a symbol can enlighten our understanding of gospel doctrine. The dove is one of the symbols of the Holy Ghost[2] and the Prophet Joseph Smith taught that the sign of the dove was manifest during the baptism of Jesus Christ as a divine witness.

Instituted before the creation of the world, the sign of the dove is a witness for the Holy Ghost; the devil cannot come in the sign of a dove. As a personage who is in the form of a

personage, the Holy Ghost cannot be transformed into a dove. It does not therefore confine itself to the *form* of the dove, but rather to the *sign* of the dove. The sign of a dove was given to John to signify the truth of the deed, as the dove is an emblem or token of truth and innocence.[3]

The Holy Ghost is compared with a dove in several of the scriptures that refer to the baptism of Jesus Christ (see Matthew 3:16; Mark 1:10; Luke 3:22; John 1:32; 1 Nephi 11:27; D&C 93:15). There are several possible reasons for the dove's connection with baptism and the third member of the Godhead. First, in ancient Israel this white bird was seen as a symbol of purity (see Leviticus 12:6-8) and that is the ritual state brought about by the baptismal ordinance (see Acts 22:16). Second, the dove signified peace after the earth was baptized in the Flood, and peace is one of the blessings that flows from reception of the gift of the Holy Ghost (see D&C 19:23; 111:8).

GOSPEL SYMBOLS TEACH OF JESUS CHRIST

The scriptures resonate with a unique symbolic language all their own. Anyone who desires to understand the vast array of emblems within their pages must first understand the general nature of symbolism, and then the particular purpose of gospel symbols. The best place to begin is to understand how a symbol is defined. The word *symbol* comes from the Greek word *symbolon,* which means "something used for or regarded as representing something else; a material object representing something, often something immaterial."[4] Things of a spiritual nature, such as doctrinal truths, would certainly fall into the last category. The Lord is the master teacher, and he frequently employs teaching devices such as metaphorical language, rituals, figures, emblems, similitudes, types, shadows, images, allegories, and parables.

The question naturally arises, *Why* does the Lord use symbolism? A partial answer can be found in a revelation given by Jehovah to Adam shortly after the Fall. After explaining the symbolism behind the ordinance of baptism, the Lord said:

> And behold, all things have their likeness, and all things are created and made to bear record of me, both things which are temporal, and things which are spiritual; things which are in the heavens above, and things which are on the earth, and things which are in the earth, and things which are under the earth, both above and beneath: all things bear record of me. (Moses 6:63)[5]

The prophet Nephi taught the very same principle, adding that "all things

which have been given of God from the beginning of the world, unto man, are the typifying" of Christ (2 Nephi 11:4). Notice the distinction here: even though there have been many thousands of symbols used throughout the history of our world, only those symbols that are revealed from heaven are specifically designed to teach and testify of our Redeemer. During his mortal ministry the Lord explained to his twelve apostles why he chooses to teach in this manner.

> And the disciples came, and said unto him, Why speakest thou unto them in parables? He answered and said unto them, Because it is given unto you to know the mysteries of the kingdom of heaven, but unto them it is not given. For whosoever hath, to him shall be given, and he shall have more abundance: but whosoever hath not, from him shall be taken away even that he hath. Therefore speak I to them in parables: because they seeing see not; and hearing they hear not, neither do they understand. (Matthew 13:10-13)[6]

Elder Bruce R. McConkie stated that the purpose of the Lord in using symbolism is both to reveal and to conceal the doctrines of his kingdom, depending upon the spiritual preparation of those to whom the symbols are exposed. This is because, as he explained, it "is never proper to teach any person more than his spiritual capacity qualifies him to assimilate." Therefore, the Lord "used parables on frequent occasions during his ministry to teach gospel truths. His purpose, however, in telling these short stories was *not* to present the truths of his gospel in plainness so that all his hearers would understand. Rather, it was to phrase and hide the doctrine involved so that only the spiritually literate would understand it, while those whose understandings were darkened would remain in darkness."[7] On the other hand, Elder McConkie emphasized that to those with eyes to see and ears to hear, the gospel is "gloriously enhanced and beautified by the abundant use of *symbols* and figurative expressions. Since Christ is the center of the gospel system and the one through whom salvation comes, most of the basic symbolical representations tie into him and his atoning sacrifice."[8]

Hence, we learn three basic reasons for the use of gospel symbolism: (1) to center attention on and testify of Jesus the Christ, (2) to enhance and beautify the doctrines of his gospel, and (3) to expand the knowledge and understanding of those who have eyes to see. Elder Orson F. Whitney provided us with this interesting perspective: "The Universe is built on symbols, lifting our thoughts from man to God, from earth to heaven, from time to eternity. . . . God teaches with symbols; it is His favorite way of teaching."[9]

INTERPRETING SYMBOLS

There often arises a problem in accurately understanding the original intent, and therefore the correct meaning, of some scriptural passages precisely because they contain complex symbolic imagery. To help remedy this problem we must first understand that the Lord's thoughts and ways are much higher and different than our own because he sees things from a purely spiritual perspective (see Isaiah 55:8-9; D&C 29:34). Therefore, if we wish to clearly understand the symbolic language of the Lord, we must learn to see as he sees, which is with our spiritual eyes (see Moses 1:11). The only way for us to see in this manner is to "search the scriptures" and *study* the gospel with the assistance of the Holy Ghost (John 5:39; D&C 88:77-79; 76:5-10).

One LDS scholar has written that when it comes to divine symbols, the "finite mind wants to pin down a one-to-one correspondence between the elements of an allegory and that which they represent, but the divine mind works in multiple layers of meaning for symbols. In scripture the meaning often lies in the aggregate of allusions and associations."[10] It is from this broad, eternal perspective that a single symbol can speak volumes to those who are properly prepared. In speaking of the magnificent Salt Lake Temple, Elder Benjamin F. Goddard said, "As I gaze upon it day after day and month after month I learn new lessons."[11] Likewise, Elder J. Golden Kimball exclaimed that "every stone in it is a sermon to me . . . every window, every steeple, everything about the Temple speaks of the things of God."[12] These men had learned to see with their spiritual eyes, and so must we if we desire to understand the symbolic language of the Lord.

Those who wish to unfold the hidden treasures of knowledge that are found throughout the scriptures must also learn to think in an ancient frame of mind. Most of our scriptures were written by Hebrews who lived long ago in a culture very much different than our own. In order for us to grasp the essence of the ancient symbols used by them, we must learn to think as they thought. Sidney B. Sperry cautioned:

> We ofttimes read our Bible as though its peoples were English or American and interpret their sayings in terms of our own background and psychology. But the Bible is actually an Oriental [or Eastern] book. It was written centuries ago by Oriental people and primarily for Oriental people. . . . In thought and speech the Oriental is an artist; the Occidental [or Westerner], on the other hand, may be thought of as an architect. When speaking, the Oriental paints a scene whose total effect is true, but the details may be inaccurate; the Occidental tends to draw diagrams accurate in detail.[13]

Because of this difference in our way of thinking, the task of interpreting ancient symbols can become a real challenge. Nevertheless, we are not left to blind chance or vain imagination on this matter, for there should be no "private interpretation" when it comes to the word of the Lord in any of its forms (2 Peter 1:20). Necessary guidance has been readily provided for us. "I make this broad declaration," said the Prophet Joseph Smith, "that whenever God gives a vision of an image, or beast, or figure of any kind, He always holds Himself responsible to give a revelation or interpretation of the meaning thereof, otherwise we are not responsible or accountable for our belief in it."[14] In other words, it is our responsibility to find out what the Lord has said on the matter. Listed below are four essential keys to the study of symbolism that will help bring us to understand this heavenly language as the Lord intended.[15]

• Search the Scriptures

God has commanded us to diligently search the scriptures in order to know his words and understand his will (see Alma 17:2; Mosiah 1:6-7). It is the design of heaven that the more we know the more we will grow, and as we gather greater gospel knowledge, we will naturally learn the language of symbolism. The scriptures themselves will often provide us with the interpretation of a particular symbol if we will only take the time to search for it. We must *study* the gospel. Partial investigation will only provide partial knowledge and may possibly even leave us with misconceptions. Though it is true that many symbols have multiple layers of meaning, it is also critical that we view each one in its proper context and not force unnatural or nondoctrinal interpretations upon them. First we must find the core essence of a symbol, and then we will be enabled to explore its meanings.

• Study the Prophets

We are greatly blessed to have the writings of so many ancient prophets restored to us in our day, but we are even more fortunate to have living prophets, seers, and revelators, whose writings can provide us with insights into the mind and will of the Lord. For example, one entire section of the Doctrine and Covenants was given to us through a latter-day prophet in order to explain the meaning of a complex set of symbols used by an ancient prophet (see D&C 77). At times the mouthpieces of the Lord, under the inspiration of heaven, can also provide us with valuable knowledge that may not be found in the written word.

• Apply the Law of Witnesses

The Lord has ordained that the law of witnesses be used in the establishment and verification of all truth (see Matthew 18:16; John 8:17; 2 Corinthians 13:1). Besides the obvious scriptural and prophetic witnesses that we should utilize to verify our personal understanding of the gospel, there is another that we should never fail to seek. The gift of the Holy Ghost is available to all baptized members of the Church to instruct them more perfectly in the doctrines of Jesus Christ and to lead them to fruitful fields of knowledge and enlightenment. The Holy Ghost, then, should always be sought after as a witness during our search for truth and understanding. "No man can receive the Holy Ghost," said the Prophet Joseph Smith, "without receiving revelations. The Holy Ghost is a revelator."[16] What more satisfying and sure witness could be given than from one who "knoweth all things" (D&C 35:19; Moroni 10:5)?

• Utilize Research Tools

Some Latter-day Saints are not aware of the wonderful research tools that are literally at their fingertips. The standard works have been greatly enhanced with a detailed footnoting system, a topical guide, a Bible dictionary, an extensive index, and excerpts from the Joseph Smith Translation of the Bible. These scriptural resources can add tremendously to the adventure of exploring the words of the Lord and his servants. For example, if readers desire to understand the symbolic significance of the rainbow in a gospel context, they could begin by looking up "rainbow" in the Bible Dictionary (p. 759), where they would notice that the first scriptural reference is to Genesis chapter 9. By turning to that chapter, they would then read in verses 8-17 about a covenant God made with Noah after the flood and how the rainbow was established as a "token of the covenant." By checking the footnotes, they would next see that the Joseph Smith Translation has restored some significant material to this chapter of Genesis and, by turning to the JST section of the Bible (p. 797), they could then read the full text and discover that this covenant actually originated between God and the prophet Enoch. Readers could then turn to the Pearl of Great Price and read a detailed account of the actual establishment of this covenant long before the time of Noah (see Moses 7:23-69). The Bible Dictionary entry we began with also points the reader to the books of Ezekiel (see 1:28) and Revelation (see 4:3), which both reveal that a circular rainbow surrounds God's heavenly throne, perhaps as a perpetual symbol of this covenant. By utilizing the research tools in this manner, students of the scriptures will find that a lifetime of learning has opened up before them.

TEMPLES OF THE MOST HIGH GOD

The symbols of the temple, whether interior or exterior, should be investigated in the very same manner that we have just outlined, which could be briefly stated as *Understand the core, and then explore.* If we will follow the sequence of this simple rule, the symbolism of the house of God will be opened up before us as our understanding blossoms line upon precious line, precept upon glorious precept.

In speaking of the temple's interior symbols, Elder John A. Widtsoe provided us with the most important key to understanding the language of the Lord. He said, "No man or woman can come out of the temple endowed as he should be unless he has seen, beyond the symbol, the mighty realities for which the symbols stand."[17] When symbols are given by revelation, they "can best be understood by revelation; and to those who seek most vigorously, with pure hearts, will the revelation be the greatest."[18] Our task is to look upon the Lord's holy houses and observe more than just ornate woodwork and beautified stone, but rather from the deepest foundation to the loftiest spire we should see the doctrines of Jesus Christ.

NOTES

1. Hugh Nibley, *The Message of the Joseph Smith Papyri: An Egyptian Endowment* (Salt Lake City: Deseret Book, 1975), 243: "One of the most puzzling episodes in the Bible has always been the story of Jacob's wrestling with the Lord. When one considers that the word conventionally translated by 'wrestled' *(yeaveq)* can just as well mean 'embrace,' and that it was in this ritual embrace that Jacob received a new name and the bestowal of priestly and kingly power at sunrise (see Genesis 32:24ff), the parallel to the Egyptian coronation embrace becomes at once apparent."

2. Bruce R. McConkie, *Mormon Doctrine*, 2d ed. (Salt Lake City: Bookcraft, 1979), 712; hereafter cited as *MD*.

3. Joseph Fielding Smith, comp., *Teachings of the Prophet Joseph Smith* (Salt Lake City: Deseret Book, 1976), 275-77, hereafter cited as *TPJS*. At another time the Prophet said that the "dove which sat upon [the Lord's] shoulder was a sure testimony that he was of God. . . . Any spirit or body that is attended by a dove you may know to be a pure spirit" (Andrew F. Ehat and Lyndon W. Cook, eds., *The Words of Joseph Smith* [Orem, Utah: Grandin Book Company, 1991], 66, hereafter cited as *WJS).* In facsimile no. 2, figure 7 of the Book of Abraham, we also read of "the sign of the Holy Ghost unto Abraham, in the form of a dove."

4. Stuart Berg Flexner, ed., *Random House Unabridged Dictionary*, 2d ed. (New York: Random House, 1993), 1926.

5. The Prophet Joseph Smith likewise taught that some scriptural symbols are meant to be understood as "figurative expressions . . . that which is spiritual being in the likeness of that which is temporal; and that which is temporal in the likeness of that which is spiritual" (D&C 77:2).

6. The Joseph Smith Translation of Matthew 13:10-11 reads, "For whosoever *receiveth*, to him

shall be given, and he shall have more abundance; but whosoever *continueth not to receive*, from him shall be taken away even that he hath." See also JST Matthew 21:34 and Alma 12:9-11.

7. *MD*, 553-54.

8. Ibid., 773. "To crystallize in our minds the eternal verities which we must accept and believe to be saved, to dramatize their true meaning and import with an impact never to be forgotten, to center our attention on these saving truths, again and again and again, the Lord uses . . . ordinances, rites, acts, and performances; he uses similarities, resemblances, and similitudes so that whatever is done will remind all who are aware of it of a greater and more important reality To liken one thing to another is one of the best teaching procedures" (Bruce R. McConkie, *The Promised Messiah* [Salt Lake City: Deseret Book, 1981], 377).

9. *Improvement Era*, August 1927, 851; hereafter cited as *IE*.

10. M. Catherine Thomas, "Jacob's Allegory: The Mystery of Christ," in Stephen D. Ricks and John W. Welch, eds., *The Allegory of the Olive Tree: The Olive, the Bible, and Jacob 5* (Salt Lake City: Deseret Book and FARMS, 1994), 13.

11. *Conference Report*, 1905, 61-62; hereafter cited as *CR*.

12. Ibid., April 1915, 79.

13. Sidney B. Sperry, "Hebrew Manners and Customs," *Ensign*, May 1972, 29-30.

14. *TPJS*, 291.

15. This list is a modified version of the one found in Gerald N. Lund, "Understanding Scriptural Symbols," *Ensign*, October 1986, 22-27.

16. *TPJS*, 328. "The Holy Ghost . . . is the spirit of revelation" (D&C 8:2-3). There are four informative articles on this subject that we recommend to the reader: James E. Faust, "The Gift of the Holy Ghost—A Sure Compass," *Ensign*, May 1989, 31-33; Loren C. Dunn, "Fire and the Holy Ghost," *Ensign*, June 1995, 22-26; Brent Bulloch, "What Is the Difference between the Holy Ghost, the Spirit of Christ, and the Light of Christ?" *Ensign*, June 1989, 26-28; Bruce R. McConkie, "Spirit of the Lord," *MD*, 752-53.

17. John A. Widtsoe, "Temple Worship," *Utah Genealogical and Historical Magazine* 12 (April 1921): 62.

18. Ibid., 63.

CHAPTER 2
The New Jerusalem Temple

As the Millennium quickly approaches, Latter-day Saints have many glorious things to look forward to, one of the most significant of which is the return of the Lord's people to Jackson County, Missouri, and the building of the New Jerusalem Temple. At this unique temple the Lord will make one of several private appearances before he comes to the entire world in the clouds of glory.[1] Because this temple has not yet been built we will need to turn to the scriptures and the teachings of the prophets in order to learn about the symbolism associated with it. But first, we would do well to understand something about the origin of temples.

TEMPLES IN HEAVEN

Both the scriptures and Hebrew tradition tell us that there is a temple in heaven (see Hebrews 8:1-2; Revelation 7:15; 14:17; 15:5; 16:17).[2] When Moses ascended Mount Sinai to meet with the Lord after the Exodus, he was shown the "pattern" of the heavenly temple and commanded to build a portable replica of what he had seen (Exodus 25:8-9, 40; 26:30; 27:8; Numbers 8:4). King Solomon likewise built his temple on Mount Moriah after a similar pattern had been revealed by the Lord (see 1 Chronicles 28:11-13, 19). This pattern of revelation has continued in the dispensation of the fulness of times.

As will be discussed later in this book, the Kirtland, Nauvoo, and Salt Lake temples were all shown in vision to prophets in our dispensation. The Lord also promised at one time to provide a vision of the Far West Temple to the First Presidency of the Church (see D&C 115:7-8, 14-16). It may come as a surprise to some that the Manti,[3] Oakland,[4] Switzerland,[5] New Zealand,[6] and Provo[7] temples were all seen in vision prior to being built. Even the design of the Idaho Falls Temple is based on the vision of an ancient Nephite temple that was shown to the architect.[8]

All Latter-day Saint temples are, in a sense, constructed after the basic pattern that was shown unto Moses on Mount Sinai. The three separate areas of the tabernacle, with their increasing degrees of holiness, correspond to the three successive degrees of glory, which LDS temple patrons experience during the endowment ceremony.[9]

Brigham Young once inquired of the Lord whether all temples should be built after the same architectural design. The Lord responded that our increasing knowledge of the principles of his gospel would cause diversity in the way temples are built.[10] Elder Orson Pratt echoed the same thought, adding that the Lord is not confined to a single design for his temples any more than he must stay with a particular plan for his numerous worlds. Indeed, said Elder Pratt, "he will construct his temples in a great variety of ways." Because "he does not reveal everything all at once" we may expect that eventually "we will have Temples, with a great many things contained in them which we now have not."[11] Yet, even with this diversity of design, the basic ritual pattern remains the same.

From accounts of Latter-day Saints who have seen beyond the veil, it is apparent that there are many temples in the spirit world. According to Orson Pratt, "when the more perfect order shall exist we shall construct [our earthly temples] through the aid of revelation, in accordance with the Temples that exist in yonder heaven."[12] At the dedication of the Salt Lake Temple President Wilford Woodruff said that we will find "many glorious temples in the heavens, and the Lord wishes us to imitate them as far as we can. It is our duty to build good temples and to make them glorious and beautiful [so] that God himself and the Son of God with his angels may visit us there."[13] President Woodruff also related an incident where he saw a heavenly temple in vision: "Joseph Smith visited me a great deal after his death, and taught me many important principles. . . . [He] continued visiting myself and others up to a certain time, and then it stopped. The last time I saw him was in heaven. In the night vision I saw him at the door of the temple in heaven."[14]

A fascinating account of the heavenly temple that houses the Lord's throne comes from Alfred D. Young who, as a newly ordained elder in 1841, was escorted there by an angel.

> While conversing a spirit came over me which created a sensation as if a quantity of blood-warm water was poured over me coming onto my head first. I was filled with light, peace, and joy. Impressed to retire into some secret place as I arose to my feet, I asked my brother if he would go with me. . . . When we had retired about 200 paces into a piece of heavy timber, I saw a light burst through the top of the trees a little southeast of me. I was wrapped in a light which far exceeded in brightness the light of the sun. A personage appeared, clothed in a white robe exceeding in brightness the light of the sun. Around his

head this light gathered into a halo of brightness exceeding in intensity everything else around. He was dressed in a white robe and his feet were bare. My nature could not bear the presence of this glorious person and I sank to the ground. . . . My spirit left my body and stood just over it. . . . The personage or angel said to me, "Follow thou me." He ascended upward in the direction from which he came and I followed him. He took me into the presence of God the Father and his Son Jesus Christ, with the exception there was a rail between us. But I saw them seated on a throne. I had in my hands many sheaves of wheat of the purest white. There was an altar on my left hand and also one directly in front of me. The one on my left appeared to be about three feet in height. The one in front about eighteen inches or about half the size of the first. I laid the sheaves of wheat that were in my hands on the altar to my left as an offering to the Lord. I bowed myself on my knees on the altar which was in front of me which was also in front of the throne. I prayed God the Father in the name of His Son Jesus Christ to accept of the offering I had laid upon the altar. While I was praying the rail was removed and I stood upon my feet. Jesus arose and stepped from the side of his Father and came near where I stood. I was in their presence and I gazed upon their glory. Jesus then said to me, "Your offering is accepted and wouldest thou know the interpretation thereof?" I replied, "Yes Lord." The angel, my conductor, said, "Look," and I saw as it were an innumerable company that had come up from all nations, kindreds, tongues, and peoples around the throne of God, and they fell down and worshipped Him and gave glory to Him. Jesus then said, "These are they [whom] thou shalt be the means of bringing into my Father's Kingdom and this is the interpretation of the offering thou hast laid upon the altar."[15]

Brigham Young said that he believed that "Enoch had Temples" in his city "and officiated therein."[16] Apostle Franklin D. Richards likewise echoed this idea but added that because the whole city was translated, these temples are now located in the spirit world. He said he wished

to speak a word in reference to the three Nephites. They wanted to tarry until Jesus came, and that they might He took them into the heavens and endowed them with the power of translation, probably in one of Enoch's temples, and brought them back to the earth. Thus they received power to live until the coming of the Son of Man. I believe He took them to Enoch's city and gave them their endowments there. I expect that in the city of Enoch there are temples; and when Enoch and his people come back, they will come back with their city, their temples, blessings and powers.[17]

THE PROMISED LAND OF ZION

With this background we will now briefly examine the history behind the first temple that was commanded to be built in our dispensation. Through his work of translating and restoring the scriptures, the Prophet Joseph Smith learned that before the Second Coming the Lord would establish a "Holy City called Zion, a

New Jerusalem" wherein a temple would be built (Moses 7:62-65). Shortly after the organization of the Church on 6 April 1830 the Lord promised that at the proper time he would reveal the location of this city and its holy temple (see D&C 28:9; 42:9, 35, 62, 67). Then in June of 1831 the Prophet saw "a heavenly vision" during which he was commanded to go to Jackson County, Missouri, in order to "designate the very spot which was to be the central place for the commencement of the gathering together of those who embrace the fulness of the Gospel."[18] On 7 July of that same year the Lord directed the Saints that they should gather in Missouri for the next Church conference and indicated that the area would be consecrated as a land of inheritance for them (see D&C 52:2, 5). On 20 July the Prophet arrived in Jackson County and inquired of the Lord[19] about the fulfillment of several ancient prophecies that concerned the fulness of times, asking: "When will Zion be built up in her glory, and where will thy Temple stand, unto which all nations shall come in the last days?" The Lord replied,

> Hearken, O ye elders of my church, saith the Lord your God, who have assembled yourselves together, according to my commandments, in this land, which is the land of Missouri, which is the land which I have appointed and consecrated for the gathering of the saints.
> Wherefore, this is the land of promise, and the place for the city of Zion.
> And thus saith the Lord your God, if you will receive wisdom here is wisdom. Behold, the place which is now called Independence is the center place; and a spot for the temple is lying westward, upon a lot which is not far from the courthouse. (D&C 57:1-3)[20]

CORNERSTONE AND FOUNDATION

On the first day of August, 1831, the Lord commanded that the land of Zion and the temple site be dedicated and consecrated unto him (see D&C 58:57). The following day, twelve men representing the twelve tribes of Israel laid a symbolic foundation for the city of Zion after which they dedicated and consecrated the land for the gathering of the saints.[21] On the following day the Prophet, accompanied by a few others, formally dedicated the temple site. Those who were present then placed a cornerstone to mark the holy spot.[22]

The symbolic foundation of Zion is mentioned several times throughout the scriptures and these passages provide an interesting correlation to the events in Jackson County, Missouri. In the New Testament we read that Abraham, Isaac, and Jacob entered "the land of promise" and "looked for a city which hath foundations, whose builder and maker is God" (Hebrews 11:8-10). In the Doctrine and Covenants this city is identified as "Mount Zion" (D&C 76:62-68). When John the

Revelator saw this heavenly city in his vision, he said that its twelve gates represented the twelve tribes of Israel and the twelve foundations represented the twelve apostles of the Lamb (see Revelation 21:12, 14). The Apostle Paul also likened apostles and prophets to a spiritual temple's foundation and Jesus Christ to the chief cornerstone (see Ephesians 2:20-21; 1 Peter 2:5). Isaiah quotes the Lord as saying: "Behold, I lay in Zion for a foundation a stone, a tried stone, a precious corner stone, a sure foundation" (Isaiah 28:16; see also 1 Peter 2:6). Other scriptures identify this "stone of Israel" as the Lord Jesus Christ because, like a rock, he is firm, stable, and endures forever (see Genesis 49:24; D&C 50:44; Moses 7:53).

On 16 December 1877, Wilford Woodruff recorded a vision of the future in his journal. Some aspects of this vision are related to the symbolism of the cornerstones and foundation of the city of Zion.

> I seemed to be on the west bank of the Missouri River opposite the city of Independence, but I saw no city. I saw the whole states of Missouri and Illinois and part of Iowa were a complete wilderness with no living human beings in them. I then saw a short distance from the river twelve men dressed in the robes of the temple standing in a square or nearly so. I understood it represented the twelve gates of the New Jerusalem and they were with hands uplifted consecrating the ground and laying the corner stones. I saw myriads of angels hovering over them and round about them and also an immense pillar of a cloud over them and I heard the singing of the most beautiful music [and] the words: "Now is established the Kingdom of our God and his Christ and he shall reign forever and ever, and the Kingdom shall never be thrown down," and I saw people coming from the river and different places a long way off to help build the temple, and it seemed that the hosts of the angels also helped to get the material to build the temple, and I saw some come who wore their temple robes to help build the temple and the city and all the time I saw the great pillar or cloud hovering over the place. . . . I could see the building going on.[23]

THE CENTER PLACE

In latter-day revelation the Lord has called the land of Zion "the center place" because it is to there that the righteous will eventually be gathered together from the four quarters of the earth (D&C 57:3). The Lord commanded the early Saints to build the temple in the very center of the city of Zion (see D&C 84:2-4). This arrangement can be clearly seen in the plat, or plan, that was drafted under the direc-

tion of Joseph Smith. It will be noticed that the plan exhibits a perfectly square city, blocked to the four directions of the compass. This is interesting in light of the vision that John the Revelator saw of the heavenly Jerusalem: "And the city lieth foursquare, and the length is as large as the breadth" (Revelation 21:16)—a plan that is also reflected in the arrangement of the tribes of Israel around the ancient tabernacle (see Numbers 1:52-2:31). This may also be significant because there is some evidence that the plan for the city of Zion in Jackson County, Missouri, was shown to Joseph Smith in a vision.[24]

THE GARDEN OF EDEN

The question naturally arises as to why Jackson County, Missouri, is so important to the Lord that he would choose to establish the throne of his millennial government there instead of anywhere else on the earth. The answer is both intriguing and quite profound. The Prophet Joseph Smith learned the original location of paradise through a revelation[25] and subsequently taught the early members of the Church that "the Garden of Eden was in Jackson [County,] Missouri. When Adam was driven out he went to a place we now call Adam-ondi-Ahman, Daviess County, Missouri. There he built an altar and offered sacrifices."[26] President Joseph Fielding Smith agreed that "the Garden of Eden was on the American continent located where the City [of] Zion, or the New Jerusalem, will be built."[27] Another early source is even more precise:

> Adam-ondi-Ahman was at the point where Adam came and settled and blessed his posterity after being driven from the Garden of Eden. This was revealed through Joseph Smith the Prophet. The Temple Block in Jackson County, Missouri, stands on the identical spot where once stood the Garden of Eden. When Adam and Eve were driven from the Garden they traveled in a north[easterly] course until they came to a valley on the east side of the Grand River.[28]

The fact that the New Jerusalem Temple will be built upon the former site of the Garden of Eden is highly symbolic in itself because the paradise once inhabited by Adam and Eve was the first place mankind stood in the presence of God; it was the earth's first temple.[29] "Right where the Prophet Joseph laid the foundation of the Temple," said Brigham Young, "was where God commenced the garden of Eden, and there he will end or consummate his work."[30] Both the tabernacle built by Moses and the temple in Jerusalem were specifically designed by the Lord to represent the Garden of Eden by their architectural decorations.[31] In using similar imagery, the Old Testament prophets taught that when Zion rose in its grandeur it

would become like paradise (see Isaiah 51:3; Ezekiel 36:35). While living in Nauvoo a young man named Samuel W. Richards had a vision in which he saw himself participate in the construction of the temple in Jackson County, Missouri, and saw the land regain its paradisiacal glory.

> I stayed and helped build the temple. I saw that temple thoroughly completed; in fact, I labored upon it until it was completed. When this was done, the vision continued, and I went and laid down my body in the ground, and my spirit left this tabernacle. Then I traversed this continent from end to end. I saw the Garden of Eden as it was in the beginning and as it will be restored again. It was a land filled with verdure and vegetation, and with all manner of fruits, on which man was living. It was filled with cities, towns and villages, and happy people, living under the administration of divine providence. It was a Garden of Eden in very deed.[32]

ADAM-ONDI-AHMAN

Adam-ondi-Ahman lies north of Independence, Missouri, and is the land where Adam and Eve dwelt following their expulsion from the Garden of Eden. The pivotal events that will transpire at Adam-ondi-Ahman will take place before the Lord appears to the Saints inside the New Jerusalem Temple.[33] It is here that Christ, the King of Israel, will receive back the keys of his kingdom from all the appointed stewards to whom they have been previously delegated.

The Lord first introduced the phrase "Adam-ondi-Ahman" in March of 1832, and he has referred to himself as "Son Ahman" in some of his revelations (D&C 78:15, 20). Orson Pratt said that Joseph Smith once received an unpublished revelation about some words from the Adamic language and from this revelation he learned that the word "Ahman" is the name of God the Father.[34] Elder Bruce R. McConkie said that "as nearly as we can tell, Man of Holiness is the English rendition of Ahman, and Son of Man of Holiness, of Son Ahman."[35] He also stated that "Adam-ondi-Ahman, a name carried over from the pure Adamic language into English, is one for which we have not been given a revealed, literal translation."[36] Nevertheless, from a combination of context and linguistics we may hazard the guess that this phrase means "Adam in the presence of God."[37]

In Doctrine and Covenants 107:53-57 the Lord revealed that three years before Adam died he called his righteous descendants into the valley of Adam-ondi-Ahman and "bestowed upon them his last blessing." The Prophet Joseph Smith said that he saw a vision of this event:

> I saw Adam in the valley of Adam-ondi-Ahman. He called together his children and blessed them with a patriarchal blessing. The Lord appeared in their midst. . . . This is why Adam blessed his posterity; he wanted to bring them into the presence of God.[38]

When the Lord appeared unto this multitude, he declared that Adam would be a "prince" forever and bring forth "a multitude of nations." It may be that the Lord revealed the premortal identity of Adam to those assembled, for "they *rose up* and blessed Adam, and called him Michael, the prince, the archangel" (D&C 107:54, emphasis added; see 78:16). We may surmise from the italicized words of this passage that those who saw the Lord on this occasion were kneeling in his presence. During this experience Adam was filled with the Holy Ghost to such a degree that he prophesied about the future of his posterity down to the very latest generation.

On 19 May 1835, the Lord identified the exact location of Adam-ondi-Ahman as Spring Hill, Missouri,[39] and confirmed that Adam would return to that very spot at some future time in order to fulfill the events seen in vision by the prophet Daniel (see Daniel 7:9-10, 13-14, 22). President Joseph Fielding Smith has provided us with many significant insights into this important gathering.

> Not many years hence there shall be another gathering of high priests and righteous souls in this same valley of Adam-ondi-Ahman. At this gathering Adam, the Ancient of Days, will again be present. At this time the vision which Daniel saw will be enacted. The Ancient of Days will sit. There will stand before him those who have held the keys of all dispensations, who shall render up their stewardships to the first Patriarch of the race, who holds the keys of salvation. This will be a day of judgement and preparation. . . . This council in the valley of Adam-ondi-Ahman is to be of the greatest importance to this world. At that time there will be a transfer of authority from the usurper and imposter, Lucifer, to the rightful King, Jesus Christ. Judgement will be set and all who have held keys will make their reports and deliver their stewardships, as they shall be required. Adam shall direct this judgement, and then he will make his report, as the one holding the keys for this earth, to his Superior Officer, Jesus Christ. Our Lord will then assume the reigns of government; directions will be given to the Priesthood; and He, whose right it is to rule, will be installed officially by the voice of the Priesthood there assembled. This grand council of Priesthood will be composed, not only of those who are faithful who now dwell on this earth, but also of the prophets and apostles of old, who have held directing authority. Others may also be there, but if so they will be there by appointment, for this is to be an official council called to attend to the most momentous matters concerning the destiny of this earth. When this gathering is held the world will not know of it; the members of the Church at large will not know of it, yet it shall be preparatory to the coming in the clouds of glory of our Savior Jesus Christ as the Prophet Joseph Smith has said. The world cannot know of it. The saints cannot know of it—except those who are officially called into this council—for it shall precede the coming of Jesus Christ as a thief in the night, unbeknown to all the world.[40]

The image of Adam sitting in exalted glory to render judgment is a most powerful one. In the Salt Lake School of the Prophets, Zebedee Coltrin related a vision that he shared with Joseph Smith and Oliver Cowdery when they all saw Adam sitting upon a golden throne.

> Once after returning from a mission, [Zebedee Coltrin] met Brother Joseph in Kirtland, who asked him if he did not wish to go with him to a conference at New Portage. The party consisted of Presidents Joseph Smith, Sidney Rigdon, Oliver Cowdery and [him]self. Next morning at New Portage, he noticed that Joseph seemed to have a far off look in his eyes, or was looking at a distance, and presently he, Joseph, stepped between Brothers Cowdery and Coltrin and taking them by the arm, said, "Let's take a walk." They went to a place where there was some beautiful grass, and grapevines and swampbeech interlaced. President Joseph Smith then said, "Now brethren we will see some visions." Joseph lay down on the ground on his back and stretched out his arms and the two brethren lay on them. The heavens gradually opened, and they saw a golden throne, on a circular foundation, something like a light house, and on the throne were two aged personages, having white hair, and clothed in white garments. They were the two most beautiful and perfect specimens of mankind he ever saw. Joseph said, "They are our first parents, Adam and Eve." Adam was a large broadshouldered man, and Eve as a woman, was as large in proportion.[41]

In Moses 5:4-8 we read about an altar built by Adam after the Fall which he used to offer up sacrifices to the Lord. President Joseph Fielding Smith taught that, of necessity, "the first sanctified temples were the mountain tops and secluded places in the wilderness. If we are correctly informed, Adam built his altar on a hill above the valley of Adam-ondi-Ahman. At that place the Lord revealed to him the purpose of the fall and the mission of the Savior."[42] The altar referred to still existed in the days of Joseph Smith and was identified as such by him.[43] In describing this altar Heber C. Kimball made a most interesting comparison when he said that it looked very much like the pulpits inside the Kirtland Temple.[44] The saints dedicated a site and laid cornerstones for a temple at Adam-ondi-Ahman, and it is worth noting that the altar of Adam and the temple site both lie in the very center of the city plat.[45]

In section 117 of the Doctrine and Covenants, verse 8, the Lord makes reference to the mountains of Adam-ondi-Ahman and "the plains of Olaha Shinehah, or the land where Adam dwelt." President Joseph Fielding Smith has provided us with the following interpretation of this unique name:

> The plains of Olaha Shinehah, or the place where Adam dwelt must be part of, or in the vicinity of Adam-ondi-Ahman. This name Olaha Shinehah, may be, and in all proba-

bility is, from the language of Adam. We may without great controversy believe that this is the name which Adam gave to this place, at least we may venture this as a probable guess. Shinehah, according to the Book of Abraham, is the name given to the sun (Abraham 3:13). It is the name applied to Kirtland when the Lord desired in a revelation to hide its identity (Sec. 82). Elder Janne M. Sjodahl commenting on the name, Olaha Shinehah, has said: "Shinehah means sun, and Olaha is probably a variant of the word Olea, which is 'the moon' (Abraham 3:13). If so the plains of Olaha Shinehah would be the Plains of the Moon and the Sun, so called, perhaps because of astronomical observations there made." We learn from the writings of Moses that the Lord revealed to the ancients great knowledge concerning the stars, and Abraham by revelations and through the Urim and Thummim received wonderful information concerning the heavens and the governing planets, or stars. It was also revealed to the Prophet Joseph Smith that Methuselah was acquainted with the stars as were others of the antediluvian prophets including Adam. So it may be reasonable that here in this valley important information was made known anciently in relation to the stars of our universe.[46]

Joseph Smith taught that the earth, sun, moon, and stars would be used by the Lord to provide signs of his Second Coming and that these signs would signal to the faithful that they must gather to Zion and her stakes to find peace and deliverance during that great and dreadful day.[47]

CURTAINS, CORDS, AND STAKES

In the book of Isaiah we see Zion directly compared to the tabernacle of Jehovah, but instead of constantly wandering through the wilderness as in the days of Moses, this tabernacle is set up on a permanent basis with its curtains stretched out, the cords lengthened, and the stakes driven firmly into the ground (Isaiah 33:20, 54:2). The Lord has decreed that the latter-day "Zion shall not be moved out of her place" but stand firm and prosper because of the strength of her stakes (D&C 82:13-14; 101:17, 20-23). This must needs be, for "the kingdom of Zion is in very deed the kingdom of our God" (D&C 105:32), and is destined to be the one kingdom that will endure forever (Daniel 2:44, Revelation 11:15).[48]

The word "stake," as used in the LDS Church, is derived directly from the symbolism of the temple. Sometimes members of the Church have called Independence, Missouri, the "center stake of Zion" but this, as President Joseph Fielding Smith explained, is an incorrect notion.

> The expression "stake of Zion" is taken from the expression in Isaiah [33:20 and 54:2]. . . . Isaiah speaks of Zion as a tent, or tabernacle, having in mind the Tabernacle which was built and carried in the wilderness in the days of Moses, and the cords are the binding cables that extend from the tent, or tabernacle, to the stakes which are fastened in the

ground. Now the Lord revealed that Zion was to be built and surrounding her would be the stakes helping to bind and keep her in place. This figure of speech has almost been lost through the intervening years, but it retains its significance, or beauty. To speak of Zion, the New Jerusalem, or even that section where the city will be built, as a stake of Zion, is a sad mistake. Zion is the tent, the stakes of Zion are the binding pegs that support her. Zion, therefore, cannot be a stake, it would be as improper to call a tent a stake as to apply this term to Zion.[49]

MOUNT ZION

We learn from the scriptures that the city of New Jerusalem[50] will not only be called by the name of "Zion" (D&C 45:66-67, Moses 7:62), but it will be known more specifically as "Mount Zion" (D&C 84:2, 133:56).[51] It was upon Mount Zion in Jerusalem that the temple complex was built and subsequently became known as "the mountain of the Lord's house" (Isaiah 2:2-3),[52] meaning the mountain upon which the temple stood (D&C 84:31-32).[53]

In some ancient Near Eastern cultures temples were purposefully designed as architectural, or artificial, mountains that represented the first solid earth that arose from the waters of chaos at the time of creation (see Genesis 1:9-10). This primordial mound was preeminently sacred and equated, by some Hebrews, with the Foundation Stone in the Holy of Holies of the Jerusalem Temple. This symbolic stone marked the navel or center of creation.[54]

Because mountaintops were rarely visited by mortals, and because of their location between heaven and earth, they were considered by the ancients to be pristine or holy ground where the veil was thin and one could more easily commune with God. Joseph Smith taught these same principles when he said that Moses received his temple endowment "on the Mountain top"[55] and when he selected men to scout new places of gathering in the West he said: "I want every man that goes to be a king and a priest. When he gets on the mountains, he may want to talk with his God."[56] The prophets of old were instructed to ascend to these solitary places, or sometimes they were taken there in the spirit, in order to view the visions of eternity or see the Lord face to face.[57]

THE HOLY CITY

While gathered inside the Kirtland Temple to receive sacred ordinances, many of the early brethren saw visions of "things which the tongue of man cannot describe in full." Among these wonderous revelations, the Prophet Joseph Smith saw into the future and "beheld the redemption of Zion," and his scribe saw "the armies of heaven protecting the Saints in their return to Zion."[58] In order for such a blessing to be

bestowed, however, the Saints must first become sanctified and united. Elder Orson Pratt declared:

> When we go back to Jackson County we are to go back with power. Do you suppose that God will reveal his power among an unsanctified people, who have no regard nor respect for his laws and institutions but who are filled with covetousness? No. When God shows forth his power among the Latter-day Saints, it will be because there is union of feeling in regard to doctrine, and in regard to everything that God has placed in their hands; and not only a union, but a sanctification on their part, that there shall not be a spot or wrinkle as it were, but everything shall be as fair as the sun that shines in the heavens.[59]

Before the Lord's chosen people will be allowed to "build up a Temple to the Lord" upon the consecrated land of Zion, the King of Righteousness will "purge the land" and "cut off the evil doer," warned Brigham Young.[60] In a rather sobering vision of the future, a man by the name of Joseph G. Nelson was shown how this cleansing process would take place.

> No doubt many of us have thought, "What shall become of the great cities and their inhabitants when the 'Lord sets His hand' to build the New Jerusalem and its glorious temple?" I have read this statement from the sayings of Heber C. Kimball, "The country will be swept so clean not even a yellow dog will oppose our coming." It was not a dream, but the experience was so realistic that the whole scene was indelibly fixed upon my mind that I need but think of it to renew the entire scene. I found myself in the presence of great buildings. Turning toward the east I saw in the center of the plaza or public park a great throng of people—men, women, and children, huddled there together and expectantly looking toward the south. Then an awful cry of fear and despair escaped them. Turning toward the south I saw the cause of their agony, for out of the clear sky there came great columns of fire which swept away the city from which they had lately fled. Then the fire came upon them and consumed *them* completely. While I marvelled, a voice said to me, "The day cometh which shall burn as an oven, and all the proud, yea, all that do wickedly shall burn as stubble, for they that come shall burn them up, saith the Lord of Hosts, that it shall leave them neither root nor branch!" I looked again, and not a vestige of [the] city or its people was left. Then I was afraid, for I saw that terrible holocaust coming toward *me*. I cried, "O, Lord Thou knowest." And the fire passed by me and left me unharmed. Shortly after this I found myself in a great plain, uninhabited. The landscape extended miles upon miles, terminating in a low range of mountains, or hills. It was twilight, and facing toward the east I saw a wonderful planet, in color like silver, which moved along the horizon toward the north. When it disappeared a wonderous light sprang up in the east, so that all might see its glory. I thought, "It is the morning of the coming of the Redeemer of the World." And I shouted, "The Lord will surely come." I perceived it was early springtime, for the earth was damp and young grass springing up from the ground.[61]

On his return trip from Zion's Camp in the year 1834, as Philo Dibble was riding on horseback across the vast wilderness, he was shown a vision of an immense city which may possibly be the future Zion.

> I looked northward and saw, apparently with my natural vision, a beautiful city, the streets of which ran north and south. I also knew there were streets running east and west, but could not trace them with my eye for the buildings. The walls on each side of the streets were as white as marble, and the trees on the outer side of the marble walls had the appearance of locust trees in autumn. This city was in view for about one hour and a half, as near as I could judge, as I traveled along. When I began to descend towards the Crooked River the timber through which I passed hid the city from my view. Every block of this mighty city had sixteen spires, four on each corner, each block being built in the form of a hollow square, within which I seemed to know that the gardens of the inhabitants were situated. The corner buildings on which the spires rested were larger and higher than the others, and the several blocks were uniformly alike. The beauty and grandeur of the scene I cannot describe. While viewing the city the buildings appeared to be transparent. I could not discern the inmates, but I appeared to understand that they could discern whatever passed outside. Whether this was a city that has been or is to be, I cannot tell. It extended as far north as Adam-ondi-Ahman, a distance of about twenty-eight miles. Whatever is revealed to us by the Holy Ghost will never be forgotten.[62]

THE TEMPLE

The New Jerusalem Temple was the very first of the temples commanded to be built in our dispensation and will be "the chief temple" once it is completed.[63] John Taylor proclaimed that it will be "the most magnificent temple that was ever formed on the earth and the most splendid that was ever erected" because, said he, the architectural plans will be revealed under the direction of the Lord himself.[64] Despite some rumors to the contrary the "temple in Jackson County will be built by Ephraim, meaning the Church as it is now constituted; this is where the keys of temple building are vested, and it will be to this Ephraim that all the other tribes will come in due course to receive their temple blessings."[65]

Many who see Joseph Smith's plan for the city of Zion wonder why there is a complex of twenty-four temples instead of just the one that was specified in the Lord's revelations. While this question has no direct answer from known historical sources, an answer may nevertheless be deduced from the available evidence. It is clear that the New Jerusalem and Kirtland temples were closely connected by their design, but many have not realized that the plans for the New Jerusalem Temple complex were actually derived from information that was revealed about the Kirtland Temple. It appears that the Lord gave revelations on these matters "line

upon line." Consider the following timeline.

• Sometime before 6 May 1833, the Lord revealed the plat, or plan, for the city of Zion (see D&C 94:1-2). One drawing of the Jackson County temple has a note written on it that verifies the divine origin of the plat's design.[66] Orson Pratt likewise testified that the plat was a revealed pattern.[67]

• On 6 May 1833, the Lord indicated that Kirtland was a "city of the stake of Zion" and must be laid out in the revealed pattern with one temple and two additional buildings forming a small complex in the center (D&C 94:1-2). The two additional buildings were to be exactly the same size as the temple (vss. 4, 11) but their "pattern" was to be revealed at a later time (vss. 5, 12). Neither of the additional buildings were to be constructed until a commandment was given to do so (see vs. 16). The Lord also promised a future revelation on the "pattern" of dedicating temple foundations "according to the order of the priesthood" (vs. 6).

• On 1 June 1833, the Lord said that the temple was to be built so that he could bestow an endowment of power upon his faithful servants (D&C 95:8-9). The dimensions of the temple were given and its upper and lower courts mentioned (vss. 15-17), but the Lord promised to give a vision of the temple to three chosen individuals sometime in the future (vss. 13-14).

• After seeing the vision of the Kirtland Temple, the First Presidency directed the leaders in Zion to build an exact replica of the Kirtland Temple complex—only three buildings.[68]

• Around 5 June 1833, the saints quarried the first stone for the Kirtland Temple.

• On 25 June 1833, the First Presidency drew up the plat for the City of Zion with its complex of twenty-four temples and sent it off to Jackson County, Missouri.

• On 2 August 1833, the Lord verified that the vision of the Kirtland Temple had been given and commanded that the temple in Zion be built after the same pattern: "Verily I say unto you, that it is my will that a house should be built unto me in the land of Zion, like unto the pattern which I have given you . . . a house built unto me for the salvation of Zion" (D&C 97:10, 12).

It is clear in the Doctrine and Covenants that the Lord only commanded that one temple be built in the city of New Jerusalem (see D&C 57:1-3; 58:57; 97:10-12). Likewise, only one temple site was originally dedicated by the Prophet Joseph Smith. So what was it that caused the First Presidency to plan for a twenty-four temple complex in Zion? It appears that the Kirtland Temple's pulpits hold the answer. There are twenty-four pulpits found inside the Kirtland Temple, with a set of initials placed upon each one to indicate the priesthood office of those sitting in each

seat. As demonstrated by the diagram in Appendix A, the names assigned to each of the twenty-four New Jerusalem temples correspond to the initials found on the Kirtland Temple pulpits.

An interesting statement by Orson Pratt implies that a revelation was given in 1839 that modified the design so that the twenty-four temples planned for the New Jerusalem became one temple with twenty-four rooms. These rooms were to be arranged in a circular pattern and connected by a huge dome.[69] The twenty-four rooms still retained their initial purpose as gathering places for the various quorums of the priesthood, and each was to bear one of the names originally assigned to the twenty-four temples by Joseph Smith.[70]

Elder Pratt was careful to point out that the pattern thus far revealed by the Lord for the temple of Zion was not necessarily the last word on the matter and that the Lord could at any time reveal more.[71] He also indicated that this particular temple would not be built as we build temples today. Because of its unique character and functions, he said, it would be built "after a celestial order"; thus, prophets, seers, and revelators would be needed to provide the plans.[72] At another time he indicated that there would be many features associated with this temple that are not found in any present house of God.[73] It is apparent that at least up to the time of Joseph Fielding Smith the plan had not been provided by revelation because he told a gathering of religious education faculty that "we don't know how the Temple will be built or what it will look like."[74] However, a vision given to John Taylor in Nauvoo, Illinois, on 18 June 1845 corresponds to the description given by Orson Pratt and may provide us with a rough idea.

I dreamt that I stood by the [Nauvoo] temple and looked up and saw that it was finished. I admired the elegance and symmetry of the building, and felt animated in my spirits and rejoiced to see the building finished. I remarked to a person standing by, what a beautiful structure this is, how elegant the design and how well it is executed. I then said it is only a very short time since we laid the topstone, and now it is finished. I knew that a great deal of the wood work was prepared, but did not anticipate that the building would be so soon completed. I felt at the same time filled with the spirit of God, and my heart rejoiced before the Lord. While I stood gazing with pleasure at the temple, I saw another tower rising like unto the one that is on the west end of the temple, and immediately exclaimed to the person that I had before conversed with, "why there is another tower." And said I, pointing my finger, "still further there is another, and yet another. We have not yet begun to see the whole." The scenery gradually changed, and a temple very much larger in dimensions than the one which we are building stood before me. There were a number of towers, placed apparently at equal distances on the outside, each of which were supported by buildings as large as this temple, and yet were united with, and were a part of the

great temple. They were of as large dimensions as that which is on this temple. From the midst of these towers and in the center of the building arose in majestic grandeur an immense, large dome that seemed to tower as high above the towers as the towers were from the earth. It was not quite finished at the top and there were some workmen employed near the top of the dome, who, in consequence of the extreme height of the building, appeared very small. I was much delighted with the scenery that presented itself to my view, and soon after awoke retaining for some time afterward the same pleasing sensation that I had enjoyed during my dream.[75]

During the winter of 1843-44 Elder Parley P. Pratt wrote a story that included a description of the temple in Jackson County. This manuscript was read in the presence of Joseph Smith during a Church council meeting but does not claim to be an actual vision. Rather, this writing was designed to combine elements of doctrine in a narrative form. In his story Elder Pratt is taken in vision by an angel to the center place where Eden once stood and Zion will stand. He is then shown a vision of the future by his angelic instructor.

> Suddenly a hand touched me, and a voice exclaimed, "Mortal, Awake! The Angel of the Prairie has returned, and the time is fulfilled. Arise! Stand upright, and look around thee." At the voice of his words I seemed to awake as from a deep sleep, the darkness dispersed, and light ineffable shone around me. I found myself in the same central position where he had left me, and which he had pointed out as the final seat of empire. But oh! how changed! Instead of a flowery plain without inhabitants, I beheld an immense city, extending on all sides and thronged by myriads of people, apparently of all nations. In the midst of this city stood a magnificent temple, which, in magnitude and splendor, exceeded everything of the kind known upon the earth. Its foundations were of precious stones; its walls like polished gold; its windows of agates, clear as crystal; and its roof of a dazzling brightness, its top, like the lofty Andes, seemed to mingle with the skies; while a bright cloud overshadowed it, from which extended rays of glory and brightness in all the magnificent colors of the rainbow. The whole buildings thereof seemed to cover some eight or ten acres of ground. "This" said the Angel of the Prairies, "is the sanctuary of freedom, the palace of the great King, and the centre of a universal government. Follow me and you shall behold the magnificence, order and glory of His kingdom." So saying, we walked together to the gates of the temple. These were twelve in number; three on each side, and all standing open. . . . By a secret watchword from the Angel to the porter or keeper of the gate, we were permitted to pass the eastern centre gate into the court yard. This was a large square surrounding the temple, and containing a square mile of land, enclosed with a strong wall of masonry, and ornamented with walks, grass plots, flowers and shady groves of ornamental trees, the whole arranged in the most perfect taste, and with an elegance, neatness and beauty, that might well compare to Eden.

Elder Pratt next describes entering the east door of the temple, and once inside

the outer court, finding doors in every direction with inscriptions above each describing the uses of the rooms behind them. His angelic guide then conducted him into the inner court of one of these vast rooms where he saw a throne with three personages seated upon it, and the Grand Presiding Council of kings and priests clad in dazzling white robes and crowns. He also saw symbols on the walls of this room that he could not understand. He was then escorted to the temple archives and into a small room where he saw "numerous sacred books and records."[76]

One final vision of the future New Jerusalem Temple can be found in the diary of Joseph Lee Robinson. This vision is unique in that it describes what we will call a rocking rainbow.

> After addressing the Throne of Grace and saying a few words, we commenced to pray for the Saints of Zion, when a heavenly vision opened to my view. A light, a beautiful light, was present before my eyes. It was in the shape and color of a rainbow, only the bow was turned down. It was perfect in shape and moved as a pendulum of a clock, back and forth, with perfect exactness. I gazed upon it for a length of time as it grew brighter until it was the purest and brightest light I had ever seen. Then as quick as thought, a very large building was present before my eyes. It was far enough away for me to have a good view. I gazed with wonder and astonishment upon a large and very beautiful house built of hewn gray stone, gray rock polished with white joints, with large and beautiful windows and door sills and caps. It was altogether the largest, most impressing and beautiful building I had ever seen. As soon as the house appeared this extraordinary light was out of my sight. Presently the voice of the Good Shepherd said to me: "This house you see is the temple of the Living God that shall be built in this generation by the hands of the Latter-day Saints, upon the consecrated spot in Jackson County, Missouri." Presently, after this and as quick as thought, I found myself in a room of that house. To me it was a heavenly place. In front of me, in the other end of the room, there was a stand, a large and beautiful stand with drapes and curtains. Over this stand this marvelous light that had led me to Zion was waving magnificently. Then the same voice said: "This is the Temple of the Living God that shall be built by the hands of the Latter-day Saints in this generation upon the consecrated spot in Jackson County, Missouri, and the pure in heart shall see the face of the Father and live. For the light you see is the glory of God that shall fill the house." Again, as quick as thought, I was removed to my former position where I gazed with wonder and admiration upon the wonderful house of God. While I was able to see the exterior of the house, the wonderful light was not visible, and I gazed again in admiration but when the house disappeared the light was visible again, waving in perfect motion until it gradually vanished from my sight and the vision closed.[77]

THE ARCHIVES OF THE TEMPLE

We do not currently have access to all of the scriptures that have been revealed to mankind throughout the ages, but we have been promised that in the due time

of the Lord these voluminous writings will be restored.[78] While we look forward with great anticipation to reading the material found in the sealed portion of the Book of Mormon, we must not forget that many records were used to compile that book. This collection of sacred writings was hidden away by those who had charge over them (see Mormon 1:3; 2:17; 6:6). Elder Orson Pratt claimed that this vast collection of records is now "under the charge of holy angels, until the day should come for them to be transferred to the sacred temple of Zion."[79] In his narrative, mentioned above, Parley P. Pratt described a room inside the New Jerusalem Temple that was set aside to hold these and other ancient records.[80] Several of the early saints have told variations of an interesting story about Joseph Smith and Oliver Cowdery seeing this collection of records when they returned the gold plates of the Book of Mormon to the Hill Cumorah. Brigham Young related the following:

> Oliver Cowdery went with the Prophet Joseph when he deposited these plates. Joseph did not translate all of the plates; there was a portion of them sealed, which you can learn from the Book of Doctrine and Covenants. When Joseph got the plates, the angel instructed him to carry them back to the hill Cumorah, which he did. Oliver says that when Joseph and Oliver went there, the hill opened, and they walked into a cave, in which there was a large and spacious room. He says he did not think, at the time, whether they had the light of the sun or artificial light; but that it was just as light as day. They laid the plates on a table; it was a large table that stood in the room. Under this table there was a pile of plates as much as two feet high, and there were altogether in this room more plates than probably many wagon loads; they were piled up in the corners and along the walls. The first time they went there the sword of Laban hung upon the wall; but when they went again it had been taken down and laid upon the table across the gold plates; it was unsheathed, and on it was writ-ten these words: "This sword will never be sheathed again until the kingdoms of this world become the kingdom of our God and his Christ." I tell you this as coming not only from Oliver Cowdery, but others who were familiar with it.[81]

The question sometimes arises as to whether or not the temple in the city of Zion will be used for the reception of endowments. Elder Bruce R. McConkie offers this insight on the matter:

> In the Nauvoo temple—as will be the case in due course in the temple in Missouri—the saints were to receive "the fulness of the priesthood" through celestial marriage, which is the patriarchal order. In it they were to "be baptized for those who are dead"; in it they were to receive honor and glory, washings, anointings, oracles, conversations, statutes and judg-ments, and much else—all "for the beginning of the revelations and foundation of Zion, and for the glory, honor, and endowment of all her municipals." In this house the Lord promised to reveal "things which have been kept hid from before the foundation of the world, things which pertain to the dispensation of the fulness of times." That is to say, the

revelations, endowments, ordinances, covenants, promises, and eternal truths received in this and all subsequent temples are for the express purpose of preparing and purifying the Lord's people, freeing them from the blood and sins of the world, so they will be ready in due course to build the New Jerusalem and the temple in that center place.[82]

Elder McConkie's statement is most informative. Those who go to build up Zion will need to be previously endowed and free from the blood and sins of this generation through the appointed means (see D&C 88:138-39)[83] because each will be required to live "the principles of the law of the celestial kingdom" (D&C 105:5). Just as temples are now like a terrestrial sphere in a telestial world, during the Millennium the New Jerusalem Temple will become like a celestial sphere within a terrestrial world, for the Lord will be there. As for "the fulness of the priesthood" mentioned above, the teachings of the prophets are clear. "You cannot receive the fulness of the priesthood unless you go into the temple of the Lord and receive the ordinances," said Joseph Fielding Smith. "No man can get the fulness of the priesthood outside the temple of the Lord."[84] The Prophet Joseph Smith was equally specific: "If a man gets a fullness of the priesthood of God he has to get it in the same way that Jesus Christ obtained it, and that was by keeping all the commandments and obeying all the ordinances of the house of the Lord."[85]

According to Orson Pratt the Lord will eventually reveal more concerning the temple ordinances than is currently available to us.[86] Speaking specifically of the New Jerusalem Temple, Elder Pratt said this: "Every ordinance that will be administered in that temple will be administered by holy hands, and you will understand and know the meaning thereof. The Lord will reveal these things in their day; he will reveal everything that is needful, so that the knowledge of God may rest upon you, and that there be no darkness with you."[87]

THRONES, ROBES, AND CROWNS

In biblical times the Holy of Holies of the temple was considered to be an earthly representation of the Lord's celestial throne room and the Ark of the Covenant represented his throne (see Isaiah 6:1; Ezekiel 1:26-28).[88] When Christ returns to reign as "the King of Zion" (Moses 7:53) it will be from the temple that his holy laws, decrees, and judgments will be sent forth (see Isaiah 2:3; D&C 38:22; 45:59). Hence, his throne will be found inside the New Jerusalem Temple as the great symbol of the Kingdom of God.[89] Those who attain exaltation in the celestial world will sit upon thrones even as their Redeemer now does and they will thereby share in his responsibilities and powers.[90]

We learn from the scriptures that the Lord will appoint kings and priests from among the faithful to reign with him during the Millennial era (see Revelation 5:10; 20:41). It is therefore appropriate that two of the symbols frequently attributed to the inhabitants of Zion are the white robe and the golden crown (see Ether 13:10; Revelation 4:4; 7:14). One interpretation of the white linen robe is that it signifies "the righteousness of the saints" (Revelation 19:8) and, of course, in the "gospel sense, a crown is the sign and symbol of eternal exaltation and dominion."[91]

Wilford Woodruff related the following dream which he had of the spirit world on 15 March 1848: "I saw Joseph and Hyrum and many others of the Latter-day Saints who had died. The innumerable company of souls which I saw seemed to be preparing for some grand and important event which I could not understand. Many were engaged in making crowns for the Saints. They were all dressed in white robes, both male and female."[92] One recent convert to the Church recorded an encounter she had with the spirits of the just on 21 February 1867 and described the type of clothing and regalia they wore.

> I dozed off and dreamed that the angels were at my bedside ready to converse with me, and that I must pray for still greater courage to behold them in the glory that surrounded them. . . . I woke up, with a shock like lightning to my whole system, far more powerful than anything I had yet experienced. The room was filled with consuming flames, as a rushing, mighty wind, and a pillar of fire far above the brightness of the noonday sun. . . . As I gazed mute and helpless toward heaven, in the midst of the light, just beneath the ceiling, I saw two immortal beings. Their countenances transcended the . . . sun. . . . They then . . . descended within a foot or two above me. They then rested their chins upon their right hands and smiled again. . . .
>
> I now beheld the full and lightning-like appearance of their countenances. On their heads were crowns of pure gold like transparent glass, inlaid with immortal stones of every conceivable color, higher and of more exceedingly fine workmanship in front than at the sides. They
>
>
>
> were dressed in robes of most exquisite whiteness and texture of pure linen. . . . Not a speck or mote was upon their countenances, which were perfectly transparent—I could see through their faces plainly as through a window. To notice all this consumed but a short time, perhaps half a minute. One of them began speaking to me. . . .
>
> He spoke four words to me, which pierced as living fire and I was as one dead before him and shrank. . . . I then looked at the other angel and saw that it was a female. She spoke and told me her name.
>
> The first did not tell me his name, but spoke of the glory that I should enjoy after my afflictions in this world were over.[93]

THE SIGN OF THE SON OF MAN

The Second Coming of the Lord in clouds of glory will be heralded by a wondrous sign in the heavens called the "Sign of the Son of Man." Not a great deal is known about this sign, but from the information that is available it would appear that Christ's Second Coming will be announced just like the first—by a heavenly sign. From various scriptural sources we learn the following about this sign.[94]

- Angels will arrive on earth and encourage the Saints to go out and meet the Bridegroom.

- Immediately thereafter a sign will appear in the heavens, probably in the east, which will gradually grow larger until it is seen by all the inhabitants of the earth.

- The wicked will call the sign a planet, comet, or star but the Saints will understand its true significance.

- There will be silence in heaven for the space of half an hour.

- Immediately thereafter the Lord will unfold the curtain of heaven, or part the veil of the heavenly temple, and reveal his face.

- Jesus Christ will come down to the earth in "power and great glory."

- All the holy angels or hosts of heaven will accompany him.

- They will come in "the pillar of heaven," which is described as "a pillar of fire."

- The Saints who survive this experience will be caught up off the earth to meet the Lord in the pillar of fire.

THE SAVIOR'S RED ROBE

When the Lord approaches the earth in his radiant glory, many will be astonished that he is not dressed in the white robes of the angels, but in scarlet red.

> And it shall be said: Who is this that cometh down from God in heaven with dyed garments; yea, from the regions which are not known, clothed in his glorious apparel, traveling in the greatness of his strength? And he shall say: I am he who spake in righteousness, mighty to save. And the Lord shall be red in his apparel, and his garments like him that treadeth in the wine-vat. And so great shall be the glory of his presence that the sun shall hide his face in shame, and the moon shall withhold its light, and the stars shall be hurled from their places. And his voice shall be heard: I have trodden the wine-press alone, and have brought judgment upon all people; and none were with me; And I have trampled them in my fury, and I did tread upon them in mine anger, and their blood have I sprinkled on my garments, and stained all my raiment; for this was the day of vengeance which was in my heart. (D&C 133:46-51)[95]

Elder Neal A. Maxwell teaches the deep significance of this robe by reminding us that having "bled at every pore, how red His raiment must have been in Gethsemane, how crimson that cloak! No wonder, when Christ comes in power and glory, that He will come in reminding red attire (see D&C 133:48), signifying not only the winepress of wrath, but also to bring to our remembrance how He suffered for each of us in Gethsemane and on Calvary!"[96] Indeed, the High Priest of ancient Israel, who was a type and shadow of the coming Messiah (see Hebrews 3:1; 5:10), had the blood of atonement sprinkled upon his temple robes during the rituals of his consecration (see Exodus 29:19-21, 32-33). In highly symbolic language we are told in the scriptures that the faithful will have their garments washed white in the atoning blood of their Redeemer (see Revelation 1:5; 5:9; 7:14-15; 1 Nephi 12:10; Alma 5:21; 13:11; 3 Nephi 27:19; Ether 13:10).

There is perhaps one other symbolic meaning behind the Lord's red vesture. Blood is a symbol of mortal life, or in other words, a fallen state (see Leviticus 17:11; Deuteronomy 12:23), a state often associated with sin. Before the Fall Adam and Eve did not have blood coursing through their veins but rather a substance of spirit that maintained them in their immortal state.[97] The same is true of resurrected beings. "When our flesh is quickened by the Spirit," said the Prophet Joseph Smith, "there will be no blood in this tabernacle."[98] This will be necessary because flesh and blood cannot inherit the kingdom of God (see 1 Corinthians 15:50).[99] In some respects, then, Christ's shed blood could be seen metaphorically as the shedding of mortality and sin, and his complete victory over them both (see John 16:33; Mosiah 15:8; Mormon 7:5-7).

THE REDEMPTION OF ZION

Though Zion was not redeemed, nor the temple raised, in the lifetime of Joseph Smith, we have ample assurance that the day of redemption will surely come, for the Lord told President Brigham Young: "Zion shall be redeemed in mine own due time" (D&C 136:18). President Joseph Fielding Smith has reminded us that the "release from the building of the temple in 1833, did not, however, cancel the responsibility of building the city and the house of the Lord, at some future time. When the Lord is ready for it to be accomplished, he will command his people, and the work will be done."[100]

Who will return to redeem Zion? Brigham Young asked, "Are we going back to Jackson County? Yes. When? As soon as the way opens up. Are we all going? O no! of course not."[101] At another time he specified that only "a portion of the Priesthood will go and redeem and build up" Zion.[102] Elder Bruce R. McConkie shares these

important insights on the matter: "After many days, a designated period in which we still live, those who are called, chosen, selected, appointed, and sent forth by the voice of the Spirit, as it speaks to the President of the Church, shall build the New Jerusalem and the holy temple."[103] He further states:

> The revealed word relative to the gathering to Independence and its environs will come through the prophet of God on earth. When it does come—with the consequent return of the saints to that Zion which shall not be moved out of its place—that call will not be for the saints in general to assemble there. The return to Jackson County will be by delegates, as it were. Those whose services are needed there will assemble as appointed. The rest of Israel will remain in their appointed places.[104]

How will the redemption of Zion be accomplished? The Lord has provided clear answers in his latter-day revelations. In D&C 103:15, he says that "the redemption of Zion must needs come by power," and in D&C 105:9-13 he specifies that this will only occur when the "elders are endowed with power from on high." This means that they must receive their temple ordinances (see D&C 38:32, 38; 43:16; 95:8) and live the full principles of the celestial law of consecration so that they will all be of one heart and one mind (see D&C 105:4-5, 88:21-22).[105]

When will Zion be redeemed? In the Lord's own due time. Though no mortal or angel knows the exact day and hour of the Second Coming (see Matthew 24:36; Mark 13:32; D&C 49:7, 133:11; JS-M 1:40) we do know that the city of the New Jerusalem and its temple will be built sometime *before* the coming of the Son of Man.[106] When the temple of temples finally stands upon the consecrated land of Zion, the Saints of the Most High God will be seen looking toward the heavens awaiting the return of their King.

NOTES

1. There will be four appearances: Adam-ondi-Ahman, New Jerusalem, Mount of Olives, and Clouds of Glory. See Robert L. Millet, "The Second Coming of Christ: Questions and Answers," in Leon R. Hartshorn, Dennis A. Wright, and Craig J. Ostler, eds., *The Doctrine and Covenants: A Book of Answers* (Salt Lake City: Deseret Book, 1996), 208-11.

2. See Peter Hayman, "Some Observations on Sefer Yesira: (2) The Temple at the Centre of the Universe," in Geza Vermes, ed., *Journal of Jewish Studies*, vol. 37, no. 2 (Autumn 1986), 176-82; David Noel Freedman, "Temple without Hands," in Avraham Biran, *Temples and High Places in Biblical Times* (Jerusalem: The Nelson Glueck School of Biblical Archaeology of Hebrew Union College, 1981), 21-30; Martha Himmelfarb, "Apocalyptic Ascent and the Heavenly Temple," in Kent Harold Richards, ed., *Society of Biblical Literature 1987 Seminar Papers* (Atlanta: Scholars Press,

1987), 210-17; Jay A. Parry and Donald W. Parry, "The Temple in Heaven: Its Description and Significance," in Donald W. Parry, ed., *Temples of the Ancient World: Ritual and Symbolism* (Salt Lake City: Deseret Book and FARMS, 1994), 515-32.

3. Lewis Anderson was president of the Manti Temple from 1903 until 1933. When he was fifteen years old he was shown a vision of the future temple. His experience is related by his daughter: "A picture came before him. It was a picture of a building. He said it looked as though someone was holding it, but could not see any hands. It stayed long enough for him to study it. He remembered all the details of the outside of the building. And he didn't have any idea what the building was, because he had never seen a building or picture like it before. Well, it just disappeared, faded away. . . . When he came home from his last mission, the Temple was ready for dedication. He hadn't seen it during construction. He had lived in Fountain Green for part of the time the Temple was under construction, and he was on a full-time mission the rest of the time. He was called to come as a recorder in the Temple, another missionary calling. When he got to the south side of Ephraim on his way to accept his calling, he saw the Temple. The vision he had long ago all came back to him. He exclaimed, 'There is the building I saw when I was a boy!' He came into the Temple that day as a recorder. Later he was called to assist Brother John D. T. McAllister in the Temple presidency. Still later he served 27 years as president of the Temple" (Barbara Lee Hargis, *A Folk History of the Manti Temple*, master's thesis, Brigham Young University, 1968, 53-54).

4. Harold W. Burton and W. Aird Macdonald, "The Oakland Temple," *IE*, 67 (May 1964): 380. In this 1924 vision Elder George Albert Smith, in the presence of a branch president, saw "a great white temple of the Lord."

5. The architect of the Swiss Temple shared some type of vision with President David O. McKay while the prophet described the building to him. Edward O. Anderson, "The Making of a Temple," *Millennial Star*, 120 (September 1958), 278, hereafter cited as *MS*.

6. President McKay spoke in the plural when he said: "I can hardly restrain myself in telling you what we have seen in vision. There may not be a temple on that high mountain . . . but I think there will be some day in the future." In *Te Karere: The Messenger* 51 (January 1957): 4-5.

7. Foreknowledge of the Provo Temple was evidently given to Brigham Young, though it is not clear if this knowledge was given to him by vision. Ben H. Bullock's parents related the following story: "During the early days of Provo, President Brigham Young asked several of the Saints to accompany him on to what is known as 'Temple Hill,' in the northeast part of Provo, Utah. We were among those present and President Young addressing us said, 'We have ascended to the summit of this beautiful hill and now you are standing on holy ground. The day will come when a magnificent temple will be erected here to our God and I want you to look and behold the scenic beauty of this wonderful valley, with these grand old mountains of Ephraim to the north [and] to the east of us, with their rugged canyons and towering peaks and to the west, we have a wonderful lake of fresh water adding more beauty, and by building the temple here on this spot of ground, there is plenty of room away from the edge of the hill for all needed purposes. . . .' I also wish to state that the late Edward H. Holt . . . also knew of this prophecy made by President Young. He said, 'Oh what a wonderful spiritual effect will be given to the students of the Brigham Young University, to have a magnificent temple on the hill and the university buildings surrounding it'" (Ben H. Bullock, *Daily Universe*, 31 March 1958). In 1951 Sidney B. Sperry reported seeing a vision of the Provo Temple in the future. (See Ernest L. Wilkinson, ed., *Brigham Young University: The First One Hundred Years* [Provo, Utah: Brigham Young University Press, 1976], 4:410).

8. After praying to know how the Savior would want the Idaho Falls Temple built, John Fetzer, Sr., "saw in vision an ancient Nephite temple which he used as the basis for his design" (Delbert V. Groberg, *The Idaho Falls Temple* [Publisher's Press, 1985], 63).

9. Church Educational System, *Old Testament: Genesis - 2 Samuel*, 2d ed., rev. (Salt Lake City: The Church of Jesus Christ of Latter-day Saints, 1981), 155-56.

10. "It was revealed here in St. George to the Prophet Brigham Young that there should be variations made in the temples to be built. This was given unto the Prophet Brigham in answer to his question, 'Oh Lord show unto thy servants if we shall build all temples after the same pattern?' The answer came. 'Do you all build your houses after the same pattern used when your family is small? So shall the growth of the knowledge of the principles of the Gospel among my people cause diversity in the pattern of temples'" (Erastus Snow, *St. George Stake Historical Record*, no. 97707, 20 November 1881).

11. *Journal of Discourses,* 26 vols. (London: Latter-day Saints' Book Depot, 1854-86), 24:25, hereafter cited as *JD*.

12. Ibid. One reported vision of the spirit world mentions a white temple still under construction. (See *Helpful Visions* [Salt Lake City: Juvenile Instructor Office, 1887], 32-33).

13. Quoted in Archibald F. Bennett, *Saviors on Mount Zion* (Salt Lake City: Deseret Sunday School Union, 1950), 210.

14. Stuy, *Collected Discourses*, 5:237, 19 October 1896. On an earlier occasion President Woodruff related the same information: "I will say here that in my dreams I have had a great many visits from the Prophet Joseph since his death. The last time I met him was in the spirit world. I met him at the Temple" (ibid., 2:106, 4 October 1890). A stake president named Heber Q. Hale saw in the spirit world "a wonderfully beautiful Temple, capped with golden domes, from which emerged a small group of men dressed in white robes who paused for brief conversation. These were the first I had seen thus clad" (Heber Q. Hale, "A Heavenly Manifestation by Heber Q. Hale, President of Boise Stake of The Church of Jesus Christ of Latter-day Saints," unpublished manuscript, cited in Duane S. Crowther, *Life Everlasting* [Salt Lake City: Bookcraft, 1967], 78). While a young child, Cora M. Pratt had what she described as "a dream, or almost a vision, for I am sure that no vision could be grander. . . . I looked up, and behold I saw a cloud of light in the east, and looking around me, I saw that it was dark with the exception of this light. In the light there appeared a grand temple, that was of pure white marble glittering like diamonds. As I stood gazing at this beautiful picture, the door opened, and the Lord, followed by the ancient apostles, came through the door out on the steps, which were round and leading down from the temple. The persons were clad in snowy white raiment, which was made loose, and hung from the shoulders, after the ancient pattern"(*Juvenile Instructor*, vol. 27, no. 18 [15 September 1893], 590; hereafter cited as *JI*).

15. Alfred Douglas Young, *Autobiographical Journal*, 1808-1842, 17 September 1841, 3-13.

16. *JD*, 18:303.

17. *JD*, 25:236-37; see 3 Nephi 28:12-16. Elder McConkie points out that since the time of Christ's resurrection, those in the city of Enoch and other translated beings, including Moses and Elijah, are no longer in a translated state but are now resurrected (*MD*, 808).

18. *Messenger and Advocate*, 1 September 1835, hereafter cited as *MA*. See also Joseph Smith, *History of The Church of Jesus Christ of Latter-day Saints*, 7 vols., 2d ed., rev., Brigham H. Roberts, ed. (Salt Lake City: The Church of Jesus Christ of Latter-day Saints, 1932-51), 2:253-59; hereafter

cited as *HC*.

19. Joseph Smith said that after arriving upon the designated land, he and his brethren sought diligently for another revelation to guide them. The Lord "manifested Himself" unto all of those who were present and designated the exact spot for the City of Zion (*HC*, 2:254).

20. Notice the "promised land" motif (see Exodus 3:8, Deuteronomy 8:7-8, Jeremiah 11:5, D&C 38:18-20).

21. *HC*, 1:199, 3 August 1831.

22. Ibid.

23. This vision was recorded by Wilford Woodruff on 15 June 1878 but was received on 16 December 1877. (See Scott G. Kenney, ed., *Wilford Woodruff's Journal* [Midvale, Utah: Signature, 1985], 7:419-23).

24. On 6 April 1837 Wilford Woodruff said that Joseph Smith "presented us in some degree the plot of the City of Kirtland (which is the strong hold of the daughter of Zion) as it was given him by vision" (*BYUS*, vol. 12, no. 4, Summer 1972, 391). A slightly different version of this quote can be found under the date of 6 April 1837 in *Journal History of The Church of Jesus Christ of Latter-day Saints*, April 6, 1830-December 31, 1972, Historical Department of the LDS Church [Salt Lake City: 1906-1972]). According to Orson Pratt (*JD*, 21:154): "I expect, when that time comes, that man will understand all the particulars in regard to the Temple to be built in Jackson County. Indeed, we have already a part of the plan revealed, and also the plat explaining how the city of Zion is to be laid off."

25. "From the Lord, Joseph learned that Adam had dwelt on the land of America, and that the Garden of Eden was located where Jackson County now is" (Jenson, *Historical Record*, vols. 7 and 8, 438; Orson F. Whitney, *Life of Heber C. Kimball* [Salt Lake City: Juvenile Instructor Office, 1888], 219).

26. Scott G. Kenney, ed., *Wilford Woodruff's Journal* (Midvale, Utah: Signature, 1984), 5:33, 15 March 1857, quoting Brigham Young. The same comments are recorded in the *Journal History* under the same date: "Now it is a pleasant thing to think of and to know where the Garden of Eden was. Did you ever think of it? I do not think many do, for in Jackson County was the Garden of Eden. Joseph [Smith] declared this, and I am as much bound to believe that as to believe that Joseph was a prophet of God."

27. Joseph Fielding Smith, *Doctrines of Salvation*, 3 vols., Bruce R. McConkie, comp. (Salt Lake City: Bookcraft, 1954-56), 3:74, hereafter cited as *DS*; Article of Faith 1:10.

28. *Life of John D. Lee* (Hartford, Conn.: Park Publishing, 1881), 91. See also Harold B. Lee, *Ye Are the Light of the World* (Salt Lake City: Deseret Book, 1974), 351; *JD*, 10:235; 11:337; *MD*, 303; *HC*, 3:35-36; D&C 116:1.

29. Donald W. Parry, "Garden of Eden: Prototype Sanctuary," in Donald W. Parry, ed., *Temples of the Ancient World: Ritual and Symbolism* (Salt Lake City: Deseret Book and FARMS, 1994), 126-51.

30. *Deseret News*, vol. 10, no. 38 (21 November 1860), 1. George Q. Cannon said that "God in His revelations has informed us that it was on this choice land of Joseph where Adam was placed and the Garden of Eden was laid out. The spot has been designated, and we look forward with peculiar feelings to repossessing that land" (*JD*, 11:336-37).

31. Martha Himmelfarb, "The Temple and the Garden of Eden in Ezekiel, the Book of the

Watchers, and the Wisdom of ben Sira," in Jamie Scott and Paul Simpson-Housley, eds., *Sacred Places and Profane Spaces* (New York: Greenwood Press, 1991), 63-78.

32. Samuel Whitney Richards, *CR*, October 1905, 87-89.

33. Bruce R. McConkie, *New Witness for the Articles of Faith* (Salt Lake City: Deseret Book, 1985), 640, hereafter cited as *NWAF*.

34. *JD*, 2:342. See also *JD*, 18:342-43; *WJS*, 64.

35. Bruce R. McConkie, *The Promised Messiah* (Salt Lake City: Deseret Book, 1981), 140; *MD*, 29. In Moses 6:57 we are informed that "in the language of Adam, Man of Holiness is his name, and the name of his Only Begotten is the Son of Man." On 9 March 1841, Joseph Smith said that "the Great God has a name by which He will be called which is Ahman" (*WJS*, 64).

36. *MD*, 19.

37. See D&C 116:1. D&C 107:53-54 connects Adam-ondi-Ahman with Adam coming back into the presence of the Lord. According to Alvin R. Dyer: "The word 'Adam' refers directly to Adam. The word 'ondi,' means nearby or connected with. The word 'Ahman' means the Lord himself" (*The Lord Speaketh* [Salt Lake City: Deseret Book, 1964], 216). For an interesting chart showing possible connections between "ondi" and similar words from various languages that mean "in the presence of," see Elwood G. Norris, *Be Not Deceived: A Scriptural Refutation of the Adam-God Theory* (Bountiful, Utah: Horizon, 1978), 88. Both Joseph Fielding Smith and Bruce R. McConkie follow the interpretation put forward by Orson Pratt that the phrase means something like "the valley of God where Adam dwelt" (*Answers to Gospel Questions* 1:12; MD, 19; JD, 17:187; 18:342-43). The similarity between *Ahman* and *Amen* as names of God should not be overlooked here (see John W. Welch, "Word Studies from the New Testament," *Ensign,* January 1995, 30; John A. Tvedtnes, "Faith and Truth," *Journal of Book of Mormon Studies*, vol. 3, no. 2 [Fall 1994], 114; hereafter cited as *JBMS*).

38. *TPJS*, 158-59. The type of "patriarchal blessing" spoken of here could be viewed in the context of D&C 124:92-93 and 107:39-41.

39. D&C 116:1. See also *HC*, 3:35.

40. Joseph Fielding Smith, *The Way to Perfection* (Salt Lake City: Deseret Book, 1966), 289-91; emphasis added. See also Orson Pratt's comments in *JD*, 17:187-88, 11 October 1874. Joseph Smith said that when Daniel speaks of "the Ancient of Days: he means the oldest man, our Father Adam, Michael" (see D&C 27:11, August 1830) and that the purpose of this grand council is to deliver up the keys of the priesthood that were bestowed as a stewardship upon Adam's posterity, back to the Son of Man in preparation for the Second Coming (*HC*, 3:386-87, 2 July 1839).

41. *Salt Lake School of the Prophets Minute Book 1883* (Salt Lake City: Pioneer Press, 1992), 64. A similar account of this vision can also be found on pages 102-103. "At my return from a mission in Kirtland, I met Joseph and he asked me if I would like to go to conference as he was going next morning. We started next morning and went to New Portage and put up with the presiding Elder of the branch. Next morning Joseph asked me and Brother Oliver Cowdery if we would take a walk with him to the wood lot. We agreed to do so and in a short time reached a place where some wild grape vines made a pretty arbor over our heads. Joseph said, 'Let us kneel down here and pray.' After prayer Joseph stretched himself upon his back upon a grassy spot with his arms extended like one upon the cross. He told me to lie by his side and Oliver in like manner on the other side. We did, all three of us looking heavenward. As I looked I saw the blue sky open; I beheld a throne, and upon

the throne sat a man and woman. Joseph asked us if we knew who they were; we answered, no. Joseph answered, 'That is Father Adam and Mother Eve.' Their heads were white as snow and their faces shone with immortal youth." This manifestation is also recorded in the journal of Wilford Woodruff under the date 11 October 1883. Another vision of the exalted Adam, seen by Elizabeth Tyler, is related as follows: "She saw a man sitting upon a white cloud, clothed in white from head to foot. He had on a peculiar cap, different from any she had ever seen, with a white robe, under-clothing, and moccasins. It was revealed to her that this person was Michael, the Archangel. She was sitting in the house drying peaches when she saw the heavenly vision, but the walls were no bar between her and the angel, who stood in the open space above her. The Prophet informed her that she had a true vision, and it was of the Lord. He had seen the same angel several times. It was Michael, the Archangel, as revealed to her" (Daniel Tyler, "Recollections of the Prophet Joseph Smith," *JI*, 27 [February 1892]: 93).

42. *DS*, 2:232.

43. For background reading on this subject, see John H. Wittorf, "An Historical Investigation of the Ruined 'Altars' at Adam-ondi-Ahman, Missouri," *Newsletter and Proceedings of the Society for Early Historic Archaeology*, Brigham Young University, 15 April 1969, 1-8.

44. Orson F. Whitney, *Life of Heber C. Kimball,* 2d ed. (Salt Lake City: Stevens and Wallis, 1945), 208-209.

45. Leland H. Gentry, "Adam-ondi-Ahman: A Brief Historical Survey," *Brigham Young University Studies,* vol. 13, no. 4 (Summer 1973), 561; hereafter cited as *BYUS*.

46. Joseph Fielding Smith, *Church History and Modern Revelation*, 2 vols. (Salt Lake City: The Council of the Twelve Apostles, 1953), 2:97-98.

47. *HC*, 2:52. See also *HC*, 3:390-91.

48. See Douglas Brinley, "What do we mean by the terms 'kingdom of God' and 'kingdom of heaven,' and are they synonymous with The Church of Jesus Christ of Latter-day Saints?" (*Ensign*, January 1996, 60-61).

49. Joseph Fielding Smith, *Church History and Modern Revelation*, 1:321-22. Orson Pratt had similar thoughts when he said, "Let me take the liberty to say to this congregation that the City of Zion when it is built in Jackson County, will not be called a Stake. We can find no mention in all the revelations that God has given, that the City of Zion is to be the Centre Stake of Zion; the Lord never called it a Stake in any revelation that has been given. It is to be the head quarters, it is to be the place where the Son of Man will come and dwell, where He will have a Temple . . . it will be the great central city, and the outward branches will be called Stakes wherever they shall be organized as such" (*JD*, 22:35). Elder Orson F. Whitney also clarified this idea by stating that "all other gathering places of God's people are only stakes of Zion, holding the outside cords and curtains of the spiritual Tabernacle of the Lord. . . . There was no stake organization in Jackson County, though that part is sometimes referred to as 'The Center Stake.' Zion is there, or will yet be there—the very City of God; but no Stake of Zion. . . . Zion is greater than any of her stakes. . . . Zion, in sacred writ, is symbolized by a tent or portable tabernacle, such as the Israelites carried with them in the Wilderness. Evidently it was the custom then, as it is now, when setting up a tent, to make it firm and secure. Hence the phrase: 'Lengthen thy cords and strengthen thy stakes,' a metaphor applied to Zion by the Prophet Isaiah (54:2; 33:20). When a tent is erected, no center stake is driven; it would be in the way—an obstacle to stumble over. Figuratively and in a large sense, the same would be true

of a Center Stake of Zion. There is no need for such a thing, and it would spoil the symbolism of the picture" (Orson F. Whitney, *Saturday Night Thoughts* [Salt Lake City: Deseret News, 1921], 183).

50. Notice the specific designation—"Zion, *a* New Jerusalem" (Moses 7:62; emphasis added); "*a* New Jerusalem" (3 Nephi 20:21-22; emphasis added); "*a* New Jerusalem" (Ether 13:6; emphasis added). This should be understood in light of the language of D&C 109:51 where it says, "Thou didst appoint a Zion unto thy people" because there have been several Zion communities established throughout the dispensations of time as sanctuaries of the "pure in heart"; see Bruce R. McConkie, *Doctrinal New Testament Commentary*, 3 vols. (Salt Lake City: Bookcraft, 1965-73), 3:580-81; hereafter cited as *DNTC*.

51. According to Elder McConkie, "All of the references to Mount Zion which talk of the Second Coming and related latter-day events appear to have in mind the new Mount Zion in Jackson County, Missouri. . . . [From D&C 133:17-22 it] seems clear that the Lord and his exalted associates shall stand in glory upon the American Mount Zion" (*DNTC*, 3:525-26).

52. This mountain is frequently described as being "holy" (Psalm 2:6; [JST] 15:1; 24:3; 48:1-2; 99:9; Isaiah 11:9; 27:13; 56:7; 57:13; Ezekiel 20:40; Joel 2:1; 3:17; Zechariah 8:3) because in the temple of Zion "the Holy One" is worshipped and reigns as King over Israel (Isaiah 27:13; 60:14; Micah 4:7; Psalm 48:1-2). The New Jerusalem is also referred to as the "mountain of the Lord" (*HC*, 6:319).

53. *MD*, 517-18. See also Erastus Snow, *JD*, 16:202.

54. John M. Lundquist, "The Common Temple Ideology of the Ancient Near East," 59-65; Richard J. Clifford, "The Temple and the Holy Mountain," 107-124, both found in Truman G. Madsen, ed., *The Temple in Antiquity* (Provo, Utah: BYU Religious Studies Center, 1984).

55. *WJS*, 119-20.

56. *TPJS*, 333. Samuel Whitney Richards attended a meeting where this same topic was discussed: "I attended four meetings of this company and at one of them, which was in charge of Hyrum Smith, and three or four of the Twelve was also present, it was said that Joseph the Prophet had remarked that he wanted young men for that mission who could go upon the mountains and talk with God face to face, as Moses did upon Mount Sinai" (*CR*, October 1905, 87-89).

57. Many prophets are known to have experienced these blessings in a mountain setting. There is some scriptural indication that the Garden of Eden was located upon a mountain, and so Adam's experiences with God may be seen in this context (see Ezekiel 28:11-16). Others who have had mountaintop experiences with Deity include Jesus Christ, Peter, James, and John (see Matthew 17:1-9; Mark 9:2-9; Luke 9:28-36; 2 Peter 1:16-19; Revelation 21:10), Abraham, Isaac, and Jacob (see Genesis 22:1-18; 28:1-22; 35:1-3), Enoch (see Moses 7:1-4), Moses (see Exodus 24:12-18; Moses 1:1-2), Elijah (see 1 Kings 19:9-13), Ezekiel (see Ezekiel 40:2), Nephi (see 1 Nephi 11:1, 7; 2 Nephi 4:25), and the brother of Jared (see Ether 3:1, 6, 13). Joseph Smith learned through revelation that the name of the brother of Jared was Mahonri Moriancumer (see *JI*, vol. 27, no. 9 [1 May 1892], 282). The context of this prophet's experience is explained in M. Catherine Thomas, "The Brother of Jared at the Veil," in Donald W. Parry, ed., *Temples of the Ancient World: Ritual and Symbolism* (Salt Lake City: Deseret Book and FARMS, 1994), 388-98.

58. *HC*, 2:381.

59. *JD*, 15:361. "If, then Zion becomes great it will be because of her sanctification" (Orson

Pratt, *JD*, 17:112).

60. *JD*, 9:270.

61. Joseph G. Nelson, *An Autobiography of Joseph G. Nelson* (Salt Lake City: Kaye F. Nelson, 1965), 59-60. See Isaiah 5:24; D&C 29:9-11.

62. Philo Dibble, *Early Scenes in Church History* (Salt Lake City: Juvenile Instructor Office, 1882), 86-87.

63. *NWAF*, 595.

64. *JD*, 10:147.

65. *NWAF*, 519.

66. The note reads: "For your satisfaction we inform you that the plot for the City and the size[,] form[,] and dimensions of the house were given us of the Lord" (sketch of the temple, 25 June 1833, ms. f13, vault, LDS Church Archives, Salt Lake City, Utah).

67. *JD*, 21:154; *Journal History*, 6 April 1837. See footnote #24 above.

68. Lyndon W. Cook, *The Revelations of the Prophet Joseph Smith* (Salt Lake City: Deseret Book, 1985), 196, 321. This letter is dated 6 August 1833, and states that the "pattern" for the two other buildings was to be revealed at a future time.

69. Consider the description of the New Jerusalem Temple in Parley P. Pratt, *The Angel of the Prairies* (Salt Lake City: Deseret News and Publishing Establishment, 1880). This narrative was written in Nauvoo during the winter of 1843-44 and was read in a council meeting attended by the Prophet. The temple described in this story bears an interesting resemblance to a temple seen in vision by John Taylor at Nauvoo on 18 June 1845. The 1839 revelation alluded to by Orson Pratt, wherein the twenty-four temples planned for New Jerusalem were combined into one temple with twenty-four rooms, may have also occurred at Nauvoo. Brigham Young proposed yet another plan for the New Jerusalem Temple but it was strictly his own opinion: "President Young said his views of the great Temple in Jackson Co[unty,] Mo. was that there would be 12 Temples surrounding a square and the square would be for a Great Tabernacle for the people while the Temples would be for giving endowments and there would be doors out of every Temple for the Priesthood (who labored in the Temples), to go into the Tabernacle to teach the people and prepare them for the endowments" (Kenney, *Wilford Woodruff's Journal*, 24 August 1867).

70. *JD*, 24:24-25.

71. Ibid., 21:330-31.

72. Ibid., 21:153-54.

73. Ibid., 19:19-20.

74. Duane S. Crowther, *Prophecy: Key to the Future* (Salt Lake City: Bookcraft 1962), 98, fn. 41.

75. Dean C. Jessee, "The John Taylor Nauvoo Journal: January 1845 - September 1845," *BYUS*, vol. 23, no. 3 (Summer 1983), 52-53. This vision occurred on 18 June 1845.

76. Parley P. Pratt, *The Angel of the Prairies*, 11-14, 20-21.

77. Diary of Joseph Lee Robinson, cited in N. B. Lundwall, *Temples of the Most High,* collector's edition (Salt Lake City: Bookcraft, 1993), 240-41.

78. Robert J. Matthews, "The Restoration of All Things: What the Doctrine & Covenants Says," in Byron R. Merrill, comp., *The Heavens Are Open* (Salt Lake City: Deseret Book, 1993), 226-29.

79. N. B. Lundwall, *Masterful Discourses of Orson Pratt* (Salt Lake City: Bookcraft, 1962), 390-91.

80. Parley P. Pratt, *The Angel of the Prairies*, 20-21.

81. *JD*, 19:37-39. Heber C. Kimball classified this unusual experience as a vision (JD, 4:105). For a listing of sources that relate this story, see Brett L. Holbrook, "The Sword of Laban as a Symbol of Divine Authority and Kingship," *JBMS*, vol. 2, no. 1 (Spring 1993), 64-65.

82. *NWAF*, 602.

83. See "Washing of Feet," in *MD*, 831.

84. *DS*, 3:131.

85. *TPJS*, 308. At another time the Prophet specified: "Those holding the fulness of the Melchizedek Priesthood are kings and priests of the Most High God, holding the keys of power and blessings" (ibid., 322). See also D&C 76:54-56 and *MD*, 425.

86. *JD*, 16:255-56, 7 October 1873: "God has ordained a building of a different pattern wherein laws, statutes, judgements, and ordinances are to be revealed for the benefit of his people . . . a place wherein the angels may come and visit, as they did in the ancient Temple; a place wherein you can receive all those ordinances which the Lord has revealed, and which he will hereafter reveal, from time to time, preparatory to the great day of the coming of the Lord." Two other sources confirm this idea: "There is yet much for us to learn concerning the temple ordinances, and God will make it known as we prove ourselves ready to receive it" (Wilford Woodruff in the Abraham H. Cannon Journal, 5 April 1894, BYU Special Collections Library, mss. 1475). "There is more revelation to come relative to salvation for the dead and all other things. The last word has not been spoken on any subject. Streams of living water shall yet flow from the Eternal Spring who is the source of all truth. There are more things we do not know about the doctrines of salvation than there are things we do know. When we as a people believe and conform to all of the truths we have received, we shall receive more of the mind and will and voice of the Lord. What we receive and when it comes are in large measure up to us. The Lord has many things he wants to tell us, but so far we have not attained that unity and spiritual stature which will enable us to pull down knowledge from heaven upon us" (Bruce R. McConkie, *Ensign*, August 1976, 11).

87. *JD*, 21:330-31.

88. Tryggve N. D. Mettinger, "YHWH SABAOTH—The Heavenly King on the Cherubim Throne," in Tomoo Ishida, ed., *Studies in the Period of David and Solomon* (Winona Lake, Ind.: Eisenbrauns, 1982), 109-38.

89. James R. Clark, *Messages of the First Presidency of The Church of Jesus Christ of Latter-day Saints*, 6 vols. (Salt Lake City: Bookcraft, 1965-1975), 1:259-60; see also Orson Pratt, *JD*, 21:153-54.

90. *MD*, 794.

91. Ibid., 173-74.

92. Matthias F. Cowley, *Wilford Woodruff: History of His Life and Labors* (Salt Lake City: Bookcraft, 1964), 328.

93. *Woman's Exponent*, vol. 3, no. 18, 15 February 1875, 139.

94. See Matthew 24:29-30; JS-Matthew 1:26, 36; D&C 29:11-12; 88:92-93, 95-97; 101:22-23; *WJS*, 181; *TPJS*, 287, 280. Wandle Mace claims that he heard Joseph Smith say that the sign of

the Son of Man was "the return of the City of Enoch to the earth" (*Joseph Smith Papers*, LDS Church Archives, Salt Lake City, Utah). Joseph Smith said that the "devil knows many signs but does not know the sign of the Son of Man, or Jesus" (*WJS*, 120). Perhaps this means that he cannot imitate this sign when he performs his false "signs and wonders" (Matthew 24:24), such as attempting to appear as a legitimate angel of light (D&C 128:20).

95. See also Isaiah 63:1-3; Revelation 19:11-13; JST Luke 22:44; D&C 19:18.

96. *Ensign*, May 1987, 72.

97. Joseph Fielding Smith, *Man: His Origin and Destiny* (Salt Lake City: Deseret Book, 1954), 362-64; Joseph Fielding McConkie and Robert L. Millet, eds., *The Man Adam* (Salt Lake City: Bookcraft, 1990), 18, 23, 45-46, 63, 83-85; *MD*, 268.

98. *TPJS*, 367. The Prophet likewise said that "all will be raised by the power of God, having spirit in their bodies, and not blood" (ibid., 199-200).

99. Ibid., 326: "Flesh and blood cannot go there, but flesh and bones quickened by the Spirit of God, can." See D&C 129:1-3; 130:22.

100. Joseph Fielding Smith, *The Way to Perfection* (Salt Lake City: Deseret Book, 1931), 268-69.

101. *JD*, 18:355.

102. Ibid., 11:16.

103. *NWAF*, 619.

104. Bruce R. McConkie, *The Millennial Messiah* (Salt Lake City: Deseret Book, 1982), 294. An article not to be missed by any serious student of this subject is Graham W. Doxey, "Missouri Myths," *Ensign*, April 1979, 64-65.

105. Orson Pratt, *JD*, 17:113: "If we go back then, we must comply with the celestial law, the law of consecration, the law of oneness"; Wilford Woodruff, *JD*, 17:250: The New Jerusalem can only be built up "by the United Order of Zion and according to the celestial law"; Joseph F. Smith, *MS*, 56:385-86: "Zion can only be built up by the law that God revealed for that purpose, which is the law of consecration"; *NWAF*, 591-92: "When Zion is fully established, it will be by obedience to the law of the celestial kingdom, which law is operative in the stakes of Zion only in part . . . when Zion is built we will have the law of consecration in its fulness"; see also ibid., 618; and *JD*, 2:261; 2:299; 13:97; 15:361; 16:276; 17:59.

106. *NWAF*, 590.

CHAPTER 3
The Kirtland Temple

Many people do not realize that the Kirtland Temple was richly adorned by the early Saints with a great variety of symbols. Unfortunately, we are not aware of any historical record that explains why they are there or what significance they had to those who chose them. Most of these emblems are found on the inside of the building and can be easily identified and comfortably interpreted within the context of ancient temple symbolism. For others no interpretation is presently available, and such will not be dealt with in this book. In this chapter we will take what is known of the identifiable symbols and show how they are related to the doctrines, revelations, and spiritual manifestations of the Kirtland era. Until more historical information is forthcoming, we feel that this is the best way to suggest interpretations for these interesting emblems.

THE KIRTLAND TEMPLE SEEN IN VISION

Shortly after the formal organization of the Church, the Lord began to prepare the Saints for temple ordinances. Beginning in the year 1831 the Lord promised his disciples that if they would sanctify themselves before him, they would be "endowed with power" and "taught from on high" (D&C 43:16). The Lord specifically commanded the Saints to gather themselves to the state of Ohio, where he would reveal to them his law and bestow upon them this promised endowment (see D&C 38:32, 38; 39:14-15). By 27 December 1832, the Lord indicated that the Saints would need to build a temple in Kirtland, Ohio, and call a solemn assembly in order for them to receive their heavenly blessing (see D&C 88:70, 119). Joseph Smith called this particular revelation the "olive leaf . . . plucked from the Tree of Paradise" because its message brought great peace to those who received it.[1]

According to Brigham Young, "Joseph [Smith] not only received revelation and commandment to build a Temple, but he received a pattern also, as did Moses for the Tabernacle, and Solomon for his Temple; for without a pattern, he could not know what was wanting, having never seen one, and not having experienced its use."[2] Accordingly, on 6 May 1833, the Lord designated Kirtland as a "stake of Zion" and said that the Saints must begin laying out the city beginning at the temple site "according to the pattern" that had already been revealed to them (D&C 94:1-2). This may possibly refer to the plan of the City of Zion, which will be discussed below.

The Lord also required that two additional buildings, the same size as the temple, be constructed directly to the south of the Lord's house. One of them was to be assigned to the First Presidency of the Church and the other was to be used for the printing of sacred material and other unspecified purposes. The Lord defined all three of the buildings in this complex as "mine houses" and imposed the very same law of sanctity upon them (vs. 15). However, he indicated that the two additional buildings should not be built until a command was given to do so (see vs. 16). The Lord also promised that at some time in the future he would reveal the "pattern" for all of these buildings (vss. 5-6, 12) and reveal how to dedicate their foundations or cornerstones "according to the order of the priesthood" (vs. 6).

On 1 June 1833, the Lord repeated his desire to endow those whom he had chosen "with power from on high" (D&C 95:8) and said that he would therefore grant a vision of the temple structure to three individuals who would need to be appointed and ordained "unto this power" (D&C 95:14). Even though the Lord had provided a broad description of the building in this revelation, and specified the purposes of certain rooms within it (see vss.15-17), this information alone was insufficient because he had also indicated that this temple would not be built "after the manner of the world" (vs. 13). A conference of high priests met on 3 June 1833, in Joseph Smith's translating room above the Newel K. Whitney store in order to choose those who would be privileged to see the temple in vision. Joseph Smith wrote:

> The next matter before the conference was to ascertain what should be the dimensions or size of the house, that is to be built for a house of worship and for the School of the Prophets. I had received a revelation on the size of the house in which the word of the Lord was that it should be fifty-five feet wide, and sixty-five feet long, in the inner court. The conference appointed Joseph Smith, Jun., Sidney Rigdon and Frederick G. Williams to obtain a draft or construction of the inner court of the house.[3]

Hence, the First Presidency was assigned the responsibility of inquiring after the Lord for the revelation. Even though we do not presently know the date of this vision, the *History of the Church* records that on the 5th and 6th of June the first stone for the temple was hauled from the quarry, the foundation was dug, and it was decided that the temple committee should obtain building materials for the structure "immediately."[4] If these actions do not indicate the approximate date of the revelation, we can still safely say that it must have occurred before the 25th of that same month, for it was on that day that the First Presidency drew up the plans for the temple complex in the city of Zion. The temple design on these plans, with only slight variations, match the way in which the Kirtland Temple was eventually constructed.[5]

Fortunately, an account of the Kirtland Temple vision was left for us by Truman O. Angell, who later became the architect for the Salt Lake Temple. He records the following incident:

> Frederick G. Williams, one of President Smith's counselors, came into the temple, when the following dialogue took place in my presence. Carpenter Rolph said: "Doctor, what do you think of the house?" He answered: "It looks to me like the pattern precisely." Then he related the following: "Joseph received the word of the Lord for him to take his two counselors, Williams and Rigdon, and come before the Lord, and He would show them the plan or model of the house to be built. We went upon our knees, called on the Lord, and the building appeared within viewing distance: I being the first to discover it. Then all of us viewed it together. After we had taken a good look at the exterior, the building seemed to come right over us; and the make-up of this hall seemed to coincide with what I there saw to a minutia." Joseph was accordingly enabled to dictate to the mechanics, and his counselors stood as witnesses.[6]

Apostle Orson Pratt confirmed that there was a considerable amount of detail seen during this vision, stating that "God revealed the *pattern* according to which that house should be built, pointing out the various courts and apartments, telling the size of the house, *the order of the pulpits*, and in fact *everything pertaining to it was clearly pointed out by revelation.* God gave a vision of these things, not only to Joseph, but to several others, and they were strictly commanded to build according to the *pattern* revealed from the heavens."[7]

Knowing that the Kirtland Temple was seen in a detailed vision presents us with the possibility that *some* of the symbolic aspects of this building were seen during the vision, as was the case with the ancient tabernacle of Moses. We must hasten to point out, however, that some of these symbols were most definitely garnered from architectural design books that were popular during the early 1830s[8] and may sim-

ply be decorative in nature. Nevertheless, we will demonstrate that their choice as emblems for the Lord's house was most appropriate because of their distinctive symbolic associations and their use upon temples in ancient times.

SACRED SPACE

The temples of ancient Israel were symbolically set apart as sacred space in a number of ways.

• **Vertical Barriers:** When Adam and Eve fell, the Lord cursed the earth (see Genesis 3:17-19), and thereafter altars and temples were usually built upon high ground (see Genesis 12:8; 2 Chronicles 3:1). Even the tabernacle, which was set upon the ground, was a replica of Mount Sinai, which had been laid out flat. Mountains, hills, platforms, ramps, and stairways all served to separate that which was below from that which was above.

• **Horizontal Barriers:** Cornerstones were used to mark the horizontal boundaries of sacred space. Walls, courts, doors, gates, veils, guards, and warning plaques all served as separators between the holy and the profane (see Exodus 27:9-18).

• **Ritual Barriers:** Israel's temples were aligned with the east. This was considered to be a sacred direction because it was from there that Jehovah would approach his house (see Ezekiel 43:2). Those who desired to worship in the temple were also required to be ritually pure before entering upon its holy ground (see Psalm 24:3-4). Now let us examine some of the symbolic images of the Kirtland temple and see how they compare with these ideas.

Raised Upon a Hill

The Kirtland Temple was built upon a hill overlooking a valley and could easily be seen by all who lived in the surrounding countryside. The School of the Prophets met inside the temple, and it could well be said by these men of God: "Come ye, and let us go up to the mountain of the Lord, to the house of the God of Jacob; and he will teach us of his ways, and we will walk in his paths" (Isaiah 2:3). In the original edition of the Doctrine and Covenants, the land of Kirtland is called by the interesting name of "Shinehah."

> The meaning of the name Shinehah was revealed anciently to Abraham. The Lord declared to this great prophet, "This is *Shinehah, which is the sun*" (Abr. 3:13; italics added). Thus, Shinehah, as applied to Kirtland, literally meant the "city of the sun." In view of the amount of celestial light which was revealed within this city, especially those rays of heavenly light restored within the walls of the Kirtland Temple, the name seems appropriate.[9]

This brings to mind the Savior's admonition to his disciples in the Sermon on the Mount that they should become as lights set upon a hill (see Matthew 5:14-16; 3 Nephi 12:14-16; 18:24) in imitation of the Master who is the light of the world (see John 1:4-9; 8:12). We are also reminded that the Lord's ancient temple stood atop the "holy hill" of Zion (Psalm 15:1) and that within its walls burned the seven-branched candlestick or Menorah, which glowed with perpetual light.[10]

Cornerstones

On 6 May 1833, the Lord promised to give a revelation concerning the dedication of the temple foundation "according to the order of the priesthood" (D&C 94:6). It is uncertain when this revelation occurred, but it is at least possible that the First Presidency may have learned this information during the vision they had of the Kirtland Temple. Joseph Smith had this to say regarding the placement of temple cornerstones.

> If the strict order of the Priesthood were carried out in the building of Temples, the first stone would be laid at the southeast corner, by the First Presidency of the Church. The southwest corner should be laid next, the third, or northwest corner next; and the fourth, or northeast corner last. The First Presidency should lay the southeast cornerstone and dictate who are the proper persons to lay the other cornerstones . . . the Melchizedek Priesthood laying the cornerstones on the east side of the Temple, and the Lesser Priesthood those on the west side.[11]

Brigham Young elaborated upon this idea when he taught that the reason for starting in the southeast is because that is the direction from whence the sun rises from the perspective of those residing in the northern hemisphere. Hence, the southeast is the direction of "most light."[12] Joseph Smith evidently learned from the revelation on laying cornerstones that twenty-four members of the priesthood were needed to perform this rite.[13] Because they were lacking the number of people needed to lay the Kirtland Temple cornerstones, it was necessary to ordain several brethren to offices in the priesthood.[14] This concept of twenty-four participants may be related to an episode in the Old Testament, where we read that at the laying of the temple foundation in Jerusalem, the participating priests were divided up into twenty-four courses (see Ezra 3:8-11), a "pattern" that had been revealed long before (1 Chronicles 28:11-13, 19). The symbolism of the temple's cornerstone is that only those who build their lives upon the rock of their Redeemer, who is the chief cornerstone, will endure the trials of mortality (see Helaman 5:12; Matthew 7:24-25).

Facing East

Like the sanctuaries of the ancient nation of Israel, the Kirtland Temple faces due east. Scriptures liken the Second Coming of the Lord to the light of the morning sun coming out of the east (see JS-M 1:26) and, of course, the statue of the angel Moroni atop many modern temples faces in that symbolic direction. The angelic statue serves to remind us that as the Millennial day dawns, the Lord will come in glory with the hosts of heaven, as trumpets announce his approach (see D&C 88:92).

There is something unusual about the layout of the Kirtland Temple that might be explained by its east-to-west orientation. Inside this temple, the Melchizedek priesthood pulpits are located in the far western portion of the building; in contrast, in all subsequent LDS temples these pulpits were located in the east. We propose that the reason for this is that the Kirtland Temple's design reflects the arrangement of the tabernacle of Moses and temple of Solomon. Evidence for this can be seen in the division of the floor plan into three distinct areas.

• First, as one enters the Kirtland Temple there is a space that was referred to as the "outer court."[15] This corresponds to the outer court of the Jerusalem Temple (see JST Ezekiel 42:3; 1 Kings 6:3; Exodus 27:9-13). The two pillars of the Kirtland Temple's dedication plaque are located at the entrance to the outer court, as were the pillars Jachin and Boaz, which stood in front of the porch of King Solomon's Temple (see 1 Kings 7:21).

• Second is the "inner court" (D&C 94:4; 1 Kings 6:36) or large hall that was also referred to by the early Saints as "the holy place,"[16] an obvious parallel to the ancient temples of Israel (Exodus 26:33). In this area the latter-day brethren were commanded to engage in two types of "offering"—the sacrament[17] and prayer (D&C 95:16). These activities are very similar to what took place inside the holy place of the ancient temple. Sacrificial emblems of bread and wine were placed on the table of shewbread and consumed by the temple priests each Sabbath day,[18] while the smoke arising from the altar of incense represented prayers ascending unto God (see Revelation 8:3-4).

• Third, the area of the Melchizedek Priesthood pulpits on the west end of the first floor was considered especially sacred. The pulpits in this section of the temple were dedicated and consecrated unto the Lord in a private ceremony immediately before the entire temple itself was dedicated.[19] The early Saints called this area of the Kirtland Temple "the most holy place,"[20] and in reference to the events of D&C 110 Elder Erastus Snow spoke of "Elijah being seen in the Holy of Holies . . . in the Arch of the Temple."[21] The arch referred to is a symbolic portal that is located on the wall

directly behind these pulpits and consists of two pillars connected by an arch with a keystone at its top. This symbol is located nowhere else inside the temple. Taken altogether, these elements remind one of the Holy of Holies inside the wilderness tabernacle. It was in the tabernacle's most holy place that the Holy One of Israel appeared unto his servants (see Exodus 25:22; Leviticus 16:2), and it was in the Kirtland Temple's most sacred space that the Lord revealed his presence anew in this last dispensation of time (see D&C 110:1-10).

Concentric Squares

The first geometric design of the Kirtland Temple that we will examine is closely connected to the idea of sacred space. This design consists of squares within squares and can be found on the top steps of the outside entryways and also on the inside woodwork of the gothic windows.

This design can serve to remind us of the Lord's law, which decrees that sacred things must be separated from the profane world in order for them to maintain their state of sanctity (see 1 Chronicles 23:13; Ezekiel 44:23; 2 Corinthians 6:16-17). The pattern of concentric squares, or zones of holiness, can be clearly seen in Ezekiel's description of a temple that was shown to him in a vision and also in the temple plans outlined by the authors of the Dead Sea Scrolls.[22] The association of this concentric order with the ancient houses of God may also be seen on a much grander scale:

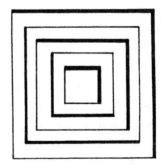

- Furthest away was the outside world or wilderness.
- Then the promised land of Israel.
- Then the chosen city of Jerusalem.
- Then Mount Zion within the city.
- Then the children of Israel around the holy mountain.
- Then the priesthood around the temple courtyard.
- Then the courtyard barrier around the temple.
- Then the temple within the courtyard.
- Then the Holy of Holies within the temple.
- Then the ark of the covenant within the Holy of Holies.

This pattern of concentricity may also be seen in the revelations pertaining to the Kirtland Temple. First, the Lord designated Ohio as a gathering place for the reception of the endowment, then he designated Kirtland as the temple city, then he identified the temple site itself, then he visited the most holy place within that temple. How appropriate it is that the emblem of the concentric squares decorates the very building that restored sacred space to the earth in the latter-days.

Dedication Plaque

The dedication plaque is located high on the eastern facade of the temple and announces to all those who approach that this is the Lord's house and has been set apart for his sacred purposes. The plaque thus serves as a separator between sacred and profane space. The wording on the plaque has been changed several times over the years but the original inscription read:

Two prominent pillars frame this plaque. When King Solomon built the Jerusalem Temple, he had two large brass pillars constructed and placed at its eastern entrance. These pillars were given the names Jachin and Boaz, meaning, respectively, "He will establish" and "In him is strength" (1 Kings 7:15-22; 2 Chronicles 3:15-17).[23] To the ancient Israelites these pillars were layered with meaning. In a religious sense they represented the gateposts of a sacred threshold over which only sanctified and properly clad priests could pass as they entered into the symbolic presence of God.[24] From a political perspective their names signified that the dynasties of the Israelite kings were established by Jehovah himself and they reigned by his power and authority.[25]

To "dedicate" something is to set it apart or to separate and reserve it for a specified purpose; to "consecrate" means something altogether different.[26] In ancient Israel, temples were formally dedicated by an act of prayer (see 2 Chronicles 5-6) but their consecration came through a ritual anointing with pure olive oil that had been aromatically spiced (see Exodus 30:22-38; Leviticus 8:10-12). This ritual anointing sanctified the object that was anointed[27] because the olive oil symbolized the Holy Ghost and it is through his power that an object becomes holy (see Alma 13:11-12).[28] Because the temple priests served inside a sanctified sanctuary, they too had to be sanctified by a ritual anointing (see Exodus 28:41). The priesthood brethren in the Kirtland Temple followed the very same pattern. First they washed their "bodies with pure water before the Lord, preparatory to the anointing with holy oil" and were then "anointed with the same kind of oil and in the man[ner] that were Moses and Aaron."[29]

An explanatory note placed before the Kirtland Temple's dedicatory prayer in the *History of the Church* states that the prayer was given by revelation, but there is no further indication of how or when this revelation might have occurred.[30] Fortunately, Oliver Cowdery recorded that on 19 March 1836, he and Joseph Smith, Sidney Rigdon, Warren Cowdery, and Warren Parrish met together for the purpose of writing the dedicatory prayer.[31] Though we do not presently know how much any of these brethren may have contributed to the creation of the prayer,[32] it is interesting to note that there are many similarities between its content and the dedicatory services of King Solomon's Temple. For example:

- A solemn assembly is held (see 1 Kings 8:1-2 / D&C 109:6, 10)
- The Lord's presence is to be continually in the temple (see 1 Kings 8:29; 9:3 / D&C 109:12)
- "Lord God of Israel"—"keepest covenant"—"walk before thee"—"mercy" (1 Kings 8:23 / D&C 109:1)
- The temple is the place of the name of God (see 1 Kings 8:16-17, 29 / D&C 109:2, 5)
- Command to build the temple is fulfilled by the Lord's people (see 1 Kings 8:19-20 / D&C 109:2-4)
- Transgress, repent, return, find favor, restore blessings (see 1 Kings 8:31-34, 46-50 / D&C 109:21)
- Petition of deliverance from enemies (see 1 Kings 8:44-45 / D&C 109:27-28)
- Condemnation of wickedness (see 1 Kings 8:32 / D&C 109:26)

- Lord to put forth his hand and make bare his arm (see 1 Kings 8:42 / D&C 109:23, 51)

- Pillar of cloud, fire and glory, mighty wind (see 1 Kings 8:10-11 / D&C 109:12, 37)

- Dedication takes place at the altar with uplifted hands (see 1 Kings 8:22, 54 / D&C 109:9, 19)[33]

- Petition has similar phraseology (see 1 Kings 8:30, 32, 34, 36, 39, 43, 45, 49 / D&C 109:77-78)

- Sacrifices are offered (see 1 Kings 8:62-64 / *HC* 2:427)[34]

- The dedicator blesses the congregation (see 1 Kings 8:14 / *HC* 2:428)[35]

- The Lord appears to the dedicator to accept the house (see 1 Kings 9:1-2 / D&C 110:1-10)

It would appear from this comparison that the material in the eighth chapter of First Kings played an important role in the creation of the Kirtland Temple's dedicatory prayer. The exact nature of that role is not clear, however. There is something else about this prayer that must also be taken into consideration before drawing a conclusion. It has become apparent that the Doctrine and Covenants and every other scriptural record revealed through Joseph Smith, is filled with an ancient Hebrew literary form known as *chiasmus*. The Hebrews utilized this literary device throughout the Old and New Testaments, but that fact was virtually unknown during Joseph Smith's lifetime. The Kirtland Temple's dedicatory prayer contains at least four sets of chiastic structures, and one of them is rather complex.[36] Thus it would seem that an ancient hand left its mark upon the dedicatory prayer.

Because this was the very first temple to be dedicated in the latter days, and the brethren had no previous experience in such an undertaking, it seems only logical that they would have turned to the most obvious example they knew of for guidance—the dedication of Solomon's Temple. It would appear that in this situation, the brethren obeyed the commandment to first study the problem out in their minds, and then they approached the Lord and relied upon him for a revelation (see D&C 9:7-8).

Squared Circles

A rather unusual design on the exterior of the temple is the quadrated circle found on the sides of the steeple. The circle is divided into four equal parts by four keystones and visually suggests to the mind the four quarters of the earth. The doc-

trine of gathering Israel from the four quarters of the earth was a constant theme during the Kirtland period (see D&C 10:65; 29:2, 7-8; 33:6; 39:22; 42:9) and the keys for this gathering were restored inside this temple by the prophet Moses (see D&C 110:11). At a meeting held inside the unfinished Nauvoo Temple, Joseph Smith was asked to explain why God gathered his people together in any age of the world. His answer was precise.

> It was the design of the councils of heaven before the world was, that the principles and laws of the priesthood should be predicated upon the gathering of the people in every age of the world. Jesus did everything to gather the people, and they would not be gathered and He therefore poured out curses upon them. Ordinances instituted in the heavens before the foundation of the world, in the priesthood, for the salvation of men, are not to be altered or changed. . . . If a man gets a fulness of the priesthood of God he has to get it in the same way that Jesus Christ obtained it, and that was by keeping all the commandments and obeying all the ordinances of the house of the Lord.[37]

Elder George A. Smith also taught that the gathering of the Lord's people plays a vital role in the process of their journey toward exaltation.

> Among the first principles that were revealed to the children of men in the last days was the gathering; the first revelations that were given to the Church were to command them to gather, and send Elders to seek out a place for the gathering of the Saints. What is the gathering for? Why was it that the Savior wished the children of Israel to gather together? It was that they might become united and provide a place wherein he could reveal unto them keys which have been hid from before the foundation of the world; that he could unfold unto them the laws of exaltation, and make them a kingdom of Priests, even the whole people, and exalt them to thrones and dominions in the celestial world.[38]

Doorways

Now we come to the doorways. The location of these two entrances correspond to the two aisles running along the axis of the inside of the building and are reached by ascending a short flight of five steps. Each doorway consists of two side pillars with an arch connecting them over the middle and a keystone at the top of the arch. These prominent keystones can also be seen at the top of the large windows of the temple. Because they are decorative instead of structural, the keystones of the

Kirtland Temple can be viewed as symbols. A keystone is the central element that locks together and supports the separate parts of the arch; and the prophet of God, says George Q. Cannon, can be likened unto a keystone, for he is "the means of upholding the work and giving it solidity."[39]

The Kirtland Temple doorways were guarded by doorkeepers, whose duty was to prevent the unworthy from entering through the portals of the Lord's house.[40] Precedence for this can be found in the Old Testament, where we read that the Levites were assigned as temple doorkeepers (see 1 Chronicles 9:17-24). They in turn represented the angels who guard the entrances into the heavenly city of God (see Revelation 21:12-13). We read in the Doctrine and Covenants that this is no mere imagery, but will become a reality for all those attempting to enter into the Lord's presence hereafter (see D&C 132:18).

On some occasions angels were dispatched from the portals of heaven to safeguard the sanctity of the Kirtland Temple. During a temple meeting of the Twelve Apostles and the Quorum of Seventy held on 28 January 1836, Roger Orton "saw a mighty angel riding upon a horse of fire, with a flaming sword in his hand, followed by five others, encircle the house, and protect the Saints, even the Lord's anointed, from the power of Satan and a host of evil spirits, which were striving to disturb the Saints."[41] On another occasion Truman O. Angell, along with Brigham Young, saw that angels were assigned as sentinels to protect the Lord's house.

> After the building was dedicated, a few of us, some six or eight, having Patriarch Joseph Smith, Sr., in company, went morning and evening to pray. . . . Right over the stand where the Brethren were praying in the Hall below were two windows in the gable When about ten rods distant we looked up and saw two Personages; before each window, leaving and approaching each other like guards would do. This continued until quite dark. As they were walking back and forth, one turned his face to me for an instant; but while they walked to and fro, only a side view was visible. I have no doubt that the house was guarded as I have had no other way to account for it.[42]

ASCENDING THE HOLY MOUNT
Pulpits

Perhaps the most interesting and symbolic feature of the temple's interior is the pulpits for the Aaronic and Melchizedek Priesthoods. They are designed to show forth the "order" of the respective priesthoods and the line of authority among their offices. As mentioned in the previous chapter and demonstrated in Appendix A, the initials on the twenty-four pulpits correspond to the names of the twenty-four temples that were at one time planned for the New Jerusalem complex in Jackson County, Missouri. These pulpits may be an echo of the twenty-four courses of temple priests that were established in ancient Israel by revelation (see 1 Chronicles 28:11-13, 19) and which in turn may be linked to the twenty-four heavenly thrones upon which sit the exalted elders of Israel (see JST Revelation 4:4, 6). The prophet Moses sat upon a special seat to instruct the children of Israel and to render judgments among them (see Exodus 18:13-26; Matthew 23:2). This chair became a symbolic fixture in the sacred buildings of later Israel. In a letter written by W. W. Phelps on 25 December 1844, he equated the temple pulpit occupied by the President of the Church with Moses' seat.[43]

Orson Pratt said that "the order of the pulpits" was revealed during the vision of the temple that was given to the First Presidency.[44] This is highly significant because when the brethren were at Adam-ondi-Ahman, Joseph Smith showed them a stone structure which he identified as the altar used by Adam to offer up sacrifices after he and Eve had been driven from the Garden of Eden. This altar was three-tiered, said Heber C. Kimball, who compared it directly to the shape of the pulpits inside the Kirtland Temple.

> The Prophet Joseph called upon Brother Brigham, myself, and others saying, "Brethren, come, go along with me, and I will show you something." He led a short distance to a place where were the ruins of three altars built of stone, one above the other, and one standing a little back of the others, like unto the pulpits in the Kirtland Temple, representing the order of three grades of Priesthood. "There," said Joseph, "is the place where Adam offered up sacrifice after he was cast out of the garden." The altar stood at the highest point of the bluff. I went and examined the place several times while I remained there.[45]

A fascinating story has been preserved for us by Wilford Woodruff about offering up prayer at the Kirtland Temple pulpits. Many years previous to this experience, the Prophet had taught the Saints: "It is the privilege of every Elder to speak of the things of God; and could we all come together with one heart and one mind in perfect faith the veil might as well be rent today as next week, or any other

time."[46] It would appear from what follows that Wilford Woodruff took this counsel to heart and sought for the blessings of heaven in the house of the Lord.

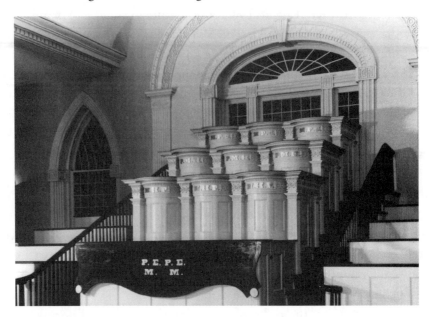

I spent the day in writing my journal and when the shades of evening began to appear I repaired to the house of the Lord in company with Elders Milton Holmes and Joseph B. Noble for the purpose of worshipping God. We entered one of the stands within the veils and fell upon our knees and Satan appeared also but not to worship God but to deprive us of the privilege. Satan strove against us with great power by tempting us and otherwise. He at one time drove me from my stand while I was striving with my brethren to enter into the visions of heaven. Notwithstanding his apparent victory good grew out of it for by going into the outer court I there found Elder Freeman Nickerson, an aged father in Israel who was faithful and prayed to God always. I solicited him to join us in prayer that we might gain a victory over Satan and get a blessing at the hand of God. He joyfully accepted the invitation and we again entered into the stand being four of us in number of one accord in one place. We had great cause to be united in heart, we all had traveled together about 1,000 miles in the spring of 1834 for the redemption of Zion. We at that time offered to lay down our lives and our offering was accepted as was Abram's. We felt, considering those circumstances, that we could kneel down and unitedly get a blessing by faith through Jesus Christ. We fell upon our knees and began to cry unto God. Satan departed, temptation found no place in our hearts. The power of God rested upon us and we were baptized with the Holy Ghost and the Spirit of God was like fire shut up in our bones. We were immersed in the liberty of the sons of God. Many great things were shown unto us. The power of God and the spirit of prophecy and revelation rested upon us. I arose and proclaimed many glorious things upon the heads of my beloved brethren that were present which were dictated in my heart by the Holy Spirit in prophecy and revelation. Our hearts were made glad and we went our way rejoicing.[47]

Across the front of the pulpits on the first floor are folding sacrament tables that are shaped like the yokes of oxen. Each table is divided down the center so that when the main veils of the room are lowered to section it off into quarters, each division of the room can still have access to the sacrament.[48] In the scriptures the yoke is a stark symbol of one's burden (see Isaiah 9:4; Jeremiah 5:5; Galations 5:1) and when Joseph Smith dedicated the Kirtland Temple, he petitioned the Lord to deliver his people from the yoke of spiritual bondage (see D&C 109:32-33; 47-48). It is by partaking of the sanctified emblems prepared upon the sacrament table that those who are humble of heart are released from the yoke of the sins that hold them bound. The Lord has offered this invitation to all those who are weighed down:

> Come unto me, all ye that labour and are heavy laden, and I will give you rest. Take my yoke upon you, and learn of me; for I am meek and lowly in heart: and ye shall find rest unto your souls. For my yoke is easy, and my burden is light. (Matthew 11:28-30; see also Psalm 55:22)

Veils

The Kirtland Temple was built with an interesting series of pillars and canvas partitions. As we have already noted, one set of these dividers dropped from the ceiling to divide the main room into four quarters. Another set also dropped to divide each row of pulpits into four individual sections. According to Joseph Smith these were more than just simple barriers, however. They had a religious significance.

> The lower room of the chapel is now preparing for painting. This afternoon the sisters met to make the veil of the Temple. Father Smith presided over them and gave them much good instruction. . . . This afternoon the sisters met again at the Temple to work on the veil. Towards the end of the day I . . . pronounced a blessing upon the sisters, for their liberality in giving their services so cheerfully, to make the veil for the Lord's House.[49]

It is clear that these partitions were considered to be temple veils along the lines of those found in the tabernacle built by Moses (see Exodus 26:31-33). Just as angels once appeared at the temple veil in ancient Jerusalem (see Luke 1:11-19) so, too, they parted the heavenly veil in mighty throngs in the Lord's house at Kirtland. After administering the ordinances of the endowment on 1 January 1836, the Prophet wrote: "Many of my brethren who received the ordinance with me saw glorious visions also. . . . Some of them saw the face of the Savior, and others were ministered unto by holy angels, and the spirit of prophecy and revelation was poured out in a mighty power."[50] On the very next day he recorded the following:

> The heavens were opened unto Elder Sylvester Smith, and he, leaping up exclaimed: "The horsemen of Israel and the chariots thereof". . . . President Rigdon arose to conclude the services of the evening by invoking the blessing of heaven upon the Lord's anointed, which he did in an eloquent manner; the congregation shouted a long hosanna: the gift of tongues fell upon us in a mighty power, angels mingled their voices with ours, while their presence was in our midst, and unceasing praises swelled our bosoms for the space of half-an-hour.[51]

On the 28th of January, about one hundred elders, seventies, and high priests met in the upper part of the temple to receive instructions on the endowment. One of the priesthood holders in attendance saw a peculiar light illuminate the room he was in, and all who were present could feel the power of God. This light enveloped Joseph Smith, Hyrum Smith, and Roger Orton, at which point the Prophet declared, "I behold the Savior, the Son of God," Hyrum Smith said, "I behold the angels of heaven," and Roger Orton proclaimed, "I behold the chariots of Israel."[52]

Even these marvelous manifestations, however, cannot compare to the pentecostal occurrences during the temple's dedication. There is an interesting historical puzzle associated with the dedicatory services of 27 March 1836, which, when understood, yields a significant insight. The incident recorded in the *History of the Church* reads as follows.

> President Frederick G. Williams arose and testified that while President Rigdon was making his first prayer, an angel entered the window and took his seat between Father Smith and himself, and remained there during the prayer. President David Whitmer also saw angels in the house.[53]

There was an immediate confusion as to the identity of this angel because he was not seen by everyone present and, based solely on the description of the type of clothing worn by the personage, the Prophet initially identified him as the Savior.[54] This misunderstanding was carried on for a number of years as evidenced by the following account of the incident.

> On the first day of the dedication, President Frederick G. Williams, one of the Council of the Prophet, and who occupied the upper pulpit, bore testimony that the Savior, dressed in his vesture without seam, came into the stand and accepted of the dedication of the house, that he saw him, and gave a description of his clothing and all things pertaining to it. . . . David Whitmer bore testimony that he saw three angels passing up the south aisle.[55]

From other sources we discover that later on during the same day Joseph Smith had learned the real identity of this heavenly visitor and so informed the congregation.

> F[rederick] G. Williams being in the upper east stand . . . rose and testified that midway during the prayer an holy angel came and seated himself in the stand. When the afternoon meeting assembled Joseph, feeling very much elated, arose the first thing and said the personage who had appeared in the morning was the angel Peter come to accept the dedication.[56]

On several different occasions Heber C. Kimball provided further insights into the dress of this angel and confirmed that it was indeed the Apostle Peter.

> During the ceremonies of the dedication, an angel appeared and sat near President Joseph Smith, Sen., and Frederick G. Williams, so that they had a fair view of his person. He was a very tall personage, black eyes, white hair, and stooped shouldered; his garment was whole, extending to near his ankles; on his feet he had sandals. He was sent as a messenger to accept of the dedication.[57]

At another time Brother Kimball reported the following:

> Some of you have got an idea that wool will not do; but let me inform you that when Peter came and sat in the Temple in Kirtland, he had on a neat woollen garment, nicely adjusted around the neck. . . . To return to the subject of the garments of the Holy Priesthood, I will say that the one which Jesus had on when he appeared to the Prophet Joseph was neat and clean, and Peter had on the same kind, and he also had a key in his hand.[58]

Frederick Kesler reported that Brother Kimball spoke of this episode on yet another occasion.

> Called on Heber C. Kimball. We called to see D[aniel] H. Wells. . . . Bro[ther] Kimball while there spoke of Joseph and of the angels visiting him and also of Peter visiting him at several times, telling how he looked, his dress, etc. His dress was a seamless knit garment similar unto our temple robes. He also carried a key with a chain attached unto it, showing he yet held the keys of the dispensation in which he lived on the earth. His countenance showed marks that he had been a man of much sorrow.[59]

Finally, Elder Erastus Snow provided an account that may explain the identity of the three angels who were seen walking up the aisle by David Whitmer. He

"spoke of the heavenly vision in the hallowed temple at Kirtland, of Peter, James, and John . . . being seen in the Holy of Holies with golden keys in their hands, in the arch of the temple, and of Joseph saying it was a witness and a testimony that the work of the brethren in building the temple was accepted."[60]

The following incident, related by Joseph Smith, occurred during the dedication services held on the evening of 27 March 1836:

> Brother George Albert Smith arose and began to prophesy, when a noise was heard like the sound of a rushing mighty wind, which filled the Temple, and all the congregation simultaneously arose, being moved upon by an invisible power; many began to speak in tongues and prophesy; others saw glorious visions; and I beheld the Temple was filled with angels, which fact I declared to the congregation. The people of the neighborhood came running together (hearing an unusual sound within, and seeing a bright light like a pillar of fire resting upon the Temple), and were astonished at what was taking place. This continued until the meeting closed at eleven pm.[61]

Sister Prescindia Huntington has also preserved a rather curious story for us about angelic visitors to the Lord's house.

> In Kirtland, we enjoyed many very great blessings, and often saw the power of God manifested. On one occasion I saw angels clothed in white walking upon the temple. It was during one of our monthly fast meetings, when the Saints were in the temple worshipping. A little girl came to my door in wonder and called me out, exclaimimg, "The meeting is on the top of the meeting house." I went to the door, and there I saw on the temple angels clothed in white covering the roof from end to end. They seemed to be walking to and fro; they appeared and disappeared. The third time they appeared and disappeared before I realized that they were not mortal men. Each time in a moment they vanished, and their reappearance was the same. This was in broad daylight, in the afternoon. A number of the children saw the same.
>
> When the brethren and sisters came home in the evening, they told of the power of God manifested in the temple that day, and of the prophesying and speaking in tongues. It was also said, in the interpretation of tongues, "that the angels were resting down upon the house."[62]

Keys

The day the Kirtland Temple was dedicated, 27 March 1836, was a very symbolic day. It was Palm Sunday, which commemorates the day that Christ descended the Mount of Olives and entered triumphantly into the city of Jerusalem and the temple courtyards to jubilant shouts of "Hosanna: Blessed is the King of Israel" as palm branches were strewn on the earth before him (John 12:12-16; Mark 11:1-11;

Matthew 21:1-16). How appropriate that on this Palm Sunday the Saints of Kirtland listened as the Prophet petitioned: "That our garments may be pure, that we may be clothed upon with robes of righteousness, with palms in our hands, and crowns of glory upon our heads" (D&C 109:76). If this connection was not striking enough, the saints engaged in two additional actions that brought this imagery to life. First, they offered up the sacred Hosanna Shout with their hands raised to heaven which signified the waving of palm branches (see Revelation 7:9-10). Second, they sang a hymn that had been composed especially for the temple dedication, "The Spirit of God Like a Fire Is Burning," which incorporated the words of the holy shout into the refrain.

As symbolic as this day was, 3 April 1836 was even more so, for it was both Easter Sunday and the Jewish Passover. Not only does Easter celebrate the resurrection of the Lord but some scholars believe that it is possible that Sunday, April 3rd is the actual date of the resurrection.[63] Passover was especially sacred to the ancient Jews, whose traditions foretold the return of the prophet Elijah on this day. In an afternoon meeting held in the Kirtland Temple on this Sabbath, Joseph Smith assisted in administering the sacrament to those assembled, and after the pulpit veils had been lowered he joined Oliver Cowdery behind them for solemn prayer. When they had finished and risen to their feet, the veil of heaven was parted before them, and they saw four heavenly beings in a series of glorious visions (see D&C 110).[64] It is evident from the very brief record that we now possess that we do not know everything that happened during these visions or even how long the whole episode lasted. There are, however, several insights available that will bring this manifestation into sharper focus for us. We will now examine the role played by each heavenly messenger in the order that they appeared.

JESUS CHRIST

For several years the Prophet Joseph Smith anticipated the Savior's visit to his temple. In a letter dated 11 January 1833 he informed W. W. Phelps that the Lord "has promised us great things; yea, even a visit from the heavens to honor us with His own presence."[65] When the Lord made his appearance on that Easter Sabbath it is significant that he proclaimed his resurrected status to the witnesses before him: "I am he that liveth, I am he who was slain" (D&C 110:4). The Prophet's account of this manifestation is quoted here in full:

> The veil was taken from our minds, and the eyes of our understanding were opened. We saw the Lord standing upon the breastwork of the pulpit, before us; and under his

feet was a paved work of pure gold, in color like amber.

His eyes were as a flame of fire; the hair of his head was white like the pure snow; his countenance shone above the brightness of the sun; and his voice was as the sound of the rushing of great waters, even the voice of Jehovah, saying:

I am the first and the last; I am he who liveth, I am he who was slain; I am your advocate with the Father.

Behold, your sins are forgiven you; you are clean before me; therefore, lift up your heads and rejoice.

Let the hearts of your brethren rejoice, and let the hearts of all my people rejoice, who have, with their might, built this house to my name.

For behold, I have accepted this house, and my name shall be here; and I will manifest myself to my people in mercy in this house.

Yea, I will appear unto my servants, and speak unto them with mine own voice, if my people will keep my commandments, and do not pollute this holy house.

Yea the hearts of thousands and tens of thousands shall greatly rejoice in consequence of the blessings which shall be poured out, and the endowment with which my servants have been endowed in this house.

And the fame of this house shall spread to foreign lands; and this is the beginning of the blessing which shall be poured out upon the heads of my people. Even so. Amen. (D&C 110:1-10)

Although we do not normally think of the Lord as bestowing keys on this occasion, as did the other heavenly visitors, Orson Pratt informs us that he did indeed give "keys of instruction and counsel and authority to his servants."[66] Franklin D. Richards added that the Lord "conversed with the Prophet Joseph and Oliver, and revealed to them their duties, and informed them that the Gospel should go from there and be preached throughout the nations of the earth."[67] At this point the Lord withdrew his presence and the veil between heaven and earth was drawn closed. The veil was then parted anew for each of the visions that followed.

MOSES

We know from modern revelation that Moses did not die but was translated and taken into heaven (see Alma 45:18-19). In a translated state Moses would have been able to confer his priesthood keys by the laying on of hands when he appeared on the Mount of Transfiguration.[68] When he appeared in the Kirtland Temple, however, he was no longer a translated being but was in a resurrected state.[69] Joseph Smith informs us that Moses committed "the keys of the gathering of Israel from the four parts of the earth, and the leading of the ten tribes from the land of the north" (D&C 110:11). Both of these concepts call for our attention. First, the Prophet explains the reason for the gathering of Israel in this way:

What was the object of gathering the Jews, or the people of God in any age of the world? . . . The main object was to build unto the Lord a house whereby He could reveal unto His people the ordinances of His house and the glories of His kingdom, and teach the people the way of salvation; for there are certain ordinances and principles that, when they are taught and practiced, must be done in a place or house built for that purpose Ordinances instituted in the heavens before the foundation of the world, in the priesthood, for the salvation of men, are not to be altered or changed. All must be saved on the same principles. It is for the same purpose that God gathers together His people in the last days, to build unto the Lord a house to prepare them for the ordinances and endowments, washings and anointings, etc.[70]

The second part of the keys delivered by Moses consisted in the *leading* of the ten tribes from the land of the north.[71] Over the years there has been some extraordinary mythology built up around the lost ten tribes of Israel and their eventual return. These tribes were scattered among the various lands north of Israel after the nation was taken captive around 721 B.C., and despite some claims to the contrary they no longer exist as an organized group.[72] The scattered tribes of ancient Israel "will be gathered as all others are gathered—through conversion."[73] Patriarchal blessings confirm that the "lost" tribes of Israel are being gathered into the Church at the present time through baptism[74] even though Ephraim now predominates and the majority of the other tribes will not be gathered until the Millennium.[75]

ELIAS

After Moses delivered his keys, "Elias appeared, and committed the dispensation of the gospel of Abraham, saying that in us and our seed all generations after us should be blessed" (D&C 110:12). To understand just who this personage was, we must first recognize that "Elias" is not only a personal name but also a descriptive title. Joseph Smith spoke of the "office of Elias" and said that the "spirit of Elias is to prepare the way for a greater revelation of God. . . . And when God sends a man into the world to prepare for a greater work, holding the keys of the power of Elias, it [is] called the doctrine of Elias."[76] The Prophet stated further that throughout the various dispensations of the gospel, there have been many "Eliases" involved in the work of restoring priesthood keys needed to bring the Saints back into the presence of God.[77]

Who, then, was the "Elias" who appeared in the Kirtland Temple and what specific keys did he restore? The Lord clarified this matter when he revealed that the angel Gabriel, who appeared inside the Jerusalem Temple to Zacharias (see Luke 1:19), is also known as Elias (see D&C 27:6-7). Joseph Smith enlightened us even

further when he said that in mortality Gabriel was called by the name of Noah.[78] Interestingly, the Prophet does mention that at some point in Church history, the angel Gabriel appeared to him and declared his dispensation, rights, keys, honors, majesty, glory, and the power of his priesthood (see D&C 128:21). And what of the keys restored by this "Elias"? As mentioned above, this angel "committed the dispensation of the gospel of Abraham." Elder Bruce R. McConkie helps us to understand the nature of these keys.

> Now what was the gospel of Abraham? Obviously it was the commission, the mission, the endowment and power, the message of salvation, given to Abraham. And what was this? It was a divine promise that both in the world and out of the world his seed should continue "as innumerable as the stars; or, if ye were to count the sand upon the seashore ye could not number them." (D&C 132:30; Gen. 17; Abr. 2:1-12.) Thus the gospel of Abraham was one of celestial marriage. . . . This power and commission is what Elias restored.[79]

ELIJAH

After Elias had finished his appointed work and withdrew himself behind the veil, "another great and glorious vision burst upon" the servants of the Lord. For untold centuries the Hebrews have looked forward with great anticipation to the return of the prophet Elijah during the Passover feast. Among other things, ancient Hebrews have believed that Elijah would be involved in the restoration of temple worship[80]; now here he stood inside a temple of the Lord to bestow "the keys of this dispensation" upon two witnesses (D&C 110:16).

In his instructions to Joseph Smith many years earlier, the angel Moroni had quoted an Old Testament prophecy about the coming of Elijah, "though with a little variation from the way it reads in our Bibles" (JS-H 1:36-39). And when Elijah made his appearance inside the Kirtland Temple, he said that the time for the fulfillment of this prophecy had fully come (see D&C 110:14). It is the interesting nature of Moroni's variant quotation that catches our attention and teaches us about the nature of Elijah's keys: "Behold, I will reveal unto you the Priesthood, by the hand of Elijah the prophet" (D&C 2:1). In what way did Elijah's keys reveal the priesthood? The word *reveal* can mean to unveil, to make known what has been concealed, to divulge, impart, disclose, or declare. It would therefore appear that Elijah's keys imparted additional knowledge and power pertaining to the use of the priesthood. Joseph Smith taught the following doctrines about Elijah and his keys:

• Elijah restored "the keys of the Priesthood" and "the keys of authority to administer in all the ordinances of the Priesthood . . . in righteousness."[81]

• Elijah revealed "the covenants of the fathers in relation to the children, and the covenants of the children in relation to the fathers," "the covenants to seal the hearts of the fathers to the children, and the children to the fathers," and the power of "Elijah [is used] to seal the children to the fathers, and the fathers to the children."[82]

• "This is the spirit of Elijah, that we redeem our dead, and connect ourselves with our fathers which are in heaven, and seal up our dead to come forth in the first resurrection; and here we want the power of Elijah to seal those who dwell on earth to those who dwell in heaven. This is the power of Elijah and the keys of the kingdom of Jehovah . . . what you seal on earth, by the keys of Elijah, is sealed in heaven; and this is the power of Elijah . . . the power of Elijah is sufficient to make our calling and election sure."[83]

• "The doctrine or sealing power of Elijah is . . . [that] you have power to seal on earth and in heaven. . . . The spirit and power of Elijah is . . . holding the keys of power."[84]

• "Now for Elijah. The spirit, power, and calling of Elijah is, that ye have power to hold the key of the revelations, ordinances, oracles, powers and endowments of the fulness of the Melchizedek Priesthood and of the kingdom of God on the earth; and to receive, obtain, and perform all the ordinances belonging to the kingdom of God, even unto the turning of the hearts of the fathers unto the children, and the hearts of the children unto the fathers, even those who are in heaven."[85]

From these quotes we learn that Elijah restored the sealing power that comes with the fulness of the Melchizedek Priesthood.[86] Parley P. Pratt tells us that this "last key of the priesthood is the most sacred of all, and pertains exclusively to the first presidency of the church, without whose sanction, and approval or authority, no sealing blessing shall be administered pertaining to things of the resurrection and the life to come."[87] Erastus Snow reported that when Elijah appeared in the Kirtland Temple to bestow his power upon the mortal leaders of the priesthood, he had a golden key in his hand.[88] Perhaps this key was a symbol of his power. According to Wilford Woodruff, the "angels who appeared in the Kirtland Temple delivered the *keys of power* to the Prophet Joseph and they are now with the Priesthood."[89]

All this brings us to a most interesting comparison between the activities that took place at the Kirtland Temple pulpits during the visions we have discussed and those that transpired on the Mount of Transfiguration. The Savior had promised his ancient apostles "the keys of the kingdom of heaven," which would grant them power to bind or seal on earth and have it sealed in the heavens (Matthew 16:19). This promise was fulfilled shortly thereafter when the Master took Peter, James, and John up on "the holy mount" (2 Peter 1:18) and gave them "the keys."[90] The tem-

ple elements of this experience are unmistakable (see Matthew 17:1-9; Mark 9:2-9; Luke 9:28-36).

- The location was a secluded and high mountain.
- The Savior was engaged in prayer.
- The Savior's clothing was white.
- The angels who appeared on the holy mountain were the very same ones that visited the Kirtland Temple.
- A cloud appeared that veiled the Father and through which his voice was heard.
- The Father gave his Son "honor and glory," which may have reference to the keys of the priesthood (see D&C 124:34, 95).
- The Savior received the fulness of the Melchizedek Priesthood.[91]
- The apostles received the "more sure word of prophecy" (see JST 2 Peter 1:16-19; D&C 131:5).
- A vision was seen of the earth in its paradisiacal state (see D&C 63:21).
- The suggestion was made that three "tabernacles" be built.
- A charge was given by the Savior not to reveal what had been experienced.

If one considers that the Kirtland Temple pulpits somewhat resemble a miniature mountain, then the parallels are even more striking.

GEOMETRIC EMBLEMS

Most of the symbols found inside the Kirtland Temple are geometric emblems that were used in ancient cultures. However, a few of these symbols do not seem to have ancient parallels, and without further information it is impossible to determine their origin or intended meaning. In this section we will explore the meaning of the figures that can be identified and indicate which ones were used as symbols among the ancient Israelites and early Christians.

Vesica Pisces

The vesica pisces symbol was commonly incorporated into early Christian architecture. Above the entrance of several gothic cathedrals Jesus Christ can be seen depicted standing or enthroned within this emblem. The vesica pisces takes its form from the space where two circles of equal diameter overlap one another, and it takes its name from the fact that it is shaped like the body of a fish. There is a wonderful

painting in the foyer of the LDS Church's Family History Library, which has incorporated the vesica pisces symbol into it. The Salt Lake Temple is depicted in the center of the painting and two superimposed circles overlap each other at the center of the temple. These circles are connected to the physical world on one side of the painting and the spiritual world on the other. Within the vesica pisces, which is formed by these intersecting circles, stands the Lord Jesus Christ.[92] The message seems to be clear—the worlds of the living and the dead converge in the temple and center upon Jesus Christ. To the ancients the meaning was essentially the same. The vesica pisces represented the joining together of the temporal and the spiritual, and a building that was decorated with this symbol invoked heaven on earth.[93] This sacred pattern is hidden in the windows of the Kirtland Temple, for "the Gothic pointed arch is half of a vesica pisces."[94] Wilford Woodruff recorded a little-known manifestation that occurred in the upper story of the Kirtland Temple which illustrates the idea that the temple is the place where heaven and earth combine.

> President Brigham Young related the circumstances of their seeing a circle of about forty persons dressed in white robes and caps in the upper story of the temple in Kirtland during the spring of 183[6] after the endowments. There was no person in that room at the time that was mortal yet the room was filled with light and many personages did appear clothed in white and frequently went to the windows and looked out so that the brethren in the street could see them plainly. Brother Young and Truman Angell stood together in the street and looked at them a long time. W. W. Phelps says he saw them for three hours. They were visible by all the brethren present. Brother Angell said they must have stood some two feet from the floor. If they were only the size of common men they could not have been seen from the place where they stood except it should be the head and those personages appeared nearly down to the waist as they looked out of the window with a front view.[95]

Tau

Tau is the nineteenth letter of the Greek alphabet and is shaped like the letter (T). A design that resembled interconnected taus once decorated the domes of the gateways leading into the temple of Jerusalem[96] and a series of interlocking taus can be seen in the woodwork of the Kirtland Temple's

first floor western window.

In the Vulgate, or ancient Latin version of the Bible, it is said that beginning at the Jerusalem Temple the angels of God placed the mark of the tau upon the foreheads of the righteous followers of Jehovah. This mark set them apart so that the destroying angels would pass them by and they would be saved in the great day of judgment that was about to befall the city (see Ezekiel 9:3-6). It is not surprising, then, that to the early Christians the tau was a symbol of "the promise of eternal life."[97] In the book of Revelation 7:3 and 9:4 we read of this action being repeated, but the language is that of being "sealed." Joseph Smith revealed that this sealing is associated with becoming a member of the church of the Firstborn (see D&C 77:11). In commenting specifically upon these verses, the Prophet said that the servants of God were "sealed in their foreheads, which signifies sealing the blessing upon their heads, meaning the everlasting covenant, thereby making their calling and election sure."[98] At another time he urged the Saints: "Make your calling and election sure. Go on from grace to grace until you obtain a promise from God for yourselves that you shall have eternal life. This is eternal life to know God and his Son Jesus Christ, it is to be sealed up unto eternal life."[99]

Meander

Among some ancient cultures the meander design represented clouds and rolling thunder.[100] From this perspective we could relate this symbol to the manifes-

tation at Mount Sinai wherein a cloud veiling Jehovah descended amidst thunder and lightning (see Exodus 19:16-20). A pillar of fire, which is one manifestation of this divine cloud, was seen on a number of occasions on top of the Kirtland Temple. In the dedicatory prayer Joseph Smith petitioned the Lord to allow his "glory," "cloven tongues as of fire," and "a rushing mighty wind" to rest down upon the house (D&C 109:12, 16, 36-37; see also Abraham 2:7). During the evening services the Prophet's petition was answered when "a noise was heard like the sound of a rushing mighty wind, which filled the Temple." Those living nearby saw "a bright light like a pillar of fire resting upon the Temple."[101] Sister Eliza R. Snow said that "a sense of divine presence was realized by all" who attended these meetings and that "on subsequent occasions . . . a pillar of light was several times seen resting down upon the roof."[102] Oliver Cowdery verified that on the evening of the dedicatory services he personally "saw the glory of God, like a great cloud, come down and rest upon

the house, and fill the same like a mighty rushing wind. I also saw cloven tongues, like as of fire rest upon many, (for there were 316 present), while they spake with other tongues and prophesied."[103]

The Lord is the source of this divine light or fire. In the eighty-eighth section of the Doctrine and Covenants, we learn that by this light's power, God is "in all and through all things, the light of truth,"

> Which truth shineth. This is the light of Christ. As also he is in the sun, and the light of the sun, and the power thereof by which it was made.
>
> As also he is in the moon, and is the light of the moon, and the power thereof by which it was made;
>
> As also the light of the stars, and the power thereof by which they were made;
>
> And the earth also, and the power thereof, even the earth upon which you stand.
>
> And the light which shineth, which giveth you light, is through him who enlighteneth your eyes, which is the same light that quickeneth your understandings;
>
> Which light preceedeth forth from the presence of God to fill the immensity of space—
>
> The light which is in all things, which giveth life to all things, which is the law by which all things are governed, even the power of God who sitteth upon his throne, who is in the bosom of eternity, who is in the midst of all things. (vss. 6-13)

When the Lord made his personal appearance in the Kirtland Temple to accept it as his own, he radiated the heavenly light of his being. "His eyes were as a flame of fire," the record testifies. "The hair of his head was white like the pure snow; his countenance shone above the brightness of the sun" (D&C 110:3).

Spirals

Several different types of spirals are carved into the temple's wood trimmings. Some of them are simple while others are fashioned into more complex designs. Most dictionaries on symbolism hold the view that the spiral is a symbol of creation, growth, and unfolding.[104] Since the Kirtland Temple was designated by the Lord as a house of learning, or unfolding (see D&C 88:119), we draw attention to Doctrine and Covenants 88:78 and 97:14 where we read that doctrines, laws, principles, and theories were to be taught within its walls. The word *theory* at first seems a bit out of place until one realizes that *theoria* is the inspection or study of symbols in the mysteries as they are presented in a regular order for the purpose of instruction. *Theoria* is the "contemplation of the symbols

of the mysteries."[105] It will be remembered that symbols relating to ancient temple mysteries were found on the Egyptian papyrus scrolls, owned by Joseph Smith. These scrolls were kept and studied by the brethren inside the Kirtland Temple.[106] The Kirtland Temple was also the place where the School of the Prophets was commanded to meet (see D&C 95:17). The purpose of the school was to edify the participants through the expounding of "all scriptures and mysteries" (D&C 97:5).

Gammadion

The gammadion emblem is a combination of four connected Greek *gammas* that are shaped like the letter (L). In its earliest form this emblem signified the motion or rotation of celestial bodies.[107] In the Kirtland Temple a pair of these symbols is located above the east pulpits on the second floor; each of them face in opposite directions. Some commentators say that when this opposing combination occurs the pair can be seen as representing the sun and the moon.[108] This symbol

was used to decorate the beautifully carved stonework of the Jerusalem temple mount during the time of Jesus Christ.[109]

These emblems remind us that the Father is involved in an endless work of creation (see Moses 7:30), and he uses these heavenly spheres to provide places of abode and "light" for his children. In Doctrine and Covenants 88:42-47 we read:

And again, verily I say unto you, he hath given a law unto all things, by which they move in their times and their seasons;

And their courses are fixed, even the courses of the heavens and the earth, which comprehend the earth and all the planets.

And they give light to each other in their times and in their seasons, in their minutes, in their hours, in their days, in their weeks, in their months, in their years—all these are one year with God, but not with man.

The earth rolls upon her wings, and the sun giveth his light by day, and the moon giveth her light by night, and the stars also give their light, as they roll upon their wings in their glory, in the midst of the power of God.

Unto what shall I liken these kingdoms, that ye may understand?

Behold, all these are kingdoms, and any man who hath seen any or the least of these hath seen God moving in his majesty and power. (See also vss. 48-68)

Several scholars have noted the very interesting parallel between the Creation account recorded in the book of Genesis and the material found in Exodus 25-40,

which describes Moses' construction of the tabernacle.[110] Evidence also exists that during the time of Zerubbabel's Temple, the Creation account was read inside the temple courts during the performance of rituals.[111]

Gonfalon

Located behind the west pulpits on the first floor is an emblem shaped like the letter (W). Two slightly different variations of this design are used throughout the building. The early Christians used a symbol similar to this called the gonfalon, which was a flag or ensign associated with religious mysteries.[112]

The twelve tribes of ancient Israel each had their own distinctive ensign, and these banners were posted around the perimeter of the tabernacle whenever they were camped (see Numbers 2:2). Isaiah spoke prophetically of "an ensign for the nations," which was to be set up on the mountains in the last days for the gathering of Israel (Isaiah 11:10-12; 18:3). Hence, this symbol can be connected with the keys of gathering that were restored by Moses inside the Kirtland Temple (see D&C 110:11). In a modern-day revelation the Lord has explained the meaning of this ensign: "For, behold, I say unto you that Zion shall flourish, and the glory of the Lord shall be upon her; And she shall be an ensign unto the people, and there shall come unto her out of every nation under heaven" (D&C 64:41-42).

Egg and Dart

A motif popularly known as the "egg and dart" can be seen on the arch surrounding the west pulpits on the first floor and also on the pillars that decorate the steeple. This design was reportedly carved on one of the altars of the Jerusalem Temple[113]; remnants from the temple built during the time of Herod clearly show that this pattern was carved into the stonework.[114] While this symbol has taken several forms over time, it originated as an alternating pattern of open lotus flowers and buds.[115] In 1 Kings 6:18 we read that the woodwork inside Solomon's temple was

"carved with knops and open flowers." One scholar has argued that the more precise rendition of this phrase in Hebrew is "buds and calyxes," specifically of the lotus.[116] The lotus is a well-known Near Eastern symbol of rebirth or resurrection and was used to decorate the Brazen Sea of Solomon's temple (see 1 Kings 7:26).[117]

Intertwined Circles

Intricate designs of interlocking circles are found throughout the Kirtland Temple, most noticeably upon the western pulpits of the first floor. The circle is a well-known symbol of eternity, and on occasion Joseph Smith used his wedding ring to illustrate the doctrine of eternal existence.[118] The teachings of the scriptures add to the significance of this symbol. The Lord has many descriptive names and titles, among which are Endless and Eternal (see Moses 1:3; 7:35; D&C 19:10-12) because his "course is one eternal round, the same today as yesterday, and forever" (D&C 35:1; see also D&C 3:2, 1 Nephi 10:19, Alma 7:20). Several passages in the Doctrine and Covenants expand upon this concept by stating that "from eternity to eternity he is the same" (D&C 76:4; see also D&C 39:1). This naturally brings up the question of whether or not "eternity," from God's perspective, consists of a set amount of time. Elder Bruce R. McConkie provides us with the following thoughts on this matter.

> As men view things from their mortal perspective, there was a *past eternity* and there will be a *future eternity*. The past eternity embraced the sphere of eternal existence which all men had as the spirit offspring of exalted Parents in [the] pre-existence. The future eternity will be that eternal sphere in which the righteous, having gained both immortality and eternal life, will themselves become exalted Parents and have a continuation of the seeds forever and ever (D&C 132:19-25). In this sense, eternity becomes a measure of eternal "time." Those past ages when all men dwelt in the presence of their Eternal Father were one eternity, and those future ages when these spirit children will have gone on to exaltation, having spirit children of their own, will be another eternity.[119]

In 1844 W. W. Phelps, who worked with the Prophet on the Egyptian papyrus rolls that had been obtained by the Church, wrote to one of Joseph Smith's brothers, stating that "eternity, agreeable to the records found in the catacombs of Egypt, has been going on in this system, (not this world) almost *two [billion] five hundred and fifty five millions of years.*"[120] Regarding this concept Elder McConkie wrote:

> How long did Adam and Abraham and Jeremiah (and all men!) spend in preparing to take the test of a mortal probation? What ages and eons and eternities passed away while Christ dwelt in the Eternal Presence and did the work then assigned to him? How can we measure infinite duration in finite terms? To such questions we have no definite answers. Suffice it to say, the passage of time was infinite from man's viewpoint. We have an authentic account, which can be accepted as true, that life has been going on in this system for almost 2,555,000,000 years. Presumably this system is the universe (or whatever scientific term is applicable) created by the Father through the instrumentality of the Son.[121]

Like many others found upon the walls of the Kirtland Temple, this design was used to decorate Herod's temple in Jerusalem[122] and it can also be seen on the ceiling of the celestial room in the Mount Timpanogos Temple.

Labyrinth

A pattern resembling a labyrinth is sculpted into the wood of the Kirtland Temple above the second floor's eastern pulpits. The labyrinth is an ancient symbol that represents a journey to a central location and then an ascension from that point. The journey is "often connected to rites of initiation, that is, symbolic ordeals that bring about the spiritual transformation of the initiate."[123] According to Brigham Young, nobody can "dwell with the Father and Son, unless they go through those ordeals that are ordained for the Church of the Firstborn. The ordinances of the house of God are expressly for the Church of the Firstborn."[124] The center space of the labyrinth thus represents the vertical axis, sacred mountain, or temple that links together the different spheres of the cosmos. This is the symbolism of the temple that King Solomon built on Mount Moriah.[125]

The early Christians built elaborate labryinths into the pavement of their churches and cathedrals. Some of these labryinths were octagonal, the number eight being symbolic of rebirth and resurrection.[126] As part of their Easter liturgy some early Christians would join hands and perform a sacred dance around the

labyrinth. Someone would stand in the center of the maze and sing out verses of a hymn while the dancers sang back the chorus. This is believed to have been symbolic of the harmony and order of the created cosmos.[127] A rather interesting octagonal labyrinth from Reims Cathedral was once decorated with figures who were shown holding some of the symbols of creation—the compass and the square.[128]

Emblems of Eden

A number of the designs that decorate the Kirtland Temple suggest the setting of the Garden of Eden.[129] This is relevant because the tabernacle and later temples of Jerusalem were specifically designed to represent paradise by way of their architectural embellishments.

FLOWERS

Various styles of flowers can be seen throughout the temple's interior and exterior, which make the edifice a virtual garden, a place of beauty and peace. These flowers evoke the three most important and symbolic of all gardens: the Garden of Eden (Creation), the Garden of Gethsemane (Atonement), and the Garden tomb (Resurrection). Looking upon these flowers, one might well rehearse Moses 1:39, for it was in these very gardens that the plan of salvation began and the immortality and eternal life of man became a reality.

We have previously pointed out that King Solomon decorated Jehovah's dwelling with many "knops and open flowers" (1 Kings 6:18, 29, 32, 35). Archaeological remains reveal that the temple at the time of Jesus Christ was decorated with various floral motifs.[130]

Some commentators on Hebrew symbolism say of flowers that in "their budding and blossoming phase, they symbolize potential; in full flower, accomplishment, maturity, and perfection."[131] Jedediah M. Grant was privileged to visit paradise in the world of spirits before he died. In attempting to describe it he said: "I have seen good gardens on this earth, but I never saw any to compare with those that were there. I saw flowers of numerous kinds, and some with from fifty to a hundred different colored flowers growing upon one stock."[132] It is one of the foundational teachings of the LDS Church that when Jesus Christ returns to reign a thousand years, the earth will be renewed and become like the Garden of Eden (See Article of Faith 1:10).

VINES

On the second floor above the eastern pulpits can be seen two flowering vines that appear to be growing along the curves of the arch and terminating at the keystone. In ancient Israel a huge golden vine hung above the front entrance of the temple; attached to the vine were golden grape clusters that were as large as a man.[133] This particular decoration may have been placed on the sacred building because to the Hebrews the grapevine was one of the symbols of the promised land (see Deuteronomy 8:8; 1 Kings 4:25; Micah 4:4).

Like most symbols the vine also has multiple meanings. The Master proclaimed that he is "the true vine" and we, as branches, receive our nourishment and strength directly from him (John 15:1-2, 5-6; see also 1 Nephi 15:15). This emblem also reminds us of the great responsibility we bear as servants of the Lord to labor in his vineyard for the salvation of all his children (see Jacob 6:3; D&C 21:9, 24:19, 39:13, 138:56). Finally, the vine is a symbol of redemption because the fruit growing upon it is used to make pure sacramental wine (see D&C 89:5-6, 27:5).[134]

WATER OF LIFE

There are four staircases inside the Kirtland Temple, each consisting of thirty-three steps. Carved upon the side of each staircase is a design strikingly similar to the Egyptian hieroglyphic that signifies the waters of life.[135] This immediately brings to mind the fountain of water that originated in the Garden of Eden and divided into four rivers that flowed forth to the four directions of the earth (see Genesis 2:8-14; Revelation 22:1-2; 1 Nephi 8:2-20).[136] It is possible that the placement of the twelve oxen in four sets of three around the Brazen Sea of Solomon's Temple was a

subtle way of illustrating these four rivers of paradise (see 2 Chronicles 4:2-5). When Ezekiel was shown the Jerusalem Temple in his vision, he saw that life-giving water issued forth from below its threshold (see Ezekiel 47:1-12; Joel 3:18), and since the temples of Israel were purposefully decorated to imitate paradise, the connection is obvious. While contemplating the doctrines of the gospel, a young missionary in England had a vision that connects this symbolism with the Salt Lake Temple.

> I was standing on the Temple Square, close to the north side of the Assembly Hall, from which the voices of children singing came. A stream of clear crystal water ran past me, which seemed to have its origin under, or near, the foundation of the Temple. Some men were standing near this stream, and one of them said to me, "Here, drink of this water, it is so refreshing. It symbolizes the eternal truths of the everlasting Gospel." Suddenly there was a violent earthquake. The earth, as the prophets said, seemed to roll to and fro, like a drunken man, insomuch [that] it was difficult to stand. Then a calm which was almost frightening took possession of the elements, and for a time darkness prevailed. Suddenly a light appeared in the far east, which light seemed to come nearer, and as it approached, the darkness vanished. "That light," said my companion, "represents the Savior, as He shall appear at His second coming." As the darkness cleared away and light appeared, there were thousands and thousands of people, men, women and children, coming from every direction. Among them a group of men appeared very close to where we were standing, and in the group were the Prophet Joseph Smith, his brother Hyrum, and John Taylor, and others of those noted men who had previously passed away. . . . When I say I saw these men, I mean just that, for if ever a man looked into the face of another, I beheld the features of the Prophet Joseph Smith and the others I have mentioned.[137]

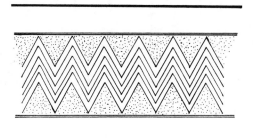

Before they were allowed to serve Jehovah in his tabernacle, the priests of ancient Israel had to undergo a ritual cleansing with water that filled the laver or Brazen Sea (Exodus 29:4). The Lord has declared that those who serve him in righteousness will someday be allowed to partake "of the fountain of the water of life freely" (Revelation 21:6; see also Revelation 22:17, Alma 5:34).[138] In several passages of scripture Jesus Christ has identified himself as "the fountain of living waters"

(Jeremiah 2:13; see also John 4:10-14, 7:37-38, Ether 12:28) and has compared the mysteries of his kingdom to "a well of living water, springing up unto everlasting life" (D&C 63:23; see also D&C 10:64-66, Isaiah 11:9).

TREE OF LIFE

Perhaps the most important symbol inside the Kirtland Temple is the Greek anthemion carved into the keystone above the second floor's eastern pulpits. The anthemion is actually a stylized form of the palmette, which in some ancient Near Eastern cultures represented the tree of life.[139] The tree of life was often associated with ancient temples,[140] and many different trees have been used to represent it. For example, in Solomon's Temple the wooden walls were carved with palm trees and cherubim to represent the tree of life and its guardian angels (see 1 Kings 6:29, 32; see also Genesis 3:22-24). Many people are not aware that the menorah built for the tabernacle was a golden almond tree whose branches were kept burning continually because it represented the "burning bush," or tree of life, that Moses encountered on Mount Sinai (see Exodus 25:31-40; Numbers 8:1-4).[141] Several Jewish traditions claim that the tree of life was an olive tree.[142] It would appear that Joseph Smith also held this particular view because he once spoke of the "olive leaf . . . plucked from the Tree of Paradise."[143]

The tree of life still exists in the presence of God (see Revelation 22:1-2) and he has made this wonderful promise to his faithful saints: "To him that overcometh will I give to eat of the tree of life, which is in the midst of the paradise of God" (Revelation 2:7). The visions of the tree of life given to Lehi and Nephi help us to understand the deep significance of this symbol and how it relates to us while we are yet in this world. One scholar has observed:

> The tree was obviously a doctrinal symbol, a "sign" that pointed beyond itself to an even greater reality. Yet the tree was of marvelous importance, for it was the symbol, even from the time of the Edenic paradise, of Jesus Christ's central and saving role and of the glorified immortality to be enjoyed by the faithful through his atoning sacrifice. Nephi's vision was to be more than an involvement with an abstract concept called the "love of God" (1 Nephi 11:22); it was a messianic message, a poignant prophecy of him toward whom all men press forward on that strait and narrow path that leads to life eternal.[144]

The Book of Mormon provides us with a marvelous insight in this regard. It

teaches that the tree of life is a symbol of Jesus Christ (see 1 Nephi 11:7, 20-22)[145] and that when we partake of the sacramental emblems, we are symbolically partaking of the fruit of that sacred tree (Alma 5:34, 62).[146]

NOTES

1. See the introductory statement of D&C 88. The opening five verses of this revelation are most probably the cause of the great peace that Joseph Smith described. There the Lord gave certain individuals the promise of eternal life in the celestial kingdom among the Church of the Firstborn. This promise was sealed upon them through the Holy Spirit of promise (see D&C 76:53; 124:124; 132:7, 18-19, 26).

2. *JD*, 2:29-31, 6 April 1853; *JD*, 13:357. See Exodus 25:8 and 1 Chronicles 28:11-12.

3. *HC*, 1:352. Since the Prophet's translating room was in the upper story of the Newel K. Whitney store and many revelations were received there, it is possible that the vision of the temple may have been seen in that location.

4. Ibid., 1:353.

5. Ibid., 1:357-62.

6. Truman O. Angell, *Autobiography*, 4-5, cited in *IE*, 45 (October 1942), 630. Angell recorded another account of this incident in a letter he sent to President John Taylor dated 11 March 1885. This letter, housed in the LDS Church Archives, reads: "F. G. Williams came into the Temple about the time the main hall 1st floor was ready for dedication. He was asked, how does the house look to you. He answered that it looked to him like the model he had seen. He said President Joseph Smith, Sidney Rigdon and himself were called to come before the Lord and the model was shown them. He said the vision of the Temple was thus shown them and he could not see the difference between it and the House as built." The law of witnesses was also to apply for a vision to be given of the Far West Temple which, again, was to be seen by all three members of the First Presidency (D&C 115:14-16, 17 April 1838).

7. *JD*, 13:357; emphasis added. At another time Elder Pratt said, "When the Lord commanded this people to build a house in the land of Kirtland, he gave them the *pattern* by vision from heaven, and commanded them to build that house according to that *pattern* and *order*; to have the architecture, not in accordance with architecture devised by men, but to have everything constructed in that house according to the *heavenly pattern* that He by His voice had inspired to his servants" (ibid., 14:273; emphasis added).

8. The works of Asher Benjamin are an obvious source for some of the symbols. See Asher Benjamin, *The American Builder's Companion*, 1806, reprinted (New York: Da Capo Press, 1972); *The Practical House Carpenter*, 1830, reprinted (New York: Da Capo Press, 1972); *Practice Of Architecture*, 1833, reprinted (New York: Da Capo Press, 1972).

9. Hoyt W. Brewster Jr., *Doctrine and Covenants Encyclopedia* (Salt Lake City: Bookcraft, 1988), 518-19. See also the entries under "Shinelah" and "Shinelane." These words are apparently from the Adamic language.

10. Church Educational System, *The Life and Teachings of Jesus and His Apostles*, 2d ed., rev. (Salt

Lake City: Corporation of the President of The Church of Jesus Christ of Latter-day Saints, 1979), 451. See also Church Educational System, *Old Testament: Genesis - 2 Samuel*, 2d ed., rev. (Salt Lake City: Corporation of the President of The Church of Jesus Christ of Latter-day Saints, 1981), 149-50.

11. *HC*, 4:331.

12. *JD*, 1:133, 6 April 1853.

13. *Journal History*, 23 July 1833; *JD*, 1:133-35; *HC*, 1:400.

14. Brigham Young, *JD*, 1:133, 6 April 1833: "When the corner stones were laid in Kirtland, they had to pick up boys of fifteen and sixteen years of age, and ordain them Elders, to get officers enough to lay the corner stones."

15. Orson F. Whitney, *Life of Heber C. Kimball* (Salt Lake City: Stevens and Wallis, 1945), 88-89.

16. *HC*, 2:428.

17. *HC*, 2:430. The place of offering up the sacramental emblems was called "the sacred desk" (ibid., 2:435). According to Zebedee Coltrin, one of the early Seven Presidents of the Seventy, Joseph Smith told those in the Kirtland Temple that they were partaking of the sacrament "after the ancient order," *Salt Lake School of the Prophets Minute Book 1883* (Salt Lake City: Pioneer Press, 1992), 53-54. For further reading see the articles by Richard Lloyd Anderson, "The Restoration of the Sacrament, Part 1: Loss and Christian Reformation," *Ensign*, January 1992, 40-46; "The Restoration of the Sacrament, Part 2: A New and Ancient Covenant," *Ensign*, February, 1992, 11-17.

18. Roy Gane, "'Bread of the Presence' and Creator-in-Residence," *Vetus Testamentum*, vol. 42, no. 2 (1992), 179-203. See also Church Educational System, *Old Testament: Genesis - 2 Samuel*, 2d ed., rev. (Salt Lake City: The Church of Jesus Christ of Latter-day Saints, 1981), 149; *BD*, 773.

19. *HC*, 2:410. The possible reason for their special dedication and consecration is that they were considered altars. They are identified as such in Keith Perkins, "The Way It Looks Today," *Ensign*, January 1979, 46-48. King Solomon offered his dedicatory prayer from the temple altar (see 1 Kings 8:54) and we suggest that the Prophet may have been imitating this pattern. Other indications that the pulpits were altars are the comparisons made by Heber C. Kimball between them and the altars found at Adam-ondi-Ahman and also the fact that the sacrificial emblems of the sacrament were offered upon them.

20. *HC*, 2:428, "Presidents Joseph Smith, Jun., Frederick G. Williams, Sidney Rigdon, Hyrum Smith, and Oliver Cowdery, met in *the most holy place* in the Lord's House, and sought for a revelation from Him . . . [on] important matters"; emphasis added.

21. A. Karl Larson and Katharine Miles Larson, eds., *Diary of Charles Lowell Walker* (Logan, Utah: Utah State University Press, 1980), 2:563, 14 August 1881.

22. See the illustration in Lawrence H. Schiffman, "Architecture and Law: The Temple and Its Courtyards in the Temple Scroll," in Jacob Neusner, Ernest S. Frerichs, and Nahum M. Sarna, eds., *From Ancient Israel to Modern Judaism* (Atlanta: Scholars Press, 1989), 1:269. See also Philip Peter Jenson, *Graded Holiness* (Sheffield: JSOT Press, 1992), 91, and Donald W. Parry, "Demarcation between Sacred Space and Profane Space: The Temple of Herod Model," in Donald W. Parry, ed., *Temples of the Ancient World: Ritual and Symbolism* (Salt Lake City: Deseret Book and FARMS, 1994), 413-39.

23. *BD*, 708. Page 626 of the same source says that Boaz can mean, "In him is might, or splendor."

24. Carol L. Meyers, Jachin and Boaz in Religious and Political Perspective," in Truman G. Madsen, ed., *The Temple in Antiquity* (Provo, Utah: BYU Religious Studies Center, 1984), 135-50.

25. John M. Lundquist, The Legitimizing Role of the Temple in the Origin of the State," in Donald W. Parry, ed., *Temples of the Ancient World*, 217-21. There is a great deal to be said about the establishment of a royal lineage in latter-day Israel. For a beginning approach to this subject, see George A. Horton, Jr., "Prophecies in the Bible about Joseph Smith," *Ensign*, January 1989, 20-25, and Joseph Fielding McConkie, "Joseph Smith as Found in Ancient Manuscripts," in Monte S. Nyman, ed., *Isaiah and the Prophets* (Provo, Utah: BYU Religious Studies Center, 1984), 11-31.

26. Temples are both dedicated and consecrated unto the Lord, whereas the private dwellings of the saints are only dedicated. Dedication of homes does not require priesthood authority; the consecration of temples does *(To Make Thee a Minister and a Witness: Melchizedek Priesthood Personal Study Guide 2* [Salt Lake City: The Church of Jesus Christ of Latter-day Saints, 1994], 143).

27. Donald W. Parry, "Ritual Anointing with Olive Oil in Ancient Israelite Religion," in Stephen D. Ricks and John W. Welch, eds., *The Allegory of the Olive Tree: The Olive, the Bible, and Jacob 5* (Salt Lake City: Deseret Book and FARMS, 1994), 271-75.

28. Ibid., 279-81. See also John A. Tvedtnes, "Olive Oil: Symbol of the Holy Ghost," 427-59 in the same volume.

29. Leonard J. Arrington, "Oliver Cowdery's Kirtland, Ohio, 'Sketch Book,'" *BYUS*, vol. 12, no. 4 (Summer 1972), 418-19. See also D&C 109:35 and Joseph Smith's record of performing this ordinance in *HC*, 2:379-80.

30. According to Orson Pratt, the Kirtland Temple was "set apart by the servants of God, and dedicated by a prayer that was written by inspiration" *(JD*, 18:132). As Elder McConkie points out: "*Inspiration* is a form of revelation. It is revelation that comes from the still small voice, from the whisperings of the Spirit, from the promptings of the Holy Ghost. All inspiration is revelation, but all revelation does not come by inspiration alone" *(MD*, 383). See also D&C 8:2-3.

31. Arrington, "Oliver Cowdery's Kirtland, Ohio, 'Sketch Book,'" 426. In Robert Woodford's study of the Doctrine and Covenants his text of this entry has "united ~~to~~" where the words "assisted in" are located (see Robert J. Woodford, *The Historical Development of the Doctrine and Covenants*, doctoral dissertation, 3 vols., Brigham Young University, April 1974, 3:1440).

32. We know that both Warren A. Cowdery and Warren Parrish served as scribes during the temple's dedication services and so it seems at least possible that they were serving in this capacity when they met with the Prophet, Sidney Rigdon, and Oliver Cowdery *(HC*, 2:411).

33. Seymour B. Young, *CR*, October 1907, 111: "'Thanks be to Thy name,' was the prayer of the Prophet Joseph Smith, as he extended his hands to heaven, and bowed before the congregation of the Saints." The entire congregation raised their hands to heaven as they gave the Hosanna Shout at the end of the dedicatory service which "sealed the proceedings of the day" *(HC*, 2:427-28); see also 382, 386. Some of the words of the Hosanna Shout were included in the hymn "The Spirit of God Like a Fire is Burning," which was written especially for the Kirtland Temple's dedication. Section 88 of the Doctrine and Covenants speaks of a salutation to be given in the temple "in the name of the Lord, with uplifted hands unto the Most High" during the "incomings" and "outgoings" of the brethren and specifies the wording to be used (vss. 120, 128-136). This salutation had a parallel in the ancient Jerusalem Temple where on the Sabbath the outgoing course of priests said to the incoming: "He that has caused His name to dwell in this house cause love, brotherhood, peace, and

friendship to dwell among you" (Alfred Edersheim, *The Temple: Its Ministry and Services,* updated version [Peabody, Mass.: Hendrickson Publishers, 1994], 110; see 2 Corinthians 13:11).

34. The sacrament was administered near the end of the temple's dedicatory services. The Lord specifically called this ordinance an "offering" (D&C 95:16).

35. See also "Eliza R. Snow's Graphic Description of the Temple and Its Dedication," in Edward W. Tullidge, *The Women of Mormondom* (New York: Tullidge & Crandall, 1877), 94.

36. Clay H. Gorton, *Language of the Lord* (Bountiful, Utah: Horizon, 1993), 112-13, 145, 284-86, 311-15. These chiastic elements are found in D&C 109:2-4, 7-19, 24-29, 29-50. The authors have also identified many other parallelisms in the remainder of this section. For articles examining chiasmus in the Book of Mormon and the Pearl of Great Price, see Paul Cracroft, "A Clear Poetic Voice," *Ensign,* January 1994, 28-31; John W. Welch, "Chiasmus in the Book of Mormon," *New Era,* February 1972, 6-11; David O. Peterson, "Chiasmus, the Hebrews, and the Pearl of Great Price," *New Era,* August 1972, 40-43; Clay H. Gorton, *A New Witness for Christ: Chiastic Structures in the Book of Mormon* (Bountiful, Utah: Horizon, 1997).

37. *TPJS,* 308. On pages 330-31 of the same volume the Prophet asks, "How are [the Saints] to become saviors on Mount Zion? By building their temples, erecting their baptismal fonts, and going forth and receiving all the ordinances, baptisms, confirmations, washings, anointings, ordinations and sealing powers upon their heads in behalf of their progenitors who are dead, and redeem them that they may come forth in the first resurrection and be exalted to thrones of glory with them. . . . The question is frequently asked, 'Can we not be saved without going through with all those ordinances?' I would answer, No, not the fulness of salvation. Jesus said, 'There are many mansions in my Father's house, and I will go and prepare a place for you.' *House* here named should have been translated kingdom; and any person who is exalted to the highest mansion has to abide a celestial law, and the whole law too."

38. *JD,* 2:214, 18 March 1855.

39. *JD,* 23:99, 20 November 1881. Similarly, Orson Hyde said, "The Presidency [is] like an arch with a keystone in the top of it. The greater weight you put upon it, the stronger it is" (*JD,* 6:157, 3 January 1858). B. H. Roberts also compared the First Presidency to the keystone of an arch (*CR,* October, 1903, 78).

40. *HC,* 2:410, 433.

41. Ibid., 2:386-87.

42. Truman O. Angell, *Autobiography,* 10, LDS Church Archives.

43. N. B. Lundwall, comp., *Temples of the Most High,* collector's edition (Salt Lake City: Bookcraft, 1993), 53.

44. *JD,* 13:357.

45. Whitney, *Life of Heber C. Kimball,* 209-10. For a discourse by Joseph Smith on the three grades of the priesthood, see *TPJS,* 322-23.

46. *TPJS,* 9, 25 October 1831.

47. Dean C. Jessee, "The Kirtland Diary of Wilford Woodruff," *BYUS,* vol. 12, no. 4 (Summer 1972), 392-93. This incident was recorded 7 April 1837. While president of the Logan Temple, Elder Marriner W. Merrill had a face-to-face confrontation with Satan over temple work, which was reported in the *Church News.* (See Rudger Clawson, "Lucifer tries to Hinder Temple Work," Church Section, *The Deseret News,* vol. 344, no. 61, 12 December 1936.) A slightly different version of this

story can be found in Nolan P. Olsen, *Logan Temple: The First 100 Years* (Providence, Utah: Keith W. Watkins and Sons, Inc., 1978), 165-67, which reads as follows: "President [Marriner W.] Merrill was sitting in his office [in the Logan Temple] one morning in the early 1890's when he heard a commotion ouside. Stepping to the window, he saw a great congregation of people coming up temple hill, some on foot, and others on horseback and in carriages. President Merrill's first thought was, 'What will we do with so many people? If we fill every room in the temple, it will not begin to hold them all.' The riders tied their horses up at the hitching posts or turned them loose in the temple corrals, and walked complacently about the front grounds, without seeming to have much purpose in mind. They were rather an odd looking group, and were dressed quite shabbily. They made no effort to enter the temple, so President Merrill went out to greet them and see what he could do for the group. He said to their leader: 'Who are you, and who are these people who have taken possession of the temple grounds unannounced?' He answered: 'I am Satan, and these are my people.' Brother Merrill asked: 'What do you want, and why have you come here?' Satan replied: 'I don't like what is being done in the Logan Temple and have come to stop it.' That was a bit of a shock to President Merrill, and he answered: 'No, we will not stop it. This is the work of the Lord and must go on. You know that you or any one else can not stop the work of the Lord.' 'If you refuse to stop it, I will tell you what I propose to do,' the adversary said. 'I will scatter this congregation of people throughout these valleys, and we will keep people from coming to the temple. We will whisper in their ears and discourage them from attending the temple. This will stop your temple work.' President Merrill then used the power of his priesthood and commanded Satan and his followers to depart from holy ground. He said that within four or five minutes there was not a person, horse or buggy in sight. They just disappeared into thin air and were gone. Then, for the next ten or twelve years we could have closed the Logan Temple, for very little work was accomplished."

48. Eliza R. Snow said, "In addition to the pulpit curtains, were others, intersecting at right angles, which divided the main ground-floor hall into four equal sections—giving to each one-half of one set of pulpits" (Edward W. Tullidge, *The Women of Mormondom* [New York: Tullidge & Crandall, 1877], 82).

49. *HC*, 2:398-99.

50. Ibid., 2:382.

51. Ibid., 2:383.

52. *Labors in the Vineyard: Twelfth Book of the Faith-Promoting Series*, 67. From the *Autobiography of Harrison Burgess*, 3-4, LDS Church Archives, Salt Lake City, Utah.

53. *HC*, 2:427.

54. "Joseph said that the personage was Jesus, as the dress described was that of our Savior, it being in some respects different to the clothing of the angels" (Lydia Knight History, cited in *The First Book of the Noble Women's Series*, 33). The Edward Partridge journal entry for 27 March 1836 records that "Doctor F. G. Williams saw an angel, or rather the Savior during the forenoon services" (*Edward Partridge Journal*, 46, LDS Church Archives, Salt Lake City, Utah).

55. *JD*, 11:10, George Albert Smith, 15 November 1864. D&C 110:7 states that the Savior personally visited the Kirtland Temple to *accept* its dedication on 3 April 1836.

56. *Truman O. Angell Journal*, 5, typescript, Special Collections, Harold B. Lee Library, Brigham Young University, Provo, Utah. See the article by Lyndon Cook, "The Apostle Peter and the Kirtland Temple," *BYUS*, vol. 15, no. 4, 550-51.

57. Whitney, *Life of Heber C. Kimball,* 103.

58. *JD,* 9:376. This idea of priestly garments being seamless is directly parallel to the robe worn by Israel's ancient high priest (see Exodus 28:31-32 and John 19:23).

59. *Frederick Kesler Diaries,* 10 March 1860, Book #3, 1859-1874, 10, Special Collections, University of Utah, Salt Lake City, Utah. Elder Kimball said on another occasion that "Peter was in the stand with a key in his hand and chain" *(Minutes of the School of the Prophets,* 18 May 1868, held in Provo, Utah).

60. A. Karl Larson and Katharine Miles Larson, eds., *Diary of Charles Lowell Walker,* 2 vols. (Logan, Utah: Utah State University Press, 1980), 2:563, 14 August 1881.

61. *HC,* 2:428.

62. Edward Tullidge, *Women of Mormondom,* 207-209.

63. John P. Pratt, "Passover: Was It Symbolic of His Coming?" *Ensign,* January 1994, 44; John P. Pratt, "The Restoration of Priesthood Keys on Easter 1836, Part 1: Dating the First Easter," *Ensign,* June 1985, 67, ftnt. 40, 68; John P. Pratt, "The Restoration of Priesthood Keys on Easter 1836, Part 2: Symbolism of Passover and of Elijah's Return," *Ensign,* July 1985, 60, 64.

64. There is no indication from the Prophet as to exactly where he and Oliver Cowdery were praying when these visions occurred. Regardless of where they were, anyone who has been inside the Kirtland Temple realizes that the area between the lowered pulpit veils is rather limited; the question naturally arises as to how all this activity could have occurred in such a small space. One vision given to an early Church member inside the Kirtland Temple helps explain what might have happened: "The Spirit of God rested upon me in a mighty power and I beheld the room lighted up with a peculiar light such as I had never seen before. It was soft and clear and the room looked to me as though it had neither roof nor floor to the building" *(Labors in the Vineyard: Twelfth Book in the Faith-Promoting Series,* 67). Elizabeth Comins Tyler also had a vision where the walls of her home disappeared so that she could see open space before her *(Juvenile Instructor,* vol. 27, no. 4 [1 February 1882], 94).

65. *HC,* 1:349.

66. *JD,* 14:273-74, 9 April 1871. See the definition of "keys" in *MD,* 409-10.

67. *CR,* April 1898, 17.

68. *DS,* 2:107, 110-11; *MD,* 438.

69. D&C 133:55; see also *MD,* 807.

70. *TPJS,* 307-308.

71. D&C 133:26 says that the lost ten tribes are located "in the north *countries*" and Jeremiah 16:15 speaks of both "the land of the north" and "the *lands* whither [the Lord] had driven them"; emphases added.

72. *NWAF,* 520-21. See especially Terry M. Blodgett, "Tracing the Dispersion," *Ensign,* February 1994, 64-70; Robert L. Millet and Joseph Fielding McConkie, "A Scriptural Search for the Ten Tribes" (pp. 103-17) in *Our Destiny: The Call and Election of the House of Israel* (Salt Lake City: Bookcraft, 1993). A longer version of this material can be found in Joseph Fielding McConkie, "A Scriptural Search for the Ten Tribes and Other Things We Lost," Religious Education Faculty Summer Lecture, Brigham Young University, 25 June 1987, 35 pp.

73. Robert L. Millet, "The Second Coming of Christ: Questions and Answers," in Leon R.

Hartshorn, Dennis A. Wright, and Craig J. Ostler, eds., *The Doctrine and Covenants: A Book of Answers* (Salt Lake City: Deseret Book, 1996), 216.

74. "When a man who is of Israel joins the Church, his tribal relationship does not change. For instance, a descendant of Judah would be classed as of the tribe of Judah, a descendant of Benjamin as of the tribe of Benjamin, and so with those of other tribes. Ephraim was blessed with the birthright in Israel [Genesis 48:5-22; Jeremiah 31:9], and in this dispensation he has been called to stand at the head to bless the other tribes of Israel [D&C 133:30-34]," *DS*, 3:247. For examples of the various tribes that are now being gathered into the Church, see Mark E. Petersen, *Joseph of Egypt* (Salt Lake City: Deseret Book, 1981), 15-17; *DS*, 3:248-49. "The tribe of Ephraim is one of the Ten Tribes. . . . There are, of course, isolated and unusual instances of people from other lost tribes gathering with Ephraim, but these are few and far between. The gathering of these other tribes is not yet, but by and by" (McConkie, *Millenial Messiah*, 320). For an overview of this doctrine, see Daniel H. Ludlow, "Of the House of Israel," *Ensign*, January 1991, 51-55.

75. *NWAF*, 529-30, 641-42.

76. *TPJS*, 335-36; "The spirit of Elias is a forerunner" (ibid., 338); "An angel came down from heaven and laid his hands upon me and ordained me to the power of Elias and that authorized me to baptize with water unto repentance. It is a power or a preparatory work for something greater. You have not power to lay on hands for the gift of the Holy Ghost but you shall have power given you hereafter, that is the power of the Aaronic Priesthood" *(WJS*, 332-33). A parallel account of these remarks bears quoting: "I saw an angel and he laid his hands upon my head and ordained me to be a priest after the order of Aaron and to hold the keys of this Priesthood which office was to preach repentance and baptism for the remission of sins and also to baptize but was informed that this office did not extend to the laying on of hands for the giving of the Holy Ghost that that office was a greater work and was to be given afterwards but that my ordination was a preparatory work or a going before which was the spirit of Elias for the spirit of Elias was a going before to prepare the way for the greater" (ibid., 327).

77. *TPJS*, 159.

78. Ibid., 157. "Noah, who is Gabriel . . . stands next in authority to Adam in the Priesthood; he was called of God to this office, and was the father of all living in his day, and to him was given the dominion." See the brief discussion on "Elias Is Noah" in Joseph Fielding Smith, *Answers to Gospel Questions* (Salt Lake City: Deseret Book , 1960), 3:138-41. See also the thoughts of Sidney B. Sperry on Noah as "the great Elias" in Ronald Vern Jackson, *The Seer—Joseph Smith* (Salt Lake City: Hawkes, 1977), 136-37.

79. *MD*, 219-20.

80. Louis Ginzberg, *Legends of the Jews*, 3:48; Stephen D. Ricks, "The Appearance of Elijah and Moses in the Kirtland Temple and the Jewish Passover," *BYUS*, vol. 23, no. 4 (Fall 1983), 483-86.

81. *TPJS*, 172.

82. Ibid., 321, 323, 337.

83. Ibid., 337-38.

84. Ibid., 340.

85. Ibid., 337.

86. The Prophet Joseph Smith said this about the keys of Elijah: "The Bible says, 'I will send you Elijah the Prophet before the coming of the great and dreadful day of the Lord; and he shall turn

the hearts of the fathers to the children, and the hearts of the children to the fathers, lest I come and smite the earth with a curse' [Malachi 4:5-6]. Now the word *turn* here should be translated *bind*, or seal. But what is the object of this important mission? Or how is it to be fulfilled? The keys are to be delivered, the spirit of Elijah is to come, the Gospel to be established, the Saints of God gathered, Zion built up, and the Saints to come up as saviors on Mount Zion [Obadiah 1:21]. But how are they to become saviors on Mount Zion? By building their temples, erecting their baptismal fonts, and going forth and receiving all the ordinances, baptisms, confirmations, washings, anointings, ordinations and sealing powers upon their heads, in behalf of all their progenitors who are dead, and redeem them that they may come forth in the first resurrection and be exalted to thrones of glory with them; and herein is the chain that binds the hearts of the fathers to the children, and the children to the fathers, which fulfills the mission of Elijah" *(TPJS,* 330). See also *WJS,* 331-32 and the discussion in *DS,* 2:118-19.

87. *MS,* 5:151.

88. A. Karl Larson and Katharine Miles Larson, eds., *Diary of Charles Lowell Walker* (Logan, Utah: Utah State University Press, 1980), 2:563.

89. L. John Nuttall Journal, 20 April 1893, 255; emphasis added. See Facsimile #2, fig. 2, "holding the key of power" and fig. 5, "the grand Key, or, in other words, the governing power." Also called "the key of this power," *TPJS,* 324; "the keys of power and knowledge," 325; "the keys of knowledge and power," 326; "the keys of power," 336; "holding the keys of power," 340; "kings and priests of the Most High God, holding the keys of power and blessings," 322. "Any person that has seen the heavens opened knows that there are three personages in the heavens who hold the keys of power, and one presides over all," 312.

90. Joseph Smith stated that "the keys" were given to Peter, James, and John "on the mount," in *TPJS,* 158. Elder McConkie likened this mountain to a "holy temple," in *Mortal Messiah,* 4:297.

91. *WJS,* 246. In reviewing these elements some LDS writers have suggested that the apostles received their endowments while on the mountain. See *DS,* 2:165; *Mortal Messiah,* 3:58; *DNTC,* 1:400.

92. See this painting by Judith Mehr in the *Ensign,* December 1988, 24-25.

93. Jonathan Hale, *The Old Way of Seeing* (Boston: Houghton Mifflin, 1994), 76-79.

94. Ibid., 77.

95. Scott G. Kenney, ed., *Wilford Woodruff's Journal* (Midvale, Utah: Signature Books, 1984), 5:120, 8 November 1857. The date 1835 has been changed to 1836 to reflect the time frame in which the endowment ceremonies were performed. President David O. McKay saw a vision in which he beheld the heavenly city of Zion and a great concourse of people, led by the Savior, who were all dressed in "a white flowing robe, and a white headdress," in Clare Middlemiss, comp., *Cherished Experiences from the Writings of David O. McKay* (Salt Lake City: Deseret Book, 1955), 102. Alfred D. Young likewise recorded a vision of the Second Coming wherein he saw the saints who are awaiting the arrival of the Savior "dressed in white robes with white coverings on their heads," in *Autobiographical Journal of Alfred Douglas Young 1808-1842,* unpublished manuscript, 4-9, BYU Special Collections Library.

96. Leibel Reznick, *The Holy Temple Revisited* (Northvale, New Jersey: Jason Aronson, 1990), 46.

97. James Hall, *Hall's Illustrated Dictionary of Symbols in Eastern and Western Art* (Cambridge:

The University Press, 1994), 6.

98. *TPJS*, 321.

99. *WJS*, 334. Elder McConkie indicates that this type of sealing is accomplished through the laying on of hands by those with the proper priesthood authority (see *MD*, 683, 361-62, 109-10, 117-18).

100. Hall, *Hall's Illustrated Dictionary of Symbols in Eastern and Western Art*, 4.

101. *HC*, 2:428.

102. Andrew Jenson, *The Historical Record*, 5:79.

103. Leonard J. Arrington, "Oliver Cowdery's Kirtland, Ohio, 'Sketch Book,'" *BYUS*, vol. 12, no. 4 (Summer 1972), 426. The parallel to the activities on the day of Pentecost is readily apparent (Acts 2:1-18). "When the apostles were raised up, they worked in Jerusalem, and Jesus commanded them to tarry there until they were endowed with power from on high [see Luke 24:49]. Had they not work to do in Jerusalem? They did work and prepared a people for the Pentecost. The kingdom of God was with them before the day of Pentecost, as well as afterwards. . . . The endowment was to prepare the disciples for their mission into the world" *(WJS*, 158). "At one time God obtained a house, where Peter washed and anointed, and so forth, on the day of Pentecost" *(WJS*, 211).

104. Ad de Vries, *Dictionary of Symbols and Imagery* (Amsterdam: North-Holland Publishing Company, 1974), 436. This source also notes that in some cases this symbol represents resurrection and immortality. There was a spiral staircase in Ezekiel's visionary temple (Ezekiel 41:7) and also in the temple described in the Temple Scroll from Qumran (see Morton Smith, "The Case of the Gilded Staircase," *Biblical Archaeology Review*, September/October 1984, 50-55; see also the response to this article by Jacob Milgrom, "Challenge to Sun-Worship Interpretation of Temple Scroll's Gilded Staircase," *Biblical Archaeology Review*, January/February 1985, 70-73). Those who receive the endowment ceremonies inside the Salt Lake Temple move in an upward spiral pattern, and both Salt Lake and Manti temples have beautiful spiral staircases. For further reading, see Jill Purce, *The Mystic Spiral: Journey of the Soul* (London: Thames and Hudson, 1974).

105. Hugh Nibley, *Approaching Zion* (Salt Lake City: Deseret Book and FARMS, 1989), 527-28. The scriptures often speak of having the mysteries of the gospel unfolded through a combination of learning and revelation (see 1 Nephi 10:19; Mosiah 2:9, 8:19; D&C 6:7; 11:7; 90:14; 76:5-10).

106. H. Donl Peterson, *The Story of the Book of Abraham* (Salt Lake City: Deseret Book, 1995), 124. For a interesting look at how these Egyptian manuscripts are related to temple ceremonies see Hugh Nibley, *The Message of the Joseph Smith Papyri: An Egyptian Endowment* (Salt Lake City: Deseret Book, 1975).

107. Goblet D'alviella, *The Migration of Symbols* (Westminster: Archibald Constable and Co., 1894), 51-53.

108. Hall, *Hall's Illustrated Dictionary of Symbols in Eastern and Western Art*, 6.

109. Joan Comay, *The Temple of Jerusalem* (London: Weidenfeld & Nicolson, 1975), 160.

110. Stephen D. Ricks, "Liturgy and Cosmogony: The Ritual Use of Creation Accounts in the Ancient Near East," in Donald W. Parry, ed., *Temples of the Ancient World: Ritual and Symbolism* (Salt Lake City: Deseret Book and FARMS, 1994), 124, fn. 15.

111. Ibid., 120-22.

112. Stephen Friar, ed., *A New Dictionary of Heraldry* (London: A & C Black, 1987), 170.

113. George Hersey, *The Lost Meaning of Classical Architecture* (Cambridge: The MIT Press, 1988), 34.

114. Comay, *The Temple of Jerusalem*, 160.

115. A. D. F. Hamlin, *A History of Ornament Ancient and Medieval* (New York: The Century Co., 1916), 107-08.

116. John Strange, "The Idea of Afterlife in Ancient Israel: Some Remarks on the Iconography In Solomon's Temple," *Palestine Exploration Quarterly*, vol. 17 (January/June 1985), 36-37.

117. Ibid. In some cultures the lotus can also symbolize initiation, Ad de Vries, *Dictionary of Symbols and Imagery*, 306.

118. *TPJS*, 181, 353-54.

119. *MD*, 240.

120. Letter from W. W. Phelps to William Smith, dated 25 December 1844, *Times and Seasons* 5 (1 January 1845), 758, hereafter cited as *TS*. Phelps called this information one of "the glorious mysteries of the kingdom." In another source Elder Phelps wrote these observations on time:

"Time is the ocean of existence, filled with elements and life for improvement by man. The presence and absence of the sun give days and nights—and the journey of the earth in her circuit, multiplies seasons and years; and years and ages make eternity; and eternity enlarges the scope of universal pleasure amid the glory of Gods.

"Again, it is revealed that one of our Father's days in Kolob, is 1000 years.

"It is also revealed, that his year is, as we count, 365,000 years.

"Then a week of his years, by the count of heaven, is 2,555,000,000 years.

"Two billions, five hundred and fifty-five millions of years! Just the length of eternity, as the martyred prophet said" (William W. Phelps, *Deseret Almanac, For the Year of Our Lord, 1852* [Great Salt Lake City: Willard Richards, 1851], 47).

In a very late reminiscence Lorenzo Snow provided this insight: "I remember once being in the office in Nauvoo where President Joseph Smith and some other brethren got to talking about the length of an eternity. One of the brethren went to work and managed to get the number of years that composed an eternity. It was somewhere in the neighborhood of 250,000 years. President Smith said that was correct. The number of years are vast and can scarcely be counted. Eternities have a beginning and an end. One eternity commences and that has an end, and so on. Eternities upon eternities" (Lorenzo Snow Papers, 16 June 1901, LDS Church Archives, Salt Lake City, Utah).

Gerald N. Lund has created the following chart to show the correspondence between God's celestial reckoning of time and man's telestial reckoning of time.

Kolob Time	Earth Time
1 day	1,000 years
1 hour	41.67 years
1 minute	253 days
1 second	4.22 days
.25 second	1.1 days
.01 second	1 hour

(Gerald N. Lund, "The Mysteries of God Revealed by the Power of the Holy Ghost," in Monte S. Nyman and Charles D. Tate, Jr., eds., *The Book of Mormon: First Nephi, The Doctrinal Foundation* [Provo, Utah: BYU Religious Studies Center, 1988], 158-59). God's reckoning of time is briefly mentioned in Psalm 90:4; 2 Peter 3:8; Abraham 3:4, 5:13, Facsimile #2, figure 1; D&C 130:4-5, 88:44, Alma 40:8.

"According to this, 1000 years of our time is equivalent to one day with the Lord. If you were to live to be 100 years old on earth, that would be 1/10 of a day with the Lord. Now suppose we divide the Lord's day into 24 equal parts, as our day is, just for comparative purposes: 100 years of our life would be equal to 1/10 of 24, or 2.4 hours. So according to this, if you live to be 100 on this earth, that would be equivalent to 2.4 hours of the Lord's time" (Eldred G. Smith, *IE*, June 1966, 513).

121. Bruce R. McConkie, *The Mortal Messiah* (Salt Lake City: Deseret Book, 1979), 1:29; see also fn. 7, pp. 32-33. For further insights into the meaning of "eternity" see Stephen E. Robinson, "Eternities That Come and Go," *Religious Studies Center Newsletter*, vol. 8, no. 3 (May 1994), 1, 4. Though it is beyond the scope of this book, we recommend that readers examine the time involved in the process of the Creation from the perspective of the article written by Thomas R. Valletta found in the *Ensign*, January 1994, 53-54. See also the article by Brian Hauglid, "Sacred Time and the Temple," in Donald W. Parry, ed., *Temples of the Ancient World: Ritual and Symbolism* (Salt Lake City: Deseret Book and FARMS, 1994), 636-645.

122. Meir Ben-Dov, *In the Shadow of the Temple* (New York: Harper and Row, 1985), 139.

123. Beverly Moon, ed., *An Encyclopedia of Archetypal Symbolism* (Boston: Shambhala, 1991), 68.

124. *JD*, 8:155.

125. Mircea Eliade, ed., *The Encyclopedia of Religion* (New York: Macmillan, 1987), 8:414. For further reading on the symbolism of the labyrinth, see W. H. Matthews, *Mazes and Labyrinths: Their History and Development* (New York: Dover Publications, 1970).

126. See 1 Peter 3:18-22 for the connection between the number eight, baptism, and the resurrection. See also Vincent Hopper, *Medieval Number Symbolism* (New York: Columbia University Press, 1938).

127. Penelope Reed Doob, *The Idea of the Labyrinth from Classical Antiquity through the Middle Ages* (Ithaca, New York: Cornell University Press, 1990), 124-25. Many Christian labyrinths were constructed of concentric circles. In most cathedrals, the labyrinth "imitates the concentric circles of the cosmos. . . . As God creates the circular cosmos with his compasses in so many illuminations, so too is the labyrinth constructed," 130. See especially Hugh Nibley's article on "The Early Christian Prayer Circle" in Hugh Nibley, *Mormonism and Early Christianity* (Salt Lake City: Deseret Book and FARMS, 1987), 45-99.

128. Doob, *The Idea of the Labyrinth*, 122.

129. "Geo Widengren has written that we find in ancient Near Eastern temples two modes of symbolism, cosmic symbolism and paradise symbolism," (Truman G. Madsen, ed., *The Temple in Antiquity: Ancient Records and Modern Perspectives* [Provo, Utah: BYU Religious Studies Center, 1984], 71). These two types of symbolism can be seen in the Kirtland, Nauvoo, and Salt Lake temples.

130. Meir Ben-Dov, *In the Shadow of the Temple*, 138-39.

131. Ellen Frankel and Betsy Platkin Teutsch, *The Encyclopedia of Jewish Symbols* (Northvale, NJ: Jason Aronson, 1992), 56.

132. *JD*, 4:136, 4 December 1856, as related by Heber C. Kimball.

133. Lawrence D. Sporty, "Identifying the Curving Line on the Bar-Kokhba Temple Coin," *Biblical Archaeologist*, Spring 1983, 121-23. Vine motifs were also carved into the stonework of the temple's courts, see James F. Strange, "The Art and Archaeology of Ancient Judaism," in Jacob Neusner, ed., *Judaism in Late Antiquity* (Leiden: E. J. Brill, 1995), 68.

134. Allen J. Christenson, "The Waters of Destruction and the Vine of Redemption," in Richard D. Draper, ed., *A Witness of Jesus Christ* (Salt Lake City: Deseret Book, 1990), 37-52.

135. See the illustrations and captions in Hugh Nibley, "Facsimile No. 1, by the Figures," *IE*, October 1969, 86-87.

136. The Slavonic version of the Book of Enoch says that the four rivers of paradise originate at the tree of life and therefore carry the tree's power, (Goodenough, *Jewish Symbols in the Greco-Roman Period*, 7:126, 128). The series of opposing volutes on the arch over the first floor western pulpits can also be seen as symbols of the water of life. In Mesopotamian art "whorls symbolize water" (Sabatino Moscati, *The Face of the Ancient Orient: A Panorama of Near Eastern Civilization in Pre-Classic Times* [Garden City, NY: Doubleday, 1962], 97-98). For an ancient Christian manuscript showing the four rivers of paradise in volute form, see John M. Lundquist, *The Temple: Meeting Place of Heaven and Earth* (London: Thames and Hudson, 1993), 91.

137. Thomas F. Greenwood, *I Remember* (Provo, Utah: Faucette Publications, 1959), 95-96. See also Fred E. Woods, "The Waters Which Make Glad the City of God: The Water Motif of Ezekiel 47:1-12," in Richard D. Draper, ed., *A Witness of Jesus Christ* (Salt Lake City: Deseret Book, 1990), 281-98; Fred E. Woods, "The Water Imagery in John's Gospel: Power, Purification, and Pedagogy," in Bruce A. Van Orden and Brent L. Top, eds., *The Lord of the Gospels* (Salt Lake City: Deseret Book, 1991), 189-206.

138. See the discussion on the water of life and its association with the temple in John M. Lundquist, "The Common Temple Ideology of the Ancient Near East," in Truman G. Madsen, ed., *The Temple in Antiquity: Ancient Records and Modern Perspectives* (Provo, Utah: BYU Religious Studies Center, 1984), 66-67.

139. "The *anthemion* is the most important and most beautiful of all Greek ornament motives. Its origin can be clearly traced back through Phoenician and Assyrian forms to the Egyptian lotus and lotus-palmette," (A. D. F. Hamlin, *A History of Ornament Ancient and Medieval* [New York: The Century Co., 1916], 104). Compare Genesis 3:24 with 1 Kings 6:29; 2 Chronicles 3:5, 7; and Ezekiel 41:18-20. For an overview of this subject, see C. Wilfred Griggs, "The Tree of Life in Ancient Cultures," *Ensign*, June 1988, 26-31. See the illustrations on page 29 that depict the tree of life as a palm tree.

140. John M. Lundquist, "The Common Temple Ideology of the Ancient Near East," 67-69.

141. N. Wyatt, "The Significance of the Burning Bush," *Vetus Testamentum*, vol. 36, no. 3 (July 1986), 361-65. "In general it may be said that most scholars now seem to suppose that the menorah originated from a sacred tree, more specifically the Tree of Life"; "The almond was originally conceived as a Tree of Life, indeed most probably the mythological Paradise Tree itself. . . . The almond is the first tree of spring in the Near East, sometimes waking as early as mid-December, when it decks

itself in radiant white . . . an ideal image of life [and] resurrection . . . whose fruit . . . has been described as 'perfect'" (L. Yarden, *The Tree of Light* [Ithaca, N.Y.: Cornell University Press, 1971], 35, 40). See also Carol L. Meyers, *The Tabernacle Menorah* (Missoula, Mont.: Scholar's Press, 1976), 36-38, 339. Aaron's rod blossoming as an almond tree inside the tabernacle thus has much more significance than is generally supposed (see Numbers 17:6-8).

142. John A. Tvedtnes, "Olive Oil: Symbol of the Holy Ghost," in Stephen D. Ricks and John W. Welch, eds., *The Allegory of the Olive Tree: The Olive, the Bible, and Jacob 5* (Salt Lake City: Deseret Book and FARMS, 1994), 429-30. For an insightful treatment of the theological connections between Jesus the Christ and the olive imagery, see the article in the same book by Truman G. Madsen, "The Olive Press: A Symbol of Christ," 1-10. Psalms 52:8 and 92:12-13 speak metaphorically of temple trees: "I am like a green olive tree in the house of God."

143. B. H. Roberts, *A Comprehensive History of the Church of Jesus Christ of Latter-day Saints*, 6 vols. (Provo, Utah: The Church of Jesus Christ of Latter-day Saints, 1930), 1:315, hereafter cited as *CHC*. This is from a letter of Joseph Smith to W. W. Phelps on 14 January 1833 and is included in the preface to section 88 of the *Doctrine and Covenants*.

144. Robert L. Millet, *The Power of the Word: Saving Doctrines from the Book of Mormon* (Salt Lake City: Deseret Book, 1994), 15.

145. Two biblical passages which either directly equate or closely associate the Lord with the Menorah / Tree of Life motif are Zechariah 4:1-14 and Revelation 1:12-13.

146. In an ancient Near Eastern context the "partaking of the fruit of the tree is a sacramental act, one that symbolizes unity with the gods; hence, the fruit is not available to mortals in the normal course of daily life but can be found only in the rituals relating to eternity" (Griggs, "The Tree of Life in Ancient Cultures," *Ensign*, June 1988, 29).

CHAPTER 4
The Nauvoo Temple

When Latter-day Saints see a house of the Lord decorated with the sun, moon, and stars, they may not realize that these architectural ornaments previously appeared on the Nauvoo Temple. In this chapter we will examine the origin and meaning of the many symbols that were once found on the exterior of this building. We also hope to provide answers to some long-standing questions about the nature of some of these emblems by exploring their meaning among the ancient Israelites and early Christians.

When the Saints settled in Commerce, Illinois, in 1839, the Prophet Joseph Smith renamed their new gathering place "Nauvoo," a Hebrew word meaning "a beautiful place."[1] During the Kirtland era the saints had learned through revelation that those who will inherit the celestial kingdom "come unto Mount Zion" and receive a *fulness* of glory by being made kings and priests of the Most High God (D&C 76:50-71). The ordinances performed inside the Kirtland Temple did not make men kings and priests, but in Nauvoo the saints received a revelation instructing them to build a temple wherein the Lord would restore further ordinances that pertained to "the *fulness* of the priesthood" (D&C 124:28-41; emphasis added). The Lord also promised in this revelation that at some future time he would show the Prophet a vision concerning "all things pertaining to this house, and the priesthood thereof" (vs. 42).

THE NAUVOO TEMPLE VISION

Even though there is no first-hand account of the actual vision that was given of the Nauvoo Temple, Joseph Smith recorded that he did indeed see one. While discussing some of the details of the building with William Weeks, the temple architect, he stated, "I wish you to carry out my designs, I have seen in vision the splen-

did appearance of that building illuminated, and will have it built according to the pattern shown me."[2] On 15 May 1844, while Josiah Quincy visited the temple site in company with the Prophet, he heard the following conversation take place: "Near the entrance to the Temple we passed a workman who was laboring on a huge sun, which had been chiselled from the solid rock. . . . 'General Smith,' said the man, looking up from his task, 'is this like the face you saw in vision?' 'Very near it,' answered the prophet."[3]

Another source informs us that there "were a great many questions asked Brother Joseph about how he kept the pattern of the temple in his mind so perfect. . . . He said, 'I will answer these questions today. When a true spirit makes known anything to you in the daytime, we call it a vision. If it is a true spirit it will never leave you, every particular will be as plain fifty years hence as now.'"[4] John Pulsipher also recorded that the pattern of the temple was received by revelation.

> Many of the Saints, men and women, had the privilege of receiving their endowments, learning the order of the priesthood, and the fall and redemption of man in the Temple, in the City of Joseph. I think it was in the month of January that I and my brother, Charles, received our endowments. The building was filled up in the nicest style. It was built according to the pattern that the Lord gave to Joseph. It was accepted of the Lord, and His holy angels have ministered unto many therein.[5]

Elder Parley P. Pratt was even more specific on the manner in which this revelation was delivered: "Who instructed [Joseph Smith] in the mysteries of the Kingdom, and in all things pertaining to Priesthood, law, philosophy, *sacred architecture*, ordinances, sealings, anointings, baptism for the dead, and in the mysteries of the first, second, and third heavens many of which are unlawful to utter? *Angels* and *spirits* from the unseen worlds."[6] The tradition that heavenly messengers were involved in revealing the pattern for the Nauvoo Temple, and that Joseph Smith then dictated those details to the architect, was repeated at least until the 1850s.[7]

ON EARTH AS IT IS IN HEAVEN

When we see representations of the sun, moon, and stars adorning the Nauvoo Temple, we quite naturally associate them with the doctrine of the three degrees of glory (see D&C 76; JST 1 Corinthians 15:41-42). But if we look closely at the order in which these astronomical emblems were arranged on the surface of the Nauvoo Temple, we will notice something very interesting. These symbols were *not* arranged in the manner of ascension through the three degrees of glory (i.e., telestial - stars; terrestrial - moon; celestial - sun). Rather, they were arranged in their

proper cosmological order as someone would view them while standing upon the earth and looking up into the heavens; first they would see the moon, then the sun, then the stars. The Nauvoo Temple was a scale model of the structure of our universe.[8]

But why would the Lord direct his prophet to place symbols of this nature on the Nauvoo Temple? The answer may lie in the type of ordinances that were restored for use in this sacred structure. We learn from Doctrine and Covenants 124:28, 40-41 that the Nauvoo Temple ordinances pertained to "the fulness of the priesthood" and if we look closely at section 76 we see that those who receive this *fulness* are known as "the church of the Firstborn" (vss. 54-56, 71). Joseph Smith said that these ordinances are "all those plans and principles by which anyone is enabled to secure the *fullness* of those blessings which have been prepared for the Church of the Firstborn."[9] Brigham Young echoed his predecessor by explaining that the saints "cannot dwell with the Father and the Son, unless they go through those ordeals that are ordained for the Church of the Firstborn. The ordinances of the house of God are expressly for the Church of the Firstborn."[10]

So how do the exterior symbols of this temple relate to the Church of the Firstborn? The answer can be found in the Joseph Smith Translation of Revelation 12:1, 7 where we read: "And there appeared a great sign in heaven, *in the likeness of things on the earth*; a woman clothed with the sun,[11] and the moon under her feet, and upon her head a crown of twelve stars. . . . The woman . . . was the church of God . . . [which] brought forth the kingdom of our God and his Christ."[12] Which church was John seeing in this vision? One LDS scholar believes that the woman John saw represented the Church of the Firstborn.[13] One of the men who helped build the Nauvoo Temple stated that the exterior symbols of that building represented the woman in John's vision.

> The order of architecture was unlike anything in existence; it was purely original, being a representation of the Church, the Bride, the Lamb's wife. John, the Revelator in the 12th chapter, first verse says, And there appeared a great wonder in heaven; a woman clothed with the sun, and the moon under her feet, and upon her head a crown of twelve stars." This is portrayed in the beautifully cut stone of this grand temple.[14]

RETURNING TO EDEN

An 1842 newspaper editorial speaks of the ideal sought for by the Saints in the city of Nauvoo: "Let the division fences be lined with peach and mulberry trees . . . and the houses surrounded with roses and prairie flowers, and their porches covered with grapevines, and we shall soon have some idea of how Eden looked."[15] We

know from historical sources that a room representing paradise was constructed inside the Nauvoo Temple and used as part of the endowment ceremony.[16] James E. Talmage notes that during the ordinances of the temple, participants experience "a recital of the most prominent events of the creative period, the condition of our first parents in the Garden of Eden [and] their disobedience and consequent expulsion from that blissful abode."[17] The prophet Jonah uttered words that typify the journey of Adam and Eve, and all temple patrons, after their expulsion from the Garden: "I am cast out of thy sight; yet I will look again toward thy holy temple" (Jonah 2:4).

DEDICATION PLAQUE

On 16 May 1845, Brigham Young decided to have a dedication plaque made for the temple. It was placed high above the three west entryways in the center of the attic story. In gold gilt lettering the inscription on this stone read:

<div align="center">

THE HOUSE OF THE LORD
Built by
THE CHURCH OF JESUS CHRIST
OF LATTER-DAY SAINTS
Commenced April 6, 1841
HOLINESS TO THE LORD

</div>

The date on the dedication plaque is symbolically significant. The month of April comes in the springtime, when the earth is renewed, as if it were recreated. April 6th is particularly significant for Latter-day Saints because that is the day on which the Church was formally organized, or created (see D&C 21:3). April 6th is also the day, in 1841, that the cornerstones were laid and the creation of the Nauvoo Temple began. While the Prophet Joseph Smith was in the land of Zion on 6 April 1833, he made some intriguing remarks that hinted at some correlations to this important day.

> It was an early spring, and the leaves and blossoms enlivened and gratified the soul of man like a glimpse of Paradise. The day was spent in a very agreeable manner, in giving and receiving knowledge which appertained to this last kingdom—it being just 1800 years since the Savior laid down His life that men might have everlasting life, and only three years since the Church had come out of the wilderness, preparatory for the last dispensation. The Saints had great reason to rejoice: they thought upon the time when this world came into existence, and the morning stars sang together, and all the sons of God shouted for joy; they thought of the time when Israel ate the "Passover," as wailing came up for the loss of the

firstborn of Egypt; they felt like the shepherds who watched their flocks by night, when the angelic choir sweetly sang the electrifying strain, "Peace on earth, good will to man"; and the solemnities of eternity rested upon them.[18]

OLIVE BRANCHES

The architectural plans of the Nauvoo Temple show two intertwined olive branches around the steeple's clock. This motif is rich in symbolic associations. The olive tree was one of the symbols of the land of Israel (see Deuteronomy 8:8), and the nation of Israel was often compared in scripture to an olive tree (see Romans 11:17; 1 Nephi 10:12, 15:12; Jacob 5:3-46, 6:1). In the story of the flood a dove brought an olive leaf to Noah as a symbol of peace (see Genesis 8:11). There is an interesting parallel to this symbolism in a comment made by Joseph Smith. As previously mentioned, in the introduction to section 88 of the Doctrine and Covenants, the Prophet connected the "olive leaf" with the feeling of peace. He then went a step further and implied that the "Tree of Paradise" was an olive tree, a view shared by some people in ancient Israel.[19]

The olive tree motif is also directly connected to the temple. The Psalms compare a righteous man to a green olive tree in the house of God (see Psalm 52:8). A vision given to Zechariah even pictures men in the temple as olive trees (see Zechariah 4:2-3, 11-14; Revelation 11:1-4). Olive oil played an important role in ancient Israel's temple rituals. Perfumed olive oil was used to anoint the temple priests as part of their consecration ceremony (see Exodus 30:22-31), and pure olive oil was used to keep the seven-branched candlestick inside the Holy Place burning continually (Exodus 27:20).

BAPTISMAL FONT

On 19 January 1841, the Lord indicated that the Nauvoo Temple would need to include a font to be used in performing baptisms for the dead (see D&C 124:29-33). This doctrine, which is only mentioned once in the Bible by Paul (see 1 Corinthians 15:29),[20] was restored to Joseph Smith at least as early as 15 August 1840.[21] The manner in which this doctrine was restored is not presently known, but Joseph Smith said that he had "knowledge independent of the Bible" on the mat-

ter.[22] On one occasion the Prophet gave a detailed description of the apostle Paul, which naturally raises the question of whether Paul was sent to instruct the Prophet on this doctrine.[23] The Prophet taught that "God decreed before the foundation of the world that [the] ordinance [of baptism for the dead] should be administered in a font prepared for that purpose in the house of the Lord"[24] because "the only way that men can appear as saviors on Mount Zion . . . [is] by actively engaging in rites of salvation substitutionally."[25]

The baptismal font seen in modern temples is derived from the basin or laver that was located in the courtyard of the tabernacle built by Moses. The laver, filled with water, was used to ritually purify the priests before they were allowed to serve inside the tabernacle (Exodus 29:4; 2 Chronicles 4:6). When the temple of Solomon was built in Jerusalem, the laver was enlarged in size and placed on the backs of twelve oxen, with three of the animals facing toward each direction of the compass (see 1 Kings 7:23-26). It was this modified form of the font that was constructed for the temple at Nauvoo.[26]

There is a great deal of symbolism associated with the temple font. First and foremost the font is a receptacle of life-giving water. Jesus Christ is described as the fountain of living waters" (see Jeremiah 2:13, 17:13; Ether 8:26, 12:28), and it is through the symbolic ordinance of baptism that the spiritually dead are brought to life through his atoning power. The twelve oxen are the most prominent feature of the baptismal font. Although the oxen are often believed to signify the twelve tribes of Israel,[27] the ancient Israelites saw the ox as the symbol of the tribe of Joseph (see Deuteronomy 33:17).[28] Because this tribe holds the birthright blessings, it also has responsibility for the salvation of the rest of the tribes of Israel (see 1 Chronicles 5:2; Jeremiah 31:9).[29] In Hebrew the name "Joseph" is *Asaph* and one of its meanings is "he who gathers."[30] This is significant because Joseph was told by his father Jacob that his "horns" would be used to "push the people together" from the ends of the earth (Deuteronomy 33:17). In our dispensation the Lord used the same phraseol-

ogy when commanding the elders of the last days to preach the everlasting gospel and convert as many as will come unto Christ (see D&C 58:44-48). The baptismal font, resting on the backs of the twelve oxen, can thus signify that the burden of vicarious work for the dead has been laid upon the tribe assigned the task of restoring the house of Israel in the last days—the birthright tribe of Joseph.

In an epistle on baptism for the dead, Joseph Smith explained that the Lord commanded that the baptismal font be placed below ground level in order for it to symbolize the death and resurrection of the recipient of this ordinance.

> The ordinance of baptism by water, to be immersed therein in order to answer to the likeness of the dead, that one principle might accord with the other; to be immersed in the water and come forth out of the water is in the likeness of the resurrection of the dead in coming forth out of their graves; hence, this ordinance was instituted to form a relationship with the ordinance of baptism for the dead, being in likeness of the dead [see Romans 6:3-5].
>
> Consequently, the baptismal font was instituted as a similitude of the grave, and was commanded to be in a place underneath where the living are wont to assemble, to show forth the living and the dead, and that all things may have their likeness, and that they may accord one with another—that which is earthly conforming to that which is heavenly, as Paul hath declared, 1 Corinthians 15:46, 47, and 48. (D&C 128:12-13)

SIGNS IN THE HEAVENS

The Lord has arranged the cosmological system so that the sun, moon, and stars can be used as celestial timekeepers and prophetic indicators. Joseph Smith taught that "God has made certain decrees which are fixed and immovable; for instance, God set the sun, the moon, and the stars in the heavens, and gave them their laws, conditions, and bounds, which they cannot pass, except by His commandments; they all move in perfect harmony in their sphere and order, and are as lights, wonders, and signs to us."[31] On one occasion Wilford Woodruff was visited by an angel who showed him how astronomical signs would be used as indicators of future events.

> I went into a little room where there was a sofa, to pray alone. . . . While I was upon my knees praying, my room was filled with light. I looked and a messenger stood by my side. I arose, and this personage told me he had come to instruct me. He presented before me a panorama. He told me he wanted me to see with my eyes and understand with my mind what was coming to pass in the earth before the coming of the Son of Man. He commenced

with what the revelations say about the sun being turned to darkness, the moon to blood, and the stars falling from heaven. Those things were all presented to me one after another, as they will be, I suppose, when they are manifest before the coming of the Son of Man.[32]

In a revelation given to President John Taylor on 16 May 1884, the Lord accepted the newly dedicated Logan Temple as his house. He then instructed the prophet how he would use the temple to reveal the nature of the heavens to his faithful servants.

This house shall be a house of prayer, a house of learning, a house of God; wherein many great principles pertaining to the past, to the present and the future shall be revealed, and my word and my will be made known; and the laws of the Universe, pertaining to this world and other worlds be developed; for in these houses which have been built unto me, and which shall be built, I will reveal the abundance of those things pertaining to the past, the present, and the future, to the life that now is, and the life that is to come, pertaining to law, order, rule, dominion and government, to things affecting this nation and other nations; the laws of the heavenly bodies in their times and seasons, and the principles or laws by which they are governed, and their relation to each other, and whether they be bodies celestial, terrestrial or telestial, shall all be made known, as I will, saith the Lord; for it is my will and my purpose to place my people in closer communion with the heavens, inasmuch as they will purify themselves and observe more diligently my law; for it is in mine heart to greatly bless and exalt my people, and to build up, exalt and beautify my Zion, inasmuch as they shall observe my law.[33]

Another early Latter-day Saint, Joseph Holbrook, was meditating upon the doctrines of the gospel when the Lord revealed to him that the celestial spheres are symbolic of the endless exaltation that awaits those who obey the Father's will.

All at once a sensation came over me that I could see worlds upon worlds and systems upon systems, an endless eternity of them that no man could number. For thousands of solar systems like unto the one that our earth forms a part seemed to pass before me in quick succession. And I marveled at the power of which all these systems moved in so much harmony, for there were systems upon systems moving in their orbit as harmonious as our earth with other planets mov[ing] in their orbits around the grand center of our system; and as space was endless so were the creations of God endless in point of time or duration. [Then the voice of the Lord said unto me:] "And all this is brought about by the revelation I have revealed to my servant, Joseph Smith, and there is an endless exaltation to man if he will so receive it."[34]

In the third chapter of the Book of Abraham we are presented with a great deal of astronomical information. This is not just a lecture on astronomy, however. By

comparing this material with the doctrines presented in the rest of the Book of Abraham, one can see that this is a symbolic lesson on the order of heavenly government and glory among heavenly beings.[35] It is with this kind of perspective that we need to view the astronomical symbols on the outside of the Nauvoo Temple. They are not just interesting decorations. They are teaching devices.

Moonstones

Moonstones decorated the base of the pillars surrounding the Nauvoo Temple. These crescent moons, carved with faces that were turned towards the ground, were identified by W. W. Phelps as "new moons."[36] The new moon was very important in ancient Israel for indicating the proper time of certain temple festivals such as Rosh Hashanah or New Year.[37]

As a sign that the Savior's Second Coming is near, the moon—along with other heavenly bodies—will cease to give off its light to the earth (see Isaiah 13:9-10, Matthew 24:29), and will take on the appearance of being bathed in blood (see Revelation 6:12-13; D&C 29:14; 34:9; 45:42; 88:87; 133:49). In several passages of scripture the sanctified church is described as being "clear as the moon" (D&C 5:14, 109:73, 105:31). The word "clear" can be defined as meaning "free from darkness . . . blame or guilt."[38]

When Joseph Smith described his vision of the three degrees of glory, he said that the middle, or terrestrial, kingdom could be compared to the brightness of the light given off by the moon (see D&C 76:71, 78; 1 Corinthians 15:40-42). At first this idea may seem to be out of place because the word *terrestrial* is most often identified with the "earth" and Latter-day Saints currently classify the earth as a *telestial* kingdom of glory. This confusion is cleared away once it is realized that the root of the word *terrestrial* (terr) pertains to the "land" that is located between the water and the sky.[39] Hence, the word *terrestrial* literally means a place located in between two others.

Sunstones

The Nauvoo Temple sunstones are probably the most unique of all LDS symbols. The sun motif is often associated with the glory of celestial beings. For example, in the book of Revelation the heavenly Bride seen by the apostle John is said to be "clothed with the sun" (12:1). She is covered "with light as with a garment" like

unto Jehovah the Bridegroom (Psalm 104:2; see also Psalm 84:11; Malachi 4:2). We are told in modern revelation that those who inherit the highest degree of glory "are celestial, whose glory is that of the sun, even the glory of God, the highest of all, whose glory the sun of the firmament is written of as being typical" (D&C 76:70).

Brigham Young helps us to understand the interesting design of the sunstones. In his description of this symbol, he states that the sun is depicted as rising.

> There are thirty capitals around the temple, each one composed of five stones, viz., one base stone, one large stone representing the sun rising just above the clouds, the lower part obscured; the third stone represents two hands each holding a trumpet, and the last two stones form a cap over the trumpet stone, and all these form the capital.[40]

President Young's description helps us to solve three minor mysteries concerning the temple's symbolic designs. The first mystery regards the sunstone motif. As far as we know there has never been any explanation about the source of the reversing diagonal pattern found directly underneath the face of the sun. We propose the following thoughts for consideration. In the passage quoted above, Brigham Young identifies this diagonal design as "clouds," which makes no sense at all until we compare it to an Egyptian counterpart found in facsimile no. 1 of the Pearl of Great Price. Figure 12 of facsimile no. 1 is an Egyptian hieroglyphic that stands for the "expanse, or the firmament over our heads." According to the LDS Bible Dictionary, this expanse includes the atmosphere, which is, of course, the location of the clouds.[41] It is also interesting to note that the overall shape of the sunstone is similar to an Egyptian hieroglyphic that represents the rising sun.[42]

Trumpetstones

The second mystery that President Young helps to clarify is the identification of the two objects seen directly above the face on the sunstone. Some writers have put forward their belief that these are cornucopia. This is simply not true. In addition to Brigham Young's comments, other contemporary accounts plainly identify these objects as trumpets.[43]

Moses was commanded by the Lord to make two silver trumpets for the priests to blow within the tabernacle complex in order to summon the children of Israel to

assemble there. These instruments also announced the beginning of holy days and memorialized certain temple ordinances (see Numbers 10:2-10). The trumpets on the sunstone are held by hands that descend from above the sun's face, implying that they originate in the heavenly realms. At the Second Coming a heavenly trump "shall sound both long and loud, even as upon Mount Sinai" (D&C 29:13; see also 26-27). The prophet Joel combines the imagery of the blast of a temple trumpet and gathering to the house of the Lord to await his coming in glory.

> Sanctify ye a fast, call a solemn assembly, gather the elders and all the inhabitants of the land into the house of the Lord your God, and cry unto the Lord. Alas for the day! for the day of the Lord is at hand. . . . Blow ye the trumpet in Zion, and sound an alarm in my holy mountain: let all the inhabitants of the land tremble: for the day of the Lord cometh, for it is nigh at hand; A day of darkness and of gloominess, a day of clouds and of thick darkness, as the morning spread upon the mountains. . . . The heavens shall tremble: the sun and the moon shall be dark, and the stars shall withdraw their shining . . . for the day of the Lord is great and very terrible; and who can abide it? (Joel 1:14-15; 2:1-2, 10-11)

Starstones

Two different types of stars decorated the exterior of the Nauvoo Temple. The first type had five points with a single ray pointed down. The second type was six-pointed on a vertical axis. The six-pointed star (without crossing lines) has been

used for centuries as a symbol of the fixed stars seen in the depths of the night sky.[44] This type of star was interspersed among the railing panels that surrounded the roofline of the temple.[45] It was also placed along the bottom of the roof's overhang so that people standing underneath the roofline would be able to look up and see these stars as if they were fixed against the sky.[46]

Stars are often used in the scriptures to symbolize the endless posterity of those who are faithful to the Abrahamic Covenant (see Genesis 15:5; Deuteronomy 1:10; 1 Chronicles 27:23; Nehemiah 9:23; D&C 132:30). It is only in the temple of the Most High God that a husband and wife enter into the Abrahamic Covenant, for "everyone in the Church who has been married in the temple has received exactly the same promise that God gave to Abraham, Isaac, and Jacob. Everyone who is married in the temple and who keeps the covenant has the

assurance that he will have eternal increase, that his posterity will be like the dust of the earth and the stars of heaven in number."[47]

Joseph Smith said that the glory of the telestial kingdom could be compared to the light emanating from the stars (see D&C 76:81, 98, 109). The word *telestial* is unique. It was evidently removed from the text of 1 Corinthians 15:40 in the ancient past and then restored by the Prophet in the Joseph Smith Translation. The root of this word, *tele-* is "a combining form meaning: at or over a distance."[48] In LDS theology the telestial kingdom is the most distant place one can be from the presence of the Lord while still retaining some degree of glory. Hence, the name of this kingdom is most descriptive. This word has several other forms that should be considered, however, because of their relationship to the temple. Dr. Hugh Nibley has pointed out that the word *telos* means "initiation," *teleiomai* means "to be initiated into the mysteries," and *teleiotes* is someone who has become complete or ritually "perfect" through a full reception of those mysteries (see Matthew 5:48; 3 Nephi 12:48).[49] Dr. John W. Welch also informs us that a *teleios* is an initiate who receives the mysteries.[50] The connection here seems to be that the telestial world is the place that has been appointed for us to accept and then be initiated into the mysteries of godliness; otherwise, as other revelations proclaim, there can be no exaltation (see D&C 131:1-4; Alma 34:32-33). Wilford Woodruff was straightforward and uncompromising on this matter when he said that "no man will receive of the celestial glory except it be through the ordinances of the house of God."[51]

The Book of Abraham presents us with an interesting array of cosmological terms. As mentioned above, this material is often thought of as just an elaborate astronomy lesson. Some people have even felt that Joseph Smith made these terms up on his own. But it should be noted that the unusual terms found within the Abrahamic scriptures are indeed ancient. The following comparison will serve to demonstrate this point.

- "Kokob, which is star" (Abraham 3:13)

- Hebrew *kokab* - star[52]

- "Kokaubeam, which signifies stars" (Abraham 3:13)

- Hebrew *kokabim* - stars[53]

- "The name of the great one is Kolob" (Abraham 3:3)

- Semitic *klb* or *qlb* - center, middle, heart[54]

- "Olea, which is the moon" (Abraham 3:13)

- Egyptian *ich* - moon and Hebrew *ya recah* - moon [55]

- "Shinehah, which is the sun" (Abraham 3:13)

- Egyptian *sheni* - 'encircle' and *hh* - eternity; *nehah* - sun [56]

- "Earth, which is called . . . Jah-oh-eh" (Fac. #2, fig. 1)

- Egyptian *yoh-heh* and Coptic *ja-i-e* - earth [57]

- "The Hebrew word Raukeeyang, signifying expanse, or the firmament of the heavens" (Fac.#2, fig.4; see also Fac.#1, fig. 12)

- Hebrew *rah-kee'ag* - meaning firmament, expanse [58]

- "Shaumau, to be high, or the heavens, answering to the Hebrew word, Shaumahyeem" (Fac.#1, fig.12)

- Hebrew *shamayim* - to be lofty, sphere of celestial bodies [59]

The most prominent type of star that adorned the Nauvoo Temple was five-pointed and had a single ray pointing down. This star was placed directly above the sunstones and took two different forms. The first form had rays of equal length. The architect's drawings show that this star was going to be outlined on or etched into the glass of the small round windows that were next to the starstones. One of the sketches of the temple shows that the glass of these windows was to be stained. It is not known for certain whether these window stars were ever incorporated into the building's design.[60] It was originally decided that the starstones would also be depicted with rays of equal length, but over time this design was modified so that the single ray on the bottom of the star was considerably elongated. Photographs and fragments of stone that have been recovered confirm that this modified version of the star was ultimately used to adorn the temple's facade.[61]

To the early Saints of our dispensation this emblem was known as "The Star of the Morning."[62] This title may help us to understand why it has an elongated ray on

the bottom. It is well-known that the morning star is the brightest object in the sky just prior to the breaking of dawn. The reason for its unusual brightness is that this star (actually the planet Venus)[63] "borrows" its light from the sun, which is directly below the horizon (see D&C 88:44; see also Fac. #2, figure 5). The elongated ray of the Nauvoo star is pointed down toward the rising sun as if the star were drawing its light from that source.

As the morning star is a herald or precursor, it has some interesting theological implications. For example, it was on a "holy mount" that Peter, James, and John received the "more sure word of prophecy," and Peter compared this experience to having "the day star arise" in their hearts (2 Peter 1:16-19). The day star and morning star are one and the same. According to the scriptures, the "more sure word of prophecy means a man's knowing that he is sealed up unto eternal life, by revelation and the spirit of prophecy, through the power of the Holy Priesthood" (D&C 131:5). Joseph Smith further taught that the more sure word of prophecy pertains to steadfast disciples of Christ making their calling and election sure, and having the promise of eternal life sealed upon them.[64] Those Saints who are wholly devoted to righteousness, says Elder McConkie, "make their calling and election sure. That is, they receive the more sure word of prophecy, which means that the Lord seals their exaltation upon them while they are yet in this life" (see D&C 132:49-50).[65] Even though "the fulness of eternal life is not attainable in mortality . . . the peace which is its *harbinger* and which comes as a result of making one's calling and election sure is attainable in this life."[66] These teachings may help to clarify what the Lord meant when he promised those who overcome the world: "I will give him the morning star" (Revelation 2:28).[67]

On the highest level of meaning, the morning star is a descriptive symbol of the Lord Jesus Christ. To those living under the Old Covenant, the coming Messiah was known as the "Star out of Jacob" (Numbers 24:17). To those under the New Covenant, the resurrected Lord revealed that he is "the bright and morning star" (Revelation 22:16).[68] When the Lord is referred to as "a light that shineth in a dark place," it is another way of stating that he is the morning star, the brightest star that heralds the dawn (2 Peter 1:19; see also 2 Corinthians 4:6; John 1:1-12; D&C 6:21,

14:9).[69] The star that announced the birth of the Savior was sometimes depicted by the early Christians as an upside-down pentagram (see Matthew 2:2).[70] One early Christian rendition of the events on the Mount of Transfiguration shows the Lord standing before a morning star emblem with an elongated bottom ray similar to the stars on the Nauvoo Temple.[71] Like our Redeemer, we too may rise in the morning of the first resurrection. "May the Lord bless us," said George Albert Smith, "and enable us to . . . rise with the Star of the Morning, and enjoy eternal glory."[72]

CELESTIAL GLORY AND POWER
The Angel Moroni

The most visible symbol on many LDS temples is the angel Moroni statue, which stands atop the highest spire. Some Latter-day Saints may not be aware that the first angel to decorate a temple in our dispensation was fashioned in a horizontal manner as if to illustrate Revelation 14:6-7.

> And I saw another angel fly in the midst of heaven, having the everlasting gospel to preach unto them that dwell on the earth, and to every nation, and kindred, and tongue, and people, saying with a loud voice, Fear God, and give glory to him; for the hour of his judgment is come: and worship him that made heaven, and earth, and the sea, and the fountains of waters.

In one of the angel's hands is an open Book of Mormon,[73] which represents the restoration of the everlasting gospel in its purity. In the other hand he holds a trumpet to his lips. We are all commanded to declare the gospel of salvation "with the voice of a trump" (D&C 24:12, 33:2, 36:1, 75:4) "like unto angels of God" (D&C

42:6). Even though there is currently no known contemporary source that identifies this angel as Moroni, the angel holds a Book of Mormon and the keys of revealing the Book of Mormon were committed to Moroni (see D&C 27:5). An experience of John Taylor also supports this interpretation. When he was living in England the young John Taylor saw a vision of an angel "flying through the midst of Heaven with a trumpet to his lips." This vision is said to have been seen on the day that this heavenly messenger visited Joseph Smith and announced the existence of the Book of Mormon.[74]

The clothing worn by the Nauvoo angel is most significant. He is described by a contemporary source as wearing a "priestly robe"[75] that reaches to his feet. On his head he wears a round cap.[76] This is the clothing that was worn by the priests of ancient Israel during their temple ministrations (see Exodus 28:40). Angels were once seen wearing this same type of clothing inside the Nauvoo Temple. Thomas Bullock, an eyewitness, tells the following story:

> At sundown [I] went to the Temple. Fourteen partook of the sacrament after which we had a most glorious time. Some of the brethren spoke in tongues. Brother Zebedee Coltrin and Brown held a talk in tongues which was afterwards interpreted and confirmed. Some prophesied. Brother Anderson related a vision and all of us rejoiced with exceeding great gladness. A light was seen flickering over brother Anderson's head while relating his vision [and] Phinehas Richards' face shone with great brightness. Two men arrayed all in priestly garments were seen in the northeast corner of the room. The power of the Holy Ghost rested down upon us. I arose full of the Spirit and spoke with great animation, which was very cheerfully responded to by all, and prophesied of things to come. A brother testified that our meeting was accepted of God.[77]

Compass and Square

Directly above the angel can be seen an architect's compass and a builder's square. These instruments are touching at their right angles, with the points of each instrument aimed in opposite directions. The compass points are directed towards the sky, while the legs of the square point towards the earth. This may be significant, for the compass is used to draw the circle—which is a symbol of the heavens, while the square is used to construct a rectangle with four equal sides—which represents the four corners of the earth.[78] In this sense these instruments could be used to remind one that the Melchizedek Priesthood presides over heavenly or spiritual concerns, while the Aaronic Priesthood has charge of all things earthly (see D&C 107:8, 14, 18, 20). It is not clear whether these symbols were ever actually placed on the temple spire because there is presently no document available that mentions

them. During the Nauvoo period of Church history, however, the scriptures were compared to the compass and square, because they were the instruments used for measuring out and determining truth. The close proximity of the compass and square to the scriptures on the drawing of the temple spire suggests this relationship.[79] Elder Parley P. Pratt recorded a remarkable vision of these emblems as he looked out into the night sky in September of 1830.

> "The sky was without a cloud; the stars shown out beautifully, and all nature seemed reposing in quiet, as I pursued my solitary way, wrapt in deep meditations on the predictions of the holy prophets; the signs of the times; the approaching advent of the Messiah, to reign on the earth, and the important revelations of the Book of Mormon; my heart filled with gratitude to God that He had opened the eyes of my understanding to receive the truth, and with sorrow for the blindness of those who lightly rejected the same, when my attention was aroused by a sudden appearance of a brilliant light which shone around me, above the brightness of the sun. I cast my eyes upward to inquire from whence the light came, when I perceived a long chain of light extended in the heavens, very bright, and of a deep fiery red. It at first stood stationary in a horizontal position; at length bending in the center, the two ends approached each other with a rapid movement, so as to form an exact square. In this position it again remained stationary for some time, perhaps a minute, and then again the ends approached each other with the same rapidity, and again ceased to move, remaining stationary, for perhaps a minute, in the form of a compass; it then commenced a third movement in the same manner, and closed like the closing of a compass, the whole forming a straight line like a chain doubled. It again remained stationary for a minute, and then faded away. I fell upon my knees in the street, and thanked the Lord for so marvelous a sign of the coming of the Son of Man."[80]

These symbols have a biblical precedent. Several architectural instruments were used by heavenly beings in the Old Testament, including the compass, measuring rod, and plumbline. These instruments served as devices of creation as well as allegorical teaching tools (see Proverbs 8:27; Amos 7:7-8; Ezekiel 40:3, 47:3; Zechariah 2:1). The early Christians employed these symbols over many centuries in their artwork. They frequently depicted the Father and the Son in the act of creating the universe with a pair of compasses. They also portrayed scores of biblical characters in white robes that were adorned with the symbol of the square.[81]

Flame

The architect's plans show a design that resembles a flame at the top of the spire. Joseph Smith taught that the glorified Lord dwells "in everlasting burnings," a flame of living light.[82] This heavenly fire was connected with the Lord's house in ancient times. During the dedicatory services of Solomon's Temple, the fires of heaven ignit-

ed and consumed the offerings that had been placed upon the sacrificial altar and then the Lord's radiating glory filled the entire house (see 2 Chronicles 7:1-3; 1 Chronicles 21:26).

As mentioned previously, this holy light of God has been seen in and around the temples of the last days and will be seen again in the future. Perrigrine Sessions recorded that in the morning and evening hours of 3 February 1845, "there was a flame of fire seen by many to rest down upon the [Nauvoo] Temple."[83] Samuel Whitney Richards testified that on 22 March 1846, visions of the future, angels, and the glory of God were seen inside that sanctuary.

> I went to my Seventies Quorum meeting in the Nauvoo Temple. The whole quorum being present consisting of fifteen members. . . . Dressing ourselves in the order of the Priesthood we called upon the Lord, his spirit attended us, and the visions were opened to our view. I was, as it were, lost to myself and beheld the earth reel to and fro and was moved out of its place. Men fell to the earth and their life departed from them, and great was the scene of destruction upon all the face of the land, and at the close thereof, there appeared a great company as it were of saints coming from the west, as I stood with my back passing to the east and the scripture was fulfilled which saith, "Come, see the desolation which the Lord hath made in the earth;" and the company of saints who had been hid as it were, from the earth; and I beheld other things which were glorious while the power of God rested down upon me. Others also beheld angels and the glory of God. . . . The sacrament was administered. Our joy increased by the gift of tongues and prophecy by which great things were spoken and made known to us.[84]

All-Seeing Eye

While engaged in research for this book we made a most interesting discovery. On two of the architectural drawings of the Nauvoo Temple, the all-seeing eye of God is depicted inside the top portion of the arched windows. So far as we know this has never been mentioned before in print. Indeed, we have never heard of it being mentioned before at all.[85]

The all-seeing eye of God is a recurring motif throughout the scriptures,[86] but when Solomon's Temple was dedicated it took on added significance, for the Lord declared: "I have hallowed this house, which thou hast built, to put my name there for ever; and mine eyes and mine heart shall be there perpetually" (1 Kings 9:3; see also 1 Kings 8:29; 2 Chronicles 6:40, 7:15-16). Perhaps, in this light, it is also significant that over the eastern, first-floor pulpits of the Nauvoo Temple was the gold-

en inscription: THE LORD HAS BEHELD OUR SACRIFICE, COME AFTER US.[87]

NOTES

1. "The name of our City (Nauvoo) is of Hebrew origin, and signifies a beautiful situation, or place, carrying with it, also, the idea of rest; and is truly descriptive of the most delightful location" (*CHC*, 4:268). "Nauvoo, a Hebrew term, signifying a beautiful place" (*HC*, 4:121). Joseph Smith presumably learned this word from Joshua Seixas, who was the Hebrew teacher for the School of the Prophets, which was held in the Kirtland Temple. The words *na-avauh* and *nauvoo* can be found in his Hebrew teaching manual. (See Joshua Seixas, Hebrew Grammar, 2d ed., 1834, 111. Compare with James Strong, *Strong's Exhaustive Concordance of the Bible*, Hebrew and Chaldee Dictionary, 75, # 4998 - 5000.)

2. *HC*, 6:196-97, 5 February 1844.

3. Henry Haskell, "Notes of Mr. Quincy's visit to Joseph Smith," Clementis Library, University of Michigan. Josiah Quincy recorded that the Nauvoo Temple was "presumably, like something Smith had seen in vision" (Josiah Quincy, *Figures of the Past from the Leaves of Old Journals* [Boston: Roberts Brothers, 1896], 389).

4. Kate Woodhouse Kirkham, *Daniel Stillwell Thomas Family History*, 30, cited in Joseph Heinerman, *Temple Manifestations* (Salt Lake City: Magazine Printing and Publishing, 1974), 48. Thomas Ford, who was governor of Illinois during Joseph Smith's lifetime, got the impression from the Saints that the Nauvoo Temple "was commenced without any previous plan; and that the master builder, from day to day, during the progress of its erection, received directions immediately from heaven as to the plan of the building" (Thomas Ford, *A History of Illinois from its Commencement As a State in 1814 to 1847* [Chicago: S.C. Griggs & Co., 1854], 404). See also Alexander Davidson and Bernard Stuvé, *A Complete History of Illinois from 1673 to 1873* (Springville: Illinois Journal Co., 1874), 516; Grace Humphrey, *Illinois: The Story of the Prairie State* (Indianapolis: Bobbs-Merrill, Co., 1917), 136.

5. E. Cecil McGavin, *The Nauvoo Temple* (Salt Lake City: Deseret Book, 1962), 196.

6. *JD*, 2:44, 6 April 1853; emphasis added.

7. J. W. Gunnison, *Westminster Review* (London), January 1853, 214. See also *Harper's New Monthly Magazine* (New York), April 1853, 612; Ellen E. Dickinson, *New Light on Mormonism* (New York: Funk & Wagnalls, 1855), 101; Harry M. Beardsley, *Joseph Smith and His Mormon Empire* (Boston: Houghton-Mifflin, 1931), 224.

8. Hugh Nibley, *Temple and Cosmos* (Salt Lake City: Deseret Book and FARMS, 1992), 15.

9. *HC*, 5:1-2, 4 May 1842.

10. *JD*, 8:154-55, 26 August 1860. Receiving the initiatory, endowment, and marriage sealing of the temple does not make one a member of the Church of the Firstborn. This process is only completed when one makes their calling and election sure (*MD*, 109-10, 117-18, 139-40).

11. This imagery of being clothed with the sun should be cross-referenced to Revelation 19:7-9, where the wife, or Bride, of the Lamb is "arrayed in fine linen, clean and white" for the marriage supper, meaning that she is wearing wedding attire. Matthew 22:1-14 speaks of the "wedding garment" worn by all those who attend this feast. The JST for verse 14 adds that those who are called and chosen, or elected, are those who "have on the wedding garment." A young English girl received a vision regarding this subject which she was able to understand only after her conversion. "She

turned to scripture reading. One idea haunted her continually—that of the 'wedding garment,' indeed she really worried and fretted about it and refused to accept the highly spiritualized sectarian version, insisting that it was a veritable garment. After a severe illness of the nature of brain fever, from which she showed some signs of recovery, she had what we would call a vision. Twelve personages entered her room and passed around her bed, following one after another until her bed was surrounded. They each pointed to her as they walked, and the last one, who seemed to be the superior, stretched out his hand and laid it on her head. He told her among other things that they wore the wedding garment; that she should live and go to 'Zion.' He told her what to use for her lame limb and how to use it. And while she gazed at them through the beautiful light that filled the room, they were gone. She was commanded not to tell all that was said to her, but that portion she did tell was considered a dream and accepted as a sure premonition of death. The doctor very much desired to remove the crooked limb as she rallied from her illness, but she clung to her promises and insisted on using what the person in the vision prescribed, and in three months she was able to walk. Being very practical, she did not spiritualize the promise that she should go to Zion, and was ready for the gospel when it came. If any proof or testimony was wanting to convince her that the Zion she had found on earth was that Zion named to her by the heavenly messenger, she had it when in the endowment robes, she beheld the wedding garment worn by the twelve angels" (*Young Woman's Journal*, 2 [March 1891]: 292-93).

12. Emphasis added; Elder George Q. Cannon clarified that the Church of God is a religious organization that is separate and distinct from the political kingdom of God, which will operate during the Millennium (*HC*, 7:382, 8 July 1855). President Brigham Young also said that this Millennial kingdom "grows out of the Church . . . but it is not the Church" (ibid.). See also the comments in *JD*, 11:275.

13. Richard D. Draper, *Opening the Seven Seals: The Visions of John the Revelator* (Salt Lake City: Deseret Book, 1991), 138-39. Two passages in the Doctrine and Covenants bear out this interpretation. First, in the Kirtland Temple dedicatory prayer Joseph Smith compared the restored Church and kingdom of God to the bride seen in John's vision (D&C 109:72-74). Second, in section 78, a revelation on the Order of Enoch and inheriting crowns in the celestial world, the Lord said of his church (vs. 14) and kingdom (vs. 18), "Ye are the church of the Firstborn" (vs. 21; compare with D&C 76:50-70).

14. Wandle Mace, *Autobiography* (1816-48), typescript, 207, Special Collections, Harold B. Lee Library, Brigham Young University, Provo, Utah, cited in Milton V. Backman, Jr., and Richard O. Cowan, *Joseph Smith and the Doctrine and Covenants* (Salt Lake City: Deseret Book, 1992), 135. Three scriptural passages equate Mount Zion, the city of the living God, the heavenly or new Jerusalem, the tabernacle/Holy of Holies, and the Bride (see Hebrews 12:22-23; D&C 76:66-67; Revelation 21:2-3, 9-10). It is on Mount Zion that one finds the Church of the Firstborn. We are told in 1 Nephi 14:18-26 that the vision seen by John the Revelator has been viewed by others. It is therefore possible that when Joseph Smith saw his vision of the Nauvoo Temple he may have seen something similar to that seen by John.

15. *TS*, 1 February 1842, 678. That the Saints were attempting to beautify Nauvoo like "the garden of the Lord" is also mentioned in *The Wasp*, 1 October 1842. Parley P. Pratt likewise compared Nauvoo and Eden (*HC*, 4:511-12).

16. George D. Smith, ed., *An Intimate Chronicle: The Journals of William Clayton* (Salt Lake City: Signature Book and Smith Research Associates, 1991), 205, 11 December 1845. For an insightful article on the Nauvoo Temple, see Lisle G. Brown, "The Sacred Departments for Temple Work in Nauvoo: The Assembly Room and the Council Chamber," *BYUS*, vol. 19, no. 3 (Spring

1979), 360-74.

17. James E. Talmage, *The House of the Lord* (Salt Lake City: Deseret Book, 1968), 83-84.

18. *HC*, 1:336.

19. Stephen D. Ricks and John W. Welch, eds., *The Allegory of the Olive Tree: The Olive, the Bible, and Jacob 5* (Salt Lake City: Deseret Book and FARMS, 1994), 429-30, 464-66. Pages 466-67 discuss the olive branch as a symbol of ancient kings and priests.

20. The writings of several scholars have demonstrated that baptism for the dead was an orthodox early Christian practice. See Hugh Nibley, *Mormonism and Early Christianity* (Salt Lake City: Deseret Book and FARMS, 1987), 100-67; Richard Lloyd Anderson, *Understanding Paul* (Salt Lake City: Deseret Book, 1983), 403-15; Sidney B. Sperry, *Paul's Life and Letters* (Salt Lake City: Bookcraft, 1955), 134-36; Daniel H. Ludlow, ed., *Encyclopedia of Mormonism*, 1:95-97; Robert L. Millet, "Was baptism for the dead a non-Christian practice in New Testament times (see 1 Cor. 15:29), or was it a practice of the Church of Jesus Christ, as it is today?" *Ensign*, August 1987, 19-20.

21. See *WJS*, 49, fn. 1, 15 August 1840.

22. *TPJS*, 179-80, 19 October 1840. From his remarks on another occasion it is clear that Joseph Smith was receiving his information on the practice by revelation: "A few very important things have been manifested to me in my absence respecting the doctrine of baptism for the dead, which I shall communicate to the Saints" (ibid., 260, 31 August 1842).

23. Ibid., 180, 5 January 1841. An interesting and perhaps related manifestation occurred when Abel "was sent down from heaven unto Paul to minister consoling words, and to committ unto him a knowledge of the mysteries of godliness" (ibid., 169, 5 October 1841). "These revelations which are reserved for and taught only to the faithful Church members in sacred temples, constitute what are called the 'mysteries of Godliness'" (Harold B. Lee, *Ye Are the Light of the World* [Salt Lake City: Deseret Book, 1974], 210-11).

24. *TPJS*, 308, 11 June 1843.

25. Ibid., 191, 3 October 1841. At other times the Prophet equated baptism for the dead with becoming a savior on Mount Zion: "those who are baptized for their dead are the saviors on Mount Zion and they must receive their washings and their anointings for their dead the same as for themselves till they are connected to the ones in the dispensation before us and trace their lineage to connect the priesthood again" (*WJS*, 370, 12 May 1844). See also *TPJS*, 223, 15 April 1842.

26. The Prophet provided a description of the temporary wooden font of the Nauvoo Temple (see *HC*, 4:446). In the *Journal History*, 14 January 1845, we read of the permanent font: "There was a font erected in the basement story of the Temple, for the baptism of the dead, and healing of the sick, and other purposes; this font was made of wood, and was only intended for the present use; but it is now removed, and as soon as the stone cutters get through with the cutting of the stone for the walls of the Temple, they will immediately proceed to cut the stone for and erect a font of hewn stone. This font will be of an oval form and twelve feet in length and eight wide, with stone steps and an iron railing; this font will stand upon twelve oxen, which will be cast of iron or brass, or perhaps hewn stone: if of brass, polished; if of iron, bronzed." It is evident from this description that there was a desire to imitate Solomon's temple font. Some members of the Church thought that the twelve oxen might be overlaid with fine gold (*TS*, 4:126).

27. Edward J. Brandt, "Why are oxen used in the design of our temples' baptismal fonts?" *Ensign*, March 1993, 54-55; Emil B. Fetzer, "Could you tell me a little about the history of our temple baptismal fonts? Why are oxen used to support the fonts?" *(New Era*, March 1976, 26-28). Each of the twelve tribes of Israel had their own individual symbol, but only Joseph was represented by

the ox. (See Ellen Frankel and Betsy Platkin Teutsch, *The Encyclopedia of Jewish Symbols* [Northvale, N.J.: Jason Aronson, 1992], 183-85). The "unicorn" of Deuteronomy 33:17 is a mistranslation and should read "wild ox" *(BD,* 786).

28. Joseph is also identified as a "bull" in Louis Ginzberg, *The Legends of the Jews,* 7 vols. (Philadelphia: Jewish Publication Society of America, 1911), 2:147.

29. *DS,* 3:247.

30. O. Odelain and R. Seguineau, *Dictionary of Proper Names and Places in the Bible* (Garden City, N.Y.: Doubleday, 1981), 40.

31. *TPJS,* 197-98, 20 March 1842.

32. Wilford Woodruff, *Collected Discourses,* 5:235-36, 19 October 1896. In what appears to be another recitation of this vision, President Woodruff said, "I saw the resurrection day. I saw armies of men in the first resurrection, clothed with the robes of the Holy Priesthood. I saw the second resurrection. I saw a great many signs that were presented before me, by this personage; and among the rest, there were seen seven lions, as of burning brass, set in the heavens. He [said], 'That is one of the signs that will appear in the heavens before the coming of the Son of Man. It is a sign of the various dispensations'" (*Collected Discourses,* 1:217, 3 March 1889). This vision was seen in 1835.

33. John Taylor Papers, LDS Church Archives, Salt Lake City, Utah, May 1884.

34. Joseph Holbrook Autobiography, typescript, BYU-S, 71-2, BYU Special Collections Library.

35. Joseph Fielding McConkie, "The Heavens Testify of Christ," in Robert L. Millet and Kent P. Jackson, eds., *Studies in Scripture, Vol. 2, The Pearl of Great Price* (Salt Lake City: Randall Book Co., 1985), 239-45. See also Andrew Skinner, "The Book of Abraham: A Most Remarkable Book," *Ensign,* March 1997, 20-21.

36. Letter to the Prophet's brother William Smith, 25 December 1844, cited in N. B. Lundwall, comp., *Temples of the Most High,* collector's edition (Salt Lake City: Bookcraft, 1993), 47. See also 1 Samuel 20:5.

37. Ellen Frankel and Betsy Platkin Teutsch, *The Encyclopedia of Jewish Symbols* (Northvale, N.J.: Jason Aronson, 1992), 113-14.

38. Carol G. Braham, ed., *Random House Webster's Dictionary,* 2d ed. (New York: Ballantine, 1996), 120.

39. Allen W. Read, ed., *Funk & Wagnalls New Comprehensive International Dictionary of the English Language: Encyclopedic Edition* (Chicago: J. G. Ferguson, 1977), 1296. See also *Cassell's New Latin Dictionary* (New York: Funk & Wagnalls, 1968), 600.

40. *HC,* 7:323. A rising sun carved in wood was used to decorate the facade of the first Salt Lake tabernacle and can now be seen in the LDS Church Museum of History and Art. What looks like rising and setting sun designs can also be seen on the Bountiful, Utah, Tabernacle facade.

41. *BD,* 675. Hugh Nibley, "Facsimile No. 1, by the Numbers," *IE,* October 1969, 86-87.

42. Hugh Nibley, *Temple and Cosmos* (Salt Lake City: Deseret Book and FARMS, 1992), 17.

43. The contemporary record is clear: "trumpet stone . . . trumpet stones" (*HC,* 7:388); "two hands holding trumpets" (ibid., 7:434); "trumpet stones" (ibid., 7:324); "two hands holding two trumpets" (*TS,* 5:759). There are also several early accounts of people who visited Nauvoo which identify these objects as trumpets.

44. "The two-axis, symmetric six-pointed star without crossing lines is often a sign for *fixed stars* (as opposed to the planets—wandering stars) and especially for the *pole star*" (Carl G. Liungman, *Dictionary of Symbols* [Oxford: ABC - CLIO, 1991], 318). This connection to the North Star is of interest because the stars that make up the Big Dipper on the Salt Lake Temple are six-pointed.

45. These stars can be seen in the daguerreotype of the temple owned by the Missouri Historical Society. A single star of this variety is also illustrated on one of the architectural drawings produced by William Weeks, which is on display in the LDS Church Museum of History and Art.

46. Several artistic renditions of the Nauvoo Temple have depicted the underhang stars as five-pointed. This is most probably a mistake because the architectural drawings quite distinctly show them as six-pointed.

47. Bruce R. McConkie, "The Promises Made to the Fathers," in Kent P. Jackson and Robert L. Millet, eds., *Studies in Scripture, Vol. 3, The Old Testament* (Salt Lake City: Randall Book, 1985), 60.

48. Carol G. Braham, ed., *Random House Webster's Dictionary*, 2d ed. (New York: Ballantine, 1996), 677.

49. Hugh W. Nibley, *Temple and Cosmos* (Salt Lake City: Deseret Book and FARMS, 1992), 27-29. "Telestial (from the Greek *telos),* which means farthest removed, as distant as you can get" (Hugh Nibley, *Approaching Zion* [Salt Lake City: Deseret Book and FARMS, 1989], 308).

50. John W. Welch, *The Sermon at the Temple and the Sermon on the Mount* (Salt Lake City: Deseret Book and FARMS, 1990), 58-61. See also the material on this same subject in John W. Welch, "New Testament Word Studies," *Ensign*, April 1993, 29-30. The KJV rendering of 1 Corinthians 15:22-24 is perhaps hiding a reference to the three degrees of glory as understood by Latter-day Saints. Only a few verses later (40-41) Paul mentions celestial and terrestrial bodies in the resurrection, but compares them to "one glory of the sun, and another glory of the moon, and another glory of the stars." It is clear that a term is missing from this text. Joseph Smith restored the word *telestial* to this text (JST 1 Corinthians 15:40; D&C 76:96-98). Verses 22-24 also speak of three classes of resurrected beings but this doctrine has been obscured by the translators who inserted the italicized word *cometh* (see *BD*, 708, "Italics"). Without this interjection the verses read: "For as in Adam all die, even so in Christ shall all be made alive. But every man in his own order: Christ the firstfruits; afterward they that are Christ's at his coming. Then the *end*," which in Greek reads *telos*. (See Richard Lloyd Anderson, *Understanding Paul* [Salt Lake City: Deseret Book, 1983], 147, fn. 31).

51. *JD*, 19:361.

52. Allen C. Myers, ed., *The Eerdmans Bible Dictionary* (Grand Rapids: Eerdmans, 1987), 969.

53. G. W. Bromiley, ed., *The International Standard Bible Encyclopedia* (Grand Rapids: Eerdmans, 1979), 1:347. In Facsimile no. 2, figure 5 we see the variation "Hah-ko-kau-beam, the stars."

54. Michael D. Rhodes, "The Joseph Smith Hypocephalus . . . Seventeen Years Later," paper (Provo, Utah: FARMS, 1994), 8. See the extensive analysis of this word in William J. Hamblin, Daniel C. Peterson, and John Gee, "'And I saw the Stars': The Book of Abraham and Ancient Geocentric Astronomy," unpublished manuscript, Brigham Young University, August 1991, 25-45. See also the interesting note by John M. Lundquist, "Was Abraham at Ebla? A Cultural Background of the Book of Abraham," in Robert L. Millet and Kent P. Jackson, eds., *Studies in Scripture, Vol. 2, The Pearl of Great Price* (Salt Lake City: Randall Book Co., 1985), 233.

55. Hugh Nibley, "The Three Facsimiles from the Book of Abraham," 1980, FARMS reprint, 38-39, 71.

56. Ibid., 71.

57. Ibid., 72; Michael D. Rhodes, "The Book of Abraham: Divinely Inspired Scripture," *Review of Books on the Book of Mormon* (Provo, Utah: FARMS, 1992), 4:124; Michael D. Rhodes, "The Joseph Smith Hypocephalus . . . Seventeen Years Later," 8. Joseph Smith translated Jah-oh-eh as "O the Earth," *TS*, 4 (13 November 1843), 373.

58. George V. Wigram, *The New Englishman's Hebrew Concordance* (Peabody, Mass.: Hendrickson, 1984), 1191; W. E. Vine, *Vine's Expository Dictionary of Old and New Testament Words* (Old Tappan, N.J.: Fleming H. Revell Company, 1985), 67.

59. James Strong, *Strong's Exhaustive Concordance of the Bible* (Nashville: Abingdon, 1986), Hebrew and Chaldee Dictionary of the Old Testament, 156.

60. There is at least one witness who said that these particular windows did have painted glass in them, and this would strongly suggest that the stars were indeed used (see Emily A. Austin, *Mormonism, Or Life among the Mormons* [Madison, Wis.: M. J. Cantwell Printer, 1882], 201-02). The Summit County Tabernacle in Coalville, Utah, designed by Truman O. Angell, is the only one of two instances known to the authors where the outline of a downward pointing pentagram was actually incorporated into the round windows of an LDS building. There are, however, many instances of upright five-pointed stars, as well as vertical and horizontal six-pointed stars, being incorporated into the round windows of early LDS meetinghouses and tabernacles. One of the architect's drawings of the Nauvoo Temple facade also shows twelve-pointed stars in the lower round windows although it is unclear if this idea was actually ever incorporated into the building. The twelve-pointed star design does find expression in the intricate grillwork on the doors of the Salt Lake Temple. Regarding the Nauvoo Temple's starstones we have the following: "Elder W[illia]m W. Player put up the first star on the southeast corner of the Temple. Elders Heber C. Kimball and William Clayton were watching the progress of the stone towards its destination: the 'stars' will add much to the beauty of the Temple" (*HC*, 7:401).

61. The model displayed on the temple grounds in Nauvoo shows a smaller version of this modified star surrounding the temple tower. There is, in fact, a stone fragment of what looks like a small version of this type of star in the display case of the Seventies Hall in Nauvoo. Upright five-pointed stars surround the tower of the St. George Temple, so it may be that this was also the case at Nauvoo as the St. George and Nauvoo temples are very close in design. One of the drawings done by William Weeks for the Nauvoo Temple shows the top of a column with what looks like a small version of the modified star attached to it. This may be a representation of the pillars that surrounded the tower or it may represent an interior column. Two physical examples of the morning star design without the elongated ray have survived from the Nauvoo period: (1) A rainspout from a Nauvoo home has this star on it and can be seen in the Nauvoo Seventies Hall display case, and (2) Two outlines of this star are cut out of the back of a sofa that was used inside the Nauvoo Temple (Marilyn Conover Barker, *The Legacy of Mormon Furniture* [Salt Lake City: Gibbs and Smith, 1995], 22).

62. This identification is made in the *Deseret News*, 20 August 1880, and refers to the star symbol that is carved upon the second-story east and west keystones of the Logan Temple. (See Nolan P. Olsen, *Logan Temple: The First 100 Years* [Providence, Utah: Keith W. Watkins and Sons, 1978], 203.) Not far from Logan another star of this same type can be seen on the southern doorway keystone of the Oneida Stake Academy building in Preston, Idaho. The elongated pentagram can be seen on the keystone of the Eagle Gate in Salt Lake City while a group of eighteen wooden, elongated pentagrams surround the Christus statue in the North Visitors' Center on Temple Square.

63. W. W. Phelps published a newspaper called the *Evening and Morning Star* beginning in June of 1832. The planet Venus is both the evening and the morning star. Another paper, begun by Parley P. Pratt in May of 1840, bore the name of the *Millennial Star*. Elder Pratt makes it clear that the Millenial Star and "the day star of the horizon" are one and the same, (vol. 1, no. 1, p. 1). The reasoning for this may be that the thousand years of the Millennium are but one day to the Lord (2 Peter 3:8) and Christ's coming heralds the dawning of this Millennial "day." At a general conference held on 7 March 1840 in New York, several members of the Church joined in singing: "How bright

the morning Star, Spreads its glorious light afar, Kindles up the rising dawn, Of that bright Millennial morn" (*TS*, 1:111). The five-pointed star is an emblem of Venus because this planet appears to trace out a precise pentagram in the heavens during an eight-year period. (See Henry Lincoln, *The Holy Place* [New York: Arcade, 1991], 69.) The Medal of Honor awarded in the various branches of the military consists of an inverted pentagram that represents Venus.

64. *TPJS*, 298-99.

65. *MD*, 109.

66. Marion G. Romney, *CR*, 1 October 1965, 20; emphasis added.

67. The comparison of pre-mortal spirits to "morning stars" (Job 38:7) may have reference to their dwelling in celestial glory. See D&C 128:23 and Isaiah 14:12-14.

68. For the theological background of this title of Christ, see McConkie, *Mortal Messiah*, 1:24-25; *MD*, 106; *DNTC*, 1:88; 3:356, 593.

69. Erastus Snow, *JD*, 20:185, "the dawn of the morning star, or a light shining in a dark place."

70. *Revell Bible Dictionary* (Old Tappan, N.J.: Fleming H. Revell Co., 1990), 659.

71. Leonid Ouspensky and Vladimir Lossky, *The Meaning of Icons* (Boston: Boston Book and Art Shop, 1952), 213.

72. *JD*, 4:333, 31 May 1857.

73. *The Diaries of Perrigrine Sessions*, Diary B, 3 February 1845, Nauvoo, Hancock County, Illinois (Bountiful, Utah: Carr Printing Co., 1967), 44.

74. *The Utah Genealogical and Historical Magazine*, April 1903, 1. A second possible reference to this vision can be found in B. H. Roberts, *The Life of John Taylor* (Salt Lake City: George Q. Cannon and Sons, 1892), 28: "He saw, in vision, an angel in the heavens, holding a trumpet to his mouth, sounding a message to the nations." In a vision given to him in 1833, before he was a member of the Church, Samuel Turnbow saw an angel in the heavens with a trumpet in his hand which he identified as Moroni (*Genealogical and Blessing Book of Samuel Turnbow with a Brief Sketch of his Life, 1804-1876*, 37-41). For the significance of Joseph Smith's reception of the gold plates from Moroni on the Israelite Day of Rememberance, see Lenet Hadley Read, "Joseph Smith's Receipt of the Plates and the Israelite Feast of Trumpets," *JBMS*, vol. 2, no. 2 (Fall 1993), 110-20.

75. *The Diaries of Perrigrine Sessions*, Diary B, 3 February 1845 (Bountiful, Utah: Carr Printing Co., 1967), 44.

76. One early source claims that Joseph Smith saw the angel Moroni wearing temple clothing. "It was while they were living in Nauvoo that the Prophet came to my grandmother, who was a seamstress by trade, and told her that he had seen the angel Moroni with the garments on, and asked her to assist him in cutting out the garments. They spread unbleached muslin out on the table and he told her how to cut it out. She had to cut the third pair, however, before he said it was satisfactory. She told the prophet that there would be sufficient cloth from the knee to the ankle to make a pair of sleeves, but he told her he wanted as few seams as possible and there would be sufficient whole cloth to cut the sleeve without piecing. The first garments were made of unbleached muslin and bound with turkey red and were without collars. Later on the Prophet decided he would rather have them bound with white. Sister Emma Smith, the Prophet's wife, proposed that they have a collar on as she thought they would look more finished, but at first the Prophet did not have the collars on them. After Emma Smith had made the little collars, which were not visible from the outside, then Eliza R. Snow introduced a wider collar of finer material to be worn on the outside of the dress. The garment was to reach to the ankle and the sleeves to the wrist. The marks were always the same" (*Eliza Munson, history*, Ms d4558, #5, 1-2; see also *Eliza Munson, history*, Ms 12506. Both manuscripts found in the LDS Church Archives, Salt Lake City, Utah). Two items of interest may be added

to this account. First, Oliver Granger had a vision of the angel Moroni in 1830 and this angel prophesied to him that the time would come when the saints would wear garments without seams (Augusta Joyce Crocheron, *Representative Women of Deseret* [Salt Lake City: J. C. Graham & Co., 1884], 24). Second, the temple robe worn by the high priest of Israel was seamless (Exodus 28:31-32) and when Christ went to his crucifixion he was wearing a seamless robe (John 19:23).

77. *Thomas Bullock Nauvoo Journal*, August 31, 1845 - July 5, 1846, *BYUS*, vol. 31, no. 1 (Winter 1991), 61. While in England in 1850 Henry Savage saw a vision of angels wearing this type of clothing: "I thought I was in America far over the ocean in the Land of Zion. I seemed to stand at the edge of a wheat field of ripened grain, looking over the field toward the west. The grain was mine and the remarkable thing about it was that while the wheat was uncut and still in the head, there was no chaff covering the kernels, which were white and beautiful. As I gasped in delight upon the beautiful grain, ready to be gathered in, the spirit whispered to me, 'This grain represents your life's labors at the end of your mortal probation.' Just then, my attention was attracted by a sound behind me and I turned about facing the east. There appeared before me a bulletin board set up. On this bulletin board a hand was writing in what seemed like living fire, with the dates thereof. I saw all the principal events in Church history in chronological order, beginning with my birth. When one event was written, it remained long enough for me to read it, then this would disappear and another take its place. Finally it reached the time of the ingathering of the harvest of 1884. The day and the month were shown me as well as the year, but when I came out of the dream or vision, I could only remember the year and that it was harvest time. When I had read this last date my attention was drawn by a sound from the north and I turned around in that direction, and I saw as it were an avenue of light reaching up from my presence into the heavens, and descending in the pillar of light, was a company of glorious beings dressed in white robes with caps on their heads that were different to any other head dress I had ever seen before; yet I had traveled in eastern lands where people wore the turban and the fez. These beings descended and embraced me and the vision closed" (Josephine Savage Jones, ed., *History of Henry Savage*, 1968, 5). A manifestation given to Elizabeth Tyler is also worth repeating here. While talking with the Prophet Joseph Smith she related that she had seen "a man sitting upon a white cloud, clothed in white from head to foot. He had on a peculiar cap, different from any she had ever seen, with a white robe, underclothing, and moccasins. It was revealed to her that this person was Michael, the Archangel. She was sitting in the house drying peaches when she saw the heavenly vision, but the walls were no bar between her and the angel, who stood in the open space above her. The Prophet informed her that she had a true vision, and it was of the Lord. He had seen the same angel several times. It was Michael, the Archangel, as revealed to her" (*JI*, vol. 27, 1892, 93).

78. Nibley, *Temple and Cosmos*, 139-73.

79. Brigham Young "proceeded to contrast their claims, using the Bible for the square, and the Doctrine and Covenants for the compass to circumscribe his merits" (*TS*, vol. 6, no. 5 [15 March 1845], 844).

80. Parley P. Pratt, *Autobiography of Parley P. Pratt* (Salt Lake City: Deseret Book, 1985), 29-31.

81. *Biblical Archaeology Review*, April 1995, 45; Clara Erskine Clement, *A Handbook of Legendary and Mythological Art* (Cambridge: Riverside Press, 1881), 290-91; Maria Gabriel Wosien, *Sacred Dance: Encounter with the Gods* (New York: Avon Books, 1974), 104; Harold Bayley, *The Lost Language of Symbolism* (London: Williams and Norgate, 1912), 1:74; Bernard Goldman, *The Sacred Portal: A Primary Symbol In Ancient Judaic Art* (Detroit: Wayne State University Press, 1966), plate 18; *Encyclopaedia Judaica*, 5:1066; *Bible Review*, August 1996, 37. The symbol of the square is "frequently seen embroidered on the borders of the robes of the sacred personages represented in early

Christian mosaics and frescoes. . . . The precise meaning of these marks has not been satisfactorily determined" (William Smith and Samuel Cheetham, *Dictionary of Christian Antiquities* [New York: Kraus Reprint Co., 1968], 1:709). An example of the gamma mark on a piece of ancient Israelite clothing can be seen in *Biblical Archaeology Review*, vol. 23, no. 1 [January/February 1997], 60. See Nibley, *Temple and Cosmos*, 107-15, for the use of the compass and square as symbols among various ancient cultures.

82. *TPJS*, 347, 361, 367, 372. See Isaiah 33:14-15; Psalm 104:4. One of the names of angels, "seraph," comes from a word root that means "to burn," Frankel and Teutsch, *The Encyclopedia of Jewish Symbols*, 54.

83. *The Diaries of Perrigrine Sessions,* 43.

84. *Journal Book of Samuel Whitney Richards*, Book No. 2, 7-8. In February 1886 the Logan Temple "was flooded from dome to foundation with a blaze of light" two nights in a row because of an assembly of heavenly beings that had gathered there (*The Life of Jonathan Hale*, 170-71, cited in Joseph Heinerman, *Temple Manifestations* [Salt Lake City: Magazine Printing and Publishing, 1974], 87).

85. There is another drawing in the William Weeks collection that shows a large all-seeing eye in the triangular pediment of a Nauvoo building although the building is not the temple.

86. See JST Genesis 7:42; Moses 7:36; Proverbs 5:21, 15:3; Psalm 33:13-14, 18; 34:15; 2 Chronicles 16:9; Jeremiah 32:19; Amos 9:8; Hebrews 4:13; 1 Peter 3:12; D&C 1:1; 121:2, 4, 24; 38:7; 67:2; 2 Nephi 9:44; Jacob 2:10, 15; Mosiah 27:31.

87. *John Pulsipher Diary*, as quoted in N. B. Lundwall, comp., *Temples of the Most High*, collector's edition (Salt Lake City: Bookcraft, 1993), 54. Another source confirms this account (*The Palmyra Courier - Journal*, 22 September 1847). See D&C 97:8, 132:49-50.

CHAPTER 5
The Salt Lake Temple

The symbols that adorn the exterior of the Salt Lake Temple have long been a source of interest to those who view them. This chapter will attempt to provide some relevant information about their origin, history, and meaning, and will also address some of the mythology and misconceptions that occasionally surround them. Before we begin our explanations of these emblems, however, it would be well for the reader to understand a few things about the temple itself. Members of the LDS Church often associate the construction of the Salt Lake Temple with an ancient biblical prophecy that speaks of a temple to be reared in the last days (see Isaiah 2:2-3). It is readily apparent that the early Saints saw a direct connection between this prophecy and the temple they built. What is perhaps less apparent is the seldom told reason for that belief. The first part of this chapter will attempt to draw together the scattered fragments of this fascinating story so that it may be seen as a whole. The remainder of the chapter will then be devoted to examining the symbols that decorate the Lord's hallowed house.

ISAIAH'S TEMPLE PROPHECY

On the night of 21 September 1823 the angel Moroni appeared to the young prophet Joseph Smith and taught him about the role he would play in the great work of the Restoration.[1] During the course of this instruction Moroni quoted many passages of scriptures to the Prophet,[2] among which was the following prophecy derived from a vision shown to Isaiah:

> And it shall come to pass in the last days, that the mountain of the Lord's house shall be established in the top of the mountains, and shall be exalted above the hills; and all nations shall flow unto it.
>
> And many people shall go and say, Come ye, and let us go up to the mountain of the

> Lord, to the house of the God of Jacob; and he will teach us of his ways, and we will walk in his paths: for out of Zion shall go forth the law, and the word of the Lord from Jerusalem. (Isaiah 2:2-3)

Not only did Moroni quote this passage of scripture to the Prophet, but we know that he also "offered many explanations" during this visitation[3] and showed Joseph Smith visions that were related to their conversation.[4] What is more, Wilford Woodruff informs us that at one time the prophet Isaiah himself appeared to Joseph Smith to explain his biblical prophecies.[5] This presents us with the possibility that Joseph Smith knew, very early on, that the Church would one day build a temple in the Rocky Mountains. This may also explain why, as early as the 1830s, the Prophet expressed his desire to gather the Saints to that location.[6] It was known among the membership of the early Church that Joseph Smith planned to establish "a literal Zion . . . [in] the tops of the mountains, in fulfillment of prophecy."[7] If Joseph Smith did indeed know about the Salt Lake Temple before it was built, he was not the only one. Many years before the Saints arrived in the Salt Lake Valley, the Lord showed a vision of this sacred building to Wilford Woodruff, who saw that the temple would be made from cut granite and that he would dedicate it when it was completed.[8]

But the visions concerning the Salt Lake Temple do not end here. After the death of Joseph Smith the responsibility of leading the Church fell upon the shoulders of Brigham Young.[9] Once, when President Young was fasting and praying about the upcoming exodus to the west, the veil of heaven was parted and the following manifestation took place:

> President Young had a vision of Joseph Smith, who showed him the mountain that we now call Ensign Peak, immediately north of Salt Lake City, and there was an ensign [that] fell upon that peak, and Joseph said, "Build under the point where the colors fall and you will prosper and have peace."[10]

Erastus Snow adds some significant information about this vision that may help to clarify its meaning. Elder Snow said that when the pioneers arrived in the Salt Lake Valley, Brigham Young told them that "this was the place he had seen long since in vision; it was here he had seen the tent settling down from heaven and resting, and a voice said unto him: 'Here is the place where my people Israel shall pitch their tents.'"[11] At another time Elder Snow said that when the Saints "reached this land the Prophet Brigham said—'This is the place where I, in vision, saw the ark of the Lord resting; this is the place . . . where the Lord will place his name amongst

his people.'"[12] With these images of the ancient tabernacle of Israel impressed upon his mind, President Young was enabled to see a direct connection between the exodus of the Latter-day Saints and the fulfillment of Isaiah's prophecy.

> Pres[ident] B[righam] Young said that the saying of the Prophets would never be verified unless the House of the Lord be reared in the tops of the mountains and the proud Banner of Liberty wave over the valleys that are within the mountains. . . . [President Young said] "I know where the spot is and I know how to make this flag." Jos[eph Smith] sent the colours and said where the colours settled there would be the spot.[13]

Upon reaching the Salt Lake Valley on 24 July 1847, President Young was shown another vision to confirm that the Saints had arrived at their long-sought destination. During this confirmatory vision the "Spirit of Light" rested down upon the prophet and "hovered over the valley."[14] Wilford Woodruff elaborated that President Young "was enwrapped in vision for several minutes. He had seen the valley before in vision, and upon this occasion he saw the future glory of Zion, and of Israel, as they would be, planted in the valleys of these mountains."[15] In this vision Brigham Young is reported to have seen the valley "peopled and inhabited while it was yet a barren waste—saw it filled with towns and villages—yes, saw it as one great city; and his prophetic vision concerning it has been ratified. . . . Brigham Young beheld it in vision, by the gift of seership, just as Joseph Smith had beheld it previously."[16] It was after this vision had closed that Brigham Young spoke the now-famous words: "This is the right place."[17] In the words of Wilford Woodruff, the Saints who were present on that day "contemplated that not many years [hence] the House of God would stand upon the tops of the mountains."[18]

President Young and seven other Church leaders crossed the valley floor on 28 July 1847 and ascended what is now called Ensign Peak. Upon reaching the summit these elders of Israel hoisted a symbolic banner that represented the ensign of an ancient Israelite prophecy and lifted up their voices to the God of Israel in sacred prayer.[19] Two days later, President Young and a few other men crossed the valley floor once again and stood on what is now Temple Square. Upon reaching this spot the prophet was shown yet another vision. This time he saw the magnificent Salt Lake Temple represented before him. Several years later, at the laying of the cornerstones for the temple, he told the assembled crowd:

> I scarcely ever say much about revelations, or visions, but suffice it to say, five years ago last July I was here, and saw in the Spirit the Temple not ten feet from where we have laid the Chief Corner Stone. I have not inquired what kind of Temple we should build. Why?

Because it was represented before me. I have never looked upon that ground, but the vision of it was there. I see it as plainly as if it were in reality before me.[20]

After this vision had closed, Brigham Young took his cane, struck it into the ground, and proclaimed: "Here we shall build a temple to our God."[21] Elder Wilford Woodruff then took a stake and drove it into the hole made by the President's cane. This spot is said to have become the exact center of the temple.[22]

The cane used by President Young on this occasion had a very interesting history. In Doctrine and Covenants section eight we read that Oliver Cowdery was given a special gift by the Lord.

Now this is not all thy gift; for you have another gift, which is the gift of Aaron; behold, it has told you many things; Behold, there is no other power, save the power of God, that can cause this gift of Aaron to be with you. Therefore, doubt not, for it is the gift of God; and you shall hold it in your hands, and do marvelous works; and no power shall be able to take it away out of your hands, for it is the work of God. And, therefore, whatsoever you shall ask me by that means, that will I grant unto you, and you shall have knowledge concerning it. Remember that without faith you can do nothing; therefore ask in faith. (D&C 8:6-10)

The original version of this revelation, which was printed in the 1833 Book of Commandments, helps to clarify what this gift was. In chapter 7 verse 3 of that book we read:

Now this is not all, for you have another gift, which is the gift of working with the rod: behold, it has told you things: behold there is no other power save God, that can cause this rod of nature, to work in your hands, for it is the word of God; and therefore whatsoever you shall ask me to tell you by that means, that will I grant unto you, that you shall know.[23]

It would appear, therefore, that "the gift of Aaron" refers to the rod of Aaron. In ancient Israel this rod was a symbol of legitimate priesthood authority and was kept inside the Holy of Holies of the tabernacle (Numbers 17:1-10). Elder Anthon H. Lund provides us with the knowledge of how Oliver Cowdery's heavenly gift was connected to the identification of the Salt Lake Temple site.

In the revelation to Oliver Cowdery in May, 1829, Bro[ther B. H.] Roberts said that

the gift which the Lord says he has in his hand meant a stick which was like Aaron's Rod. It is said Bro[ther] Phineas Young got it from [Oliver Cowdery] and gave it to President Young who had it with him when he arrived in this [Salt Lake] valley and that it was with that stick that he pointed out where the Temple should be built.[24]

The cornerstones of the Salt Lake Temple were laid on 6 April 1853. When the chief cornerstone was placed in its southeast position, President Young stood upon it, and proclaimed to those assembled that the building of this temple would fulfill the ancient prophecy of Isaiah, saying:

> It is our unspeakable privilege to stand here this day, and minister before the Lord on an occasion which has caused the tongues and pens of Prophets to speak and write for many scores of centuries which are past. . . . We dedicate this, the South-East Cornerstone of this Temple, to the Most High God. May it remain in peace till it has done its work, and until He who has inspired our hearts to fulfil the prophecies of His holy Prophets, that the House of the Lord should be reared in the "Tops of the Mountains," shall be satisfied, and say, "It is enough."[25]

Elder Parley P. Pratt made it known that during the cornerstone ceremonies he had been allowed to see in vision that the Prophet Joseph Smith, and many other angelic visitors, were standing above the temple's foundation and observing the rites.[26] Exactly forty years following this manifestation, when the temple was dedicated, President Wilford Woodruff revealed that during the services his eyes were allowed to see within the veil. He beheld that Joseph Smith had returned, with many others from the spirit world, to witness the dedication of a prophecy in stone. Among this heavenly host he saw the Savior and the prophet Isaiah.[27]

ORIGIN OF THE TEMPLE SYMBOLS

All of this brings us to the great question. What exactly did Brigham Young see when he beheld the temple in his vision? Did he see the symbols that now decorate its exterior? The available records indicate that what President Young saw was the building itself, but no historical sources suggest that the structure had any more than an elementary symbolism attached to it. After his vision Brigham Young went to the architect's office and drew a very basic sketch of the building's design upon a slate. He explained:

> There will be three towers on the east, representing the President and his two councilors; also three similar towers on the west representing the Presiding Bishop and his two councilors; the towers on the east the Melchizedek priesthood, those on the west the

Aaronic priesthood. The center towers will be higher than those on the sides and the west towers will be a little lower than those on the east end. The body of the building will be between these and pillars will be necessary to support the floors.[28]

When it came time to produce the architectural drawings for the temple Brigham Young offered an interesting invitation. He said that after he had dictated his plans through revelation, personal knowledge, and the assistance of the brethren,

then if "any good man on earth will suggest any improvements, we will receive them and adopt them."[29] This process of creating initial ideas and then carefully refining them can be clearly seen on the many architectural plans that were drafted for this project. President Young's daughter Susa said that he "was fond of symbols, especially when the representations were artistic and had meaning."[30] In his desire to teach silent sermons for ages to come, Brigham Young drew upon the following sources as he endeavored to infuse artistry and symbolic meaning into the towering walls of the House of the Lord:

• **Direct Revelation:** As previously mentioned, Brigham Young was shown a vision of the Salt Lake Temple's structure and he knew that it had a complex of towers that were symbolic of the order of the priesthood. But what about the iconographic emblems that adorn the temple's facade? A comparison between the symbols of the Nauvoo and Salt Lake temples reveals that the emblems adorning the Salt Lake sanctuary are based on those of the Nauvoo Temple.[31] Joseph Smith received a heavenly vision of the Nauvoo Temple, and he also saw some of the symbolic representations that he incorporated into the building's exterior.[32] It could therefore be said that at least some of the symbols found on the Salt Lake Temple are derived from revelation.

• **Personal Knowledge:** Those responsible for perfecting the aesthetics of the Lord's holy house employed their knowledge of scriptures in the cause. Truman O. Angell, the architect of the temple, explained to John Taylor that Brigham Young had selected some of the symbols for the structure only "after [an] intense study of scripture, particularly [the] Old Testament."[33] Indeed, several of the structural and decorative elements of the Salt Lake Temple seem to be derived from the biblical account of Solomon's Temple. Other elements of the temple's design can be seen in the texts of the New Testament, Book of Mormon, Doctrine and Covenants, and Pearl of Great Price.

• **Recommendations:** There are several known instances of recommendations being made for the improvement of the temple's structure and appearance. We will only mention one of them here. There was considerable discussion among the Saints about what type of material should be used to build the massive edifice. Some recommended various types of stone, some brick, adobe, and others wood. Wilford Woodruff had received a revelation many years before the Saints arrived in the Rocky Mountains that it would be built of cut granite. Evidently, he sat by in silence while these deliberations carried on. "Whenever President Young held a council of the brethren of the Twelve," he said, "and talked of building the temple of adobe or brick, which was done, I would say to myself, 'No, you will never do it'; because I

had seen it in my dream built of some other material."[34]

After extensive discussion the matter was voted upon during the October 1852 general conference of the Church. It was unanimously decided that, considering the nature of the task at hand, the Saints would only use "the best materials that [could] be furnished in the mountains of North America."[35] This decision was not without its consequences, however. The plans for the exterior of the temple had been drawn long before it was decided to construct it of solid granite. The plans called for detailed symbolism to be displayed on the facade of the building but granite could not be chiseled in such a detailed manner. It is likely that this is the reason why some of the symbols that were originally planned for the temple were never actually incorporated.[36]

The symbols of the Salt Lake Temple may be understood in several different contexts. First, they may be viewed collectively. It has already been stated in this chapter that the symbols of this temple are a variation of the symbols that once adorned the temple in Nauvoo. From this perspective they have the very same meaning—the temple represents the heavenly Zion. Second, the symbols may be viewed individually. Each symbol is unique, and each has the marvelous ability to teach the eternal truths of the gospel of Jesus Christ. "Every one" of these symbols, said George A. Smith, "conveys a moral lesson, and all point to the celestial world."[37] Third, these emblems may be studied in groups. During the research for this book it was noted that they naturally fall into four distinct categories: (1) Sacred Space, (2) Divine Presence, (3) Restoration, and (4) Cosmology. This is the context that will be explored throughout the remainder of this chapter.

Even though the information that follows is based upon the best sources that are currently available, it is not meant to be authoritative or exhaustive. There are still some aspects of this subject that are not clearly understood, and unless documentation is forthcoming, we may have to await the explanations of those who knew for sure. Nevertheless, we believe that the material presented below is based on sound reasoning and is supported by the scriptures.

SACRED SPACE
The Mountain of the Lord

Mountains are natural symbols of strength, stability, and endurance and typify the living God who is steadfast forever (see Daniel 6:26). As Elder James H. Anderson said, the granite material of the building is as "enduring as the everlasting hills" and therefore "a fitting emblem of the eternal nature of the sacred ordinances to be administered within the Temple."[38] The idea of ascension readily presents itself

to those who look up at the towering spires; as patrons receive the ordinances inside the Salt Lake Temple, they literally and figuratively ascend a holy mount. It was at *Bethel*, a Hebrew word meaning "house of God," that the patriarch Jacob saw angels ascending into the presence of the Lord (see Genesis 28:10-19). Only those with "clean hands, and a pure heart" may "ascend into the hill of the Lord" (Psalm 24:3-4), for it is a "mountain of holiness" (Jeremiah 31:23).[39]

In ancient times the Lord led the nation of Israel to Mount Sinai in order to bring them into his presence. In the valley of the Great Salt Lake the Saints of the last days have literally moved a mountain and refined and beautified it so that they too can be brought into the presence of the Lord.

Cornerstone

The priesthood ceremony of laying temple cornerstones was revealed by the Lord in the days of the Kirtland Temple (see D&C 94:6), possibly to teach the principle that the foundation of the Church and Kingdom of God is the power of the holy priesthood (see Revelation 21:14). The cornerstones of the Salt Lake Temple were laid in their place on 6 April 1853. Twenty-four of the elders of latter-day Israel laid the four cornerstones in a clockwise fashion starting with the southeast corner. According to Brigham Young,

> The First Presidency proceeded to the southeast corner to lay the first stone, though it is customary to commence at the northwest corner—that is the beginning point, most generally, I believe, in the world. At this side of the equator we commence at the southeast corner. We sometimes look for light, you know, brethren. You old men that have been through the mill pretty well, have been inquiring after light, which way do you go? You tell me that you go to the east for light. So we commence by laying the corner stone on the southeast corner, because there is the most light. . . . Now who do we set, in the first place, to lay the chief, the southeast corner stone—the corner from whence light emanates to illuminate the whole fabric that is lighted? We begin with the First Presidency, with the Apostleship, for Joseph commenced always with the keys of the Apostleship, and he, by the voice of the people, presiding over the whole community of Latter-day Saints, officiated in the Apostleship as first President. . . . We set the Bishop at the second corner of the building. The Melchizedek Priesthood, with the altar, fixtures and furniture belonging thereunto, is situated [i]n the east, and the Aaronic Priesthood belongs in the west; consequently the Presiding Bishop laid the second stone. . . . We started at the southeast corner, with the Apostleship; then the lesser Priesthood laid the second stone; we bring them in our ranks to the third stone which the High Priests and Elders laid; we take them under our wing to the northwest corner stone, which the Twelve and Seventies laid, and there again join the Apostleship. It circumscribes every other Priesthood, for it is the Priesthood of Melchizedek, which is after the order of the Son of God.[40]

The temple cornerstone ceremony is related symbolically to the concept of creation because the laying of the stones marks the initial stages of the temple's creation. Similarly, when God created the earth, he is metaphorically said to have measured it out with an architect's line, laid a cornerstone, and established its foundations (see Job 38:4-6). The cornerstone is the first and most important stone that is laid because it establishes the straightness and strength of the foundation. Jesus Christ, the Firstborn, is often referred to in the scriptures as "the rock" or "stone" of Israel and the "cornerstone" of Zion (see Deuteronomy 32:4, 15; 2 Samuel 23:3; Genesis 49:24; D&C 50:44; Isaiah 28:16; 1 Peter 2:6-8). In Ephesians 2:20-22 he is specifically likened unto a temple cornerstone, and his apostles and prophets are said to form the foundation.

Keystones

All of the keystones on the Salt Lake Temple bear a symbol of one type or another except for two. The large, blank keystones on the east and west central towers are rather curious. They are located on the same level as the sunstones and are directly above the all-seeing eye. If we take into account that the keystone is the most important part of an arch and secures everything into place, we can readily see a doctrinal correspondance to it. Elder Erastus Snow said that God has revealed unto us

a new and everlasting covenant, the holy covenant of marriage for time and all eternity. . . . This new and everlasting covenant reveals unto us the keys of the Holy Priesthood and ordinances thereof. It is the grand keystone of the arch which the Lord is building in the earth. In other words, it is that which completes the exaltation and glory of the righteous who receive the everlasting Gospel, and without it they could not attain unto the eternal power and Godhead and fulness of celestial glory.[41]

Joseph Smith taught the Saints that in the "celestial glory there are three heavens or degrees; And in order to obtain the highest, a man must enter into this order of the priesthood (meaning the new and everlasting covenant of marriage); And if he does not, he cannot obtain it" (D&C 131:1-3). It is only in the temples of God that men and women can enter together into this eternal covenant relationship (D&C 132:18-24). The unadorned keystones of the temple may serve to remind us of this vital truth.

Recordstones

There are two recordstones associated with the Salt Lake Temple. The first is a stone box that was filled with a variety of books, pamphlets, historical records, and coins, and placed in the foundation near the southeast corner of the building on 13 August 1857. These items were removed from the stone in 1993, which was the centennial year of the temple.[42] The second recordstone is the capstone upon which the Angel Moroni stands. This stone was put into place on 6 April 1892 and was filled with scriptures, music, various literary works, coins, photographs, and a polished brass plaque inscribed with historical information.[43]

Anciently, the record of Jehovah's covenant with Israel was written upon stone tablets and kept inside the ark of the covenant, which in turn was placed inside the Holy of Holies of the temple (see Exodus 40:20; 25:21). Several different types of records are utilized in latter-day temple work. Joseph Smith directed in Doctrine and Covenants 128:24 that "a book containing the records of our dead" should be kept inside the temple. This genealogical record is at the very core of performing vicarious ordinances on behalf of our ancestors. While being guided through the spirit world by her mother, a woman named Harriet Beals saw the Prophet Joseph Smith helping to prepare vital genealogical records.

> I was very pleasantly surprised to see the Prophet Joseph Smith walking up and down a very long room and he had his hands clasped behind him, his head bowed as though in thought. At long tables on either side of the room and down the center also, many men sat writing as fast as they could and once in awhile the Prophet would stop and speak to one of the men and they would answer then go right on writing as fast as before. Among these men were the Prophet's brother Hyrum, also other men I had known well. . . . I said, "What is the Prophet Joseph and his brother Hyrum, and all the other men doing in there?" She answered, "Preparing genealogy so that the work can be done on earth for those who have died without having the privilege of hearing the gospel themselves."[44]

Because genealogical work is limited by fragmentary information and imprecise records, the Lord will provide means whereby exacting records will eventually be obtained. Elder Orson Pratt provides an insight into how this will be done:

> Here comes in, again, the use of a Temple of the Lord. The Most High says—"I deign to reveal unto you hidden things, things that have been kept hid from the foundation of the world." Among these hidden things that are to be revealed are the books of genealogy, tracing individuals and nations among all people back to ancient times. . . . It may be inquired—"How can all this be done?" We answer, by the Urim and Thummim, which the Lord God has ordained to be used in the midst of his holy house, in his Temple. . . . When

that instrument is restored to the house of God, to the Temple of the Most High, our ancestry, that is, the ancestry of all the faithful in the Church of Jesus Christ of Latter-day Saints, will be made manifest. Not all at once, but by degrees. Just as fast as we are able to administer for them, so the Lord God will make manifest, by the manifestation of holy angels in his house, and by the Urim and Thummim, those names that are necessary, of our ancient kindred and friends, that they may be traced to the time when the Priesthood was on the earth in ancient days.[45]

Another record kept by commandment is that of the various temple ordinances that are performed (see D&C 127:5–9). During an extensive experience beyond the veil Heber Q. Hale learned that "authorized representatives and families in the spirit world have access to our Temple records and are kept fully advised of the work done therein."[46] A worker in the St. George Temple named John Lang had a manifestation that helped him to understand the order of heaven in this regard.

One day while baptismal rites were being performed, I distinctly heard a voice at the east end of the font, very close to the ceiling, calling the names of the dead to witness their own baptism, allowing a moment for each spirit to present itself. After hearing many names called, I noticed a difference in the pronunciation of some of them. It seemed that the spirit who was calling must have a different list [than] ours. I was so impressed at the time that I placed my arm about the shoulders of Bro[ther] W. T. Morris, clerk, who was passing, and called his attention to the sound of the voice, but it was not discernable to him. This occurrence had taken place in March of 1928, and it continued to prey upon my mind for some months, until one day in Oct[ober] I had gone to an upper room of the Temple, as was my custom, to offer secret prayer, asking for the assistance of God in my work, and to thank Him for showing me that there was a recording angel in His house, to keep a perfect record of that which transpired. I had finished my prayer and was about to leave the room when the question flashed through my mind, "But where and how does he get these names? Some of them were not pronounced the same as ours." God knew my thoughts; I never asked of Him to know. The explanation came to me in these words: Every spirit that comes to earth has a guardian angel, whose duty it is to keep a record of the individual's parentage, the conditions under which it was born, its inheritance, environment, thoughts and desires, and when the individual's life is completed, the guardian angel's mission ends. It returns, makes its report and hands in the record it has kept. This record is placed upon the other book, spoken of as The Book of Life." All this gave me to understand that in this other book is preserved the names and perfect dates of every spirit that ever came to earth.[47]

In speaking of the ultimate use to which these records will be put, Elder Orson Pratt explained:

The sacred books kept in the archives of eternity are to be opened in the great judgment day, and compared with the records kept on the earth; and then, if it is found that

things have been done by the authority and commandment of the Most High, in relation to the dead, and the same things are found to be recorded both on earth and in heaven, such sacred books will be opened and read before the assembled universe in the day of judgment, and will be sanctioned by Him who sits on the throne and deals out justice and mercy to all His creations.[48]

Capstones and Terminals

The capstone is an obvious symbol of completion or perfection. When the capstone of the temple was finally laid on 6 April 1892, a special service was held that was attended by many thousands of people. After the completion of the temple President Wilford Woodruff petitioned the Lord, saying: "We pray thee, Heavenly Father, to accept this building in all its parts from foundation to capstone, with the statue that is on the latter placed, and all the finials and other ornaments that adorn

its exterior."[49] In scripture Jesus Christ is identified as the "finisher of our faith," the one who will bring those who persevere with honor to a realization of their full potential in the world to come (see Hebrews 12:2).

A granite sphere sits atop each of the six spires of the temple; on five of these spheres is placed an ornamental terminal. Originally, these terminals were plated with gold and each terminal was fitted with eight large incandescent light bulbs to illuminate the temple.[50] Together with the statue of the Angel Moroni, who was lit by a bulb attached to his crown, they must have provided an inspiring sight—the house of God with its spires all ablaze in golden light against the backdrop of the night sky.

The ornamental terminals have two elements that are paralleled by temple decorations in the time of Jesus Christ. Chains are attached near the center of each terminal to an object that resembles a crown. On the Jerusalem Temple two large golden chains ran vertically up the front part of the building past four golden crowns that were placed above the windows of the porch. These crowns were themselves symbolic of four crowns that the Lord commanded to be fashioned and kept "for a memorial in the temple of the Lord" (Zechariah 6:11-14).[51]

Battlements

A rather striking feature of the Salt Lake Temple is the battlements that are placed along the roofline, towers, and buttresses. This interesting architectural feature gives the temple a decidedly defensive character that might at first seem strangely out of place for a house of God. However, Solomon's Temple also had a "fortress-like quality," which was related to "its capacity as treasury and storehouse."[52] The temple is a place specifically set apart for the Saints to lay up for themselves "a treasure in heaven, yea, which is eternal, and which fadeth not away" (Helaman 5:8).

The battlements also fit better into the overall scheme of the Salt Lake sanctuary when it is remembered that in the Hebrew language the root of the word *temple* means "to separate or withdraw from the profane world."[53] This brings to mind the doctrine of *Zion.* Psalm 48 speaks of the towers and bulwarks of the city of Zion, which provide a refuge for the Lord's people as they worship him in the temple on Mount Zion. In the latter days the Lord has likewise directed that "the gathering together upon the land of Zion, and upon her stakes, [will] be for a defense, and for a refuge from the storm" (D&C 115:6). It is the power of the Lord that provides this respite, for he is our fortress and high tower (see Psalms 46:1, 7, 11; 61:2-4; 62:2, 7; Proverbs 18:10; 2 Samuel 22:2-3). The battlements can thus be seen as a symbol of separation from the world and refuge from the storm, as well as the protection of those holy ordinances that are practiced within the Lord's house.

Statue Niches

Two flights of stairs lead up to two sets of large wooden doors on the east and west ends of the temple. Beside each set of doors is a granite niche. For a number

of years the statues of Joseph and Hyrum Smith, which are now located on Temple Square, occupied the niches on the east end of the building.[54] In biblical times all the entrances to the Jerusalem Temple were carefully guarded by the priests (see 2 Chronicles 8:14), and we read in the book of Revelation that angels guard the entrances leading into the celestial city of God (see Revelation 21:12). The doors of Solomon's Temple had cherubim, or guardian angels, carved upon them (see 1 Kings 6:32, 35), and in the tabernacle built by Moses, these cherubim were sewn directly into the veils (see Exodus 36:35). According to the scriptures those desiring to enter into the presence of the Lord will be required to pass by angelic sentinels (see D&C 132:18-19). Brigham Young taught that it "is absolutely necessary that the Saints should receive the further ordinances of the house of God before this short existence shall come to a close, that they may be prepared and fully able to pass all the sentinels leading into the celestial kingdom and into the presence of God."[55] According to the early brethren these sentinels will include the prophets and apostles of the various dispensations, including the Prophet Joseph Smith.[56]

Samuel Roskelley, who served as the recorder for the Logan Temple, recounted an experience that demonstrates how the Lord, when necessary, will send angelic beings to guard his earthly temples. At one time federal agents threatened to destroy the Logan Temple and confiscate its valuable records. In great distress Brother Roskelley petitioned the Lord to intervene and provide divine protection.

> When Brother Roskelley reached the front door of the temple, there stood two giant men dressed in complete armor, with head dress, breast plate, spears and full regalia. They gave him a friendly nod as he passed, unlocked the door and entered the temple. As he neared his office, there stood two more large men dressed in full armor. And as he went to the record vaults on the third floor, he came to two other huge men, both dressed in full armor. As soon as he was sure the records were safe, he asked who they were. They told him: "We are Nephite Warriors, and we are here in answer to your prayers." They then told him not to worry, that they would not allow the temple to be injured or the records to be destroyed in any way. When Brother Roskelley related the incident to President Taylor, he was told that they were, indeed, Nephite soldiers, and that this was not the first time they had been assigned to protect the temple and its people.[57]

Elder Vaughn J. Featherstone has also expressed the idea that there are "hosts of unseen sentinels watching over and guarding our temples. Angels attend every door. As it was in the days of Elisha so it will be for us. 'Those that be with us are more than they that be against us.'"[58]

Doors

The doors of the Salt Lake Temple bear an interesting resemblance to the ones built for Solomon's sanctuary. Solomon's doors were made of wood, with two leaves and golden hinges, and were carved with palm trees and open flowers (see 1 Kings 6:31-35; 7:50). The doors of the Salt Lake Temple follow this very same pattern. Jesus Christ used the imagery of the door when he taught his followers saying: "I am the door: by me if any man enter in, he shall be saved" (John 10:9). In the Book of Mormon we learn that the "keeper of the gate is the Holy One of Israel; and he employeth no servant there; and there is none other way save it be by the gate; for he cannot be deceived, for the Lord God is his name" (2 Nephi 9:41).

The wood of the temple doors may also serve in a symbolic capacity. The Lord has commanded his servants to beautify his holy houses with wood from "the precious trees of the earth" (D&C 124:26; see also Exodus 25:5; 1 Kings 5:6; 6:32, 34; Isaiah 60:13). The solid oak doors of the Salt Lake Temple may serve to remind us of two important truths. First, obedience to temple ordinances makes it possible for us to regain access to the Tree of Life (see Revelation 2:7; 22:14). Second, the nature of temple sacrifice was changed forever when Jesus Christ wrought out the eternal atonement upon a tree (see Acts 5:30; 1 Peter 2:24).

The golden hinges on the doors of the Salt Lake Temple are shaped like flowering vines. These ornamental features were also used on the temples of ancient Israel. The wooden doors of Solomon's Temple were not only secured with gold hinges but

they also displayed the carvings of open flowers upon them (see 1 Kings 6:32, 35; 1 Kings 7:50). The vine was considered by the ancient Israelites to be one of the symbols of the promised land of inheritance (see Deuteronomy 8:7-8), and in several passages of scripture it is believed to represent the chosen people of Israel.[59] A huge golden grapevine hung above the entrance of the Jerusalem Temple during the time of

Jesus Christ.[60] It is perhaps no coincidence that shortly before the Lord declared that he is "the true vine" and his people are the fruitful branches, he was speaking to the twelve apostles about his Father's house (John 15:1-8; 14:2-3).

The next item of interest on the doors is the bottom panel. The overall design on the panel is a squared-circle. The square is decorated at the corners with deeply carved foliage. Within the square is a set of three concentric circles. The innermost circle contains an intricate vine pattern, in the middle of which is an armorial shield.

On the surface of the shield there is an insignia of intertwined letters, supposedly T - H - E - O - F - L. Though there is no explanation for this symbol found in any known historical source, this cryptic configuration may possibly stand for the phrase: "The House of the Lord."[61]

The doorknob plates are literally covered with symbols. The lower half of the plate is made up almost entirely of floral designs: acanthus leaves, roses, ivy leaves, and various flowers. These patterns immediately bring to mind the lush verdure of the Garden of Eden. Also in this area of the doorplate is a design that resembles a seashell. In a temple context the seashell can be seen as another symbol of paradise because the shell is a sign of water and the Water of Life originates in the garden of the Lord (see Revelation 21:6; 22:1, 17). The shell's placement on the door is of interest because the priests of the Jerusalem Temple were required to ritually cleanse their entire bodies with pure water before they were permitted to pass over the threshold of the temple and serve before the Lord.[62] There is some indication that the Jerusalem Temple at the time of Jesus Christ was decorated with the seashell motif.[63]

There are many other symbols on the upper half of the doorknob plates, including:

• **1853-1893.** These are the years of the beginning and completion of the temple. This forty-year period reminds us that the children of Israel wandered forty years in the wilderness before they entered into the promised land. The early Saints of our dispensation also had their share of wandering, but after enduring the trials of their faith they received tremendous blessings. Whether our trials last forty years or throughout our entire lifetime, we must remember what the Lord has said: "My people must be tried in all things, that they may be prepared to receive the glory that I have for them, even the glory of Zion; and he that will not bear chastisement is not worthy of my kingdom" (D&C 136:31).

• **Wooden Doors.** A miniature entryway is depicted directly behind the doorknob and is decorated with woodlike planks, large hinges, intricate grillwork, and a key-

stone. Temple doors can be seen as symbolic of entry into the courts of heaven. Several scriptures teach us the doctrines associated with this emblem. "The gate of heaven is open unto all, even to those who will believe on the name of Jesus Christ, who is the Son of God" (Helaman 3:28). Nevertheless, "strait is the gate, and narrow is the way, which leadeth unto life, and few there be that find it" (Matthew 7:14). We must therefore "enter in at the strait gate, and continue in the way which is narrow, until [w]e shall obtain eternal life" (Jacob 6:11).

• **Handclasp.** In the top arch of the doorplate is a handclasp enclosed within a circle. The combination of these two symbols can provide a meaningful message. In the Joseph Smith Translation of Genesis 24:9 we learn that the handclasp is one of the symbols of covenant making. The circle, on the other hand, has been looked upon for millennia as a sign representing the concept of eternity (see 1 Nephi 10:19). When brought together in the context of the Lord's house, these two emblems can be interpreted to mean that *temple covenants are meant to endure forever.*

• **Olive Branches.** Two olive branches laden with fruit surround the handclasp design. Throughout the scriptures the house of Israel is compared to an olive tree (see 1 Nephi 15:12, Jacob 5:1-6:1, Romans 11:16-24). The prophet Lehi taught that the branches of the olive tree represent the various groups of this chosen house (see 1 Nephi 10:12-14). Because the olive branches surround the encircled handclasp on the doorplate, one could interpret this entire group of symbols to mean that *only those belonging to the house of Israel may enter into eternal covenants.* Olive wood was so highly valued in ancient Israel that it was used to construct the doors leading into the Holy of Holies of the Jerusalem Temple (see 1 Kings 6:31-33).

• **Holiness to the Lord.** This phrase was engraved upon the golden crown of the chief temple priest in ancient Israel (see Exodus 28:36). It served as a perpetual reminder to the house of Israel that those who would "ascend into the hill of the Lord" and worship in his sanctified courts must do so with "clean hands, and a pure heart" (Psalm 24:3-4). Only in such a state of inner cleanliness is it possible to "wor-

ship the Lord in the the beauty of holiness" (1 Chronicles 16:29) for, as the Psalmist said, "Holiness becometh thy house, O Lord, for ever" (Psalm 93:5).

• **Palmette**. Palm trees decorated the interior of Solomon's Temple (see 1 Kings 6:29); in this context they were symbolic of the Tree of Life.[64] In the Psalms we read that: "The righteous shall flourish like the palm tree. . . . Those that be planted in the house of the Lord shall flourish in the courts of our God" (Psalm 92:12-13). Palm branches are also associated with the Hosanna Shout that is offered up in the temples of God (see John 12:13, Revelation 7:9-10, D&C 109:76).

• **Beehive**. There are twenty-four beehives on the exterior of the temple located either on the doorknobs or on the intricate round medallions that cover the glass windows of the doors. The bee and its hive became part of LDS tradition when the Book of Mormon was translated and Joseph Smith first learned that the Jaredites carried the honey bee with them on their journey to the promised land. The bee is called by the name *deseret* in the Book of Mormon (see Ether 2:3; 1 Nephi 17:5). Although some critics of the Church have supposed that this was just another word created in the imagination of Joseph Smith, *deseret* is actually an Egyptian word that signifies "the Red Crown (*deshret*) of Lower Egypt."[65] This pharaoh's crown had a bee antenna protruding from its top. According to Hugh Nibley,

> In Egypt the bee is, before all else, a sign of royalty. Everyone knows that the oldest title placed before the name of a king was the "insibya," the combined signs of "the sedge and the bee"; but the sedge is a later addition, an emblem of temporal political power, according to recent studies, while the bee-sign originally stood alone as the supreme symbol of sacral primal kingship in Egypt.[66]

There seems to be some type of connection between the bee and the concept of a promised land. The Jaredites brought *deseret,* the honey bee, with them on the long and difficult voyage to their promised land. The land promised to the ancient Israelites was described as a land flowing with milk and honey (see Exodus 3:8, Leviticus 20:24, Deuteronomy 8:7-8, Jeremiah 11:5). This honey was sacrificed as a firstfruits offering on the altar of the Jerusalem Temple (see 2 Chronicles 31:5). The early Latter-day Saints were promised a land of inheritance in Jackson County,

Missouri, and it too was said to be flowing with milk and honey (see D&C 38:18-19). Interestingly, Joseph Smith mentioned that the honey bee played a vital role in beautifying the land of Zion.[67] And, of course, when the Latter-day Saints arrived in the Salt Lake Valley, they named their land of promise *Deseret* and "adopted as their emblem the honey bee and the hive, symbols of industry."[68]

The bee was viewed symbolically in several ancient cultures. For instance, the bee represented "government in good order" among the Hebrews.[69] Perhaps a comparison could be made between bees working in their hive and the temple priests of Israel who labored "according to their order" (1 Chronicles 6:32).[70] The bee was also used as a symbol by the early Christians. Church fathers such as Ambrose, Basil, Jerome, Tertullian, and Augustine all made comparisons between the the life of Jesus Christ and the life of the bee. Some Christians even saw the bee as a symbol of the soul of man.[71]

• The Gates of Heaven: The grandeur of the temple doors and their myriad decorations evoke the words of the patriarch Jacob when he saw the Lord in a vision at Bethel: "This is none other but the house of God, and this is the gate of heaven" (Genesis 28:17). Franklin D. Richards taught that "the Temples, the houses of our God, when acceptably dedicated become to us the gates of heaven."[72] Following are three accounts of prophets in our dispensation who, within the portals of the Salt Lake Temple, have had experiences similar to that of Jacob. The first is a little-known account by John Lee Jones involving President Wilford Woodruff at the temple's dedication.

The twenty one days of meeting in that holy house was truly a feast to the Latter-Day Saints. The Holy Ghost was poured out upon the saints [and they were blessed with] the visit of holy angels in the Temple. Some of the saints had visions, some heard angelic singing from heavenly choirs in the audience room of the Temple. President Wilford Woodruff told some of the saints that our Savior had appeared unto him in the east room in the Holy of Holies, and told him that he had accepted of the Temple and of the dedicatory services, and that the Lord forgave us his saints who had assisted in any manner towards the erection and completion of the Temple—that our sins were forgiven us by the Lord Jesus Christ. He said the light and power of this Temple would be felt all over the earth, that our enemies should not have power over his saints. The Lord is going to give his saints the good things of the earth in greater abundance. Seek for the Spirit of God and we shall triumph, that if the saints would be faithful their sins should be blotted out. A halo of light was seen hovering around the speaker in the Temple. A little boy saw three angels dressed in white and directed his mother's attention to the heavenly vision but she could not see anything. President Woodruff saw the Savior and talked with him face to face.[73]

The second account of the Lord appearing in the temple comes from the pen of Lorenzo Snow's granddaughter Allie Pond. This manifestation occurred when Lorenzo Snow sought divine counsel after the death of President Woodruff.

One evening while I was visiting Grandpa Snow in his room in the Salt Lake Temple, I remained until the doorkeepers had gone and the night-watchman had not yet come in, so Grandpa said he would take me to the main, front entrance and let me out that way. He got his bunch of keys from his dresser. After we left his room and while we were still in the large corridor, leading to the celestial room, I was walking several steps ahead of Grandpa when he stopped me saying: "Wait a moment Allie, I want to tell you something. It was right here that the Lord Jesus Christ appeared to me at the time of the death of President Woodruff. He instructed me to go right ahead and reorganize the First Presidency of the Church at once and not wait as had been done after the death of the previous presidents, and that I was to succeed President Woodruff." Then Grandpa came a step nearer and held out his left hand and said, "He stood right here, about three feet above the floor. It looked as though He stood on a plate of solid gold." Grandpa told me what a glorious personage the Savior is and described His hands, feet, countenance and beautiful white robes, all of which were of such a glory of whiteness and brightness that he could hardly gaze upon Him. Then Grandpa came another step nearer me and put his right hand on my head and said: "Now, grandaughter, I want you to remember that this is the testimony of your grandfather, that he told you with his own lips that he actually saw the Savior here in the Temple, and talked with Him face to face."[74]

A third account is of a vision given to Elder Melvin J. Ballard while he was serving in a missionary capacity.

When I was doing missionary work with some of our brethren, laboring among the

Indians, seeking the Lord for light to decide certain matters pertaining to our work there, and receiving a witness from Him that we were doing things according to His will, I found myself one evening in the dreams of the night, in that sacred building, the Temple. After a season of prayer and rejoicing, I was informed that I should have the privilege of entering into one of those rooms, to meet a glorious Personage, and as I entered the door I saw, seated upon a raised platform, the most glorious Being my eyes have ever beheld, or that I conceived existed in all the eternal worlds. As I approached to be introduced, he arose and stepped towards me with extended arms, and he smiled as he softly spoke my name. If I shall live to be a million years old, I shall never forget that smile. He took me into His arms and kissed me, pressed me to His bosom, and blessed me, until the marrow in my bones seemed to melt! When He had finished, I fell at His feet, and as I bathed them with my tears and kisses, I saw the prints of the nails in the feet of the Redeemer of the world. The feeling that I had in the presence of Him who hath all things in His hands, to have His love, His affection, and His blessings was such that if I ever can receive that of which I had but a foretaste, I would give all that I am, all that I hope to be, to feel what I then felt.[75]

DIVINE PRESENCE
Alpha and Omega Scroll

The Alpha and Omega Scroll is located on each of the center towers of the temple at the level of the moonstones. This symbol consists of three distinct elements. First there is the scroll itself. By comparing two parallel biblical passages, it becomes apparent that the scroll is a symbol of the word of the Lord (see Ezekiel 2:7; 3:1-4; Revelation 10:8-11). The Redeemer's holy words are described as "sweeter than honey" to those who receive them (Psalm 119:103).

The second element is the writing upon the scroll. In pronounced gold lettering are the words of the Lord, proclaiming, "I AM ALPHA AND OMEGA." This

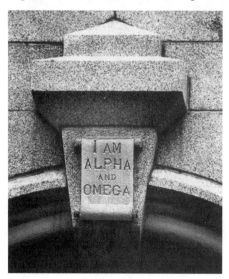

phrase actually consists of two parts. The first two words, "I AM," constitute one of the sacred names of Jehovah (see Exodus 3:13-14). It is most appropriate that these words should adorn this hallowed building because the temple is the place appointed for the name of the Lord to reside (see 2 Samuel 7:13; 1 Kings 8:20; D&C 109:2, 5; 110:7). The third element is the words ALPHA and OMEGA. These are the first and last letters of the Greek alphabet, and they mean, quite literally, "I am Alpha and Omega, the beginning and the end, the first and the last"

(Revelation 22:13). It would appear that this phrase is equivalent to the Lord saying: "Endless is my name; for I am without beginning of days or end of years" (Moses 1:3; see also 7:35; D&C 19:10). Yet another way to express the eternal nature of Jesus Christ would be to say that he is "Alpha and Omega, the beginning and the end, whose course is one eternal round, the same today as yesterday, and forever" (D&C 35:1; see also 76:4; 1 Nephi 10:19). How appropriate that the Lord would speak these words while standing upon the pulpits of the Kirtland Temple immediately before the temple keys of previous dispensations were restored to the earth (see D&C 110:4). The gospel is the same throughout all generations of time, and the words on the temple scroll bear witness to this divine truth.

Handclasp

A pair of clasped right hands can be seen on both the east and west center spires in the top of the arch of the lower windows. The earliest known printed explanation of this symbol is that it represents the "right hands of fellowship" mentioned in Galatians 2:9.[76] The handclasp emblem

is also featured prominently in the garden and celestial rooms of the Salt Lake Temple.[77] The rays of light surrounding the exterior handclasp are quite curious, but when this motif is viewed in a spiritual light it takes on added meaning. At the cornerstone ceremony of the Salt Lake Temple, Bishop Edward Hunter taught that temples provide us with a means of fellowship with those beyond the veil.

> We will build a temple. . . . We will rear a superstructure wherein we can receive the ministrations of angels and holy beings; wherein we can receive instructions, and perform offices for the redemption of our dead, receive keys for the resurrection of the Saints of God, wherein we can meet the spirits of just men made perfect, and again strike hands with the martyred Prophets, Joseph and Hyrum, and all those who have suffered and died for the testimony of Jesus.[78]

In Jeremiah 31:32 the Lord uses the imagery of the handclasp to signify the act of entering into a covenant with him, and in Isaiah 56:4-7 he says that those who "take hold" of his covenant will receive a handclasp from him within the walls of his house on the holy mountain.[79] When Elder Matthew Cowley looked upon this symbol on the Salt Lake Temple, it reminded him of the marriage covenant, which is

sealed by a handclasp over the altar for time and all eternity.[80] The joining together of ten fingers may also be significant in this context because in some ancient Jewish circles the number ten represented completion, wholeness, or perfection, and that is what temple marriage affords to the faithful.[81]

All-Seeing Eye

There are two all-seeing eyes located high atop the center towers of the temple, one on the east end and one on the west. At the dedication of King Solomon's Temple Jehovah promised that his eyes would be upon that place perpetually (see 1 Kings 8:29, 9:3). Called "the all-searching eye of the Great Jehovah" by the early brethren,[82] this emblem represents God's ability to see all things (see D&C 88:41, 130:7). There is some evidence that the eyes were originally painted blue,[83] which could be significant because in ancient Israel blue was the color of royalty and was considered sacred to Jehovah.[84] There may be an even more striking connection, however, for some who have had the privilege of seeing Jehovah in our dispensation

have reported that he has blue eyes. While meeting with the School of the Prophets in Kirtland, Ohio, John Murdock experienced the following:

> In one of those meetings the prophet told us if we could humble ourselves before God, and exercise strong faith, we should see the face of the Lord. And about midday the visions of my mind were opened, and the eyes of my understanding were enlightened, and I saw the form of a man, most lovely, the visage of his face was sound and fair as the sun. His hair a bright silver grey, curled in most majestic form, His eyes a keen penetrating blue, and the skin of his neck a most beautiful white and he was covered from the neck to the feet with a loose garment, pure white, whiter than any garment I have ever before seen. His countenance was most penetrating, and yet most lovely. And while I was endeavoring to comprehend the whole personage from head to feet it slipped from me, and the vision was closed up. But it left on my mind the impression of love, for months, that I never felt before to that degree.[85]

The observer will note that there are rays of light, or "glory," radiating out in all directions from the image of the eye. These radiating beams remind us that God dwells in a place of eternal light, glory, and power, or what Joseph Smith described as "everlasting burnings."[86] According to latter-day revelation, heavenly eyes are said to represent one who is filled with "light and knowledge" (D&C 77:4). If our eye

is single to the glory of God, we too may someday be "filled with light" and comprehend all things (D&C 88:67).

Each of the all-seeing eyes is a right eye and is looking out from behind a veil. The veil on the east side of the temple has a tassel attached to it while the veil on the west side of the building does not. Tassels were worn on the clothing of the ancient Israelites to remind them to live a life of holiness by obeying the commandments of Jehovah and also to mark them as the covenant people (see Numbers 15:37-40). The scriptures indicate that the Lord can see us through the veil that now separates the earthly and heavenly worlds (see D&C 38:7-8). The Psalmist said, "The Lord looketh from heaven; he beholdeth all the sons of men. From the place of his habitation he looketh upon all the inhabitants of the earth. . . . Behold the eye of the Lord is upon them that fear him, upon them that hope in his mercy" (Psalm 33:13-14, 18). The Lord had said that at some future time, "the veil of the covering of [his] temple, in [his] tabernacle, which hideth the earth, shall be taken off, and all flesh shall see [him] together" (D&C 101:23).

Pillars, Compass, and Square

Three symbolic elements that were originally planned for the Salt Lake Temple but never actually incorporated are the pillars, architect's compass, and builder's square. Each of these elements were used in the decorative programs of previous LDS temples. The two pillars hark back to the dedication plaque of the Kirtland Temple, which was flanked by columns; the compass and square motifs are familiar from the spire ornaments of the temple in Nauvoo.

The two pillars immediately bring to mind the brass pillars constructed at the direction of King Solomon to stand at the entrance to the temple of Jehovah (1 Kings 7:13-22; 2 Chronicles 3:17). These two gigantic pillars were called *Jachin* and *Boaz*, symbolic names which mean, respectively, "He will establish" and "In him is strength" (*BD*, 708). These symbolic representations may also serve the faithful as a reminder of the Redeemer's declaration:

> Him that overcometh will I make a pillar in the temple of my God, and he shall go no more out: and I will write upon him the name of my God, and the name of the city of my God, which is new Jerusalem, which cometh down out of heaven from my God: and I will write upon him my new name. (Revelation 3:12)

The compass and square motifs were widely used in symbolic and ritual contexts among the ancient Hebrews and early Christians. On one level they can be seen as symbols of creation. There are a number of early Christian artistic depictions of God the Father or his Son Jesus Christ creating the cosmos with a pair of compasses (see Job 26:9-11; Proverbs 8:27-29). Both the ancient Israelites and the followers of Jesus Christ wore the symbol of the square upon their garments, and the Savior is sometimes depicted in early Christian artwork with a golden square upon his robe. This mark is sometimes also depicted in early Christian mosaics on hangings or veils.[87]

RESTORATION
Angel Moroni

The architectural drawings of the Salt Lake Temple up until 1887 showed that there were to be two Nauvoo-style horizontal angels, one on each center spire, wearing priestly robes and holding a trumpet with one hand and an open book with the other (see D&C 128:20). On 19 August 1891 President Wilford Woodruff and his counselors in the First Presidency accepted the design of a single upright angel to grace the east center tower. Some commentators have expressed their opinion that this angel represents not just one personage but many who were involved in the restoration of the gospel to the earth.[88] While there were indeed many heavenly mes-

sengers involved in the overall process of the restoration,[89] it is still clear that this statue represents the Nephite prophet Moroni.

The world-renowned sculptor Cyrus E. Dallin stated that his specific commission from the First Presidency was to create a statue of the "angel 'Moroni.'"[90] Any remaining doubt about the angel's identity can be resolved by comparing the scripture that served as the inspiration for the Nauvoo Temple angel and a statement made by the Lord himself.

> And I saw another angel fly in the midst of heaven, having the everlasting gospel to preach unto them that dwell on the earth, and to every nation, and kindred, and tongue, and people, saying with a loud voice, Fear God, and give glory to him; for the hour of his judgment is come: and worship him that made heaven,

and earth, and the sea, and the fountains of waters. (Revelation 14:6-7)

> And now, verily saith the Lord, that these things might be known among you, O inhabitants of the earth, I have sent forth mine angel flying through the midst of heaven, having the everlasting gospel, who hath appeared unto some and hath committed it unto man, who shall appear unto many that dwell on the earth.
>
> And this gospel shall be preached unto every nation, and kindred, and tongue, and people.
>
> And the servants of God shall go forth, saying with a loud voice: Fear God and give glory to him, for the hour of his judgment is come;
>
> And worship him that made heaven, and earth, and the sea, and the fountains of waters. (D&C 133:36-39; see also JS-H 1:30-43)[91]

When the Salt Lake Temple was dedicated, many angels were seen visiting the building. On 8 April 1893 for example, President Woodruff reported "seeing a vision of thousands of the Lamanites enter the temple by the door in the west end of the temple and [they] could do as much ordinance work in an hour as the other brethren could do in a day."[92] On the 17th of April, while dedicatory services were still being held, a member of the Tabernacle Choir named Andrew Smith, Jr., witnessed the arrival of many apostles and prophets from the spirit world.

> President George Q. Cannon announced that a certain brother would read the dedicatory prayer. When he did so, I concluded that I would keep my eyes open and look at him instead of closing them as I had done on previous occasions. On reflection I came to the conclusion that I would pay as strict attention to the prayer with my eyes open as I could when I kept them closed. A few moments after the Apostle began to read, a scale seemed to remove from my eyes, and a bright light appeared above his head from behind his shoulders upward. This light remained in that position a few moments and then raised until I could see the face of a personage in the midst of it. It was the countenance of President Brigham Young. I turned my gaze away for a moment, as if to ascertain whether I was looking with my own eyes. On again looking toward the stand I beheld the entire personage of President Young, clothed in robes. He soon retired toward the rear of the stand and disappeared behind President Wilford Woodruff. After he had vanished I again turned my attention to the Elder who was reading, when I saw a light similar to what had appeared previously, and then I beheld the person of President John Taylor, who seemed to be looking towards the reader. I also saw a personage whom I took to be Hyrum Smith, although he appeared to be more square in build than he is represented to be in his pictures; then Orson Pratt, whom I at once recognized; then there were three large men whom I could not identify. There were others of more slender build whom I also failed to recognize. There were, in all, about twelve men whom I saw during the dedicatory prayer. When the prayer was concluded and just before the sacred 'Hosannah' shout, I noticed a bright halo of light surrounding several of the brethren, and the speakers during the same services were seemingly encircled by a brightness which appeared to emanate from their own persons.

While President George Q. Cannon was making the concluding remarks during this session, I was overcome and wept for joy. Having bowed my head for a short time I saw nothing for a few moments. On raising it again I saw a brilliant light over the head of each member of the First Presidency while they sat upon the stand.

Whichever way any of the speakers turned while addressing the people, the light followed every movement made by them.

The number of personages seen by me during the services subsequent to the reading of the dedicatory prayer was about twelve, making as near as I can state, about twenty four in all.

At the afternoon session on the same day I saw several personages, and immediately felt a desire to communicate the information of what I saw to Brother George Kirkman, who was sitting near me. The vision then became dim. I turned to him and told him of those appearances. On directing my gaze once more toward the Mechizedek stand, I could see nothing more, the vision having closed.[93]

• **Trumpet toward the East.** Most often Latter-day Saints see the Moroni statue as a herald of the restoration of the gospel to the earth, and so it is. "The idea conveyed by the statue is that of a herald, or messenger," said Elder James H. Anderson, "in the act of blowing a trumpet, an embodiment of the prophecy of an angel bringing the Gospel to the earth in this latter-day dispensation."[94]

But there is another layer of meaning for us to explore. In his inspired revision of the book of Matthew, the Prophet Joseph Smith clarified several concepts about the Second Coming. We learn, for instance, that "as the light of the morning cometh out of the east, and shineth even unto the west, and covereth the whole earth, so shall also the coming of the Son of Man be . . . for the Son of Man shall come, and he shall send his angels before him with the great sound of a trumpet, and they shall gather together the remainder of his elect from the four winds, from one end of heaven to the other" (JS-M 1:26, 37; see also D&C 29:13, 43:18, 88:94). In vision the prophet Ezekiel saw "the glory of the God of Israel" come from the east and enter the eastern gate of the temple "and, behold, the glory of the Lord filled the house" (Ezekiel 43:1-5; compare 1 Kings 8:10-11, D&C 84:5). Among the early Christians, east was considered the symbolic direction of light, life, and truth.[95]

• **Robe and Crown.** Gilded with twenty-two carat gold, the statue of Moroni is wearing both a robe and a crown.[96] Joseph Smith said that when the angel Moroni appeared to him the first time, he "had on a loose robe of most exquisite whiteness. It was a whiteness beyond anything earthly I had ever seen; nor do I believe that any earthly thing could be made to appear so exceedingly white and brilliant" (JS-H 1:31). The scriptures are consistent in teaching that white robes are symbolic of the

righteousness of the saints (see Psalm 132:9; Isaiah 61:10; Revelation 19:8; 2 Nephi 4:33; 9:14; D&C 29:12; 109:76). A golden crown was worn in the temple precincts by Israel's high priest (see Exodus 28:36) and is a symbol of eternal exaltation, which is often described as "glory" (1 Peter 5:4; Revelation 4:4, 10-11; D&C 20:14; 75:5; 81:6; 88:107; Moses 7:56).

Towers

In Doctrine and Covenants 124:28 the Lord announced that he would restore the fulness of the priesthood and bestow it upon the faithful within the walls of the temple. It will be recalled that when Brigham Young went to the architect's office to make his first drawing of the Salt Lake Temple, he said that the towers on the east side would represent the First Presidency of the Church and the Melchizedek Priesthood while those on the west stood for the Presiding Bishopric and the Aaronic Priesthood (see D&C 107:1-6).[97] After laying the southeast cornerstone, Brigham Young taught the Saints that the Salt Lake Temple would be built strictly for the purposes of the priesthood.[98] Parley P. Pratt, while standing on the northeast cornerstone, explained what some of those purposes were:

> The Lord has appointed a Holy Priesthood on the earth, and in the heavens, and also in the world of spirits; which Priesthood is after the order or similitude of His Son; and has committed to this Priesthood the keys of holy and divine revelation, and of correspondence, or communication between angels, spirits, and men, and between all the holy departments, principalities, and powers of His government in all worlds.
>
> And again—the Lord has ordained that all the most holy things pertaining to the salvation of the dead, and all the most holy conversations and correspondence with God, angels, and spirits, shall be had only in the sanctuary of His holy Temple on the earth, when prepared for that purpose by His Saints; and shall be received and administered by those who are ordained and sealed unto this power, to hold the keys of the sacred oracles of God.[99]

Each tower of the temple has twelve small pinnacles rising from it in three levels. According to Truman O. Angell, these structures are not merely decorative but do in fact have a symbolic meaning. From his explanation it would seem that the pinnacles on the east towers represent the Twelve Apostles while those on the west

stand for the High Council.[100] One scholar has noted that the number twelve is symbolic of the priesthood, and multiples of that number can represent the fulness of the priesthood.[101]

A curious ornament is found atop each of the pinnacles. Since the time of the dedication there has been a myth circulating that these are "flamestones." This is not

so. Elder James E. Talmage correctly identified them as acanthus clusters or buds, and they can be clearly identified as such from the architectural drawings.[102] The connection between these buds and the towers representing the priesthood is most interesting because Aaron's budding rod was a sign of his legitimate priesthood authority (see Numbers 17:1-13). The acanthus plant was used in ancient cultures to decorate temple roofs,[103] and because of its distinctive characteristics it was seen as a symbol of resurrection (see Job 14:7-14) and paradise.[104] One early document even says that acanthus leaves decorated the Table of Shewbread inside the Jerusalem Temple during the time

of Jesus Christ.[105] Acanthus leaves, as a decorative device, are found throughout the interior of the Salt Lake Temple.

Some commentators have claimed that the number of windows on the corner towers of the Salt Lake Temple correspond to the various offices of the Aaronic and Melchizedek priesthoods. There is no indication from historical sources, however, that this interpretation was intended by the original designers. Rather, because the towers on the west end are lower than those on the east, an odd-sized space was left at the top and so the architect planned to place an oval window there instead of an elongated one. Eventually it was decided to simply leave those smaller spaces blank, so now there are five windows on the east corner towers but only four on the west.

Dedication Plaque

The dedication plaque on the central eastern tower has several elements that invite discussion. First, there is the stone used in the construction of the plaque. Heber C. Kimball prophesied that oolite stone from the Manti Temple quarry

would be used to build the Salt Lake sanctuary as well.[106] This stone was in fact used to construct the dedication plaque and also the inner portions of many of the windows.

"Holiness To The Lord" is the first phrase carved into the dedication plaque, and all the lettering is beautifully overlaid with gold. In ancient times this phrase was engraved into the golden crown worn by the chief temple priest in the nation of Israel (see Exodus 28:36; 39:30). These words serve to remind those who desire to participate in temple blessings that they must dedicate themselves to walking in the path of righteousness and exemplifying the Holy One of Israel (see D&C 20:69). Those who worship in the Lord's house can perceive an unmistakable sense of sanctity sur-

rounding them. They ofttimes feel constrained to acknowledge that the consecrated courts they tread are holy indeed (see D&C 109:12-13; Psalm 93:5).

The next line of words on the dedication plaque identify the building as "The House Of The Lord." In the New Testament Jesus Christ said that he had no place "to lay his head" (Luke 9:58). Joseph Smith and Brigham Young stated, respectively, at the cornerstone ceremonies of both the Nauvoo and Salt Lake temples that these buildings were designed to remedy that situation.[107] Another prophet, President Ezra Taft Benson, reiterated this concept at the cornerstone ceremony of the Jordan River Temple, saying that "when the Savior walked this earth, He stated that there was no place to lay His head (see Matthew 8:20). He may have been referring to the fact that in His day there was no temple in the Holy Land which had not been desecrated. Today there are many dedicated temples, hallowed places where the Son of Man may come."[108]

There are two different ways that the Lord can manifest himself to the righteous in his holy house. The first is by the power of the Spirit as expounded by Elder John A. Widtsoe:

> It is a great promise that to the temples God will come, and that in them men shall see God. What does this promised communion mean? Does it mean that once in a while God may come into the temples, and that once in a while the pure in heart will see God there; or does it mean the larger thing, that the pure in heart who go into the temples may there,

by the Spirit of God, always have a wonderful rich communion with God? I think that is what it means to me and to you and to most of us. We have gone into these holy houses, with our minds freed from the ordinary earthly cares, and have literally felt the presence of God. In this way the temples are always places where God manifests himself to man and increases his intelligence. A temple is a place of revelation.[109]

In a revelation given to President John Taylor after the dedication of the Logan Temple the Lord said much the same thing: "And inasmuch as [the temple] shall be preserved pure and not be defiled my presence shall be there, even the power of my Spirit, the gift of the Holy Ghost; which shall be in this house hereafter more fully understood."[110]

Not only does the Lord make himself manifest in his temples through the power of the Spirit, but he also makes personal appearances according to his will. While speaking face to face with Joseph Smith and Oliver Cowdery inside the Kirtland Temple, the Lord of Hosts proclaimed, "For behold, I have accepted this house, and my name shall be here; and I will manifest myself to my people in mercy in this house. Yea, I will appear unto my servants, and speak to them with mine own voice, if my people will keep my commandments, and do not pollute this holy house" (D&C 110:7-8; see also 109:5). According to Elder Bruce R. McConkie, the house of the Lord is the place set apart for such a direct manifestation.[111] We also learn the following from Elder McConkie:

> Now this Lord, whose face has been seen by hosts of the righteous and whose face will yet be seen by multitudes that cannot be numbered, is in our midst from time to time, and we as a people do not see him nearly as often as we should. We are not speaking of him being in our midst in the spiritual sense that he is here by the power of his Spirit. We are speaking of his personal literal presence.[112]

The beginning and ending dates of the temple's construction are the last items on the dedication plaque: April 6, 1853, and April 6, 1893. This forty-year time span is paralleled by the forty years that ancient Israel wandered in the wilderness before entering their land of inheritance (see Numbers 14:26-34). When Wilford Woodruff led the saints into the Salt Lake Temple to dedicate it to the Most High God, some who were present compared it to Joshua leading the children of Israel into the promised land.[113]

The sixth of April is an especially sacred day among Latter-day Saints. Not only was it the day that the Church of Jesus Christ was formally restored to the earth but "apparently Christ was born on the day corresponding to April 6 (D&C 20:1)."[114] There is also a possibility that this was the day of the resurrection of the Redeemer of all mankind.[115]

COSMOLOGY

The astronomical emblems of the temple can be seen from several different perspectives. From the scriptures we learn the purposes of the heavenly bodies: (1) They testify of the creation and the Creator's almighty power to keep them all in their order and assigned orbit; (2) They are timekeepers that determine the occasions for worship in Israel, counting hours, days, weeks, months, and years; (3) They are used by the Lord for signs and wonders such as the Sign of the Son of Man, which will be given before Christ's Second Coming; (4) They provide the earth with light, and because they do so in various degrees, they symbolically represent the three degrees of glory.

The cosmological symbols of the Salt Lake Temple are a variation of the symbols on the temple at Nauvoo, and so on a collective level they represent the heavenly Bride that was seen in vision by the apostle John (Revelation 12:1). These emblems are not arranged in the ascending order of the three degrees of glory (stars, moon, sun) but in their proper cosmological sequence (earth, moon, sun, stars). These symbols can also provide us with a great deal of instruction on the individual level.

Earthstones

The earthstones are located at the base of each buttress and they rest upon the surface of the earth. Truman O. Angell informs us that on the original architectural drawings for the temple, these stones depicted "the different portions of the earth; or such a portion on each one as corresponds with the axis of the earth." The earth was going to be shown rotating around the base of the temple because the symbolic message meant to be conveyed by these stones is that "the Gospel has come for

the whole earth."[116] Because the temple was built of granite, however, the great detail that had been originally planned for the earthstones could not be implemented, and today only semi-spherical pedestals remain.[117]

The earth is called "the footstool of God," which refers to the place upon which a king places his feet while seated upon his throne (Isaiah 66:1; see also Matthew 5:35; 1 Nephi 17:39; 3 Nephi 12:35; D&C 38:17; Moses 6:9, 44; Abraham 2:7). Even though the earth is now a telestial kingdom it is in a transitional state.

This world was first created spiritually by the Father in a celestial sphere. Brigham Young taught that it existed "near the throne of our Father in heaven."[118] When the Son created the earth's physical form it was in a terrestrial condition and remained as such until the Fall of mankind brought about its current telestial state. With the coming of the Millennium this earth will ascend once again to a terrestrial degree of glory and finally, at the end of one thousand years of peace, it is destined to become one of the celestial kingdoms of God (see D&C 77:1; 88:17-20, 25-26).[119]

> The angels do not reside on a planet like this earth; But they reside in the presence of God, on a globe like a sea of glass and fire, where all things for their glory are manifest, past, present, and future, and are continually before the Lord.
>
> The place where God resides is a great Urim and Thummim. This earth, in its sanctified and immortal state, will be made like unto crystal and will be a Urim and Thummim to the inhabitants who dwell thereon, whereby all things pertaining to an inferior kingdom, or all kingdoms of a lower order, will be manifest to those who dwell on it; and this earth will be Christ's.
>
> Then the white stone mentioned in Revelation 2:17, will become a Urim and Thummim to each individual who receives one, whereby things pertaining to a higher order of kingdoms will be made known;
>
> And a white stone is given to each of those who come into the celestial kingdom, whereon is a new name written, which no man knoweth save he that receiveth it. The new name is the key word. (D&C 130:6-11)

The Prophet Joseph Smith provided an interesting insight into this passage when he said that the "Urim and Thummim is a small representation of this globe," meaning the celestialized earth.[120]

Moonstones

Directly above the earthstones the moon is depicted progressing around the temple through its four monthly phases. One of the architectural plans of the Salt Lake Temple show the phases of the moon and their correspondence to the months of the year. The ancient Israelites used the phases of the moon to calibrate their calendar and at the beginning of each month, when the "new moon" was seen, trumpets were blown by the temple priests and certain sacrifices were offered up to Jehovah.[121]

The moon lends itself to several different symbolic interpretations. The phases that the moon passes through are a natural reminder of the various stages of human progression—birth, life, death, and resurrection.[122] The very nature of the moon's phases may also be seen as typical of a temple patron's ritual journey from a state of

darkness to one of light.[123] On some of the early architectural drawings of the Salt Lake Temple, the moon was depicted with a face just like the moonstones that decorated the Nauvoo Temple.

Sunstones

Symbols of the sun are found on the buttresses directly above the moon. Beginning with the very month of the temple's dedication, there has been a myth circulated which states that there are fifty-two rays of light on the sunstones, sup-

posedly representing the fifty-two weeks of the sun's yearly cycle. This is simply not true. There are forty rays of light emanating from each sun and on the original drawings there were even less. It is unclear how this myth began. There is some indication that even after the temple was dedicated a plan was proposed to gild the sunstones with gold and shade the areas in between the rays so that "orbs of golden light" would be seen by those standing below.[124]

The sun is a symbol of the glory of the celestial kingdom and its light is often compared to

the radiant brightness of celestial beings (see Psalm 84:11; Matthew 13:43; 17:2; Revelation 1:16; 19:17; 1 Nephi 1:8-9; JS-H 1:30-32). As an example, the account of Joseph Smith's first vision immediately comes to mind.

> I saw a pillar of light exactly over my head, above the brightness of the sun, which descended gradually until it fell upon me.
>
> It no sooner appeared than I found myself delivered from the enemy which held me bound. When the light rested upon me I saw two Personages, whose brightness and glory defy all description, standing above me in the air. One of them spake unto me, calling me by name and said, pointing to the other—*This is My Beloved Son. Hear Him!* (JS-H 1:16-17)

Cloudstones

High above the sunstones on the east center tower can be seen two "clouds and descending rays of light."[125] It was the original intention of the temple's designers to have cloudstones completely encircle each of the six towers, making eight emblems per tower.[126] The plans were dramatically modified, however, and the two cloudstones that exist today are slightly different from each other. The one on the north side of the tower is carved to represent billowy clouds while the one on the south is flattened out and looks more dense. An early architectural drawing of these symbols shows one of them as black and the other as white, each having a hand-held trumpet descending from them. This is evidently a modified version of the upper part of the Nauvoo Temple's sunstones, which also had hands and trumpets descending from the heavens.[127]

The architect of the Salt Lake Temple did not provide any interpretation for these emblems. Consequently, some writers have expressed their view that they represent the rays of gospel light dispelling the clouds of apostasy and error. Even though it is possible to interpret the cloudstones in this manner, it is preferable to see them in their proper context. First, they must be seen in light of the iconography found on the Nauvoo Temple, where the clouds and trumpets were placed in a cosmological setting. The same is true with the Salt Lake Temple, where the cloudstones are placed above all of the other astronomical emblems. More than anything else, their meaning is hinted at by the hand of the celestial being who holds the trumpet and the correspondence between the shape of each cloud and the architectural drawing which shows that one

of them is white and the other black. When it is remembered that Brigham Young decided on the temple's symbolic program after an intense study of the Old Testament, it is easy to see an exact parallel. Once the temples of ancient Israel were dedicated, they were filled with the "cloud of the Lord," which radiated his glory. During the heavenly manifestations at Mount Sinai, the children of Israel saw this cloud as both dark and bright, and it was accompanied by the blasting of a trumpet (see Exodus 40:34-38; Numbers 9:15; 1 Kings 8:10).

Saturnstones

An examination of the earliest temple drawings reveals that it was initially planned to place representations of the planet Saturn above the sunstones on the north and south walls at the top of each buttress. This planet was to have been surrounded by six-pointed stars, and together these two symbols would have represented the heavenly regions beyond the sun. Elder Orson Pratt, whose observatory was near the southeast corner of the temple, gave lectures on astronomy in 1853 while the temple plans were being prepared. These lectures included a significant amount of material on the planet Saturn, and it is therefore possible that his lectures influenced the placement of this symbol on the temple's facade.[128] In ancient times the planet Saturn was seen as a symbol of both the Covenant People and also of their Messiah.[129] Saturn was also associated anciently with the observance of the Sabbath day.[130]

Because the astronomical symbols of the Salt Lake Temple are arranged in their cosmological order, they may be viewed as keepers of time. The Lord has decreed by law that the heavenly bodies move harmoniously in their appointed courses so that they can serve as reliable indicators of time—minutes, hours, days, weeks, months, and years (Genesis 1:14-18; D&C 88:42-44). The astronomical symbols of the Salt Lake Temple correspond to this pattern. At the base of each buttress is the earth, which, on the original plans, was shown rotating on its axis. One rotation of the earth is equal to a day, but on the plans it is shown rotating several times around the temple, perhaps in one week's time. Next appears the moon, whose four quarters are representative of a full month's time. Above this is the sun, which is used to record the passage of a year. Above them all was to be the planet Saturn. Perhaps the early brethren decid-

ed to include this planet because they saw a correspondence between the very long time it took to make one full revolution through the heavens and the description of Kolob, found in Abraham 3:4-9.

> And the Lord said unto me, by the Urim and Thummim, that Kolob was after the manner of the Lord, according to its times and seasons in the revolutions thereof; that one revolution was a day unto the Lord, after his manner of reckoning, it being one thousand years according to the time appointed unto that whereon thou standest. This is the reckoning of the Lord's time, according to the reckoning of Kolob.
>
> And the Lord said unto me: The planet which is the lesser light, lesser than that which is to rule the day, even the night, is above or greater than that upon which thou standest in point of reckoning, for it moveth in order more slow; this is in order because it standeth above the earth upon which thou standest, therefore the reckoning of its time is not so many as to its number of days, and of months, and of years.
>
> And the Lord said unto me: Now, Abraham, these two facts exist, behold thine eyes see it; it is given unto thee to know the times of reckoning, and the set time, yea, the set time of the earth upon which thou standest, and the set time of the greater light which is set to rule the day, and the set time of the lesser light which is set to rule the night.
>
> Now the set time of the lesser light is a longer time as to its reckoning than the reckoning of the time of the earth upon which thou standest.
>
> And where these two facts exist, there shall be another fact above them, that is, there shall be another planet whose reckoning of time shall be longer still;
>
> And thus there shall be the reckoning of the time of one planet above another, until thou come nigh unto Kolob, which Kolob is after the reckoning of the Lord's time; which Kolob is set nigh unto the throne of God, to govern all those planets which belong to the same order as that upon which thou standest.

A design known as the "squared-circle" is found on each of the towers above the level of the sunstones. For some unknown reason this design has been mistaken by some commentators for the Saturnstones. This is a separate symbol, however. If we consult the original 1854 plans for the temple, we see that the squared-circle emblem was depicted alongside the planet Saturn; both were separate and distinct. Dr. Hugh Nibley has indicated in his writings that the geometric emblems of the circle and the square represent, respectively, the circumference of the heavens and the four quarters of the earth.[131] When these two signs are joined, they form an appropriate symbol for a temple, for it is there that heaven and earth combine.

Starstones

There are three types of five-pointed stars on the Salt Lake Temple: small stars with one point up, small stars with one point down, and large upright stars. As will

be demonstrated in the following section, six-pointed stars represent the fixed stars in the sky, so we may therefore infer that the five-pointed stars are symbolic of something else. Since there is currently no known explanation for why these stars are so arranged, we will propose a logical explanation from facts that are known.

First, we will discuss the large upright stars. Originally it was planned that these stars were to cover all four sides of both the east and west towers for a total of eighty stars. For some unspecified reason it was eventually decided that these stars would only adorn the east towers, and so now there are only forty large stars. Brigham Young often spoke of the superiority of the Melchizedek Priesthood over the Aaronic, stating that this is the reason why the eastern towers are higher than those on the west. Perhaps the stars were omitted from the western towers to reflect the idea that the Melchizedek Priesthood is the "governing" power in the kingdom of God (see Abraham 3:3, 9; Fac. #2, Figure 5).

The small upright and upside-down stars are an interesting puzzle. The original temple plans show a very different arrangement for both these types of stars compared to how they presently appear. This provides a vital clue to understanding these stars. As before mentioned, Truman O. Angell said that the symbols of the Salt Lake Temple were based on the Nauvoo Temple. In the architectural plans it is clear that the upside-down stars that we now see were originally meant to look exactly like those on the Nauvoo Temple, with an elongated point on the bottom. We can therefore safely say that these emblems represent the morning star. The scriptures compare the "sons of God" to "morning stars" (Job 38:7; D&C 128:23). According to Elder McConkie "sons of God" is a title that can only be obtained after reception of the temple ordinances.[132] These stars are found on the keystones above the arched windows and doorways of the main body of the building.

The small upright five-pointed stars are only found on the tower keystones above each of the arched windows. These stars could be interpreted by a combination of symbolic ideas. First, it was determined at the beginning of this chapter that the towers of the temple represent the priesthood. Second, the scriptures often symbolically compare people to stars (see Numbers 24:17; 1 Nephi 1:10). Thus, the combination of these two concepts could be understood to teach that only those people

who attach themselves to the priesthood of God, and partake of the power of godliness through its ordinances, will be enabled to see the face of God and inherit everlasting life (see D&C 84:19-26; Daniel 12:2-3). Such blessings are available only within the walls of the Lord's house.

Big Dipper

High up on the west center tower of the temple we see the constellation Ursa Major, commonly known as the Big Dipper. The seven stars that make up this constellation are six-pointed, a design used for centuries to represent fixed stars in the sky.[133] The Big Dipper has been used for thousands of years as a guide to the traveler and the lost. By following an imaginary line out from the pointer stars of this constellation, one can find the North Star and thus determine his location. To have this particular symbol adorn the temple is most appropriate for, as Hugh Nibley has stated many times, the temple is the place where one takes his "bearings on the universe and in the eternities, both in time and space."[134] The Big Dipper is positioned on the temple's tower so that one may actually follow the pointer stars of this stationary symbol and locate the North Star out in the heavens.

The location of this symbol on a tower that represents the priesthood helps us to better understand Truman O. Angell's explanation that the Big Dipper is meant to teach those who look upon it that "the lost may find themselves by the Priesthood."[135] Elder Benjamin F. Goddard gave a similar explanation in a general

conference address, stating, "As that constellation in the heavens is always pointing unto the north star, so this Temple points unto God, and indicates to the saints that therein they may learn more perfectly how to walk in the way of the Lord, and how to gain an exaltation in His presence."[136] That holy presence, according to some ancient Hebrews, was located near the North Star, "the point around which the constellations turned, where was located the summit of the heavenly mountain and the throne of the Most High" (Isaiah 14:13; Psalm 48:2).[137]

NOTES

1. For insights into the symbolic significance of the autumn equinox to the Israelites, see Lenet Hadley Read, "Joseph Smith's Receipt of the Plates and the Israelite Feast of Trumpets," *JBMS*, vol. 2, no. 2 (Fall 1993), 110-20.

2. Kent P. Jackson, "Moroni's Message to Joseph Smith," *Ensign,* August 1990, 13-16. A more detailed analysis by the same author is published as "The Appearance of Moroni to Joseph Smith," in Robert L. Millet and Kent P. Jackson, eds., *Studies in Scripture, Vol. 2: The Pearl of Great Price* (Salt Lake City: Randall Books, 1985), 348-59.

3. JS-H, 1:29-47 (see v. 41). Moroni also quoted and explained two other scriptures that deal with temples (see Malachi 3:1 and 4:1-6). Almost immediately after the formal organization of the Church, the Lord himself began instructing the Saints on temples (see D&C 36:8, December 1830) and their functions (see D&C 38:32, 2 January 1831).

4. H. Donl Peterson, "Moroni: Joseph Smith's Tutor," *Ensign,* January 1992, 22.

5. Wilford Woodruff, *JD*, 16:266-67. Joseph Smith received "many visits" from angels who held important keys during previous dispensations (*HC*, 4:537; see also D&C 128:20-21). For a list of most of these angels, see Richard C. Galbraith, *Scriptural Teachings of the Prophet Joseph Smith* (Salt Lake City: Deseret Book, 1993), 7. As with Moroni, these ministering angels came to teach the Prophet about the nature and fulfillment of ancient prophecies (see JS-H 1:53-54; *JD*, 16:265). It is possible that these same visitors were among the "many angels" who were present during the First Vision (see H. Donl Peterson and Charles D. Tate, Jr., eds., *The Pearl of Great Price: Revelations from God* [Salt Lake City: Bookcraft and Provo: BYU Religious Studies Center, 1989], 83). If Isaiah were among the angels present during the First Vision, it might explain why the Lord quoted Isaiah's words to the Prophet (see JS-H 1:19; Isaiah 29:13).

6. "From the days of Oliver Cowdery and Parley Pratt on the borders of the Lamanites [1831] Joseph Smith longed to be" in the Rocky Mountains (Thomas Bullock Minutes, 24 September 1848, LDS Church Archives, cited in Ronald K. Esplin, "'A Place Prepared': Joseph, Brigham and the Quest for Promised Refuge in the West," *Journal of Mormon History* 9, [1982], 86). The plan to gather in the Rockies was again brought up by the Prophet in 1832, 1834, 1836, and 1838 (see Lewis Clark Christian, "Mormon Foreknowledge of the West," *BYUS*, vol. 21, no. 4 [Fall 1981], 403-15). See also Paul Thomas Smith, *Prophetic Destiny: The Saints in the Rocky Mountains* (American Fork, Utah: Covenant Communications, Inc., 1996).

7. George J. Adams, speaking at general conference, directly after and at the request of President Joseph Smith, stated that "there shall be a literal Zion established in a literal manner . . . [and] it shall be at the tops of the mountains and all nations shall flow unto it" (Thomas Bullock Minutes, 8 April 1844, cited in Esplin, *"A Place Prepared,"* 96. See also the so-called "Rocky Mountain Prophecy" in *HC*, 5:85. Jonathan Dunham, who was assigned by the Prophet to help prepare for the westward journey, made the similar statement four years earlier that a "new scene of things [is] about to transpire in the west, in fulfilment of prophecy. . . . There is a place of safety preparing for [the Saints] away towards the Rocky Mountains" (Jonathan Dunham letter, ca. 28 August 1840, cited in Esplin, "A Place Prepared," 90). Upon entering the Salt Lake Valley, President Brigham Young said emphatically that the pioneers had "come here according to the suggestion and direction of Joseph Smith" (Thomas Bullock Diary, 27 July 1847, cited in Esplin, "A Place Prepared," 13). Erastus Snow also testified that the Saints had gathered to the Rocky Mountains because God had promised through his servant Joseph Smith that it would be a land of inheritance for them (see *JD*, 16:207, 4 September 1873).

8. *Wilford Woodruff's Journal*, 31 December 1893. Another account of this vision, given by President Woodruff on 1 August 1880, states that he saw that the temple was made out of "cut granite stone" (*JD*, 21:299-300; see also *CR*, April 1893). This vision was received on 6 July 1841 in Boston, Massachuetts (L. John Nuttall papers, Container #4, Letter Press Book #4, Mss. 188, 285, Harold B. Lee Library, Special Collections, Provo, Utah). The Erastus Snow journal entry for 12 April 1893 also mentions a recital of this vision. Wilford Woodruff had another vision of the Salt Lake Temple before the Saints arrived in the Salt Lake Valley. In his journal entry for 13 May 1847 he recorded: "I dreamed last night we had arrived at our journey's end where we built up a stake of Zion. As we came onto the place there was an open vision of a temple presented before me. I asked some brethren that stood by me if they saw it. They said they did not. I gazed upon it and it was glorious. It appeared as though it was built of white and blue stone. The sight of it filled me with joy and I awoke and behold it was a dream" (Scott G. Kenney, ed., *Wilford Woodruff's Journal* [Midvale, Utah: Signature Books, 1983], 3:175). This is significant because Elder Woodruff was with Brigham Young when the President saw a vision of the Salt Lake Temple a few days after the Saints arrived in the Salt Lake Valley.

9. See Brent L. Top and Lawrence R. Flake, "The Kingdom of God Will Roll On: Succession in the Presidency," *Ensign*, August 1996, 22-35, and Ronald K. Esplin, "Joseph, Brigham and the Twelve: A Succession of Continuity," *BYUS*, vol. 21, no. 3 (Summer 1981), 301-41.

10. George Albert Smith, *JD*, 13:85-86, 20 June 1869. On 9 March 1845 Brigham Young dreamed of climbing a mountain with Joseph Smith and discovering the destination of the Saints (Seventies Book B, 9 March 1845, LDS Church Archives). This mountain could be interpreted as Ensign Peak and, hence, this may date the reception of this particular vision. Brigham Young said: J[oseph] S[mith] & myself [had] both seen this place years ago & that is why we [are] here" (Thomas Bullock Minutes, 24 July 1849, LDS Church Archives). John Daniel Thompson McAllister reported that during the groundbreaking for the temple, Brigham Young told the gathered crowd that "he had left Nauvoo, not knowing which way to go, only he had learned by dreams, visions and revelations, that there was a good place in the mountains for the saints" (Andrew Jenson, *Latter-day Saint Biographical Encyclopedia*, 1:334). See the comments by Joseph F. Smith, *JD*, 24:155-56. The ensign or banner on the mountain is mentioned in Isaiah 5:26; 11:10-12; 13:2; 18:3; 49:22; 62:10; Jeremiah 4:6; 51:27; and Zechariah 9:16.

11. *CHC*, 3:279, 25 July 1880. In the scriptures the tabernacle was known as "the tent of the testimony" (Numbers 9:15). The close relationship between the ensign, the temple, and the prophecy of Isaiah is put forward in the LDS Hymn, "High on the Mountain Top."

12. *JD*, 16:207, 14 September 1873. The Jerusalem Temple was considered by the Israelites to be the preeminent place for the Lord's "name" (2 Samuel 7:13, 1 Kings 8:18-19). Heber C. Kimball said that this concept applied to the Salt Lake Temple as well (*JD*, 2:34). To Brigham Young's understanding, the place where the ark of the covenant rested was the place to build the temple (*JD*, 2:29).

13. *John D. Lee Diary*, 13 January 1846, LDS Church Archives, cited in D. Michael Quinn, "The Flag of the Kingdom of God," *BYUS*, vol. 14, no. 1 (Autumn 1973), 105-14. On 15 July 1846 President Young stated that the next temple built after Nauvoo would be located in the Rocky Mountains (Willard Richards Diary, cited in Esplin, "A Placed Prepared," 105).

14. *Manuscript History of Brigham Young*, 23 July 1847.

15. *CHC*, 3:224. President Young stated on 30 June 1867: "The people have hardly commenced to realize the beauty, excellence, and glory that will yet crown this city. I do not know that I will live in the flesh to see what I saw in vision when I came here. I see some things, but a great deal more has yet to be accomplished" (*JD*, 12:94). Wilford Woodruff's contemporary account of this vision

concurs: "While [we were] gazing upon the scene before us, many things of the future concerning the valley were shown to him in a vision" (*Wilford Woodruff's Journal*, 24 July 1847).

16. Orson F. Whitney, *CR*, April 1916, 67. See also Orson F. Whitney, *CR*, October 1910, 52.

17. According to one source Brigham Young struck his cane on the ground and said, "This is the place; this is the place; this is the place" ("An Autobiography of Gilbert Belnap," LDS Church Archives). Wilford Woodruff recalled many years after the event that after the vision had closed President Young said, "It is enough. This is the right place. Drive on" (*Deseret Evening News*, 26 July 1880).

18. Scott G. Kenney, *Wilford Woodruff's Journal* (Midvale, Utah: Signature Books, 1983), 3:234.

19. "Brigham Young, Heber C. Kimball and his associates went up on the hill and toward Ensign Peak which was the name they gave it. . . . While they were up there looking around they went through some motions that we could not see from where we were, nor know what they meant. They formed a circle, seven or eight or ten of them. But I could not tell what they were doing. . . . They hoisted a sort of flag on Ensign Peak. Not a flag, but a handkerchief belonging to Heber C. Kimball, one of those yellow bandana kind" (William C. A. Smoot, *Salt Lake Tribune*, 18 March 1910, 2). Smoot saw this symbolic action as "hoisting an ensign to the world," for such it was represented to be when they unfurled the handkerchief to the breeze at that time. I took it to be emblematic of what should be done later" (Ibid., 27 March 1910, 12).

20. *JD*, 1:133. Another reference to this vision is found in *JD*, 1:27, 14 February 1853, wherein President Young said that he received "a revelation from heaven" and saw the temple before him and knew that was the spot to build the temple. There are several accounts of people who were shown visions of the Salt Lake Temple before its was built. Elder Heber C. Kimball evidently had a vision of the future while in the presence of Amanda H. Wilcox and shared it with her. Elder Kimball reportedly said, "'Next comes the Temple. What do you expect to see there?' I told him that I expected to see the Savior, Joseph, Hyrum and others. He said, 'Have you seen the Temple picture?' I said that I had not. He then put his hand on my shoulder and said, 'Now look.' 'Oh, how white and beautiful,' I exclaimed. He then removed his hand and the vision was gone" (Carol Lynn Pearson, *Daughters of Light* [Provo, Utah: Trilogy Arts, 1973], 56). A patriarch named Galston L. Braley was granted a vision of the future during his conversion to the Church. "I must say that I was an amateur in that kind of thing, but I tackled it anyway, having faith. I seemed to lose track of things about me, and was carried away into a mental state which I haven't a name for. I was transported from where I was, across the broad Kansas plains, deserted and burnt, over the Rocky Mountains and into the valleys occupied then by the Saints. I saw them happy and very busy and somewhat prosperous, as I went about. Then I saw them become very lean. I saw the Church in dire trouble. I saw the leaders of the Church hunted and persecuted. And I went as I saw this. I saw some of them thrown into prison, I saw the Church robbed and hated. Later I saw a change come, a great change. The field became ripe to harvest, there was plenty everywhere; confidence was restored; the Elders went about unmolested; the brethren were no longer in prison. Elders of the Church had political positions thrust upon them and I saw the Church overcome her adversaries, and come into her own. I saw Salt Lake City and her beautiful Temple" (*Deseret News*, Church Section, 3 November 1934, 2, 8). Finally, we have another vision given to a new convert in England. "One remarkable instance I will relate. Ann Chester, whom I baptized just before I went to New Castle, wrote me shortly after that she received a great deal of opposition from her friends and relatives and she wished to have an assurance that she was doing as God desired her to. She therefore asked for a testimony from him. She said that she thought that if anything came to her room she possibly might be frightened and she therefore asked to see something in the clouds. The next day about two o'clock as she was working

by a window there came a cloud which opened like curtains and she beheld an old English church building upon a hill surrounded by a multitude of people in great tumult and confusion. The building took fire and was consumed and then the sea appeared with ships sailing towards a distant land. There was a rapid succession of cities, villages, haystacks, fields, and wood passing like a panorama and then she beheld the mountains and a long line of people with what she called little wheelbarrows winding their way among them. Then she beheld the temple with the sun shining upon it. She came to the valleys the next year and crossed the plains in the first handcart company. Thus she saw in vision at midday the journey which she made the year following" ("Autobiography of Benjamin Ashby," 19, BYU Special Collections Library).

21. *Journal History*, 28 July 1847, LDS Church Archives.

22. Susan Young Gates and Leah D. Widtsoe, *The Life Story of Brigham Young* (New York: Macmillan, 1931), 104-05. Wilford Woodruff adds the following details about this incident: "We walked along until we came to this Temple Block. It was covered with sagebrush. There was no mark to indicate that God intended to place anything there. But while walking along Brother Brigham stopped very suddenly. He stuck his cane in the ground and said, 'Right here will stand the great Temple of our God.' We drove a stake in the place indicated by him, and that particular spot is situated in the middle of the Temple site" (Brian H. Stuy, *Collected Discourses*, 5 vols. [Burbank, Calif.: B.H.S. Publishing, 1988], 2:208, 6 April 1891).

23. Lyndon Cook, *The Revelations of the Prophet Joseph Smith*, 16.

24. Anthon H. Lund Journal, 5 July 1901, LDS Church Archives. Heber C. Kimball also had a rod given to him by the Lord through the Prophet whereby he could receive revelations (Stanley B. Kimball, ed., *On the Potter's Wheel: The Diaries of Heber C. Kimball* [Salt Lake City: Signature, 1987], 65, 85, 93). Wilford Woodruff had a special rod that he wished "to deposit in the most holy and sacred place in the holy temple of God on the consecrated hill of Zion" (*Wilford Woodruff Journal*, 23 August 1844).

25. *JD*, 2:29, 33, 6 April 1853.

26. Ibid., 1:14, 7 April 1853.

27. Andrew Jenson Diaries, 7 April 1893, LDS Church Archives. See the parallel but more detailed remarks by President Woodruff in Archibald F. Bennett, *Saviors on Mount Zion* (Salt Lake City: Deseret Book, 1950), 142-43. This is a stenographic report in which the Savior is said to have personally visited the temple during the dedication. The Erastus Snow journal entry for 12 April 1893 confirms that "the Son of God was with us and attending these services." For a discussion of the angelic visitors that were seen during the dedication see Joseph Heinerman, *Temple Manifestations* (Salt Lake City: Joseph Lyon and Associates, 1974), 125-57.

28. William Ward, *Deseret News*, 16 April 1892. For an idea of what Brigham Young drew for Truman Angell, see the sketch made by William Ward in Paul C. Richards, "The Salt Lake Temple Infrastructure: Studying It Out in Their Minds," *BYUS*, vol. 36, no. 2 (1996-97), 205. In a letter from architect Truman O. Angell to President John Taylor dated 29 April 1886 he stated that the "original design was to represent the greater priesthood with the east end, and the lesser with the west end, therefore the difference in height" (Truman O. Angell, Sr., to President John Taylor, John Taylor Letter File, LDS Church Archives). Several times President Young emphasized that the Salt Lake Temple would be strictly "for the priesthood to meet in and receive instruction in the things of God" (*JD*, 8:202-203, 8 October 1860).

29. *JD*, 1:278, 14 February 1853.

30. Susa Young Gates, *The Life Story of Brigham Young* (New York: Macmillan, 1931), 325.

31. Letter from Truman O. Angell, Sr., to President John Taylor, John Taylor Letter File, LDS

Church Archives, 11 March 1885. The architectural and symbolic similarities between the exterior design of the two buildings can best be seen by comparing their plans side by side.

32. There is an interesting statement by a non-Mormon visitor to Salt Lake which may show a parallel between Joseph Smith's Nauvoo Temple vision and Brigham Young's Salt Lake Temple vision: "The ornamentation of the building is intended to be symbolical of that employed on the celestial courts above. Its plan is already partially developed to Brigham by revelation through an angel, but will be communicated in all its particulars only as required during the progress of the work" (Fitz Hugh Ludlow, *The Heart of the Continent* [1870], 505). This is very much like an earlier statement of Truman O. Angell that the temple was to be "ornamented in many places. The whole structure is designed to symbolize some of the great architectural work above" (*Deseret News*, 17 August 1854).

33. Letter from Truman O. Angell, Sr., to President John Taylor, John Taylor Letter File, LDS Church Archives, 29 April 1886.

34. *JD*, 21:299-300. Other references to this revelation, which occured on two successive nights, can be found in the Abraham H. Cannon Journal, vol. 16, 54-55, BYU Special Collections Library; L. John Nuttall Papers, 7 October 1891, Mss. 188, Container #4, Letter Press Book #4, 285, BYU Special Collections Library; Frederick William Hurst Diary, Fall / Winter, 1892-1893, LDS Church Archives.

35. C. Mark Hamilton, "The Salt Lake Temple: A Symbolic Statement of Mormon Doctrine," in Thomas G. Alexander, ed., *The Mormon People: Their Culture and Traditions* (Provo, Utah: Brigham Young University Press, 1980), 107-108.

36. "Only on one occasion did I suggest a feature of the general design; in the first sketches the windows were set near the outside surface of the walls, I recommended that these be set in a considerable distance, so that the thickness of the walls and the strength of the structure be properly indicated. This was adopted" (William Ward as quoted in *Temple Souvenir Album, April, 1892* [Salt Lake City: Magazine Printing Co., 1892], 5-8).

37. James H. Anderson, "The Salt Lake Temple," *Contributor*, 14 (April 1893): 275. "You will see that the architect has tried to interpret the word of God in the decorations on the building" (David A. Smith, *CR*, October 1921, 141).

38. Anderson, "The Salt Lake Temple," 265.

39. Mount Sinai was set apart as holy ground by a barrier which was set up around it (Exodus 19:12). Many LDS temples are likewise surrounded by an enclosure because they are dedicated and consecrated unto holy purposes.

40. *JD*, 1:133, 135-36. Joseph Smith taught the following about the cornerstone ceremony: "If the strict order of the Priesthood were carried out in the building of Temples, the first stone would be laid at the south-east corner, by the First Presidency of the Church. The south-west corner should be laid next, the third, or north-west corner next; and the fourth, or north-east corner last. The First Presidency should lay the south-east corner stone and dictate who are the proper persons to lay the other corner stones the Melchizedek Priesthood laying the corner stones on the east side of the Temple, and the Lesser Priesthood those on the west side" (*HC*, 4:331).

41. Erastus Snow, *JD*, 24:161, 24 July 1883. The earliest architectural plans show acanthus buds where the blank keystones and keystones with the Alpha and Omega scrolls are now located.

42. Paul C. Richards, "The Salt Lake Temple Infrastructure: Studying It Out in Their Minds," *BYUS*, vol. 36, no. 2 (1996-97), 208.

43. Dean R. Zimmerman, "The Salt Lake Temple," *New Era*, June 1978, 35-36.

44. Cora Anna Beal Peterson, *Biography of William Beal*, 9-10, cited in Duane S. Crowther, *Life Everlasting* (Salt Lake City: Bookcraft, 1967), 102.

45. *JD*, 16:260-61. Perhaps this is the reason why Wilford Woodruff consecrated Joseph Smith's seerstone upon one of the altars of the Manti Temple (*HC*, 6:230).

46. Heber Q. Hale, "A Heavenly Manifestation by Heber Q. Hale, President of Boise Stake of The Church of Jesus Christ of Latter-day Saints," unpublished manuscript, cited in Duane S. Crowther, *Life Everlasting* (Salt Lake City: Bookcraft, 1967), 221.

47. "A Testimony Received by John Mickelson Lang in the St. George Temple in the Year 1928," unpublished manuscript in the possession of Ruth Gregory, Smithfield, Utah, cited in Crowther, *Life Everlasting*, 139. This mention of guardian angels should be understood in light of the comments by Elder Bruce R. McConkie (*MD*, 341-42, 621-22).

48. *JD*, 7:84. See Revelation 20:12; D&C 128:7-8; 132:19. D&C 88:2 also speaks of "the book of the names of the sanctified, even them of the celestial world."

49. *The Contributor*, April 1893, vol. 14, no. 6, 294. Joseph Smith taught that the "spirit of Elias is first, Elijah second, and Messiah last. Elias is a forerunner to prepare the way, and the spirit and power of Elijah is to come after, holding the keys of power, building the Temple to the capstone, placing the seals of the Melchizedek Priesthood upon the house of Israel, and making all things ready; then Messiah comes to His Temple, which is last of all" (*TPJS*, 340).

50. Raynor, *The Everlasting Spires*, 145.

51. Joseph Patrich, "Reconstructing the Magnificent Temple Herod Built," *Bible Review*, October 1988, 25.

52. Truman G. Madsen, ed., *The Temple in Antiquity: Ancient Records and Modern Perspectives*, Provo, Utah: BYU Religious Studies Center, 1984), 149, fn. 19. A battlement-like structure may have also been placed along the roofline of the temple built by Herod. For an illustration see Joseph Patrich, "Reconstructing the Magnificent Temple Herod Built," *Bible Review*, October 1988, 28.

53. Donald W. Parry, ed., *Temples of the Ancient World*, 416.

54. James E. Talmage, *The House of the Lord* (Salt Lake City: Deseret Book, 1968), 151.

55. *JD*, 12:163. Brigham Young taught this principle on many occasions stating that we must learn the "laws and ordinances, by which we can be prepared to pass from one gate to another, and from one sentinel to another, until we go into the presence of our Father and God" (*JD*, 2:139); "You may receive the endowments in store for you, and possess the keys of the eternal Priesthood, that you may receive every word, sign and token, and be made acquainted with the laws of angels, and of the kingdom of our Father and our God, and know how to pass from one degree to another, and enter fully into the joy of the Lord" (*JD*, 2:315); "Those who are counted worthy to dwell with the Father and the Son have previously received an education fitting that society; they have been fully acquainted with every password, token and sign, which has enabled them to pass the porters through the door into the celestial kingdom" (*JD*, 10:172); "Your endowment is, to receive all those ordinances in the house of the Lord, which are necessary for you, after you have departed this life, to enable you to walk back to the presence of the Father, passing the angels who stand as sentinels, being enabled to give them the key words, the signs and tokens, pertaining to the holy Priesthood, and gain your eternal exaltation in spite of earth and hell" (*JD*, 2:31).

56. George Q. Cannon, *JD*, 23:360-61, 29 October 1882: "although Joseph had gone behind the veil he stood at the head of this dispensation If we get our salvation we shall have to pass by him; if we enter into our glory it will be through the authority that he has received. We cannot get around him." According to Brigham Young "no man in this dispensation will enter the courts of heaven, without the approbation of the Prophet Joseph Smith, Jun[ior]. Who has made this so? Have I? Have this people? Have the world? No; but the Lord Jehovah has decreed it. If I ever pass into the heavenly courts, it will be by the consent of the Prophet Joseph. If you ever pass through the gates

of the Holy City, you will do so upon his certificate that you are worthy to pass. Can you pass without his inspection? No; neither can any person in this dispensation, which is the dispensation of the fulness of times. In this generation, and in all the generations that are to come, every one will have to undergo the scrutiny of this Prophet" (*JD*, 8:224). See also Brigham Young's comments in *JD*, 4:271-72; 5:331-32.

57. Nolan P. Olsen, *Logan Temple: The First 100 Years* (Providence, Utah: Keith W. Watkins and Sons, Inc., 1978), 171-72.

58. Elder Vaughn J. Featherstone, "Come Up to the Temples of the Lord," A Temple Statement for Utah South Area, unpublished manuscript, April 1987, 1 page.

59. *BD*, 787.

60. Joseph Patrich, "Reconstructing the Magnificent Temple Herod Built," *Bible Review*, October 1988, 21, 24.

61. Allen H. Barber, *Celestial Symbols* (Bountiful, Utah: Horizon, 1989), 152-53.

62. Alfred Edersheim, *The Temple: Its Ministry and Services*, updated edition (Peabody, Mass.: Hendrickson, 1994), 112-13.

63. See the commentary and illustrations in M. Avi-Yonah, "The Facade of Herod's Temple: An Attempted Reconstruction," in Jacob Neusner, ed., *Religions in Antiquity* (Leiden: E. J. Brill, 1968), 33-35. The door hardware of the Manti Temple is covered with symbolism of great significance (See Hugh Nibley, "Decorative Hardware with Intricate Meanings," in Victor J. Rasmussen, *The Manti Temple Centennial: 1888-1988* [Provo, Utah: Community Press, 1988], 33-36).

64. John Strange, "The Idea of Afterlife in Ancient Israel: Some Remarks on the Iconography in Solomon's Temple," *Palestine Exploration Quarterly*, 1985, 17:36. At the laying of the Salt Lake Temple's cornerstones, Brigham Young made this remark regarding paradise: "The Lord wished us to gather to this place, he wished us to cultivate the earth, and make these valleys like the Garden of Eden . . . and build a temple (*JD*, 1:277, 14 February 1853).

65. Manfred Lurker, *The Gods and Symbols of Ancient Egypt* (London: Thames and Hudson, 1974), 44.

66. Hugh Nibley, *Abraham in Egypt* (Salt Lake City: Deseret Book, 1981), 226. See "The Deseret Connection" on pages 225-57 of this book. The Egyptian *tj.t dsr.t* "denotes kings and gods, 'especially with reference to their position in the Temple,'" 241; "the Egyptians draw a bee to represent the king," 253, fn. 26. See also Stephen Parker, "Deseret," in Daniel H. Ludlow, ed., *Encyclopedia of Mormonism* (New York: Macmillan, 1992), 1:370-71. Elder McConkie tied together the ideas of royalty and the temple when he wrote that: "Holders of the Melchizedek Priesthood have power to press forward in righteousness, living by every word that proceedeth forth from the mouth of God, magnifying their callings, going from grace to grace, until through the fulness of the ordinances of the temple they receive the fulness of the priesthood and are ordained *kings and priests*. Those so attaining shall have exaltation and be kings, priests, rulers, and lords in their respective spheres in the eternal kingdoms of the great King who is God our Father" (*MD*, 425). "Those who endure in perfect faith, who receive the Melchizedek Priesthood, and who gain the blessings of the temple (including celestial marriage) are eventually ordained *kings and priests*. These are offices given faithful holders of the Melchizedek Priesthood, and in them they will bear rule as exalted beings during the millennium and in eternity," (Ibid., 599). See also ibid., 424, 594, and 613.

67. *HC*, 1:197, 2 August 1831.

68. George Albert Smith, *Sharing the Gospel with Others* (Salt Lake City: Deseret News Press, 1948), 134.

69. Steven Olderr, *Symbolism: A Comprehensive Dictionary* (London: McFarland & Co., 1986),

10. Along these same lines Heber C. Kimball said that the land of Deseret was the Kingdom of God on the earth and was "organized after the order of God, and it is organized after the order of the Church of the Firstborn" (*JD*, 5:130, 2 August 1857).

70. For a number of years there has been a claim circulated in LDS literature that the ancient Hebrew temple priests wore the symbol of the beehive on their sacred clothing. Each of those who have made this claim have stated that this information can be found in the *Mishnah* but a specific reference has never been cited. So far as can be determined, no such reference exists. It is possible that this misunderstanding occurred when someone misread the material found in E. Cecil McGavin, *Mormonism and Masonry* (Salt Lake City: Stevens and Wallis, 1947), 66-67.

71. Hilda M. Ransome, *The Sacred Bee* (Boston: Houghton Mifflin, 1937), 144-54.

72. *JD*, 25:231.

73. *Biography of John Lee Jones*, 147-48, 6 April 1893. There are two other accounts of these three angels, one of which states that they, and other angels who were seen, were all wearing temple robes. "George Monk, of Payson, a boy 11 years of age, accompanied his mother and grandmother to one of the dedication services. He saw a spiritual personage at the southeast circular window, looking into the hall. He called his mother's attention to the man, but she did not see him. Then he asked her to look at two others whom he saw floating across the upper part of the room and standing on the gallery railing. Five others entered through the southeast window in the gallery, and seated themselves on the wide ledge under the windows. But neither the mother nor grandmother saw them. When John Henry Smith was pronouncing the benediction, the boy said to his mother, 'Mamma, look at the one standing under the clock; he is the prettiest of them all. See! he is holding up both hands like this,' at the same time holding his own hands up in illustration. The mother and grandmother heard what the boy was telling them, and noted the look of ecstacy on his face, but they did not see what he evidently beheld. He stated that all those heavenly beings whom he saw were dressed in beautiful white clothing, and his description corresponded with what we know as Endowment Robes. He said that they were all very beautiful men, with wavy hair, but the one who stood on the canopy above the Melchizedek stand was the grandest. Duncan M. McAllister heard the boy relate all this, seated in the same place that he occupied on the occasion of the dedication, and all of us who heard him felt sure that he told the truth. The grandmother heard an unseen choir of angels singing, on that occasion, but the boy did not hear it" (Newel K. Young, *Lesson Book For The Ordained Teachers: No. 1, Some Of Life's Discoveries* [Salt Lake City: Presiding Bishopric of the LDS Church, 1934], 71-72).

74. Quoted in LeRoi C. Snow, "Remarkable Manifestation to Lorenzo Snow," *Deseret News*, 2 April 1938, 8.

75. Bryant S. Hinckley, *Sermons and Missionary Service of Melvin Joseph Ballard* (Salt Lake City: Deseret Book, 1949), 156.

76. James H. Anderson, "The Salt Lake Temple," 277. This interpretation, given in 1893, is the first known because Truman O. Angell did not mention the handclasp in his published articles of 1854 and 1874. The next most official interpretation of the handclasp comes in a 1912 article copyrighted by President Joseph F. Smith. In this article it is said that: "The Clasped Hands are emblematic of the strong union and brotherly love characteristic of Latter-day Saints, through which they have been enabled to accomplish so much both at home and abroad" (D. M. McAllister, *A Description of the Great Temple*, illustrated edition [Salt Lake City: Bureau of Information, 1912], 10).

77. Jay M. Todd, "In His Holy House," *Ensign*, March 1993, 34-35, 38-39.

78. *JD*, 2:38, 6 April 1853. The contents of D&C 129 would have an especially pertinent appli-

cation in these circumstances. "I expect to strike hands and embrace my friends who have gone before, who have proved themselves faithful and true" (John Taylor, *JD*, 18:313, 31 December 1876).

79. The KJV of this passage is a disputed translation. Verse 5 could read: "I shall give to them in my house and in my walls a hand and a name" (Edward J. Young, *The Book of Isaiah* [Grand Rapids, Mich.: Eerdmans, 1972], 3:388, 392). See also the important material discussed under the heading 'Names, Signs, and Seals' in Hugh Nibley's article "On the Sacred and the Symbolic" in Parry, ed., *Temples of the Ancient World*, 557-59. In one ancient document the Lord commands an angel saying: "Give to the Man Adam your hand, and covenant with him by law" (Hugh Nibley, *Enoch the Prophet* [Salt Lake City: Deseret Book and FARMS, 1986], 145-46). See the extensive article by Todd M. Compton, "The Handclasp and Embrace as Tokens of Recognition" in John M. Lundquist and Stephen D. Ricks, eds., *By Study and Also By Faith*, 2 vols. (Salt Lake City: Deseret Book and FARMS, 1990), 1:611-42. A Christian ivory carving from about 400 A.D. shows Jesus Christ ascending into heaven after his resurrection by grasping a right hand that is being offered to him through what looks like a veil (Beverly Moon, ed., *An Encyclopedia of Archetypal Symbolism* [Boston: Shambhala, 1991], 458).

80. *CR*, October 1952, 26-27.

81. Frankel and Teutsch, *The Encyclopedia of Jewish Symbols*, 173-74.

82. Brigham Young, *JD*, 2:32, 6 April 1853; Orson Hyde, *JD*, 2:84, 6 October 1854.

83. Richard Neitzel Holzapfel, *Every Stone A Sermon* (Salt Lake City: Bookcraft, 1992), 116, fn. 9.

84. G. W. Bromiley, ed., *The International Standard Bible Encyclopedia* (Grand Rapids, Michigan: Eerdmans, 1979), 1:731. Jehovah's throne is described as being blue (Ezekiel 1:26).

85. *John Murdock Journal*, 13, cited in *Ensign*, January 1993, 37. Another vision of the Savior wherein he is described as having blue eyes can be found in *The Life and Record of Anson Call*, BYU Special Collections Library, 22-23. Joseph Smith recounted the First Vision to a Jewish convert in Nauvoo and said that the Savior had blue eyes (*Alexander Neibaur Journal*, 24 May 1844, BYU Special Collections Library).

86. The masthead of John Taylor's newspaper *The Mormon* was decorated with an all-seeing eye surrounded by rays of light. He identified this divine light as "a blaze of glory" (*CHC*, 4:62). Joseph Smith's comment on "everlasting burnings" can be found in *TPJS*, p. 347. See also Isaiah 33:14; Genesis 15:17, Exodus 3:2, 24:17; 1 Nephi 1:6; Helaman 5:23-24; 3 Nephi 17:24; 19:13-14.

87. John Block Friedman, "The Architect's Compass in Creation Miniatures of the Later Middle Ages," in H. G. Fletcher III, ed., *Traditio: Studies in Ancient and Medieval History, Thought, and Religion* (New York: Fordham University Press, 1974), 30: 419-429; John W. Welch and Claire Foley, "Gammadia on Early Jewish and Christian Garments," *BYUS*, vol. 36, no. 3 (1996-97), 253-258.

88. *DNTC*, 529-31.

89. Brian L. Smith, *Ensign*, October 1994, 62-63.

90. Albert L. Zobell, Jr., "Cyrus Dallin and the Angel Moroni Statue," *IE*, April 1968, 5-6.

91. The Lord very distinctly uses the singular "angel" here. Joseph Smith employed the singular also and said that "John saw the angel having the holy Priesthood who should preach the everlasting gospel to all nations—God had an angel, a special messenger, ordained and prepared for that purpose in the last days" (*WJS*, 366, 12 May 1844). For a discussion of Moroni's many appearances to Joseph Smith and others see H. Donl Peterson, "Moroni: Joseph Smith's Tutor," *Ensign*, January 1992, 22-29. The rumor sometimes circulates that the face of Moroni is modeled after the sculptor's

mother. The reasoning is that he did not personally believe in angels but was convinced by his 'angel mother' to accept the commission by President Woodruff to create the statue (*Ensign*, March 1993, 14). Close-up photographs of the statue indicate, however, that the face is definitely masculine (ibid., 43). Notice in this source that Dallin's sculpture was based on Revelation 14:6.

92. *Journal of Jesse Nathaniel Smith*, 393, 8 April 1893, as quoted in Joseph Heinerman, *Temple Manifestations* (Salt Lake City: Magazine Printing and Publishing, 1974), 132.

93. *MS*, vol. 58, no. 13, 20 March 1896, 205-206. This manifestation is also recorded in the *Salt Lake Temple Historical Record* under the date of 17 April 1893: "Andrew Smith, Jr., at the temple dedicatory service, held in the upper assembly room of the temple, on 17 April 1893, while John W. Taylor was reading the prayer, saw a very bright light appear above and beyond him (John W. Taylor). Brother Smith saw in the midst of that heavenly light, the persons of President Brigham Young, John Taylor, Patriarch Hyrum Smith, Orson Pratt and eight others whom he could [not] name. A similar bright light surrounded George Q. Cannon, Lorenzo Snow and Heber J. Grant while each one of them were addressing the congregation and several personages appeared in the illuminations: Jedediah M. Grant was one of them, he stood by his son Heber while the latter was speaking. The same light surrounded President Snow while he was directing the sacred 'Hosanna' shout, and it rested over the heads of each one of the First Presidency. Brother Smith stated that he thought he must have seen as many as twenty-four of the spiritual personages. At the afternoon session, the same day, he saw several others of these glorified persons, and asking George Kirkman, who sat by him if he saw them, the vision was closed then." At another of the dedicatory services this brilliant manifestation of light was seen by at least two brethren. "On another occasion during the dedication proceedings, President Joseph F. Smith was addressing the assemblage, which was very large. In all his previous speaking he had exhibited great power and freedom, the people being frequently melted to tears under the influence which accompanied his addresses. At this particular time, however, he appeared to have some difficulty in expressing himself with the ease and fluency that hitherto characterized his utterances. One of the Elders who was standing on the Aaronic stand saw this and was looking intently at the speaker. As he did so he observed a light appear suddenly in front of the Melchizedek Stand. This light was of a yellowish or golden tint and exceedingly brilliant. Its intensity was so great that, when in contact with the front pillars which support the canopy, it caused the white paint upon them to appear of a dark hue. At the same instant of this appearance President Smith suddenly spoke with the same potent influence which had characterized his previous addresses, and continued to hold his auditors as if they were spellbound, to the close of his remarks. The Elder referred to, learned that one other of the brethren, besides himself had seen this manifestation of the Spirit of Light" (*The Contributor*, vol. 16, 117).

94. James H. Anderson, "The Salt Lake Temple," *The Contributor*, vol. 14, no. 6 (April 1893), 274.

95. J. C. J. Metford, *Dictionary of Christian Lore and Legend* (London: Thames and Hudson, 1983), 88.

96. The object on the head of the angel is sometimes mistaken for a halo, but if one looks at either a model of the statue or close-up photographs of the head it becomes clear that this is a crown. It tapers off on both sides, completely surrounds the angel's head, and indents his hair. Elder James H. Anderson positively identified the object as a crown in "The Salt Lake Temple," *The Contributor*, vol. 14, no. 6 (April 1893), 274.

97. Brigham Young told Truman O. Angell after drawing a rough sketch of the temple: "There will be three towers on the East, representing the President of the Church and his two Counsellors; also three similar towers on the West representing the Presiding Bishop and his two Counsellors; the

towers on the East the Melchizedek priesthood, those on the West the Aaronic priesthood. The center towers will be higher than those on the sides, and the West towers a little lower than those on the East end" (*Temple Souvenir Album, April, 1892* [Salt Lake City: Magazine Printing Co., 1892], 5-8).

98. In the temple, said Brigham Young, "you will see the priesthood in its order and true organization. . . . The temple will be for endowments—for the organization and instruction of the priesthood" (*JD*, 8:202-203).

99. *JD*, 2:45-46.

100. Truman O. Angell, "The Salt Lake City Temple," *MS*, vol. 36, no. 18 (5 May 1874), 274.

101. Richard D. Draper, *Opening the Seven Seals: The Visions of John the Revelator* (Salt Lake City: Deseret Book, 1991), 46, 56, 83-84.

102. Talmage, *The House of the Lord*, 147.

103. Michael Zohary, *Plants of the Bible* (New York: Cambridge University Press, 1982), 165.

104. Steven Olderr, *Symbolism: A Comprehensive Dictionary* (London: McFarland & Co., 1986), 1.

105. Letter of Aristeas to Philocrates, 70, in James H. Charlesworth, ed., *The Old Testament Pseudepigrapha*, 2 vols. (Garden City, New York: Doubleday, 1985), 2:17.

106. Orson F. Whitney, *Life of Heber C. Kimball*, 5th ed. (Salt Lake City: Bookcraft, 1974), 435-36.

107. *HC*, 4:329; *JD*, 2:29, 33.

108. Ezra Taft Benson, *Teachings of Ezra Taft Benson* (Salt Lake City: Bookcraft, 1988), 249-50.

109. John A. Widtsoe, "Temple Worship," *Utah Genealogical and Historical Magazine* 12 (April 1921): 56.

110. The dedicatory prayer for the Logan Temple may be found in *MS*, 46:386-91, 17 May 1884. The Lord's revelation in response to this prayer is found in the John Taylor Papers, LDS Church Archives. The date of this revelation is May 1884.

111. "If the Lord has occasion to visit any particular part of his kingdom, the place where he will come will be the sanctuary that is appointed, the house that has been dedicated to him, the house that is his all who are entitled to see the face of the Lord will receive that blessing in the House of the Lord (see D&C 97:15-16)" (Bruce R. McConkie, "The Promises Made to the Fathers," in Kent Jackson and Robert Millet, eds., *Studies in Scripture, Volume 3, The Old Testament* [Salt Lake City: Randall Book, 1985], 48).

112. McConkie, *Promised Messiah*, 611.

113. "On the morning of the 6th of April, 1893, Wilford Woodruff, President of the Church, led the way through the south-west door into the sacred precincts. The event has been not inaptly likened to that of Joshua leading Israel into the promised land" (James E. Talmage, *The House of the Lord* [Salt Lake City: Deseret, 1971], 132).

114. *MD*, 132.

115. John P. Pratt, "Yet Another Eclipse for Herod," *The Planetarian*, vol. 19, no. 4 (December 1990), FARMS reprint, 11-12.

116. Truman O. Angell, "The Salt Lake City Temple," *MS*, vol. 36, no. 18 (5 May 1874), 275.

117. Talmage, *The House of the Lord*, 148, states that the earthstones, as they currently appear, are "cut to show part of the surface of a sphere." On page 275 of Anderson's *Contributor* article it also states that the earthstones "have a sphere cut upon their exposed surface."

118. *JD*, 17:143, 19 July 1874. See also *JD*, 9:317, 13 July 1862 and *Wilford Woodruff's Journal*, same date, which says that we are currently "millions of miles from the presence of God." John Taylor taught that the earth was "first organized, near the planet Kolob" (John Taylor, "The Origin and Destiny of Woman," *The Mormon*, New York City, 29 August 1857).

119. "This earth will be rolled back into the presence of God and crowned with Celestial Glory" (*WJS*, 60).

120. William Clayton, *An Intimate Chronicle*, 96. This material is a slightly different version of D&C 130.

121. Alfred Edersheim, *The Temple: Its Ministry and Services* (Peabody, Massachusetts: Hendrickson Publishers, 1994), 156-58, 229-39.

122. Steven Olderr, *Symbolism: A Comprehensive Dictionary* (London: McFarland & Co., 1986), 89. See also Arnold van Gennep, *The Rites of Passage* (Chicago: University of Chicago Press, 1960), 181, 184.

123. Mircea Eliade, *Cosmos and History: The Myth of the Eternal Return* (New York: Harper, 1959), 59-88.

124. Anderson, "The Salt Lake Temple," 275.

125. Truman O. Angell, "The Salt Lake City Temple," *MS*, vol. 36, no. 18 (5 May 1874), 275. The iconographic source for this symbol may possibly be traced to Nauvoo. See the illustration in James B. Allen and Glen M. Leonard, *The Story of the Latter-day Saints*, 2d ed. (Salt Lake City: Deseret, 1992), 203.

126. See the Truman O. Angell front and side elevations of 1854 and the Frederick Hawkins Piercy engraving of 1856.

127. This is borne out by Brigham Young's identification of the design on the bottom of the Nauvoo sunstones as "clouds."

128. Orson Pratt, *Wonders of the Universe*, comp. N. B. Lundwall (Salt Lake City: N. B. Lundwall, 1937), 129-41.

129. Gerhard Kittel, *Theological Dictionary of the New Testament* (Grand Rapids, Mich.: Eerdmans, 1964), 1:505. See also David Hughes, *The Star of Bethlehem: An Astronomer's Confirmation* (New York: Walker and Company, 1979), 128, 187, 190.

130. Richard A. Proctor, "Saturn and the Sabbath of the Jews," in *The Great Pyramid: Observatory, Tomb, And Temple* (London: Chatto & Windus, 1883), 243-71.

131. Hugh W. Nibley, "The Circle and the Square," *Temple and Cosmos* (Salt Lake City: Deseret Book and FARMS, 1992), 139-73. The squared-circle design can also be seen on the dedication plaque of the Las Vegas Temple in gold leaf. In the Talmud (Tractate Eruvin, 14b) it is said that the Brazen Sea had a square base and the laver resting upon it was round. See an illustration of this in Yigael Yadin, *The Temple Scroll: The Hidden Law of the Dead Sea Sect* (London: Weidenfeld and Nicholson, 1985), 129-30. The "image of the 'squared circle' on the synagogue floor—the Zodiac surrounded by the seasons—represented the sphere of the heavens and the four corners of the earth, a common motif in the ancient world, representing the cosmos" (Frankel and Teutsch, *The Encyclopedia of Jewish Symbols*, 199).

132. *MD*, 139-40, 179-80, 705-706, 745.

133. Carl G. Liungman, *Dictionary of Symbols* (Santa Barbara, Calif.: ABC-CLIO, 1991), 318. The original plans for the Salt Lake Temple show the planet Saturn positioned among a field of six-pointed stars that represent the heavens. The six-pointed star design, along with the sun and crescent moon, can also be seen on Joseph Smith's Nauvoo Mansion House rainspout, which is displayed in the LDS Church Museum of History and Art.

134. Hugh W. Nibley, *Temple and Cosmos*, 15. For the relationship between the temple and the north star, see Nibley, *The Temple in Aniquity*, 22-23, 25. See also the Big Dipper illustrations and their commentaries in Nibley, *Temple and Cosmos*, 16, 18, 115, 229. Some scholars believe that the "seven stars" in Revelation 1:16 refer to the Big Dipper (Gerhard Kittel, *Theological Dictionary of the*

New Testament, 1:504).

135. Truman O. Angell, "The Temple," *Deseret News*, 17 August 1854.

136. *CR*, 8 October 1905, 63.

137. George A. Buttrick, ed., *The Interpreter's Bible* (New York: Abingdon, 1956), 5:262. For further reading on the assembly of the gods, or council in heaven, see Joseph Fielding McConkie, "Premortal Existence, Foreordinations, and Heavenly Councils," in Wilfred C. Griggs, ed., *Apocryphal Writings and the Latter-day Saints* (Provo, Utah: BYU Religious Studies Center, 1986), 173-198; Joseph Fielding McConkie, "The Grand Council," in Robert L. Millet and Kent P. Jackson, eds., *Studies in Scripture: Volume 2, The Pearl of Great Price* (Salt Lake City: Randall Book Co., 1985), 63-76.

CHAPTER 6
The Symbol of Our Faith

At the beginning of his service as President of the Church, Howard W. Hunter invited every Latter-day Saint to "establish the Temple of the Lord as the great symbol of their membership and the supernal setting for their most sacred covenants."[1] He taught that as we attend the holy house of God, we will "learn more richly and deeply the purpose of life and the significance of the atoning sacrifice of the Lord Jesus Christ." He further encouraged every member of the Church to "make the temple, with temple worship and temple covenants and temple marriage, our ultimate earthly goal and the supreme mortal experience."[2] President Ezra Taft Benson also urged the Saints to instill a deep sense of what the temple signifies in their young children.

> The temple is a sacred place, and the ordinances in the temple are of sacred character. Because of its sacredness, we are sometimes reluctant to say anything about the temple to our children and grandchildren. As a consequence, many do not develop a real desire to go to the temple, or when they go there they do so without much background to prepare them for the obligations and covenants they enter into. I believe a proper understanding or background will immeasurably help prepare our youth for the temple. This understanding, I believe, will foster within them a desire to seek their priesthood blessings just as Abraham sought his.[3]

President Harold B. Lee once related a story that beautifully illustrates this important precept. President Lee was handed a note by one of the watchmen on Temple Square that read as follows.

> One morning not so long ago I was sitting at the desk of the temple gate house reading when my attention was drawn to a knock on the door. There stood two little boys, aged about seven or eight years. As I opened the door, I noticed that they were poorly dressed

and had been neither washed nor combed. They appeared as if they had left home before father or mother had awakened that morning. As I looked beyond these little fellows, I saw two infants in pushcarts. In answer to my question as to what they wanted, one of the boys pointed to his little brother in the cart and replied: "His name is Joe. Will you shake hands with little Joe? It is little Joe's birthday—he is two years old today, and I want him to touch the temple so when he gets to be an old man he will remember he touched the temple when he was two years old." Pointing to the other little boy in the other cart, he said this: "This is Mark, he's two years old too." Then, with a solemn, reverent attitude rare in children so young, he asked, "Now can we go over and touch the temple?" I replied: "Sure you can." They pushed their little carts over to the temple and lifted the infants up, and placed their hands against the holy building. Then as I stood there with a lump in my throat, I heard the little boy say to his infant brother, "Now, Joe, you will always remember when you was two years old you touched the temple." They thanked me and departed for home.[4]

Not only did these children touch the temple but the temple had obviously touched them and had become a symbol of their faith. After the demonstration of their faith in the house of the Lord, these little children went "home," and the Lord has told us that if we desire to return to our heavenly home we too must become as little children in the purity of our faith (see Matthew 18:2-4). But let us be even more specific on this matter. In order for anyone to return back to the presence of the Father, they must receive the ordinances of the temple and then remain true and faithful to them for, as President Benson stressed, they are "the only means by which we can one day see the face of God and live."[5] In even more straightforward language this prophet of God has declared: "We will not be able to dwell in the company of celestial beings unless we are pure and holy. The laws and ordinances which cause men and women to come out of the world and become sanctified are administered only in these holy places. They were given by revelation and are comprehended by revelation. It is for this reason that one of the Brethren has referred to the temple as the 'university of the Lord.'"[6]

President Brigham Young explained how the symbols presented within the temple ordinances will play an essential role in our ascension back into the presence of our Father.

> Let me give you a definition in brief. Your endowment is, to receive all those ordinances in the house of the Lord, which are necessary for you, after you have departed this life, to enable you to walk back to the presence of the Father, passing the angels who stand as sentinels, being enabled to give them the key words, the signs and tokens, pertaining to the holy Priesthood, and gain your eternal exaltation in spite of earth and hell.[7]

President Joseph Fielding Smith was just as explicit in teaching that there is a

divinely appointed and altogether necessary way for us to regain the presence of God.

> The ordinances of the temple, the endowment and sealings, pertain to exaltation in the celestial kingdom, where the sons and daughters are. . . . Sons and daughters have access to the home where [God] dwells, and you cannot receive that access until you go to the temple. Why? Because you must receive certain key words as well as make covenants by which you are able to enter. . . . You get your key in the temple, which will admit you.[8]

The reason we must receive the temple ordinances is simple: they are the rituals of righteousness, and the covenants taken upon oneself in that sacred place are the means provided whereby we may come up unto "the stature of the fulness of Christ" (Ephesians 3:14). If we wish to dwell in the presence of pure and glorified beings we must become as they are, for the Lord has irrevocably decreed that "no unclean thing can inherit the kingdom of heaven" (Alma 11:37).[9] But returning to our heavenly home is not the end of our potential glory.

THE SYMBOL OF ETERNAL LIFE

There is one last symbol that needs to be mentioned as this book draws to a close. In the sealing rooms of the Lord's house hang mirrors on opposite walls. The stunning effect produced by these mirrors is a reflection that seems to go on endlessly in both directions. This symbol serves to remind couples who kneel at the altar that if they remain true to their covenants, their union will be sealed for time and all eternity, and they will be granted eternal life, which is the greatest gift of God. It is as if, for this moment in time, the couple kneels in the very midst of eternity. In one direction they see eons past, which were spent in preparation to receive the blessings of this day. In the other direction they glimpse the boundless possibilities that await the faithful sons and daughters of God.

The Lord has taught us the vital interconnection between obedience to the law of eternal marriage and the endowment of everlasting life:

> And again, verily I say unto you, if a man marry a wife by my word, which is my law, and by the new and everlasting covenant, and it is sealed unto them by the Holy Spirit of promise, by him who is anointed, unto whom I have appointed this power and the keys of this priesthood; and it shall be said unto them—Ye shall come forth in the first resurrection; and if it be after the first resurrection, in the next resurrection; and shall inherit thrones, kingdoms, principalities, and powers, dominions, all heights and depths—then shall it be written in the Lamb's Book of Life, that he shall commit no murder whereby to shed innocent blood, and if ye abide in my covenant, and commit no murder whereby to

shed innocent blood, it shall be done unto them in all things whatsoever my servant hath put upon them, in time, and through all eternity; and shall be of full force when they are out of the world; and they shall pass by the angels, and the gods, which are set there, to their exaltation and glory in all things, as hath been sealed upon their heads, which glory shall be a fulness and a continuation of the seeds forever and ever.

Then shall they be gods, because they have no end; therefore shall they be from everlasting to everlasting, because they continue; then shall they be above all, because all things are subject unto them.

Then shall they be gods, because they have all power, and the angels are subject unto them. Verily, verily, I say unto you, except ye abide my law ye cannot attain to this glory. (D&C 132:19-21)

Temple marriage is an order of the priesthood. "It is the patriarchal order that opens the door to a continuation of the family unit in eternity."[10] The Prophet Joseph Smith has stated plainly that unless "a man and his wife enter into an everlasting covenant and be married for eternity, while in this probation, by the power and authority of the Holy Priesthood, they will cease to increase when they die; that is, they will not have any children after the resurrection."[11] It must be clearly understood, however, that celestial marriage is only "the gate to an exaltation in the highest heaven of the celestial world. . . . Those who have been married in the temple for eternity know that the ceremony itself expressly conditions the receipt of all promised blessings upon the subsequent faithfulness of the husband and wife. Making one's calling and election sure is in *addition* to celestial marriage."[12]

The material that has been presented in this book seems to bear a witness all its own. First that the Lord truly lives and he has been intimately involved in the establishment and adornment of his earthly temples. Second, that Joseph Smith was an extraordinary prophet of God who was in close communion with the heavens, perhaps more so than we usually imagine. Third, that symbols are an integral part of the gospel of Jesus Christ and their study can open up a new dimension of personal understanding for those who have eyes to see.

We have focused a great deal in this book on the *meaning* of some of the symbols that are associated with the Lord's house. But ultimately, it is the underlying *purpose* of those emblems that matters the most. Each symbol of the gospel has been carefully crafted to teach, testify, and remind us of the Son of God. But the glory of the gospel is that we have the opportunity to become like him. It is in the ordinances of the temple that we encounter symbols that have been designed to make this wonderous transformation possible. And so we must turn to the mountain of the Lord, to the house of the God of Jacob. The path that leads to eternal life passes through its hallowed doors.

NOTES

1. *Ensign,* July 1994, 5.

2. President Howard W. Hunter, "A Temple-Motivated People," *Ensign,* February 1995, 5.

3. President Ezra Taft Benson, "What I Hope You Will Teach Your Children about the Temple," *Ensign,* August 1985, 8.

4. President Harold B. Lee, *Ensign,* February 1971, 35.

5. Benson, "What I Hope You Will Teach Your Children about the Temple," 44. Elder Bruce R. McConkie has also taught that the "purpose of the endowment in the house of the Lord is to prepare and sanctify his saints so that they will be able to see his face . . . [and] bear the glory of his presence in the eternal worlds" (*Promised Messiah*, 583).

6. Ezra Taft Benson, *The Teachings of Ezra Taft Benson* (Salt Lake City: Bookcraft, 1988), 252.

7. John A. Widtsoe, comp. *Discourses of Brigham Young* (Salt Lake City: Deseret Book, 1941), 416. See also his similar comments in *HC*, 7:240; *JD*, 1:278; 2:315; 10:172.

8. *DS*, 2:40-41. A vision given to John Powell in 1867 confirms this doctrine. An angel guided him through the three degrees of glory, and he said that by seeing them he greatly desired to be there. "Having these thoughts on my mind continuously the Lord opened the vision of my mind, and lo and behold! a beautiful temple stood before me. I saw many people going to the temple. I went into it and there saw my wife, Fanny, dressed in her priestly robes, administering to some persons. When she got through she came to me and administered to me. I learned by this manifestation that I was not qualified, but had to receive the blessings of the administrations of the Holy Temple in this life before I could enjoy those degrees of glory that I had seen. This knowledge caused a change in my feelings. I then desired to live that I might prove myself worthy before God and my brethren, and attend to those ordinances that He had ordained for the salvation of the dead as well as the living" (*Journal of John Powell*, unpublished manuscript, 76-78). We hasten to point out, however, that according to President Joseph Fielding Smith, the temple ordinances pertain to the celestial kingdom alone and to no other eternal destination (*DS*, 2:329).

9. See also 1 Nephi 10:21; 15:34; Alma 7:21; 40:26; Helaman 8:25; 3 Nephi 27:19. As the temple is a type and shadow of God's heavenly kingdom, no unclean thing is permitted to pass over its threshold (see D&C 94:8, 97:15, 109:20).

10. *NWAF*, 312. "Celestial marriage is a holy and an eternal ordinance; as an order of the priesthood, it has the name the *new and everlasting covenant of marriage*" (*MD*, 118).

11. *TPJS*, 300-01. "Every person married in the temple for time and for all eternity has sealed upon him, conditioned upon his faithfulness, all of the blessings of the ancient patriarchs, including the crowning promise and assurance of eternal increase, which means, literally, a posterity as numerous as the dust particles of the earth" (Bruce R. McConkie, *The Millenial Messiah* [Salt Lake City: Deseret Book, 1982]), 264.

12. *MD*, 118. "The holy of holies in the Lord's earthly houses are symbols and types of the Eternal Holy of Holies which is the highest heaven of the celestial world" (*DNTC*, 3:589). For further study on making one's calling and election sure, see Bruce R. McConkie, "Make Your Calling and Election Sure," *DNTC*, 3:323-53; Roy W. Doxey, "Accepted of the Lord: The Doctrine of Making Your Calling and Election Sure," *Ensign*, July 1976, 50-53; Blaine M. Yorgason, "The Highest Blessings of the Gospel," in *Spiritual Progression in the Last Days* (Salt Lake City: Deseret

Book, 1994), 225-66; Andrew C. Skinner, "Nephi's Ultimate Encounter with Deity: Some Thoughts on Helaman 10," in *The Book of Mormon: Helaman through 3 Nephi 8, According to Thy Word* (Salt Lake City: Bookcraft, 1992), 115-27. "Then I would exhort you to go on and continue to call upon God until you make your calling and election sure for yourselves, by obtaining this more sure word of prophecy, and wait patiently for the promise until you obtain it" (*TPJS*, 298-99; see also 150- 51; 305).

APPENDIX A

NOTE: The six-pointed stars at the beginning of each appendix come from the architectural drawings of the Salt Lake Temple. According to the handwritten notes on the drawings, these stars were to be placed in the round windows that are located on the sides of the center towers.

The following chart shows the correspondence between the names of the twenty-four temples that were once planned for the city of New Jerusalem in Jackson County, Missouri, and the twenty-four pulpits inside the Kirtland Temple. The information used in creating this chart can be found in B.H. Roberts, ed., *History of The Church of Jesus Christ of Latter-day Saints*, 7 vols. (Salt Lake City: Deseret Book, 1980), 1:357-62; Richard O. Cowan, "The Great Temple of the New Jerusalem," in Arnold K. Garr and Clark V. Johnson, eds., *Regional Studies in Latter-day Saint Church History: Missouri* (Provo, Utah: Department of Church History and Doctrine, Brigham Young University, 1994), 137-154.

NEW JERUSALEM TEMPLES	KIRTLAND TEMPLE PULPITS
(1,2,3) The House of the Lord, for the Elders of Zion, an Ensign to the Nations	(P.E.M) Presidency Elders Melchizedek (Elders)
(4, 5, 6) The Holy Evangelical House, for the High Priesthood of the Holy Order of God	(M. H. P.) Melchizedek High Priesthood (High Priests)
(7, 8, 9) The Sacred Apostolic Repository, for the use of the Bishop	(P. M. H.) Presiding Melchizedek High Priesthood (Quorum of the Twelve)
(10, 11, 12) The House of the Lord, for the Presidency of the High and most Holy Priesthood, after the order of Melchizedek, which was after the order of the Son of God, upon Mount Zion, city of the New Jerusalem	(M. P. C.) Melchizedek Presiding Council (First Presidency)

NEW JERUSALEM TEMPLES	KIRTLAND TEMPLE PULPITS
(13, 14, 15) The House of the Lord for the Deacons in Zion, Helps in Government	(P. D. A.) Presidency Deacons Aaronic (Deacons)
(16, 17, 18) The House of the Lord for the Teachers in Zion, Messenger to the Church	(P. T. A.) Presidency Teachers Aaronic (Teachers)
(19, 20, 21) The House of the Lord, for the Highest Priesthood after the Order of Aaron; the Law of the Kingdom of Heaven, and Messenger to the People	(P. A. P.) Presidency Aaronic Priests (Priests)
(22, 23, 24) The House of the Lord for the Presidency of the High Priesthood, after the Order of Aaron, a Standard for the People	(B. P. A.) Bishop Presiding Aaronic (Presiding Bishopric)

APPENDIX B
The Temple on the Celestial Earth

The text that follows is a partial account of a vision shown to Alfred Douglas Young on 16 September 1841. It can be found in the book *Alfred Douglas Young: Autobiographical Journal 1808-1842* (Provo, Utah: Brigham Young University Library, 1958), 10-11, 13. A copy of this book may be found in the Brigham Young University Special Collections Library in Provo, Utah. This manifestation has been included in this book in order to illustrate the idea that temples are an eternal part of the gospel and will continue to play a role in the future lives of the Saints.

Some background information on this experience is in order. The day prior to this manifestation, Alfred Douglas Young had been ordained an elder. As he was conversing with his brother on the doctrines of the gospel, he was overcome by a feeling of peace and prompted to retire to a secluded place. He invited his brother to accompany him. When they had gone a considerable distance into the woods, a bright light appeared above them and a angel in a brilliant white robe appeared. Alfred's spirit apparently left his body at this point and accompanied the angel upward into the heavens, where he was shown a series of visions, the last of which is described here:

> I saw the earth move, it appeared to fold together from the four corners into a comparatively small space. It appeared like unto a small parcel, passed away and I saw it no more.[1]
>
> Again my guide said to me, "Look." I looked, and beheld a new earth[2] having the appearance of a sea of glass,[3] and upon it was a multitude of inhabitants and a temple[4] of the Lord God. The angel said to me, "Draw near to the Temple," I did so, and he accompanied me. He conducted me into the lower courts where I saw twelve baptismal fonts[5] and twelve foundations which were of different and beautiful materials,[6] but as a whole, they were the foundation of a grand and beautiful temple.
>
> The angel conducted me upwards onto the next floor of the temple above the baptismal font. This part of the temple was constructed of different material from the lower courts. It was beautiful beyond my capacity to describe. There I was shown all of the vari-

ous rooms or departments for the different grades of the priesthood.[7]

From this place the angel conducted me up a stairway to what appeared to be the upper or highest story of the temple.[8] It far exceeded in beauty and richness anything that I had before seen. I can only compare it to a very clear glass mingled with gold.[9]

All these departments had suitable accommodations for the use for which they were designed including seats for those receiving endowments and for those administering therein,[10] or for people who might gather together for instructions, and so forth.

I saw in the upper court a seat or throne especially fitted up for the sitting of Jesus Christ and of his Father. I also saw before this throne two altars—one about three feet high and the other about eighteen inches or half the height of the other.[11]

Up to this time I had seen no person in this temple but the angel who conducted me. He said again to me, "Look." As I looked the walls of the upper courts of the temple were as transparent glass. I saw many people come up around the temple and fall down and worship God. Afterward they went into the lower court of the temple and were baptized.[12] I saw them pass through all the various grades of the priesthood from one floor to the other until they came into the upper court. They appeared to have some kind of offering in their hands, what it was, was not clearly made manifest to me.[13] This they laid on the highest altar and bowed on their hands and knees on the lesser altar and there made their final covenants before the throne of God. After this they received an inheritance on the new earth.[14] Enough was shown me in this temple to give me some idea of the great work to be done in the millennium[15] and the vision closed. The angel conducted me back to where my body lay on the ground. I saw it and my brother still standing by it. . . .

In the year 1858, I was counseled by Apostle George Albert Smith to write this vision and have it placed upon the church record, but up to this time, September 1888, it has not been accomplished.

NOTES

1. "The earth is utterly broken down, the earth is clean dissolved, the earth is moved exceedingly" (Isaiah 24:19-20); "The earth should be wrapped together as a scroll, and the heavens and the earth should pass away" (3 Nephi 26:3); "The earth shall be wrapped together as a scroll" (Mormon 5:23); "And the end shall come, and the heaven and the earth shall be consumed and pass away, and there shall be a new heaven and a new earth" (D&C 29:23); "Notwithstanding it shall die, it shall be quickened again" (D&C 88:26). See also JS-Matthew 1:35.

2. See Isaiah 65:17; Ether 13:8-9. "And I saw a new heaven and a new earth: for the first heaven and the first earth were passed away" (Revelation 21:1).

3. See Revelation 4:6; 15:2. When the earth becomes a sea of glass and fire, it will serve as a massive Urim and Thummim (see D&C 130:7-11).

4. Speaking of the celestial city which he saw descending towards the celestialized earth, John the Revelator said: "And I saw no temple therein: for the Lord God Almighty and the Lamb are the temple of it" (Revelation 21:22). Most commentators use this verse to suggest that the temple is obsolete in the celestial kingdom but they fail to recognize that verse 16 answers why John does not see a temple structure—the celestial city itself is one gigantic Holy of Holies, formed in a perfect

cube (compare 1 Kings 6:20). Notice the subtle play on words in D&C 76:66 where the heavenly city—Mount Zion—is called "the holiest of all," meaning the Holy of Holies. The scriptures leave no doubt that there is indeed a temple in heaven (see Revelation 7:15).

5. This is an unusual feature but since the twelve oxen underneath the font in Solomon's Temple are often said to signify the twelve tribes of Israel (see Numbers 7:1-6), we may venture to guess that in this particular temple there is a font provided for each individual tribe.

6. "And the wall of the city had twelve foundations, and in them the names of the twelve apostles of the Lamb. . . . And the foundations of the wall of the city were garnished with all manner of precious stones" (Revelation 21:14, 19).

7. This may be a faint allusion to the twenty-four rooms of the New Jerusalem Temple.

8. The three levels of this temple may correspond to the three degrees of glory.

9. "The city was pure gold, like unto clear glass . . . the street of the city was pure gold, as it were transparent glass" (Revelation 21: 18, 21).

10. Dr. Hugh Nibley points out that the temple ordinances we receive now are only types, shadows, and images of the ordinances that the faithful will receive later (Hugh Nibley, *Old Testament and Related Studies* [Salt Lake City: Deseret Book and FARMS, 1986], 104, 178, 160-61).

11. Earlier in his experience Alfred Young saw these same altars in the heavenly temple indicating that he is now seeing the heavenly temple on the celestialized earth.

12. Baptism serves more than one purpose. It is one of the "articles of adoption" that must be subscribed to in order for one to enter into the kingdom of God (*TPJS*, 328). Even Jesus Christ had to be baptized to "gain admission to the celestial kingdom" (*MD*, 71). "Though he is the King of the kingdom, though he authors and proclaims his Father's plan of salvation, though he ordains and establishes the laws governing all things, yet he cannot enter the kingdom of heaven without baptism" (*Mortal Messiah*, 1:402).

13. See Revelation 7:9; 4:10-11.

14. "He that overcometh shall inherit all things" (Revelation 21:7).

15. Because this is a vision of the celestial earth it is difficult to understand how the ordinances he saw relate to the millennium, since by the time the earth is celestialized all millennial work will have been completed. A temple on the celestial earth makes sense however when one considers this statement by Joseph Smith: "When you climb up a ladder, you must begin at the bottom, and ascend step by step, until you arrive at the top; and so it is with the principles of the Gospel—you must begin with the first, and go on until you learn all the principles of exaltation. But it will be a great while after you have passed through the veil before you have learned them. It is not all to be comprehended in this world; it will be a great work to learn our salvation and exaltation even beyond the grave" (*TPJS*, 348).

APPENDIX C

The Significance of April 6

The date "April 6" is prominently displayed on the dedication plaque of the Salt Lake Temple's east center tower. It was on this day that the cornerstones of the Salt Lake Temple were laid (1853), the capstone placed (1892), and the dedicatory prayer offered up to the Lord (1893).[1] April 6th has a preeminent place in LDS Church history because it was on this day in 1830 that The Church of Jesus Christ of Latter-day Saints was formally organized.[2] This date was not chosen at random, however, but was decided upon by the Lord Himself. The Prophet Joseph Smith stated that by way of revelation the Lord "pointed out to us the precise day upon which, according to His will and commandments, we should proceed to organize His Church once more here upon the earth."[3]

The Lord did not say why it was necessary for His Church to be reestablished on this particular day, but some Latter-day Saints believe that this was done in order to commemorate His birth. The evidence that leads to such a conclusion is found in Doctrine and Covenants section 20 verse 1, which reads:

> The rise of the Church of Christ in these last days, being one thousand eight hundred and thirty years since the coming of our Lord and Savior Jesus Christ in the flesh, it being regularly organized and established agreeable to the laws of our country, by the will and commandments of God, in the fourth month, and on the sixth day of the month which is called April.

It is perhaps significant that only three years later the Prophet Joseph Smith connected the date of April 6 with the organization of the restored Church, the creation of the world and the sons of God shouting for joy, the Passover feast of ancient Israel, and the birth and death of the Lord Jesus Christ.[4]

While the modern world has become accustomed to thinking that the Messiah was born in the month of December, LDS writers Hyrum M. Smith and Janne M. Sjodahl point out that some "scholars (Griswell, among others) consider it probable that [Jesus Christ] was born on the tenth day of the Jewish month of Nisan, which in the year of the Nativity has been calculated to correspond to Saturday, April the 5th. But as He was born at night, and Saturday expired at sunset, the date would be more precisely, April the 6th, and that would be the beginning of Sunday, 'our Lord's day.' On this supposition the date was most appropriate."[5] Brigham Young University religion professor Richard O. Cowan explains in more detail.

Most biblical scholars agree that the Savior could not have been born in December because shepherds would not have been out at night with their flocks during that season of the year. Many suggest spring as a more probable time.

Evidence from the Book of Mormon confirms that Christ was born during the spring. The Nephites counted their years from the time when they saw the wondrous signs of His birth. Almost exactly thirty-three years later, on the fourth day of the first month in the thirty-fourth year, the sign of the crucifixion was seen (see 3 Nephi 2:8; 8:5). This meant that the Lord was born and later died at the same time of year. The New Testament records that His crucifixion occurred at the time of the Passover, a Jewish holiday celebrated during the early spring. All this evidence points to the conclusion that Jesus Christ was born during the early spring and accords with the instructions in *Doctrine and Covenants* 20:1 that the Church should be organized on Tuesday, 6 April 1830, eighteen hundred and thirty years after the Savior had come in the flesh.

During the centuries after the Savior's birth, some Christians began to combine their celebration of that event with northern Europeans' observance of the winter solstice. Even though we know the Savior was born in April, it is appropriate to remember His life at any time of the year. Hence we join other Christians each December in celebrating the momentous event in Bethlehem.[6]

There are a number of LDS Church leaders who have publicly accepted the idea that April the 6th is the date of the Savior's birth. Among this group are Orson Pratt,[7] Joseph F. Smith,[8] James E. Talmage,[9] Charles W. Nibley,[10] Melvin J. Ballard,[11] Harold B. Lee,[12] Spencer W. Kimball,[13] and Neal A. Maxwell.[14] And while an article in the *Encyclopedia of Mormonism* acknowledges that April the 6th "may be the anniversary of the Lord's birth" it must be kept in mind that it is currently not possible to state this with any degree of finality.[15] Only a direct revelation from the Lord can settle this issue.

NOTES

1. Other significant April 6 dates include: Solemn Assembly held in the Kirtland Temple 6 April 1837 (see *Brigham Young University Studies*, vol. 12, no. 4, Summer 1972, 389); Nauvoo Temple cornerstones laid 6 April 1841 (see *History of the Church*, 4:327–30); Old Tabernacle on Temple Square dedicated 6 April 1852; St. George Temple dedicated 6 April 1877. "Significantly, Joseph [Smith] was finally released from Liberty Jail, with a subsequent escape en route, on April 6, 1839—both the Savior's and His Church's birthday (D&C 20:1). Though Joseph would have been unaware of it, it was also Passover time, often the celebration of the occasion when ancient Israel was spared from the angel of death and released from bondage!" (Neal A. Maxwell, *But for a Small Moment* [Salt Lake City: Bookcraft, 1986], 18). Charles W. Nibley, second counselor in the First Presidency, believed that it was possible that Joseph Smith first saw the Father and the Son on 6 April 1820 (see B. H. Roberts, *A Comprehensive History of The Church of Jesus Christ of Latter-day Saints* [Salt Lake City: Deseret News Press, 1930], 6:542–43).

2. Lorenzo Snow said that April 6 is "the anniversary of our birth as a Church and the ushering in of the dispensation of the fullness of times" (Eliza R. Snow, *Biography and Family Record of Lorenzo Snow* [Salt Lake City: Deseret News Press, 1884], 412).

3. *History of the Church*, 1:64.

4. Ibid., 1:336–37.

5. Hyrum M. Smith and Janne M. Sjodahl, *Doctrine and Covenants Commentary* (Salt Lake City: Deseret Book, 1978), 98.

6. Richard O. Cowan, *Answers to Your Questions About the Doctrine and Covenants* (Salt Lake City: Deseret Book, 1996), 23–24. For two articles that address the April 6 issue from a scientific and ritualistic perspective see John P. Pratt, "The Restoration of Priesthood Keys on Easter 1836, Part 1: Dating the First Easter," *Ensign*, June 1985, 59–68; John P. Pratt, "Passover: Was it Symbolic of His Coming?" *Ensign*, January 1994, 38–45.

7. See *Journal of Discourses*, 15:256.

8. See Brian H. Stuy, ed., *Collected Discourses* (Woodland Hills, Utah: B.H.S. Publishing, 1992), 5:26–27.

9. See James E. Talmage, *Jesus the Christ* (Salt Lake City: Deseret Book, 1983), 98.

10. See B. H. Roberts, *A Comprehensive History of The Church of Jesus Christ of Latter-day Saints* (Salt Lake City: Deseret News Press, 1930), 6:542–43.

11. See Bryant S. Hinckley, *Sermons and Missionary Services of Melvin J. Ballard* (Salt Lake City: Deseret Book, 1949), 166.

12. See *Ensign*, July 1973, 2.

13. See *Ensign*, May 1980, 54.

14. See Neal A. Maxwell, *But for a Small Moment* (Salt Lake City: Bookcraft, 1986), 18.

15. Daniel H. Ludlow, ed., *Encyclopedia of Mormonism* (New York: Macmillan, 1992), 1:61–62.

APPENDIX D

The Weathervane Angel

Some people wonder if the horizontal or flying angel that once adorned the spire of the Nauvoo Temple was meant to represent a particular heavenly personage or if it was just a generic representational figure. While there is no known contemporary source that directly labels this angel as "Moroni," there are three pieces of evidence that point in that direction: (1) the flying angel prophecy found in the 14th chapter of the book of Revelation, (2) the clothing worn by the weathervane angel, and (3) the book that the weathervane angel holds in his right hand.

When the angel Moroni made his first appearance to Joseph Smith on 22 September 1823, he informed the young Prophet that the Book of Mormon plates contained "the fullness of the everlasting gospel" and that because of the work that God desired him to perform, his name would be had for both good and evil "among all nations, kindreds, and tongues."[1] This announcement by Moroni had close textual ties to a prophecy that is found in the book of Revelation, chapter 14, verses 6 and 7. In this ancient scriptural passage the Apostle John says,

> And I saw another angel fly in the midst of heaven, having the *everlasting gospel* to preach unto them that dwell on the earth, and to *every nation, and kindred, and tongue, and people*,
> Saying with a loud voice, "Fear God, and give glory to Him; for the hour of His judgment is come: and worship Him that made heaven, and earth, and the sea, and the fountains of waters" (emphasis added).

On 3 November, 1831, the Lord Jesus Christ not only affirmed that He had sent one of His holy angels to commit the "everlasting gospel" to the inhabitants of the earth, but He also directly tied that event to the aforementioned prophecy of John the Revelator. In Doctrine and Covenants section 133, verses 36 through 39, we read the following words.

> And now, verily saith the Lord, that these things might be known among you [i.e., the gathering of Israel, the Second Coming, the judgment of the ungodly], O inhabitants of the earth, I have sent forth mine angel flying through the midst of heaven, having the *everlasting gospel*, who hath appeared unto some and hath committed it unto man, who shall appear unto many that dwell on the earth.
> And this gospel shall be preached *unto every nation, and kindred, and tongue, and people*.
> And the servants of God shall go forth, saying with a loud voice: "Fear God and give glory to Him, for the hour of His judgment is come.
> And worship Him that made heaven, and earth, and the sea, and the fountains of waters"[2] (emphasis added).

Joseph Smith made a direct connection between the angel of the Revelation 14 prophecy and Moroni, the angel who introduced the fullness of the gospel in the dispensation of the fullness of times. At a public gathering of Latter-day Saints held in Nauvoo, Illinois, the Prophet spoke of the angel coming forth as recorded in the revelation of Saint John on the Isle of Patmos, which reads: "I saw another angel fly in the midst of heaven, having the everlasting gospel to preach to them that dwell on the earth, and to every nation, and kindred, and tongue, and people, saying with a loud voice, 'Fear God, and give glory to Him; for the hour of His judgment is come'" (Revelation 14:6–7).

"The Prophet said this was the angel that appeared unto him and commissioned him to preach the gospel. His was a divine mission that God would honor, and he wished the Saints to understand this, and to be firm and know most assuredly that this was so. Yes, verily so.

"This was a testimony that I was glad to hear. It was given in such a kind manner, and with such force and power, that it seemed to me no man could disbelieve such a powerful statement as he made that day, and the Spirit of God seemed to carry his words deep into the hearts of the people."[3]

Perrigrine Sessions, who was present on the day that the angel weathervane was hoisted into place atop the Nauvoo Temple spire, provides us with two interesting and important pieces of information that tie the temple's weathervane angel to Moroni. He writes: "[O]n this day [3 February 1845] they raised the [vane] which is the representation of an angel in his priestly robe with the Book of Mormon in one hand and a trumpet in the other."[4] Most Latter-day Saints would not normally associate the angel Moroni with a "priestly robe" but, then again, most Latter-day Saints are not aware of a story told by Eliza Munson. She relates, "It was while they were living in Nauvoo that the Prophet came to my grandmother, who was a seamstress by trade, and told her that he had seen the angel Moroni with the garments on, and asked her to assist him in cutting out the garments."[5] The fact that the weathervane angel is holding an open Book of Mormon in his right hand makes his connection to Moroni very close indeed. The Lord Himself states in one Doctrine and Covenants revelation that He sent the angel Moroni to the earth "to reveal the Book of Mormon, containing the fullness of [His] *everlasting gospel*" (D&C 27:5, emphasis added; cf. Revelation 14:6).

When the architectural plans for the Salt Lake Temple were first drawn up it was decided that each of that building's center towers would be adorned with the same type of flying weathervane angel that was utilized in Nauvoo—complete with open book and priestly robes. But over time it was decided that a single, monumental, upright angel would adorn the center tower on the eastern end of the building. It is

interesting to note that the sculptor of the angelic statue, Cyrus Dallin, understood this angel to be a representation of Moroni,[6] as did the person who hoisted the statue into place[7] and those who viewed it at the temple's dedicatory services.[8]

NOTES

1. *Times and Seasons*, vol. 3, no. 12, 15 April 1842, 753.

2. Contemporaries of the Prophet Joseph Smith who publicly declared or alluded to the fact that Moroni was the angel of the Revelation 14 prophecy include:

— Orson Pratt: (Elden J. Watson, ed., *The Orson Pratt Journals* [Salt Lake City: E. J. Watson, 1975], 54, 1 April 1835; see also *Journal of Discourses*, 14:299).

— Edward Partridge: (*Messenger and Advocate*, vol. 1, no. 4, January 1835, 60).

— John Taylor: (Letter, John Taylor to Leonora Taylor, 30 January 1840, LDS Church Archives, Salt Lake City, Utah, cited in *Brigham Young University Studies*, vol. 27, no. 2, Spring 1987, 84; see also *Times and Seasons*, vol. 4, no. 22, 1 October 1843, 351).

— Wandle Mace: (Wandle Mace Autobiography, BYU Special Collections, Writings of Early Latter-day Saints, 75–76, *ca.* November 1841–Summer 1842).

— John Greenhow: (*Times and* Seasons, vol. 4, no. 13, 15 May 1843, 196–97).

— Oliver Cowdery: (Reuben Miller Journal, 21 October 1848, cited in *Deseret News*, 13 April 1859).

3. James Palmer, Reminiscence and Journal, 73–76, LDS Church Archives, Salt Lake City, Utah, cited in Hyrum L. Andrus and Helen M. Andrus, comp., *They Knew the Prophet* (Salt Lake City: Deseret Book, 1999), 175. Some notes that Willard Richards took during one of Joseph Smith's Nauvoo sermons have led to confusion over the identity of the Revelation 14 angel. These notes read as follows: "The Son of God will do as He ever has done from the beginning. Send forth His angels. If the reapers do not come, the wheat cannot be saved. Nothing but [the] Kingdom being restored, can save the world. Like unto a treasure hid in a field. This figure is a representation of the [Kingdom] in the last days. Michael = Adam. Noah. I am Gabriel—Well says I. Who are you? I am Peter, the angel flying through the midst of heaven Moroni delivered the Book of Mormon" (Andrew F. Ehat and Lyndon W. Cook, eds., *The Words of Joseph Smith: The Contemporary Accounts of the Nauvoo Discourses of the Prophet Joseph* [Orem, Utah: Grandin Book, 1991],13). An uncritical reading of these notes could lead one to believe that the apostle Peter is the angel of Revelation 14. It might be helpful, however, for those who come to this conclusion to read the entire set of Willard Richards' notes in *The Words of Joseph Smith* to see how fragmentary and oddly punctuated they are. Kent Jackson, in his book on Joseph Smith and the Bible, renders this passage in the following manner: "The angel flying through the midst of heaven: Moroni delivered the Book of Mormon" (Kent P. Jackson, comp. and ed., *Joseph Smith's Commentary on the Bible* [Salt Lake City: Deseret Book, 1994], 225). This passage might also be rendered as follows: "Michael [is] Adam. Noah, 'I am Gabriel.' 'Well,' says I, 'Who are you?' 'I am Peter.' The angel flying through the midst of heaven, Moroni, delivered the Book of Mormon."

4. Perrigrine Sessions, *The Diaries of Perrigrine Sessions* (Bountiful, Utah: Carr Printing Co., 1967), B.43–44.

5. Statement of Eliza Munson cited in H. Donl Peterson, *Moroni: Ancient Prophet, Modern Messenger* (Bountiful, Utah: Horizon, 1983), 165. For a statement by Esther Johnson that an angel

showed Joseph Smith the pattern for priestly clothing see MS d 4057, fd 2, LDS Church Archives, Salt Lake City, Utah.

6. Cyrus E. Dallin: "I considered that my 'Angel Moroni' brought me nearer to God than anything I ever did" (*Improvement Era*, vol. 56, no. 4, April 1953, 234).

7. William Y. Jeffs, who had served as the hoisting engineer for the Salt Lake Temple since 1891, wrote in his journal that he lifted into place "the last rock—the capstone, [and] also Moroni, the statue" (William Y. Jeffs Journals 1886–1893, privately held by Donald R. Jeffs, Salt Lake City, Utah).

8. "Its polished towers and glittering spires can be seen far down the valley. All are lighted with electricity. Even Moroni, whose statue, fourteen feet high covered with gold-leaf, surmounts the capstone of the highest central tower, bears upon his crown an electric jet of 300-candle power" (*San Francisco Chronicle*, 7 April 1893).

APPENDIX E

Inverted Five-Pointed Stars

Some critics of The Church of Jesus Christ of Latter-day Saints claim that the inverted five-pointed stars that adorn some LDS temples are occultic or even Satanic in nature. These detractors also argue that since the disciples of Jesus Christ never utilized this nefarious emblem in the past, its prominent display by the LDS Church is yet another evidence that "Mormons" aren't Christians.[1] These charges can be easily dismissed by taking a careful look at the historical records of the early Latter-day Saints and their ancient counterparts.

The Early Latter-day Saints

The Prophet Joseph Smith informed the architect of the Nauvoo Temple, William Weeks, that he had seen that sanctuary in a heavenly vision[2] and intended to construct it according to the "pattern" that he had been shown.[3] Wandle Mace, who served as the foreman for all of the framework in the Nauvoo Temple, provides a clue about the type of pattern that the Prophet saw in his vision. He states,

> The order of architecture was unlike anything in existence; it was purely original, being a representation of *the Church, the Bride, the Lamb's wife*. John the Revelator, in the 12 chapter [and] first verse of [the book of Revelation] says, "And there appeared a great wonder in heaven; a woman clothed with the *sun*, and the *moon* under her feet, and upon her head a crown of twelve *stars*." This is portrayed in the beautifully cut stone of this grand temple.[4]

The inverted starstones on the Nauvoo Temple are unique because their bottom rays are elongated. This exact same style of star was used to decorate the two main towers of the LDS temple in Logan, Utah. James A. Leishman, who was present in 1880 when one of the starstones was secured in its place on the eastern tower, reveals what this symbol meant to the late-nineteenth-century Saints. He said, "Carved upon the keystone is a magnificent star, called the *Star of the Morning*, being in an elevated position, it looks out in bold relief upon the rising sun."[5]

After John the Revelator was shown the vision of the woman who represented the heavenly Church (Revelation 12:1) he heard Jesus Christ refer to Himself as "the bright . . . morning star."[6] The writings of early Latter-day Saints confirm that they recognized Jesus Christ as the Morning Star,[7] and they also reveal that for them the star that heralds the dawn (i.e., the planet Venus) was a symbolic harbinger of the thousand-year span when the Savior would reign personally upon the earth. In 1840 Elder Parley P. Pratt, a member of the Quorum of the Twelve Apostles, wrote the fol-

lowing in a Church periodical: "Now the bright and morning Star / Spreads its glorious light afar / Kindles up the rising dawn / Of that bright Millennial morn."[8] Thus, even before the Nauvoo Temple began to rise out of the ground the Latter-day Saints viewed the Morning Star as the Millennial Star[9] and directly associated it with the Lord Jesus Christ. Far from being an emblem of evil, President Brigham Young commented that "the 'stars' [would] add much to the beauty of the [Nauvoo] Temple."[10]

Once Brigham Young had led the Latter-day Saints into the Salt Lake Valley he decided to decorate the Salt Lake Temple with the same type of symbolic emblems that had adorned the exterior of the Nauvoo Temple, with a few modifications. The earliest architectural drawings for the Salt Lake Temple (1854) show that the initial plan was to utilize the elongated bottom-ray star design from Nauvoo,[11] but over time it was determined that the star's rays would all be equal in length. Despite this decision, President Young decided in 1859 to place the elongated star design from the Nauvoo Temple on the Eagle Gate that stood at the edge of his property.[12]

Cultural Context

During the lifetimes of Joseph Smith and Brigham Young, the inverted five-pointed star was utilized in the United States of America without any association with the devil or with the occult. The U.S. Congress set a standard for the design of the American flag on 4 April, 1818, but it did not provide instructions for the form of the stars to be displayed in the canton or blue field. Both before and after this Congressional standard was set (between 1777 and 1876) it was not difficult to find inverted five-pointed stars adorning the star-spangled banner.[13] One version of the "Great Star" flag (which could be seen most often between 1837 and 1845) is of particular interest because it displayed numerous upright five-pointed stars that were arranged in such a manner that they formed one large, inverted five-pointed star.[14]

During the American Civil War the inverted five-pointed star could be seen in several different settings. It was displayed on various battle flags, embroidered on badges of rank, attached to the top and front of headgear, and etched into uniform decorations. Three enormous inverted five-pointed stars were even placed on top of the stand where President Andrew Johnson reviewed the troops after the Civil War had ended.[15] In 1861 the inverted five-pointed star design began to appear on some of the uniforms of the United States Navy. Then in 1862 it was decided that this form of star would be the most prominent feature on the Navy's Medal of Honor. Other branches of the military followed suit and today the inverted five-pointed star can be seen decorating the Medal of Honor for the United States Army and the United States Air Force.[16]

Since the days of Joseph Smith and Brigham Young the inverted five-pointed star has continued to be used as a symbol in the United States of America without any connection whatsoever to either Satan or the occult. This type of star has been prominently displayed on items such as Christmas decorations, consumer products, Boy Scout insignia, restaurant signs, the logos of major political parties, military equipment, and various uniforms of the United States Navy.

The Early Christians

Some critics of the LDS faith emphatically declare that Christians have *never* used the inverted five-pointed star as a symbol—but this is simply not true. The early Christians believed that Jesus Christ was the "Star" prophesied to arise out of the House of Israel[17] and sometime after A.D. 312 the Emperor Constantine had the *Chi-Rho* cross of Jesus Christ engraved on one side of his round royal seal—a symbol he claimed to have seen in vision—and on the other side he had an inverted five-pointed star inscribed.[18] While it is not known why Constantine chose to combine the cross of Christ with the inverted five-pointed star, it is interesting to note that the official seal of the city of Jerusalem from 300–150 B.C. also displayed an encircled and inverted pentagram.[19] Perhaps there is a connection between these two seals since the Savior's crucifixion took place in the city of Jerusalem.

Another example of the inverted five-pointed star being associated with the Christian cross can be seen in the portfolio of a man named Villard de Honnecourt (A.D. 1230). This architect, who worked for the Cistercian Order of monks, drew a "tabernacle" in his sketchbook and between its pillars he placed an inverted five-pointed star with an elongated ray on the bottom.[20] This shrine is surmounted by the three crosses of Golgotha, which clearly implies that this particular type of star was considered to be an orthodox Christian symbol.

There are other examples of this style of star that are relevant to this discussion. For instance, there is an enormous, and intricately carved, inverted pentagram in the center of the north transept rose window of Amiens Cathedral in France.[21] This house of worship was built between A.D. 1220 and 1410, and surely those who constructed it would be considered disciples of Jesus Christ. As would the residents of Hanover, Germany who, during the fourteenth century, placed a huge inverted (and encircled) five-pointed star on the steeple of their Marktkirche or Market Church.[22]

And then there is the north rose window found in Sens Cathedral in France (A.D. 1140–1164). Not only is there a stylized inverted pentagram taking up the majority of this window's space, but if one looks closely enough they will see that there is a depiction of the Lord Jesus Christ right in the center of this stained-glass marvel.[23]

We must not neglect to mention the fact that there are early Christian artworks depicting the Star of Bethlehem (i.e., the "Star in the East") as an inverted pentagram. The golden interlaced star shown in the Berthold Missal is a particularly striking and beautiful example. It was drawn in a Benedictine Abbey in Weingarten Germany sometime between A.D. 1200 and 1232.[24] Another five-pointed nativity star with one ray on the bottom can be seen at the top of a late twelfth-century pillar inside the Cathedrale Saint-Sauveur in France.[25]

What did the inverted, five-pointed star mean to the early Christians? A clue may be found in some of the artworks of the Greek and Russian Orthodox churches. In some paintings that illustrate the events that occurred on the Mount of Transfiguration, artists from these denominations depict the Redeemer of the world standing before a large, inverted five-pointed star (sometimes with an elongated ray on the bottom).[26] The apostle Peter said of himself and the other two apostles who witnessed the transfiguration of the Lord on this mountain that they received the "more sure word of prophecy" and because of this the "day star" arose in their hearts.[27] Both the NIV (New International Version) and NASB (New American Standard Bible) translations of the New Testament change the words "day star" to "morning star."[28] Thus, there is an ancient Christian connection between the inverted five-pointed star and one of the titles of the holy Messiah.

The Inverted Star and the Devil

How did this ancient and venerable Christian symbol ever become associated with Satan, the arch-enemy of Jesus Christ? It appears that the person who made the first formal connection between this emblem and the Adversary was a Frenchman named Alphonse Louis Constant (1810–1875). He was ordained as a deacon in the Roman Catholic Church in 1835, but he had to abandon his plan to be ordained as a priest the following year because he was defrocked. This drastic, but understandable, action was taken against Alphonse because he was deeply involved in studying the occult.

Alphonse eventually decided to give himself a pseudonym (Eliphas Levi Zahed) and then he began to publish books on occultic subjects. Alphonse indicated in his writings that he was aware of the Hebrew Day of Atonement ritual wherein goats became symbols of sin[29] and when he published his first book in 1854 he used this biblical imagery to mock the Roman Catholic Church. In this volume he printed a drawing of a priestly hand making "the sign of excommunication" and fashioned it so that the shadow being cast by it looked like a demonic goat's head and vaguely followed the outline of an inverted five-pointed star.[30]

The first time that Alphonse made a written connection between the inverted five-pointed star, the goat, and Satan was in a book that he published in 1855[31] and

the first time that he made a pictorial connection between the father of all lies and the inverted star was in a book that he published in 1861.[32] However, it was not until the late twentieth century that this nefarious and twisted combination of symbols was introduced into the broader culture of the world.

Despite the private interpretation that a single, embittered individual assigned to the inverted five-pointed star in the mid-nineteenth century it must not be forgotten, as one non-LDS commentator puts it, that this icon *"originally had no demonic meaning*, but over the centuries it has *mistakenly* come to represent evil."[33]

NOTES

1. In 1985 LDS Church Architect Emil B. Fetzer stated that the inverted stars on early LDS temples were not sinister but were "symbolic of Christ." He said that when the LDS Church "uses the pentagram or sunstone in an admirable, wholesome and uplifting context, this does not preclude another organization's using the same symbols in an evil context" ("The Public Forum," *Salt Lake Tribune*, 13 November 1985, A–15).

2. See D&C 124:42. Joseph Smith disclosed in the early 1830's that by way of vision he had "seen the inside of every building that had been built unto the Lord upon this earth" in previous dispensations (Truman O. Angell Journal, 5, LDS Church Archives, Salt Lake City, Utah).

3. "In the afternoon, Elder William Weeks (whom I had employed as architect of the temple), came in for instruction. I instructed him in relation to the circular windows designed to light the offices in the dead work of the arch between stories. He said that round windows in the broad side of a building were a violation of all the known rules of architecture, and contended that they should be semicircular—that the building was too low for round windows. I told him I would have the circles, if he had to make the temple ten feet higher than it was originally calculated; that one light at the center of each circular window would be sufficient to light the whole room; that when the whole building was thus illuminated, the effect would be remarkably grand. 'I wish you to carry out my designs. *I have seen in vision the splendid appearance of that building illuminated, and will have it built according to the pattern shown me'*" (B. H. Roberts, ed., *History of the Church*, rev. ed. [Salt Lake City: The Church of Jesus Christ of Latter-day Saints, 1932–1951], 6:196–97, emphasis added; cited hereafter as *HC*). The Prophet evidently saw, in vision, the details of the symbols that he used to decorate the Nauvoo Temple. Josiah Quincy reports: "Near the entrance to the temple we passed a workman who was laboring upon a huge sun, which he had chiseled from the solid rock . . . 'General Smith,' said the man, looking up from his task, 'is this like *the face you saw in vision?'* 'Very near it,' answered the prophet" (Josiah Quincy, *Figures of the Past From the Leaves of Old Journals* [Boston: Roberts Brothers, 1883], 389, emphasis added).

4. Wandle Mace, Autobiography, 207, Special Collections, Harold B. Lee Library, Brigham Young University, Provo, Utah, emphasis added. Joseph Smith revealed the connection between the heavenly woman and the Church in his revision of the Bible. He modified Revelation chapter 12 verses 1 and 7 to read: "And there appeared a great sign in heaven, in the likeness of things on the earth; a woman clothed with the sun, and the moon under her feet, and upon her head a crown of twelve stars [T]he woman . . . was the Church of God" (JST Revelation 12:1, 7). The New Testament refers to the heavenly Church as the "Church of the Firstborn" (Hebrews 12:23) and when Joseph Smith intro-

duced the ordinances that were to be practiced in the Nauvoo Temple he made it known that they pertained directly to "the Church of the Firstborn" (*HC,* 5:1–2). Elder Franklin D. Richards said that the woman being "clothed with the sun" had reference to her "putting on her royal robes of the Priesthood" (Brian H. Stuy, ed., *Collected Discourses* [Burbank, California: B.H.S. Publishing, 1987–1992], 4:374; compare with the old Nauvoo Temple weathervane angel who was dressed in priestly robes). A poem about the Morning Star—published in the *Millennial Star* in 1843—combines the elements of the "Morning Star," the "Millennial morning," and the "Bridegroom" coming to wed His Bride (*Millennial Star,* vol. 4, no. 7, November 1843, 112). It should be apparent from the foregoing that the sun, moon, and stars on the Nauvoo Temple *do not* represent the three degrees of glory that are mentioned in 1 Corinthians 15:40–42 and D&C 76. They are not arranged in the ascending order of the post-resurrection rewards (stars [telestial], moon [terrestrial], sun [celestial]) but rather in cosmological order as they would be seen from the earth (moon, sun, stars).

5. *Deseret Evening News,* vol. 13, no. 228, 20 August 1880, 3. The architectural drawing of the old Nauvoo Temple faÁade shows that in the early stages of construction the designers planned to place inverted stars with equal-length rays on square stones. These stars would have matched the size of those found in the round stained-glass windows that were to be located next to them (for an illustration see *Improvement Era,* October 1968, 16).

At some point in time it was decided that the starstones would be rectangular in shape and the architect revised the form of the stars so that the bottom and top two rays were elongated (for an illustration see *Ensign,* July 1977, 82). This configuration may be related to the notion that "the bright and morning Star / Spreads its glorious light afar" (*Times and Seasons,* vol. 1, no. 7, May 1840, 111). It may likewise correspond to Parley P. Pratt's poem called "The Morning Star" which says, "Lift up your heads—behold from far / A flood of splendor streaming! / It is the bright and Morning Star / In living lustre beaming" (*Millennial Star,* vol. 4, no. 7, November 1843, 112).

Ultimately, it was decided that the bottom ray of the star would be the only one lengthened (for an illustration see Richard N. Holzapfel and T. Jeffery Cottle, *Old Mormon Nauvoo: 1839–1846* [Provo, Utah: Grandin Book, 1990], 97). It should be noted that the starstones of the Nauvoo Temple are located directly above depictions of the "rising" or morning sun (*HC,* 7:323–324), and the elongated ray of each star is pointed down toward the sun as if the star were drawing its light from that source (just as Venus / the Morning Star actually does).

6. Revelation 22:16.

7. See *Messenger and Advocate,* vol. 1, no. 10, July 1835, 160.

8. *Times and Seasons,* vol. 1, no. 7, May 1840, 111.

9. The *Evening and Morning Star* was first published in June, 1832. In the prospectus of this paper (written in February, 1832) William W. Phelps stated that the Evening Star was "the forerunner of the night of the end" of the present age and the Morning Star was "the messenger of the day of redemption," or the Millennial day. Furthermore, he said that his periodical would "borrow its light" just as Venus (the Evening Star and Morning Star) did. He also mentioned "the Lord's house," or temple, in the prospectus (*Times and Seasons,* vol. 5, no. 14, 1 August 1844, 609–11). In the inaugural issue of this paper Elder Phelps reiterated its Millennial connections (see *Evening and Morning Star,* vol. 1, no. 1, June 1832, 6). Parley P. Pratt made the connection between the "day star" and the "morning" of the Millennium in 1837 (*Messenger and Advocate,* vol. 3, no. 28, January 1837, 448). He continued making this connection when he wrote in the prospectus of the *Millennial Star:* "The long night of darkness is now far spent—the truth revived in its primitive simplicity and purity, like *the day-star of the horizon,* lights up the dawn of that effulgent morn when the knowledge of God will cover the earth as the waters cover the sea." He then wrote of "the tabernacle of God and His sanctuary [which] will be

with man, in the midst of the holy cities" (*Millennial Star*, vol. 1, no. 1, May 1840, 1, 9–10, emphasis added; cited in *HC*, 4:145, footnote.). It might be noted here that in some renditions of Ecclesiasticus 50:5–7 (also called Ben Sira or the Book of Sirach) there is a connection made between the Morning Star and the ancient temple of Israel (for one rendition of this passage see *The Contributor*, vol. 3, no. 2, November 1881, 55).

10. *HC*, 7:401.

11. Truman O. Angell's 1854 architectural drawing of the east side of the Salt Lake Temple shows one inverted five-pointed star with an elongated bottom ray between two upright five-pointed stars in the top of the tall windows. Both of these types of stars were eventually moved to keystones above the doors and windows (upright on the towers / inverted on the main body of the temple) and their rays were equalized in length.

12. Truman O. Angell was the architect for the Eagle Gate. Since he also worked as an architect on the Nauvoo, Logan, and Salt Lake temples it would be logical for the inverted and elongated star on the Eagle Gate to have a meaning similar to, or the same as, the temple stars. The Eagle Gate displays three symbols—an eagle, a beehive, and an inverted star with an elongated bottom ray. Some of the early Saints saw the eagle as a representation of "American liberty" (Parley P. Pratt, *The Autobiography of Parley P. Pratt* [Salt Lake City: Deseret Book, 1985], 149). The beehive, of course, represented the territory of "Deseret" (see Ether 2:3)—which the Saints viewed as "the kingdom of God" on the earth (George D. Watt, ed., *Journal of Discourses* [London: Latter-Day Saint's Book Depot, 1858], 5:129; ibid., 5:164–165). In 1849 some of the Saints decorated a flag with a beehive—the emblem of the proposed "State of Deseret"—and they also adorned it with a "rising star." A toast was then offered: "May the new star Deseret be as the star of Bethlehem, a guide to the nations" (B. H. Roberts, *A Comprehensive History of The Church of Jesus Christ of Latter-day Saints* [Provo, Utah: Brigham Young University Press, 1965], 3:434). Orson F. Whitney made the connection between the "rising . . . star" and "Deseret" (*The Contributor*, vol. 11, no. 3, January 1890, 120) and so did Jedediah M. Grant, but he specifically linked "Deseret" to the rising "day star" or Morning Star (*The Contributor*, vol. 4, no. 9, June 1883, 324). It is curious, and perhaps significant, that one reporter learned from "Mr. William Weeks" (the Nauvoo Temple architect) that the moons on the pilasters of that temple "represent the rising moon in its first quarter" (*Springfield Republican*, Springfield, Massachusetts, 19 October 1844). Another reporter was told that the sun on the Nauvoo Temple was a "rising sun" (*Globe*, Washington, D.C., 19 November 1844). Hence, the Nauvoo Temple pillars were decorated with a rising moon, a rising sun, and a rising star (cf. Isaiah 60:1; D&C 115:5–6).

13. For a photograph of Commodore Matthew Perry's 1854 American flag—with all five-pointed stars inverted—see Margaret Sedeen, *Star-Spangled Banner: Our Nation and Its Flag* (Washington, D.C.: The National Geographic Society, 1993), 69.

14. For one illustration see Sedeen, *Star-Spangled Banner: Our Nation and Its Flag*, 70.

15. For example see Henry Woodhead, ed., *Echoes of Glory: Arms and Equipment of the Confederacy* (Alexandria, Virginia: Time-Life Books, 1998), 83, 167, 259; William C. Davis, *Brothers in Arms* (Edison, New Jersey: Chartwell Books, 1995), 124, 138–39, 141; Don Troiani, *Regiments and Uniforms of the Civil War* (Mechanicsburg, Pennsylvania: Stackpole Books, 2002), 206; William C. Davis, *The Illustrated Encyclopedia of the Civil War: The Soldiers, Generals, Weapons, and Battles* (Guildford, Connecticut: Lyons Press, 2001), 52, 99, 105; Neil Kagan, ed., *Great Battles of the Civil War* (Birmingham, Alabama: Oxmoor House, 2002), 54, 146, 274, 375, 434; Ron Field and Robin Smith, *Uniforms of the Civil War* (Guildford, Connecticut: Lyons Press, 2001), 50; Philip Katcher, *Flags of the Civil War* (Oxford, England: Osprey Publishing, 2000), 36 [notice that this star has an elongated bottom ray], 114; Bryan S. Bush, *The Civil War Battles of the Western Theatre* (Paducah, Kentucky: Turner

Publishing Co., 2000), 143. The inverted five-pointed star was considered to be so harmless during the Civil War era that around 1861 a person in Kansas had no qualms about emblazoning it on a baby blanket (see Sedeen, *Star-Spangled Banner: Our Nation and Its Flag*, 195) and soldiers did not hesitate to display it in the outline of their battle flag's Christian cross (Kagan, ed., *Great Battles of the Civil War*, 314).

16. See Gordon Hardy, ed., *Above and Beyond: A History of the Medal of Honor from the Civil War to Vietnam* (Boston: Boston Publishing, 1985), 124. Since the Navy was the first branch of the military to adopt the inverted star insignia it is perhaps relevant that in ancient times the "Star of the Sea" was sometimes depicted as an inverted five-pointed star (for an illustration from A.D. 1533 see Harold Bayley, *The Lost Language of Symbolism* [London: Williams and Norgate, 1912], 1:257).

17. See Numbers 24:17. "In Christian writings, the Messiah is seen in the star symbolism of Numbers 24:17 (as in the Messianic Anthology found in the Dead Sea Scrolls)" (Michael Green, *The Second Epistle General of Peter and the General Epistle of Jude* [Grand Rapids, Michigan: Eerdmans, 1987], 99). Some of the Jews in the ancient world said that the "Star" of Numbers 24:17 "is the Messiah" (Rabbi Sohar Cadash [14th century], vol. 85, c. 340). The pseudepigraphical *Testament of Judah* (4:24) says of this "Star" that He will be found "walking with the sons of men in meekness and righteousness, and no sin shall be found in Him." Alfred Edersheim notes that "the so-called Messiah Haggadah *(Aggadoth Mashiach)* opens as follows: 'A star shall come out of Jacob [Numbers 24:17]. There is a Boraita in the name of the Rabbis [which speaks of the] heptad in which the Son of David cometh . . . [And it is said that] in the fifth [there will be] great abundance and *the Star shall shine forth from the East, and this is the Star of the Messiah*. And it will shine *from the East* for fifteen days'" (Alfred Edersheim, *The Life and Times of Jesus the Messiah* [Grand Rapids, Michigan: Eerdmans, 1971], 1:211–12, emphasis added). "Our Rabbis," says a text written about A.D. 1760, "have a tradition that in the week in the which the Messiah will be born, there will be *a bright Star in the east, which is the Star of the Messiah*" (Pesikita, fol. 58, c. 1, emphasis added). The Joseph Smith Translation of Matthew 3:2 reads: "Where is the child that is born, *the Messiah of the Jews?* For we have seen *His star in the east*, and have come to worship Him" (emphasis added). Thus, a star in the eastern sky was associated in ancient times with the Messiah. The Morning Star shines in the eastern sky but that is not to say that the star of Bethlehem was necessarily the Morning Star. Nevertheless, this loose connection may explain why some early Christians depicted the star of Bethlehem as an inverted five-pointed star (a symbol of Venus).

18. See Ernst Lehner, *Symbols, Signs, and Signets* (New York: World Publishing, 1950), 107. Why would the early Christians associate Jesus Christ with the five-pointed star? The Savior called Himself "the bright . . . morning star" (Revelation 22:16) which is the planet Venus. "The pentagram within a circle . . . can be called a design-iconic symbol for the planet Venus. This planet is the only one in our system that can clearly be identified with a graphic structure unambiguously derived from a plotting of its astronomical movements in space. . . . If one knows the ecliptic . . . and can pinpoint the present position of the planets in relation to the constellations of fixed stars in the zodiac . . . it is possible to mark the exact place in the 360 degrees of the zodiac where the Morning Star first appears shortly before sunrise after a period of invisibility. If we do this, wait for the Morning Star to appear again 584 days later (the synodic orbital time of Venus) and mark its position in the zodiac, and then repeat this process until we have five positions of Venus as the Morning Star, we will find that exactly eight years plus one day have passed. If we then draw a line from the first point marked to the second point marked, then to the third, and so on, we end up with a pentagram. . . . 'It was only the planet Venus that possessed the five-pointed star sign. Not one of the innumerable stars above us can by its orbit recreate this sign. . . . Moreover, the points of the pentagram pointed to five different groups of stars

or constellations It was only later discovered that the five points moved slowly throughout the vault of heaven as if they were the hands of a giant clock. . . . Over a period of four years each point of the pentagram was displaced one day, a 365th part of the zodiac circle After 1,460 solar years the 'hands' stood at their original places'" (Carl G. Liungman, *Dictionary of Symbols* [Denver, Colorado: ABC-CLIO, 1991], 333–34). The five-pointed star would appear either upright or invert-ed depending upon when a person began to observe and plot the positions of Venus.

Another, and shorter, way to arrive at the star design would be as follows. In the same volume just cited [28:23, pentagon] it is stated: "If one plots the position of the planet Venus in the zodiac when it first appears as the Morning or Evening star after a period of invisibility, then waits until Venus disappears again, then repeats the procedure the next time Venus reappears either as the Morning or the Evening star, and does this for a period of 1,460 days (i.e., exactly four years), and a line is drawn between each of the positions, from the first to the second, etc. the design revealed when all the points have been joined together is that of an exactly regular pentagon." If lines are then drawn to connect each of the interior points of the pentagon a five-pointed star is formed.

Also notice that if each of the sides of an upright pentagon are extended in both directions, to a distance equal to the length of the side, the lines will touch and an inverted star will be formed.

19. See Georgette Corcos, ed., *The Glory of the Old Testament* (New York: Villard Books, 1984), 158.

20. See Hans R. Hahnloser, *Villard de Honnecourt* (Graz, Austria: Akademische Druk-u. Verlagsanstalt, 1972), plate #18; Theodore Bowie, *The Sketchbook of Villard de Honnecourt* (Bloomington, Indiana: Indiana University Press, 1959), 88–89.

21. See Martin Hꞏrlimann, *French Cathedrals* (New York: Viking Press, 1967), 149; Roland Bechmann, *Villard de Honnecourt* (Paris: Picard, 1991), 334.

22. See Christian Norberg–Shulz, *The Concept of Dwelling: On the Way to Figurative Architecture* (New York: Rizzoli, 1985), 74.

23. See Lawrence Lee, *Stained Glass* (New York: Crown Publishers, 1976), 22. There are numer-ous inverted five-pointed stars surrounding a statue of Mary and the Christ child in the French Cathedral of Chartres (*ca.* A.D. 1150).

24. See *Revell Bible Dictionary* (Old Tappan, New Jersey: Fleming H. Revell, 1990), 659; Gertrud Schiller, *Iconography of Christian Art* (Greenwich, Connecticut: New York Graphic Society, 1971), 1, plate 271.

25. See Yves Christe, et. al., *Art of the Christian World, A.D. 200–1500: A Handbook of Styles and Forms* (New York: Rizzoli, 1982), 346.

26. See Leonid Ouspensky and Vladimir Lossky, *The Meaning of Icons* (Boston, Massachusetts: Boston Book and Art Shop, 1952), 213; Engelina Smirnova, *Moscow Icons: 14th–17th Centuries* (Oxford: Phaidon, 1989), figure 121; V. N. Lazarev, *Moscow School of Icon Painting* (Moscow: Ishkusstvo, 1971), figures 25 and 48.

27. 2 Peter 1:19; see also D&C 131:5. Joseph Smith connected the ideas of having "the day Star arise" in one's heart, receiving the "more sure word of prophecy," and "making [one's] calling and election sure" (Andrew F. Ehat and Lyndon W. Cook, eds., *The Words of Joseph Smith: The Contemporary Accounts of the Nauvoo Discourses of the Prophet Joseph* [Orem, Utah: Grandin Book, 1991], 207; compare Bruce R. McConkie, *Doctrinal New Testament Commentary* [Salt Lake City: Bookcraft, 1973], 3:356).

28. See Revelation 2:26, 28.

29. See Leviticus 16:5, 7–10, 20–22.

30. This book was called *The Doctrine of Transcendental Magic*. For the illustration under discus-sion see Eliphas Levi, *Dogma et Rituel de la Haute Magie*, translated by Arthur E. Waite (England: Rider and Co., 1896), vol. 1, "The Candidate," 2.

31. This book was called *The Ritual of Transcendental Magic*. For the text see Levi, *Dogma et Rituel de la Haute Magie*, 2:35–36. Alphonse's first two books were published together as a single volume in 1856 under the title *Transcendental Magic: Its Doctrine and Ritual,* but this combined set was not translated into English (by Arthur Edward Waite) until 1896.

32. This book was called *The Key of the Great Mysteries*. For an illustration see Eliphas Levi, *La Clef des Grands MystÉres* (Paris: La Diffusion Scientifique, 1976), 244. In 1861 Alphonse made a second visual connection between Satan and the inverted star when he published *The Mysteries of the Qabalah*. For an illustration see Eliphas Levi, *The Mysteries of the Qabalah* (Wellingborough, Northamptonshire: Thorsons Publishers Ltd., 1974), 59.

33. Tom Ogden, *Wizards and Sorcerers: From Abracadabra to Zoroaster* (New York: Facts On File, 1997), 172, emphasis added. Some critics feel that even though the inverted five-pointed star has an ancient Christian background it should be abandoned by the LDS Church simply because some modern groups have come to regard it as a sign of evil (note that modern occultic groups also make prominent use of the upright five-pointed star). The inverted cross of the apostle Peter provides a good parallel. Even though some modern groups have come to view this as an evil emblem it has not caused the Roman Catholic Church to abandon it as a Christian symbol. Latter-day Saints are not the only modern Christians to publicly display the inverted five-pointed star. Anyone who visits Manger Square in Bethlehem during the Christmas season will see that the city's nativity scene depicts the Star of Bethlehem as a five-pointed star with a single ray pointing down.

SELECTED BIBLIOGRAPHY

BOOKS

Brewster, Hoyt W. *Doctrine and Covenants Encyclopedia*. Salt Lake City: Bookcraft, 1988.

Bromiley, G. W., ed. *The International Standard Bible Encyclopedia*, 4 vols. Grand Rapids, Mich.: Eerdmans, 1979.

Clark, James R. *Messages of the First Presidency of The Church of Jesus Christ of Latter-day Saints*, 6 vols. Salt Lake City: Bookcraft, 1965-1975.

Comay, Joan. *The Temple of Jerusalem*. London: Weidenfeld & Nicolson, 1975.

Cook, Lyndon W. *The Revelations of the Prophet Joseph Smith*. Salt Lake City: Deseret Book, 1985.

D'alviella, Goblet. *The Migration of Symbols*. Westminster: Archibald Constable and Co., 1894.

de Vries, Ad. *Dictionary of Symbols and Imagery*. Amsterdam: North-Holland Publishing, 1974.

Draper, Richard D. *Opening the Seven Seals: The Visions of John the Revelator*. Salt Lake City: Deseret Book, 1991.

Edersheim, Alfred. *The Temple: Its Ministry and Services. Updated edition*. Peabody, Mass.: Hendrickson Publishers, 1994.

Ehat, Andrew F., and Lydon W. Cook. *The Words of Joseph Smith*. Orem, Utah: Grandin Book, 1991.

Eliade, Mircea. *Cosmos and History: The Myth of the Eternal Return*. New York: Harper, 1959.

Frankel, Ellen and Betsy Platkin Teutsch. *The Encyclopedia of Jewish Symbols*. Northvale, N.J.: Jason Aronson, 1992.

Gorton, Clay H. *Language of the Lord*. Bountiful, Utah: Horizon, 1993.

Hall, James. *Hall's Illustrated Dictionary of Symbols in Eastern and Western Art*. Cambridge: University Press, 1994.

Hamlin, A. D. F. *A History of Ornament: Ancient and Medieval*. New York: The Century Company, 1916.

Heinerman, Joseph. *Temple Manifestations*. Salt Lake City: Magazine Printing and Publishing, 1974.

Hersey, George. *The Lost Meaning of Classical Architecture*. Cambridge: MIT Press, 1988.

Holzapfel, Richard Neitzel. *Every Stone A Sermon*. Salt Lake City: Bookcraft, 1992.

Journal of Discourses. 26 vols. London: Latter-day Saints' Book Depot, 1854-1886.

Kenney, Scott G., ed. *Wilford Woodruff's Journal*. 9 vols. Midvale, Utah: Signature Books, 1983-85.

Kittel, Gerhard. *Theological Dictionary of the New Testament.*, 10 vols. Grand Rapids, Mich.: Eerdmans, 1964-76.

Larson, Karl A., and Katharine Miles Larson, eds. *Diary of Charles Lowell Walker.* 2 vols. Logan, Utah: Utah State University Press, 1980.

Liungman, Carl G. *Dictionary of Symbols.* Oxford: ABC-CLIO, 1991.

Ludlow, Daniel H., ed. *Encyclopedia of Mormonism.* 4 vols. New York: Macmillan, 1992.

Lundquist, John M. *The Temple: Meeting Place of Heaven and Earth.* Thames and Hudson, 1993.

Lundwall, N. B., comp. *Temples of the Most High.* Collector's edition. Salt Lake City: Bookcraft, 1993.

Madsen, Truman G., ed. *The Temple in Antiquity: Ancient Records and Modern Perspectives.* Provo, Utah: BYU Religious Studies Center, 1984.

McAllister, D. M. *A Description of the Great Temple.* Illustrated edition. Salt Lake City: Bureau of Information, 1912.

McClung, William Alexander. *The Architecture of Paradise: Survivals of Eden and Jerusalem.* Berkeley: University of California Press, 1983.

McConkie, Bruce R. *Mormon Doctrine.* 2d ed. Salt Lake City: Bookcraft, 1979.

_____. *Doctrinal New Testament Commentary.* 3 vols. Salt Lake City: Bookcraft, 1965-73.

_____. *A New Witness for the Articles of Faith.* Salt Lake City: Deseret Book, 1985.

McGavin, E. Cecil. *The Nauvoo Temple.* Salt Lake City: Deseret Book, 1962.

Myers, Allen C., ed. *The Eerdmans Bible Dictionary.* Grand Rapids, Mich.: Eerdmans, 1987.

Olderr, Steven. *Symbolism: A Comprehensive Dictionary.* London: McFarland & Co., 1986.

Nibley, Hugh W. *The Message of the Joseph Smith Papyri: An Egyptian Endowment.* Salt Lake City: Deseret Book, 1975.

_____. *Abraham in Egypt.* Salt Lake City: Deseret Book, 1981.

_____. *Mormonism and Early Christianity.* Salt Lake City: Deseret Book and FARMS, 1987.

_____. *Temple and Cosmos.* Salt Lake City: Deseret Book and FARMS, 1992.

Parry, Donald W., ed. *Temples of the Ancient World: Ritual and Symbolism.* Salt Lake City: Deseret Books and FARMS, 1994.

Pratt, Parley P. *The Angel of the Prairies.* Salt Lake City: Deseret News and Publishing Establishment, 1880.

Ransome, Hilda M. *The Sacred Bee.* Boston: Houghton Mifflin, 1937.

Reznick, Leibel. *The Holy Temple Revisited.* Northvale, N.J.: Jason Aronson, 1990.

Ricks, Stephen D., and John W. Welch, eds. *The Allegory of the Olive Tree: The Olive, the Bible, and Jacob 5.* Salt Lake City: Deseret Book and FARMS, 1994.

Roberts, B. H. *A Comprehensive History of The Church of Jesus Christ of Latter-day Saints.* 6 vols. Provo, Utah: The Church of Jesus Christ of Latter-day Saints, 1930.

Smith, Joseph. *History of The Church of Jesus Christ of Latter-Day Saints.* 7 vols. Salt Lake City: The Church of Jesus Christ of Latter-day Saints, 1932-51.

Smith, Joseph Fielding, comp. *Teachings of the Prophet Joseph Smith*. Salt Lake City: Deseret Book, 1976.

_____. *Church History and Modern Revelation*. 2 vols. Salt Lake City: The Council of the Twelve Apostles, 1953.

_____. *Doctrines of Salvation*. 3 vols. Salt Lake City: Bookcraft, 1954-56.

Strong, James. *Strong's Exhaustive Concordance of the Bible*. Nashville: Abingdon, 1986.

Talmage, James E. *The House of the Lord*. Salt Lake City: Bookcraft, 1963.

Temple Souvenir Album. Salt Lake City: Magazine Printing Co., 1982.

Vine, W. E. *Vine's Expository Dictionary of Old and New Testament Words*. Old Tappan, NJ: Fleming H. Revell Co., 1985.

Welch, John W. *The Sermon at the Temple and the Sermon on the Mount*. Salt Lake City: Deseret Book and FARMS, 1990.

Whitney, Orson F. *Life of Heber C. Kimball*. Salt Lake City: Juvenile Instructor Office, 1888.

Wigram, George V. *The New Englishman's Hebrew Concordance*. Peabody, Mass.: Hendrickson, 1984.

ARTICLES

Arrington, Leonard J. "Oliver Cowdery's Kirtland, Ohio, 'Sketch Book.'" *Brigham Young University Studies*, vol. 12, no. 4 (Summer 1972), 410-26.

Anderson, James H. "The Salt Lake Temple." *The Contributor*, vol. 14, no. 6 (April 1893), 243-303.

Angell, Truman O. "The Temple." *Deseret News*, 17 August 1854.

_____. "The Salt Lake City Temple." *Millennial Star*, vol. 36, no. 18 (5 May 1874), 273-75.

Benson, Ezra Taft. "What I Hope You Will Teach Your Children about the Temple." *Ensign*, August 1985, 6-10.

Blodgett, Terry M. "Tracing the Dispersion." *Ensign*, February 1994, 64-70.

Christenson, Allen J. "The Waters of Destruction and the Vine of Redemption." In Richard D. Draper, ed., *A Witness of Jesus Christ*. Salt Lake City: Deseret Book, 1990. 37-52.

Compton, Todd M. "The Handclasp and Embrace as Tokens of Recognition." In *By Study and Also By Faith*, edited by John M. Lundquist and Stephen D. Ricks. 2 vols. Salt Lake City: Deseret Book and FARMS, 1990, 1:611-42.

Cook, Lyndon W. "The Apostle Peter and the Kirtland Temple." *Brigham Young University Studies*, vol. 15, no. 4 (Summer 1975), 550-52.

Doxey, Graham W. "Missouri Myths." *Ensign*, April 1979, 64-65.

Doxey, Roy W. "Accepted of the Lord: The Doctrine of Making Your Calling and Election Sure." *Ensign*, July 1976, 50-53.

Esplin, Ronald K. "'A Place Prepared': Joseph, Brigham and the Quest for Promised Refuge in the West." *Journal of Mormon History*, vol. 9 (1982), 85-111.

Gane, Roy. "'Bread of the Presence' and Creator-in-Residence." *Vetus Testamentum*, vol. 42, no. 2 (1992), 179-203.

Gentry, Leland H. "Adam-ondi-Ahman: A Brief Historical Survey." *Brigham Young University Studies*, vol. 13, no. 4 (Summer 1973), 553-76.

Griggs, Wilfred C. "The Tree of Life in Ancient Cultures." *Ensign,* June 1988, 26-31.

Hamblin, William J., Daniel C. Peterson, and John Gee. "'And I Saw the Stars': The Book of Abraham and Ancient Geocentric Astronomy." Unpublished manuscript, Brigham Young University, August 1991. 48 pp.

Hamilton, Mark C. "The Salt Lake Temple: A Symbolic Statement of Mormon Doctrine." In *The Mormon People: Their Character and Traditions*, edited by Thomas G. Alexander. Provo: Brigham Young University Press, 1980. 103-27.

Jessee, Dean C. "The Kirtland Diary of Wilford Woodruff." *Brigham Young University Studies*, vol. 12, no. 4 (Summer 1972), 365-99.

_____. "The John Taylor Nauvoo Journal." *Brigham Young University Studies*, vol. 23, no. 3 (Summer 1983), 1-105.

Ludlow, Victor L. "The Temple Structure as a Symbol." *Principles and Practices of the Restored Gospel.* Salt Lake City: Deseret Book, 1992. 360-63.

Lund, Gerald N. "The Mysteries of God Revealed by the Power of the Holy Ghost." In *The Book of Mormon: First Nephi, The Doctrinal Foundation*, edited by Monte S. Nyman and Charles D. Tate, Jr. Provo, Utah: BYU Religious Studies Center, 1988. 151-59.

Matthews, Robert J. "Adam-ondi-Ahman," *Brigham Young University Studies*, vol. 13, no. 1 (Autumn 1972), 27-35.

McConkie, Joseph Fielding. "The Heavens Testify of Christ." In *Studies in Scripture: Volume 2, The Pearl of Great Price*, edited by Robert L. Millet and Kent P. Jackson. Salt Lake City: Randall Book, 1985. 239-45.

_____. "Premortal Existence, Foreordinations, and Heavenly Councils." In *Apocryphal Writings and the Latter-day Saints*, edited by Wilfred C. Griggs. Provo, Utah: BYU Religious Studies Center, 1986. 173-98.

_____. "A Scriptural Search for the Ten Tribes and Other Things We Lost." *Religious Education Faculty Summer Lecture*, Brigham Young University, 25 June 1987. 35 pp.

Millet, Robert L., and Joseph Fielding McConkie. "A Scriptural Search for the Ten Tribes," pp. 103-17. In *Our Destiny: The Call and Election of the House of Israel.* Salt Lake City: Bookcraft, 1993.

Nibley, Hugh W. "Decorative Hardware with Intricate Meanings." In *The Manti Temple Centennial: 1888-1988*, edited by Victor L. Rasmussen. Provo, Utah: Community Press, 1988. 33-36.

_____. "Facsimile No. 1, by the Numbers." *Improvement Era*, October 1969, 85-88.

_____. "The Three Facsimiles from the Book of Abraham." Provo, Utah: The Foundation for Ancient Research and Mormon Studies, 1980, 92 pp.

Patrich, Joseph. "Reconstructing the Magnificent Temple Herod Built." *Bible Review*, October 1988, 16-29.

Pratt, John P. "Passover: Was It Symbolic of His Coming?" *Ensign*, January 1994, 38-45.

_____. "The Restoration of Priesthood Keys on Easter 1836, Part 1: Dating the First Easter." *Ensign,* June 1985, 59-68.

_____. "The Restoration of Priesthood Keys on Easter 1836, Part 2: Symbolism of Passover and of Elijah's Return." *Ensign,* July 1985, 55-64.

Rhodes, Michael D. "The Book of Abraham: Divinely Inspired Scripture." In *Review of Books on the Book of Mormon*, edited by Daniel C. Peterson. Vol. 4. Provo, Utah: Foundation for Ancient Research and Mormon Studies, 1992. 120-26.

_____. "The Joseph Smith Hypocephalus . . . Seventeen Years Later." Provo, Utah: Foundation for Ancient Research and Mormon Studies, 1994, 14 pp.

Richards, Paul C. "The Salt Lake Temple Infrastructure: Studying It Out in Their Minds." *Brigham Young University Studies*, vol. 36, no. 2 (1996-97), 203-25.

Ricks, Stephen D. "The Appearance of Elijah and Moses in the Kirtland Temple and the Jewish Passover." *Brigham Young University Studies*, vol. 23, no. 4 (Fall 1983), 483-86.

Robinson, Stephen E. "Eternities That Come and Go." *Religious Studies Center Newsletter*, vol. 8, no. 3 (3 May 1994), 1, 4.

Strange, John. "The Idea of Afterlife in Ancient Israel: Some Remarks on the Iconography in Solomon's Temple." *Palestine Exploration Quarterly,* vol. 17 (January - June 1985), 35-40.

Welch, John W. "New Testament Word Studies." *Ensign,* April 1993, 28-30.

Wittorf, John H. "An Historical Investigation of the Ruined 'Altars' at Adam-ondi-Ahman, Missouri." *Newsletter and Proceedings of the Society for Early Historic Archeology*, no. 113 (15 April 1969), 1-8.

Woods, Fred E. "The Waters Which Make Glad the City of God: The Water Motif of Ezekiel 47:1- 12." In *A Witness of Jesus Christ*, edited by Richard D. Draper. Salt Lake City: Deseret, 1990. 281-98.

_____. "The Water Imagery in John's Gospel: Power, Purification, and Pedagogy." In *The Lord of the Gospels*, edited by Bruce A. Van Orden and Brent L. Top. Salt Lake City: Deseret Book, 1991. 189-206.

Wyatt, N. "The Significance of the Burning Bush." *Vetus Testamentum*, vol. 36, no. 3 (July 1986), 361-65.

Zimmerman, Dean R. "The Salt Lake Temple." *New Era*, June 1978, 33-36.

INDEX